THE COLOR BOOK

THE COLOR BOOK

By Wendon Blake/Paintings by Ferdinand Petrie

WATSON-GUPTILL PUBLICATIONS/NEW YORK

Copyright © 1981 by Billboard Ltd.

First published 1981 in the United States and Canada by Watson-Guptill Publications,
a division of Billboard Publications, Inc.,
1515 Broadway, New York, N.Y. 10036

Library of Congress Cataloging in Publication Data
Blake, Wendon.
 The color book.
 1. Color in art. 2. Color guides. 3. Painting
—Technique. I. Petrie, Ferdinand, 1925–
II. Title.
ND1488.B55 1981 752 81-277
ISBN 0-8230-0694-8 AACR1

Manufactured in Japan

First Printing, 1981

CONTENTS

Color is Logical. People often say that a "color sense" is some sort of gift, some magic power that you're born with. Supposedly, only a few lucky artists are born with this power, while all the others simply have to struggle with color all their lives. This is a myth—a terribly discouraging myth that leads beginning painters to believe that color is a lot harder than it has to be. The fact is that a good "color sense" isn't merely a matter of instinct, but something you can develop, just like your drawing skill. Observing and painting the colors of nature is a logical process. And there are logical ways to plan a harmonious color scheme, to organize your colors to enhance the composition of your paintings, and to use color to create a convincing sense of space, light, and atmosphere. The purpose of this book is to demonstrate that effective color in a painting isn't a matter of witchcraft, but a logical process that every painter can learn.

Theory Versus Practice. This is a practical book, not a theoretical one. The book focuses entirely on the concrete color problems of the artist who's standing at the easel—or maybe sitting under a tree—trying to paint a convincing picture of what he or she sees. Scientific color theories are generally useless to the working artist who wants practical help in rendering the colors of a tree or a sky. So you'll find no color theory in this book and only a single diagram: the classic color wheel which (as you'll soon see) is actually a practical guide to color mixing and color harmony. Instead of theories, throughout *The Color Book*, you'll find practical guidance on how color behaves in nature and how to make color behave in your paintings.

Observing the Colors of Nature. The first goal of this book is to train your powers of observation so you'll know what to look for in nature. To do this, *The Color Book* devotes a good deal of space to the subject of values. A knowledge of values will enable you to judge the comparative lightness or darkness of your subject—as though your eye were a camera loaded with black-and-white film. You'll also learn about color perspective, which means observing how colors change as they recede from the foreground into the distance. Since the colors of nature also change at different times of the day and in different kinds of weather, you'll learn how the colors of nature behave early in the morning, at midday, in late afternoon, in the evening, under sunny skies, under cloudy skies, and on overcast or misty days. And since light and color are inseparable, you'll

also learn about the behavior of light: how light behaves on cubical, rounded, conical, and irregular forms; how the direction of the light actually molds the forms; and how the light changes in different kinds of weather. You'll find out how to judge whether your subject is high, low, or middle key, and also whether it's high, low, or middle contrast. Finally, you'll find out how to observe the distribution of the values in your subject and to record these values in simple preliminary sketches that will be an invaluable aid in planning a successful picture.

Color Technique. Throughout *The Color Book*, you'll learn how to convert your observations directly into finished paintings. Based on your observation of values, you'll discover how to plan and execute paintings in just three or four basic values—all you'll really need for a successful picture. You'll find out how to mix colors and how to test all the colors on your palette to determine how they behave in mixtures. You'll see how colors affect one another when they're placed side-by-side in a painting—and you'll study how to exploit these side-by-side placements to control the brightness and value of your colors. You'll learn how to develop harmonious color schemes in your pictures and how to compose your color to lead the viewer's eye through the painting. Then you'll look over the shoulder of noted painter Ferdinand Petrie as he paints thirty step-by-step demonstrations that show you a wide range of color techniques—different methods of applying color to the painting surface to produce a variety of color effects.

Oil, Watercolor, and Acrylic. The book is divided into three separate parts on each of the three major painting media: oil, watercolor, and acrylic. For each medium, Ferdinand Petrie paints ten step-by-step demonstrations showing every significant painting operation; there are detailed captions describing the specific colors, color mixtures, and techniques of applying these colors to the painting surfaces. Then, to enable you to compare the methods of handling color in each medium, each series of demonstrations follows the same sequence. For instance, Ferdinand Petrie begins by painting two pictures with limited palettes, then moves on to more advanced techniques in each medium as he shows you various underpainting and overpainting methods. Thus, *The Color Book* is planned not only to broaden your knowledge of color, but to introduce you to a spectrum of painting techniques.

Bristle Brushes. Stiff, white hog bristle brushes do most of the heavy work in oil painting, since they can carry lots of color and they can cover a lot of space quickly. At the top is a squarish brush called a *bright.* (When that squarish shape is a bit longer, it's called a *flat*.) The tapered brush in the middle is called a filbert. At the bottom is a *round* bristle brush—the favorite shape of the Old Masters.

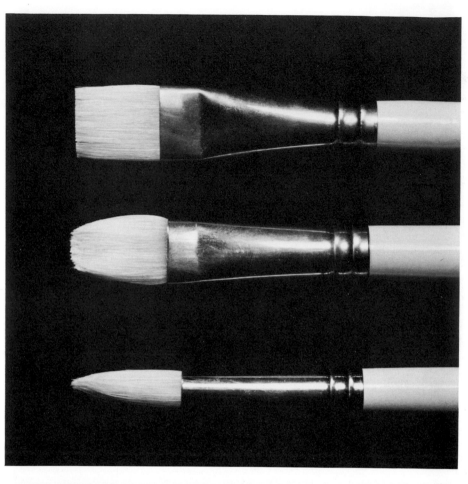

Soft-Hair Brushes. Oil painters frequently do their more detailed work and their blending with brushes that are made of softer, more delicate hairs than the stiff hog bristles. At the top is a small, flat sable brush, and right below that is a round sable that comes to a sharp point that will draw precise lines. The third brush from the top is a soft, white nylon that's become popular because it handles very much like sable, but costs a lot less than the natural hair. At the very bottom is a flat, oxhair brush—another inexpensive and practical substitute for sable.

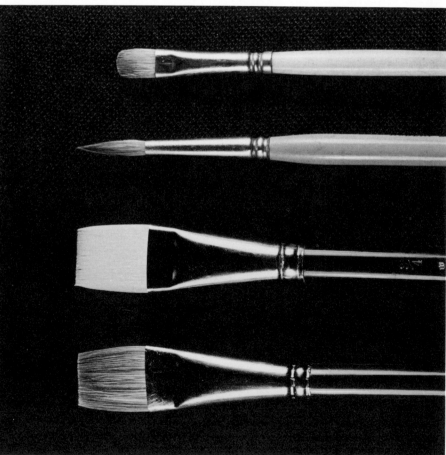

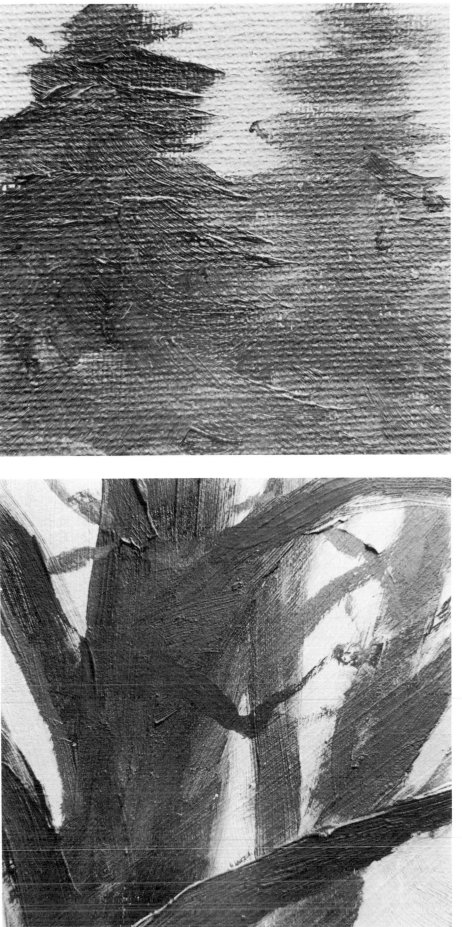

Canvas. The favorite painting surface of most oil painters is canvas—either cotton or linen—or the less expensive canvas boards, which are thin canvas that the manufacturer has pasted onto stiff cardboard. This photograph shows an enlarged section of a painting of trees. You can see how the weave of the canvas softens the brushstroke. At the same time, the irregular surface of the canvas creates tiny pockets of shadow between the fibers. When you choose your canvas, bear in mind that it comes in different degrees of roughness, and remember that the texture of the cloth will influence the character of your color. The rougher the canvas, the more blurred your strokes will look.

Panel. For painters who prefer to work on a smooth surface, the usual choice is a panel made of hardboard or plywood. If you buy your panels in an art supply store, they're usually precoated with a white, water-based *primer* called *gesso*, or possibly with white oil paint. You can also buy raw hardboard or plywood (wherever you buy lumber), plus a tin of gesso, and do the priming yourself. As you can see in this enlarged section of a tree painted on a gesso panel, the strokes of oil paint are sharper and more distinct than the strokes on canvas. They're also smoother. Colors tend to look brighter on a smooth painting surface.

Round Brushes. In contrast to oil painting, most of the work in watercolor painting is normally done with round, soft-hair brushes. At the top is a big, round sable brush that will carry lots of fluid color and cover large areas of watercolor paper with a few strokes. Because sable is so expensive, artists often choose a substitute like oxhair, or like the soft, red nylon brush that's second from the top. Still another substitute for sable is the third brush from the top, which is soft, white nylon. At the bottom of the picture is the classic brush of the Chinese and Japanese masters, made of various inexpensive (and unidentified) animal hairs in a bamboo handle.

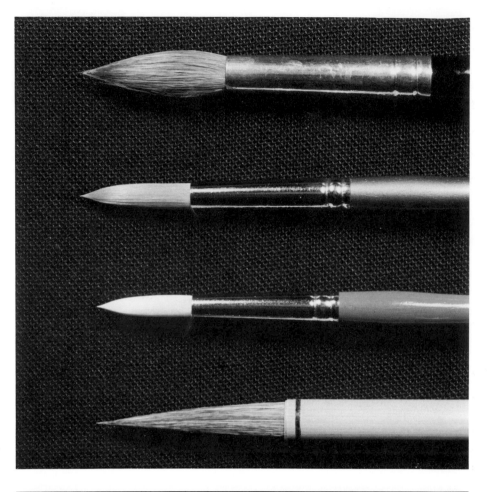

Flat Brushes. To cover a really large area with big, rapid strokes, some watercolorists choose a large, flat brush like the sturdy white nylon at the top of this picture. In the middle is a stiff, white bristle brush—the kind used in oil painting—which is good for two very different purposes: for making rough, ragged strokes of watercolor; and for correcting a watercolor by scrubbing out a passage with clear water. At the bottom is the flat brush used by most watercolorists: a big, soft, oxhair brush for covering broad areas like skies. Big, flat brushes *are* available in sable, of course, but most watercolorists use oxhairs and nylons because they're less costly.

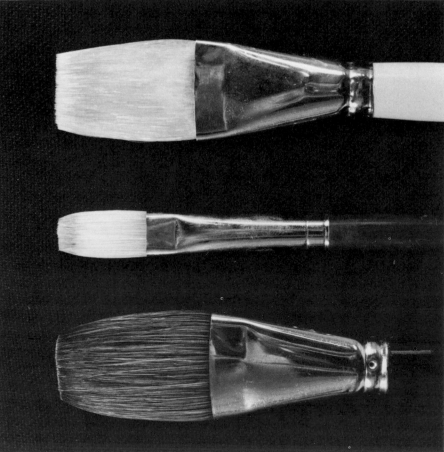

Textured Paper. Watercolorists generally work on paper that has a texture—or *tooth*—that tends to soften and break up the brushstroke, as seen in this detail of another painting of trees. Like canvas, the paper has peaks and valleys that produce microscopic shadows. The rougher the paper, the deeper these pockets of shadow, which add a hint of shadow to your color. The most popular and versatile paper is called *cold-pressed* ("not" in Britain); its mild texture enlivens your strokes without adding too much shadow. The paper called *rough* has a more pronounced texture; despite its slightly shadowy surface, many artists like the ragged texture because it demands bold strokes and powerful color.

Smooth Paper. Like the gesso panels that some artists prefer for oil painting, smooth paper produces brushstrokes that have sharper outlines, as you see in another enlarged section of a painting of some trees. The color also looks brighter on the smooth paper, since the painting surface has an unbroken surface with no microscopic pockets of shadow. However, smooth paper remains a "special taste" for a limited number of watercolorists; most watercolorists prefer a more strongly textured sheet.

Bristle Brushes. Acrylic painters use all sorts of brushes. For bold strokes on a rough-textured surface—like canvas or rough watercolor paper—they're apt to use a big, white, sturdy nylon brush like the one at the top of this picture; a squarish hog bristle brush like the one you see in the middle of the picture; or the tapering bristle brush, called a *filbert*, at the very bottom. All these brushes are extremely versatile in that they'll not only carry stiff color—straight from the tube or diluted with a touch of water—but they'll also work well with highly fluid color that's diluted with lots of water or painting medium. A filbert makes a slightly softer, more ragged stroke than a square brush.

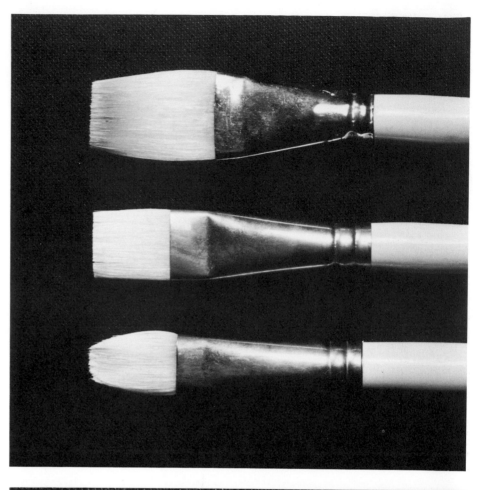

Soft-Hair Brushes. For smooth, precise brushwork, and for acrylic paintings executed in fluid color, soft-hair brushes are the most popular painting tools. At the top is a flat sable brush, similar to the kind used for oil painting. Beneath that is a less expensive, white nylon brush that handles very much like sable. The big, round brush, tapering to a sharp point, is also costly sable, but a less expensive oxhair brush will do the job almost as well. Another inexpensive alternative to a round sable brush is a round, white nylon brush like the one you see at the bottom.

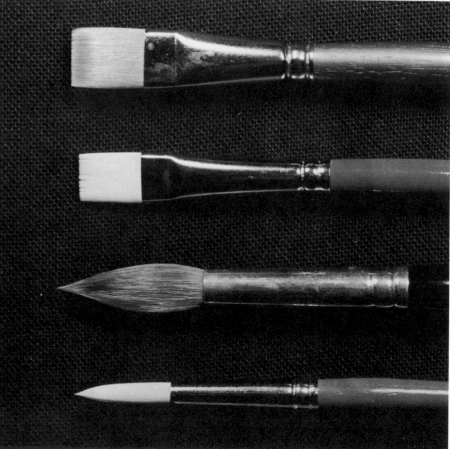

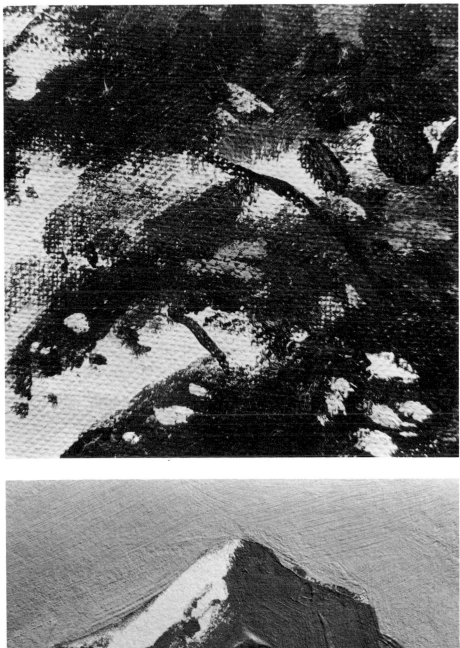

Canvas. The woven texture of linen or cotton canvas produces rough, soft-edged brushstrokes in this acrylic closeup of trees—just as this surface does when you work in oil. The texture of the cloth combines with the microscopic shadows between the fibers to lend a certain magical softness to your colors. The rougher the canvas, the more pronounced this effect will be. The texture of watercolor paper—another popular surface for acrylic painting—has a similar influence on your colors.

Gesso Board. For a smoother surface, many acrylic painters choose a sheet of hardboard or illustration board that they coat with a smooth layer of acrylic gesso. (It's also possible to work directly on illustration board or on smooth, stiff paper *without* the gesso priming.) The paint looks smoother and the color appears brighter on such a surface. The ridges of thick color on the mountain peak indicate the thick impasto strokes that can be painted on this kind of surface. Further down, the color is smoother and more fluid.

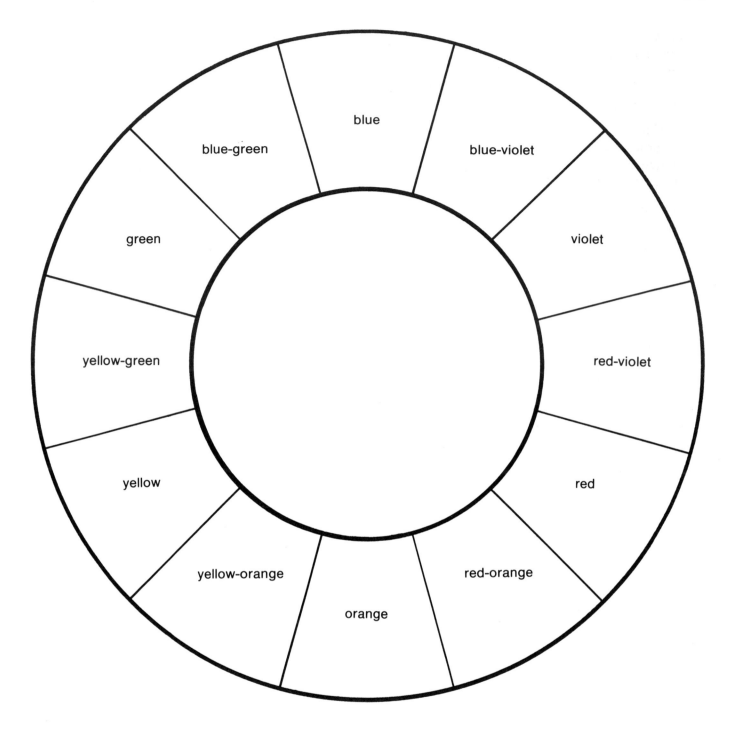

Classifying Colors. It's helpful to memorize the classic diagram that artists call a *color wheel*. This simple diagram contains the solutions to a surprising number of color problems you may run into when you're working on a painting. For example, if you want a color to look *brighter*, you'd place a bit of that color's complement nearby to strengthen it. You'll find the complement directly across the wheel from the other color. On the other hand, if you want to *subdue* that original color, you'd blend a touch of its complement into the original color. If color harmony is your problem, one of the simplest ways to design a harmonious color scheme is to choose three or four colors that appear side-by-side on the color wheel, and build your painting around these *analogous* colors. Then, to add a bold note of contrast, you can enliven your color scheme by introducing one or two of the complementary colors that appear on the opposite side of the wheel from the original colors that you've chosen for your painting.

Talking About Color. When artists discuss color, they use a number of words that may or may not be familiar to you. Because many of these words will appear in this book, this page will serve as a kind of informal glossary of color terms.

Hue. When you talk about color, the first thing you'll probably do is talk about its hue. That is, you'll name the color. You'll say that it's red or blue or green. That name is the *hue.*

Value. As you begin to describe that color in more detail, you'll probably say that it's dark or light or something in between. Artists use the word *value* to describe the comparative lightness or darkness of a color. In judging value, it's helpful to pretend that you're temporarily colorblind, so that you see all colors as varying tones of black, gray, and white. Thus, yellow becomes a very pale gray—a light or high value. In the same way, a deep blue is likely to be a dark gray or perhaps black—a low or dark value. And orange is probably a medium gray—a middle value.

Intensity. In describing a color, artists also talk about its comparative intensity or brightness. The opposite of an intense or bright color is a subdued or muted color. Intensity is hard to visualize, so here's an idea that may help: pretend that a gob of tube color is a colored light bulb. When you pump just a little electricity into the bulb, the color is subdued. When you turn up the power, the color is more intense. When you turn the power up and down, you don't change the hue or value—just the brightness or *intensity.*

Temperature. For psychological reasons that no one seems to understand, some colors look warm and others look cool. Blue and green are usually classified as cool colors, while red, orange, and yellow are considered warm colors. Many colors can go either way. A bluish green seems cooler than a yellowish green, while a reddish purple seems warmer than a bluish purple. And there are even more subtle differences: a red that has a hint of purple generally seems cooler than a red that has a hint of orange; a blue with a hint of purple seems warmer than a blue that contains a hint of green. All these subtle differences come under the heading of *color temperature.*

Putting It All Together. When you describe a color, you generally mention all four of these factors: hue, value, intensity, and temperature. If you want to be very technical, you might describe a particular yellowish green as "a high-value, high-inten-

sity, warm green." Or you might say it more simply: "a light, bright, warm green."

Primary, Secondary, and Tertiary Colors. The primaries are blue, red, and yellow—the three colors you can't produce by mixing other colors. To create a secondary, you mix two primaries: blue and red to make violet; blue and yellow to make green; red and yellow to make orange. The six tertiary colors are blue-green, yellow-green, blue-violet, red-violet, red-orange, and yellow-orange. As you can guess, the tertiaries are created by mixing a primary and a secondary: red and orange produce red-orange, yellow and orange produce yellow-orange, etc. You can also create tertiaries by mixing uneven amounts of two primaries: a lot of red and a little yellow will make red-orange; a lot of blue and a little yellow will make blue-green, and so forth.

Complementary Colors. The colors that are opposite one another on the color wheel are called *complementary colors* or just *complements.* As you move your eye around the color wheel, you'll see that blue and orange are complements, blue-violet and yellow-orange are complements, violet and yellow are complements, and so forth. Memorize these pairs of complementary colors, since this information is useful in color mixing and in planning the color scheme of a painting. One of the best ways to subdue a color on the palette—to reduce its intensity—is to add a touch of its complement. On the other hand, one of the best ways to brighten a color in your painting is to place it next to its complement. Placing complements side by side is also one of the best ways to direct the viewer's attention to the center of interest in a painting, since this always produces a particularly vivid contrast.

Analogous Colors. When colors appear next to one another—or fairly close—on the color wheel they're called *analogous* colors. They're considered analogous because they have something in common. For example, blue, blue-green, green, and yellow-green are analogous because they *all* contain blue. Planning a picture in analogous colors is a simple, effective way to achieve color harmony.

Neutral Colors. Brown and gray are considered neutral colors. A tremendous variety of grays and browns—which can be quite colorful in a subtle way—can be mixed by combining the three primaries or any pair of complements in varying proportions. For example, various combinations of reds and greens make a diverse range of browns and grays, depending upon the proportion of red and green in the mixture.

Color in Oil Painting. In the 500 years since oil paint was developed in fifteenth-century Flanders, artists have discovered a fascinating variety of ways to render the colors of nature in this versatile medium. Each method of applying oil paint to canvas produces its own unique kind of color effect. The range of possibilities is so rich and diverse that few artists have attempted to try them all—and most contemporary artists limit themselves to a narrow range of techniques. This book attempts to open your eyes to a variety of oil painting techniques. You'll start with the simplest and most direct techniques used by contemporary painters, and then move on to a variety of innovative techniques that may seem new to you, though many were developed centuries ago.

Values. Before you begin to experiment with the varied and often surprising oil painting techniques in this book, it's important to know the basics. Thus, *Color in Oil Painting* will serve both as an introduction to color for the beginning oil painter and as a review of color fundamentals for the more experienced reader. The first subject reviewed is values. Since you must know how to judge values—the comparative lightness or darkness of the colors of nature—you'll first find a brief analysis of this important subject. Then you'll learn how to paint your own value scale in oil colors—by making a chart that you can post on your studio wall as a permanent reference to help you identify values. You'll also learn how to simplify the values of nature by planning a picture in which there are just three or four basic values—and you'll watch noted artist Ferdinand Petrie paint a picture step-by-step, first in three values, then in four values.

Color Control. After learning about values, you'll explore what the oil colors on your palette can do. After reviewing a series of guidelines on how to mix oil colors, you'll learn how to conduct a series of tests to determine how your tube colors behave in mixtures. The result of your tests will be a series of color charts. These will serve as a permanent color reference, to be tacked on your studio wall beside your value scale. *Color in Oil Painting* also contains a series of color illustrations that will show you how to place colors side-by-side in an oil painting to increase or reduce their brightness, to make them look darker or lighter, and to create the illusion of three-dimensional space. Another series of illustrations will show you four different ways to achieve color harmony. You'll also see how to paint the varied colors of early morning, midday, late afternoon, and night in oil. And you'll find that the colors of an oil painting can be planned to reinforce your composition.

Step-by-Step Demonstrations. The heart of *Color in Oil Painting*, of course, is the series of ten step-by-step demonstrations in which Ferdinand Petrie shows you the varied ways oil paint can be applied to a canvas or a panel—with brush or knife—to achieve the richest possible variety of color effects. To teach you more about values, he begins by painting a picture entirely with two muted oil colors, plus white. Then he shows you how to paint a picture with just the three primary colors—red, yellow, and blue, plus white—to help you discover the surprising diversity of color mixtures you can produce with just three colors. Then he goes on to show how you can use a full palette of oil colors to produce a subdued picture, and use the same full palette to create a brighter picture. You'll then find a fascinating series of demonstrations of Old-Master techniques of underpainting and overpainting in oil: a monochrome underpainting followed by a colorful overpainting; an underpainting in a limited color range followed by an overpainting in a full range of color; a full-color underpainting followed by a full-color overpainting; and a roughly textured underpainting followed by a colorful overpainting that makes expressive use of the underlying texture. A demonstration of the wet-into-wet technique shows how to mix oil colors directly on the painting surface. And a final demonstration shows how to achieve textural richness and brilliant color by painting a picture entirely with a knife.

Light and Shade. Color doesn't exist without light, of course, so *Color in Oil Painting* concludes with a section on light and shade. You'll see how to use oil paint to render the pattern of light and shade on the geometric forms that underlie the shapes of nature—cubical, rounded, and conical—as well as irregular forms. There's also guidance about how to paint different kinds of lighting that are common in nature: side, three-quarter, front, back, top, and diffused lighting. A series of pictures shows you how oil paint can capture the varied light effects of different types of weather. And a concluding series of step-by-step demonstrations explains how to analyze the tonal range of your subject—the factors called *key* and *contrast*.

A New Look at Oil Painting. As you can see, *Color in Oil Painting* actually deals with a lot more than the usual problems of color mixing and color harmony. Its real purpose is to encourage you to take a fresh look at this marvelous medium and its amazing diversity of color effects.

Buying Brushes. There are three rules for buying brushes. First, buy the best you can afford—even if you can afford only a few. Second, buy big brushes, not little ones; big brushes encourage you to work in bold strokes. Third, buy brushes in pairs, roughly the same size. This is how these pairs of brushes would work: if you're painting a sky, for example, you'll probably want one brush for the blue areas and for the gray shadows on the clouds, and another brush to paint the pure white areas of the clouds.

Brushes for Oil Painting. Begin with a couple of really big bristle brushes, around 1″ (25 mm) wide for painting your largest color areas. You might want to try different shapes: one can be a flat, while the other might be a filbert, and one might be just a bit smaller than the other. The numbering systems of manufacturers vary, but you'll probably come reasonably close if you buy a number 11 and a number 12. You'll also need two or three bristle brushes about half this size, numbers 7 and 8 in the catalogs of most brush manufacturers. Again, try a flat, a filbert, and perhaps a bright. Then, for painting smoother passages, details, and lines, you'll find three soft-hair brushes useful: one that's about ½″ (13 mm) wide; one that's about half this wide; and a pointed, round brush that's about ⅛″ or ³⁄₁₆″ (3 to 5 mm) thick at the widest point.

Knives. For scraping a wet canvas when you want to correct or to repaint something, a palette knife is essential. Many oil painters also prefer to mix colors with a knife (rather than a paintbrush). If you like to *paint* with a knife, however, don't use a palette knife. Instead, buy a painting knife with a short, flexible, diamond-shaped blade.

Painting Surfaces. When you're starting to paint in oil, you can buy inexpensive canvas boards at any art supply store. Canvas boards are made of canvas that has been coated with white paint and glued to sturdy cardboard. They come in standard sizes that will fit into your paintbox. Later, you can buy stretched canvas: sheets of canvas precoated with white paint, nailed to a rectangular frame made of wooden "stretcher bars." If you like to paint on a smooth surface, buy sheets of hardboard and coat them with acrylic gesso, a thick, white paint that you buy in cans or jars.

Easel. An easel is helpful, but not essential. Basically, an easel is just a wooden framework with two "grippers" that hold the canvas upright while you paint. The "grippers" slide up and down to fit larger or smaller paintings—and to match your height. If you'd rather not invest in an easel, you can always hammer a few nails partway into the wall and rest your painting on them. If the heads of the nails overlap the painting, they'll hold it securely. You can also use your paintbox lid as an easel.

Paintbox. To store your painting equipment and to carry your gear outdoors, a wooden (or aluminum) paintbox is a great convenience. The box has compartments for brushes, knives, tubes, small bottles of oil and turpentine, and other accessories. It usually holds a palette—plus some canvas boards—inside the lid.

Palette. A wooden paintbox often comes with a wooden palette. Before you squeeze out your paint on it, rub the palette with several coats of linseed oil to make the surface smooth, shiny, and nonabsorbent. When the oil is dry, the palette won't soak up your tube colors, and the surface will be easy to clean at the end of the painting day. A paper palette is even more convenient. This looks like a sketchpad, but the pages are nonabsorbent paper that comes in standard sizes that fit into paintboxes. At the beginning of the painting day, you squeeze out your colors on the top sheet. When you've finished painting, you just tear off and discard the sheet.

Odds and Ends. To hold your turpentine and your painting medium—which might be plain linseed oil or one of the mixtures you'll read about shortly—you should buy a pair of metal palette cups (or "dippers") to clip onto your palette. You'll also need a few sticks of natural charcoal—not charcoal pencils or compressed charcoal—to sketch the composition on your canvas before you start to paint. Then you'll need to keep a clean rag or paper towel handy to dust off the charcoal and make the lines paler before you start to paint. Smooth, absorbent, lint-free rags are also good for wiping mistakes off your painting surface. Paper towels or a stack of old newspapers (which is a lot cheaper) is essential for wiping your brush after you've rinsed it in solvent.

Work Layout. Before you start to paint, lay out your equipment in a consistent way so that everything is always in its place when you reach for it. If you're righthanded, place the palette on a table to your right, along with a jar of solvent, your rags and newspapers, your paper towels, and a clean jar in which you store your brushes (hair end up). Also, establish a fixed location for each color on your palette. One good arrangement is to place your *cool* colors (black, blue, green) along one edge, and the *warm* colors (yellow, orange, red, brown) along another edge. Put a big dab of white in a corner where it won't be fouled by other colors.

Color Selection. When you walk into an art supply store, you'll probably be dazzled by the number of different colors you can buy. But there are far more tube colors in existence than any artist can use. In reality, all the oil paintings in this book are done with roughly a dozen colors, about the average number used by most professionals. So the colors listed below can be enough for a lifetime of painting. You'll notice that most colors are in pairs—two blues, two reds, two yellows, two browns—and that one member of each pair is bright while the other is more subdued. This combination should give you the greatest possible range of color mixtures. Now here's a suggested palette.

Blues. Ultramarine blue is a dark, subdued hue with a faint hint of violet. Phthalocyanine blue is much more brilliant and has surprising tinting strength. Since this means that just a little goes a long way when you mix it with another color, you must always add phthalocyanine blue very gradually to your mixtures. Although these two blues will do almost every job, you may want to keep a tube of cerulean blue handy for painting skies, distant hills, and other atmospheric tones. This beautiful, delicate blue can be considered an optional color.

Reds. Cadmium red light is a fiery red with a hint of orange. (All cadmium colors have tremendous tinting strength, so remember to add them to mixtures just a bit at a time.) Alizarin crimson is a darker red and has a slightly violet cast.

Yellows. Cadmium yellow light is a dazzling, sunny yellow with tremendous tinting strength, like all the cadmiums. Yellow ochre is a soft, tannish tone. If your art supply store carries two shades of yellow ochre, buy the lighter one.

Browns. Burnt umber is a dark, somber brown. Burnt sienna is a coppery brown that has a suggestion of orange.

Green and Orange. Although nature is full of greens—and so is your art supply store—you can mix an extraordinary variety of greens with the colors on your palette. But it *is* convenient to have just one green available in a tube. The most useful green is a bright, clear hue called viridian. The reds and yellows on your palette will make a variety of oranges, but you still may enjoy having the brilliant, sunny cadmium orange on your palette. Both viridian and cadmium orange are optional colors.

Black and White. The standard black used by almost every oil painter is ivory black. The white you buy can be either zinc white or titanium white. Al-ways buy the biggest tube of white you can find because you'll be using lots of it.

Linseed Oil. Although the color in the paint tubes already contains linseed oil, the manufacturer adds only enough oil to produce a paste thick enough to squeeze out in little mounds around the edge of your palette. To make the paint more fluid, you can add more linseed oil to the color on your palette. So pour some oil into one of the metal cups (or "dippers"). You can then dip your brush into the oil, pick up some paint on the tip of the brush, and blend oil and paint together on your palette to produce the consistency you want.

Solvent. You'll also need a big bottle of turpentine or one of the petroleum solvents—called mineral spirits, white spirit, or rectified petroleum—to fill the second metal cup you have clipped to the edge of your palette. You can then add a few drops of solvent to the mixture of paint and linseed oil on your palette. The more solvent you add, the thinner the paint will become. (Some oil painters prefer to pre-mix their linseed oil and solvent, 50–50, in a bottle before they start. They then keep this thin "painting medium" in one palette cup and pure solvent—for thinning it further—in the other.) For cleaning your brushes as you paint, you can pour some solvent into a small jar and keep it handy. Then, when you want to rinse out the color on your brush before picking up fresh color, you simply swirl the brush around in the solvent and wipe the bristles on a newspaper.

Painting Mediums. The simplest painting medium is the traditional 50–50 blend of linseed oil and solvent. Many painters are satisfied to thin their paint with that medium for the rest of their lives. However, after you've tried the traditional medium, you might like to try some commercial mediums, available in art supply stores. The most popular ones are usually a blend of resin, solvent, and perhaps some linseed oil and are called damar, copal, mastic, or alkyd mediums. The resin that's added is really a kind of varnish that adds luminosity to the paint and makes it dry more quickly.

Varnishes. A finished oil painting is normally protected by a layer of varnish. There are two types, retouch varnish and picture varnish. As soon as the painting surface feels dry to your fingertips, you can brush or spray on a coat of *retouch varnish* to make the surface appear glossy. After your painting has been dry for about six months, most oil paintings are ready for a coat of *picture varnish*. So buy a bottle of both retouch and picture varnish.

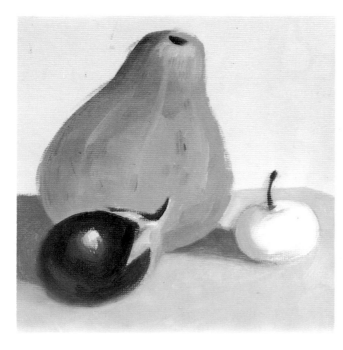

Vegetables and Fruit. To learn about values—the comparative lightness and darkness of colors—paint a series of little pictures entirely with mixtures of black and white. When you convert the colors of this still life into values, the dark purple eggplant is almost black, the yellow-orange squash is gray, and the pale yellow apple is almost white.

Kitchen Containers. Study your subject and mix each value on the palette before you start to paint. After you've applied these mixtures to the canvas, you can make adjustments by blending a lighter or darker tone into the wet color. In this kitchen still life, the brown pitcher becomes a deep gray, the light green bowl becomes a soft gray, and the pale blue glass is almost white.

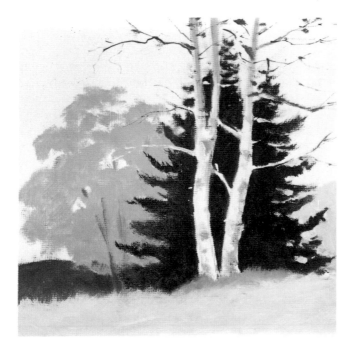

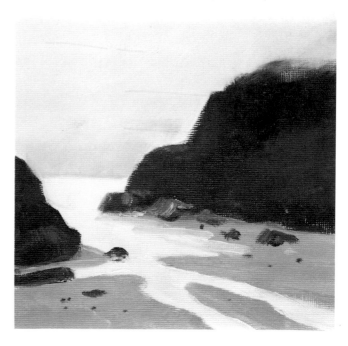

Trees. In translating this landscape into values, the pale birches appear almost white against the dark gray that represents the deep blue-green evergreens. The soft green distant trees become a pale gray, the sunlit yellow-green grass in the foreground is represented by a value similar to that of the pale birches, and the deeper green of the shadowy grass becomes a dark gray.

Beach. In this coastal landscape, the pale blue sky becomes a delicate gray (almost white)—a value that's also mirrored in the tide pools. The dark brown rock formations convert to a dark gray and the tan patches of sand between the pools become a medium gray. Paint your value studies on small canvas boards with broad, simple strokes. Don't worry about detail.

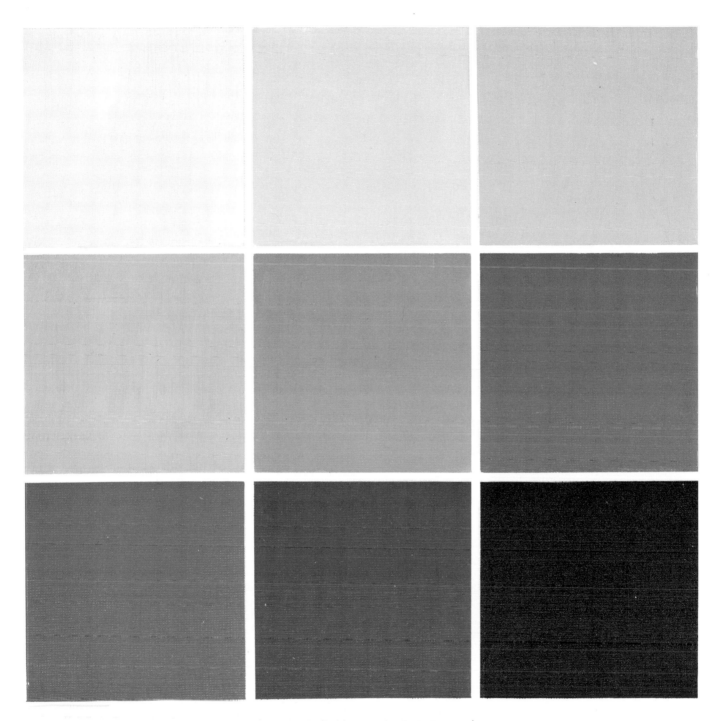

Classifying Values. The job of converting color into value becomes a lot easier if you take the time to paint a value scale and tack it on your studio wall. You'll find it convenient to refer to the value scale as you paint. Eventually, you'll memorize it without even trying. At that point, you can drop the scale into a drawer and consult the "chart" in your head. Theoretically, the values of nature are as infinite as the colors. But this scale simplifies the number of possibilities to just ten values—all you really need. Squeeze out plenty of black and white on your palette, and then carefully paint a series of nine squares on a canvas board, starting with the palest gray

at the upper left, gradually making each square a bit darker, and finishing with a black square at the lower right. The tenth value—pure white—is the tone of the bare canvas. It takes time and patience to paint (and often repaint) these squares to get the sequence of the values exactly right. But once the chart is finished, you'll be able to look at the pale yellow of a lemon and find its value at the upper end of the scale, or study the deep purple of a plum and find its value at the lower end of the scale. If you find it helpful, you can assign numbers or letters of the alphabet to the ten values on the scale.

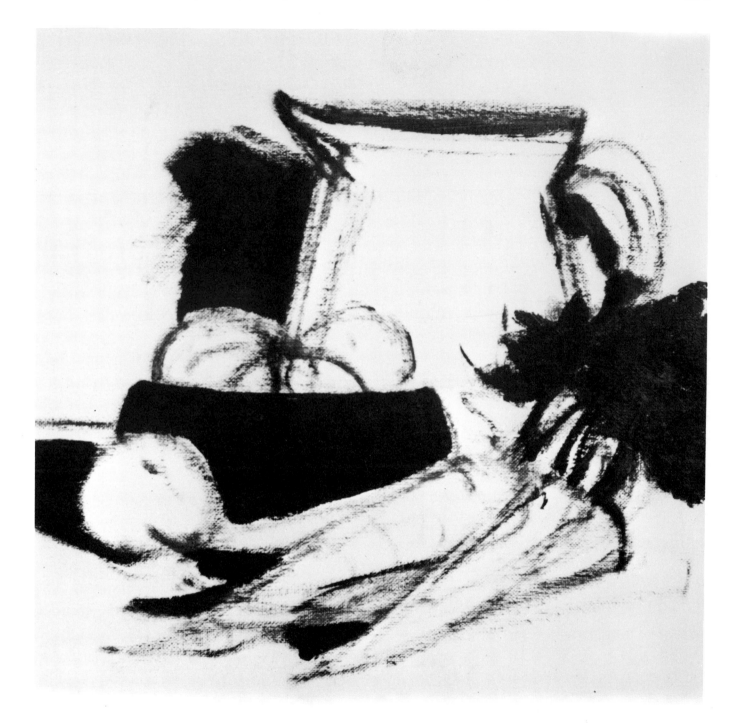

Step 1. When a professional painter looks at nature, he knows that he can't possibly match the infinite number of values that he sees. Nor does he *want* to match them, since such a jumble of values would produce a hopelessly confusing painting. So the professional looks for some way of *simplifying* the values of nature to produce a strong, dramatic pictorial design. Many painters find that they can create a satisfying picture with just three dominant values: a *dark*, a *light*, and a so-called *middletone* that falls somewhere between the dark and the light. In this still life, painted in just three values, the artist begins by dipping a small brush into pure black, diluted with lots of turpentine, and then draws the pitcher, bowl, fruit and vegetables with quick, rough strokes, just to indicate their shapes and their placement on the canvas. Picking up a bigger brush, he adds a touch of white to the black, and then blocks in the darkest tone in the still life. This tone appears on the bowl, on the carrot tops at the right, and in the shadows that are cast by the pitcher, the bowl, and the other objects lying on the tabletop. At this stage, the artist works with broad, flat areas of tone, diluting his color with enough turpentine to make the paint flow smoothly.

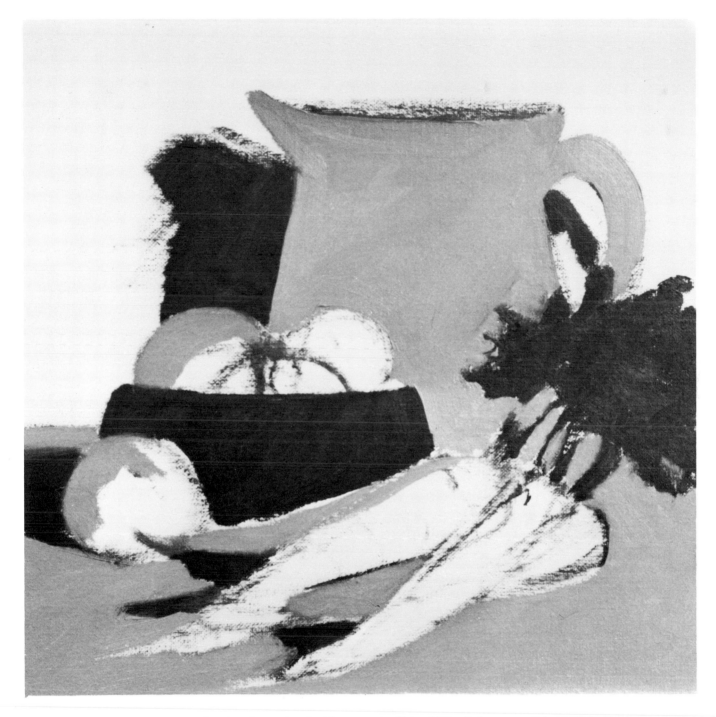

Step 2. Studying his subject closely, the artist decides that the middletone—which he finds toward the middle of the value scale—appears on the pitcher, on the table-top, and on the shadow sides of the fruit and vegetables. With a big brush, he mixes this value on his palette by blending a bit of black into quite a lot of white. Then he covers the middletone areas of the canvas with broad, flat strokes. (It's a good idea to keep one brush for the darks, another for the middletones, and still another for the lights.) The light tone of the wall behind the pitcher and the lighted areas of the fruit and vegetables are all represented by the bare, untouched canvas. Even at this early stage, the three values are already obvious. Having chosen his values carefully and rendered them with the minimum number of strokes, the artist has already given us a clear idea of the forms and the distribution of light and shade. The picture is already a satisfying pictorial design.

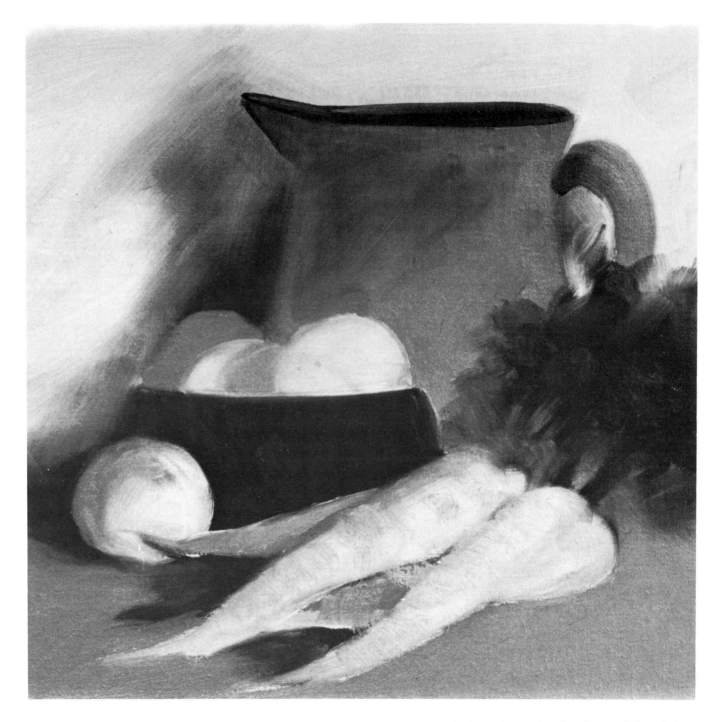

Step 3. The artist covers the patches of bare canvas with a pale mixture of white and just a speck of black to produce a delicate gray. Now the entire canvas is covered with wet color, which the artist can modify by blending in additional touches of tone. He decides that the shadows at the left of the pitcher and bowl actually contain two values: the dark that appears on the bowl and the middletone that already appears on the pitcher and tabletop. At the edge of the shadow, he blends the middletone into the dark shadow tone of Step 1. He also decides that the opening at the top of the pitcher is the same dark that appears in the shadows. To make the shape of the pitcher round, he adds just a few touches of dark, leaving most of the pitcher the original middletone. In the same way, he adds a few lighter touches to the carrot tops and to the shadows cast by the carrot, although the original darks still dominate. He blends the lights and middletones of the fruit and vegetables so they flow softly together, though the two values are still obvious. The painting is gradually becoming more realistic as the artist makes adjustments, but the three values are still clearly defined.

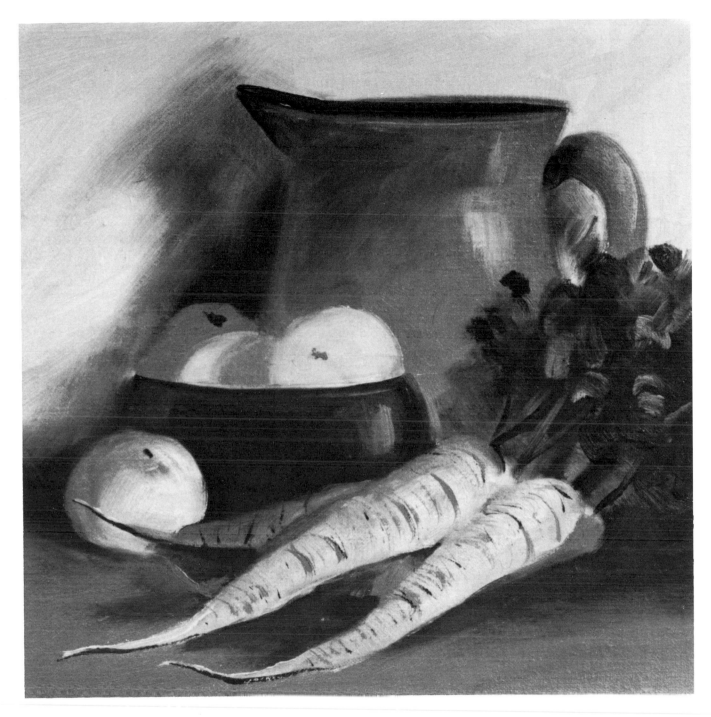

Step 4. To make the carrot tops more realistic, the artist works some strokes of the middletone into the darks at the extreme right. He also extends the dark value downward to create a shadow beneath the carrot tops and the carrots in the lower right. To suggest highlights on the pitcher and bowl, he adds a few strokes of the light value that appears on the wall and on the lighted areas of the fruit and vegetables. With a small, round soft-hair brush, he picks up the middletone to render the rounded shape and texture of the carrots. And with dark paint, he adds stems to the carrot tops and fruit. In this final stage, all the forms and details are fully realized—yet virtually the entire job has been done with the three original values. But why go to all the trouble of painting these "practice pictures" in black-and-white when your goal is to paint pictures in *color*? There are two reasons. First, when you start to mix colors, your experience with values will make it easier to decide how light or dark these mixtures should be. Second, your entire painting, even when it's in full color, will look more convincing, better organized, and truer to nature if the values are accurately rendered.

Step 1. If three values aren't quite enough, four values—light, dark, and two middletones—will often do the job. In fact, many landscape painters consistently work with just four values. You can carefully select these values from the squares on the scale to reproduce the distribution of lights, darks, and middletones in the subject. In this study of trees and rocks by the side of a lake, the artist begins by diluting the black on his palette with a lot of turpentine and makes a rough drawing of the shapes with the point of a small brush. Then, selecting his dark from the lower end of the value scale, he blocks in the shape of the evergreen and its shadow on the ground with black that's modified with just a touch of white. At this stage, he concentrates entirely on the shape of the silhouette, merely suggesting a few details within the foliage. Presumably, the actual evergreen is a blackish or bluish green that's transformed into a blackish gray when the artist converts color to value.

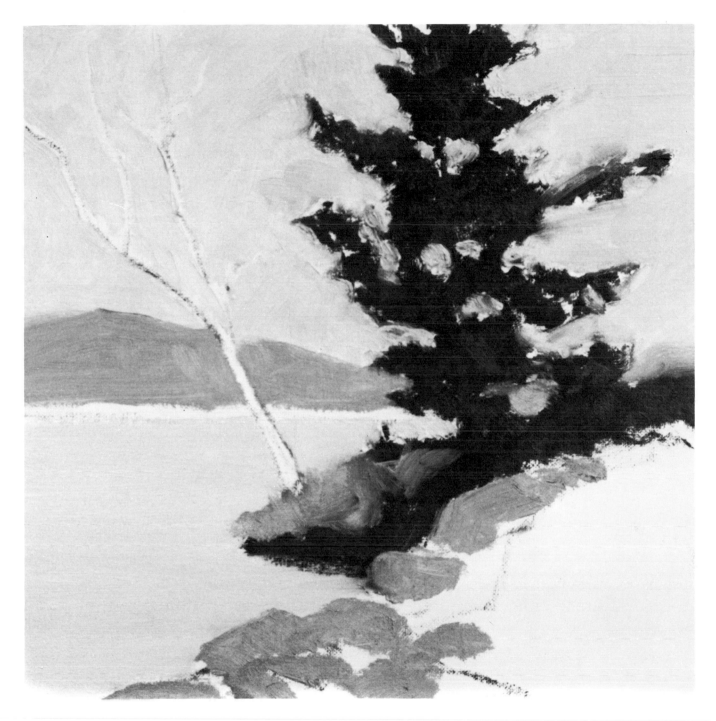

Step 2. The lightest color in the landscape is the pale blue of the sky, which reappears in the water, since the water normally reflects the color of the sky. Studying the value of the sky, the artist decides that it should be represented by a light gray from the upper end of the value scale. Mixing a lot of white with a touch of black, the artist covers the sky and water with broad strokes of this mixture. Then he looks carefully at the color of the distant shore, which is covered with soft green foliage. At the same time, he studies the light brown of the rocks along the shoreline in the foreground, and the sunlit patch of grass just to the left of the tree. He decides that all three of these colors are actually the same value, so he chooses a middletone from the middle area of the value scale and mixes a medium gray on his palette for these three areas of the landscape. For all these broad, flat shapes, the artist works with big, flat bristle brushes, using separate brushes for the dark, light, and middletone. There are still three patches of bare canvas: the leafless tree that leans out over the water, the ground in the lower right-hand corner of the picture, and the pale strip beneath the distant shore.

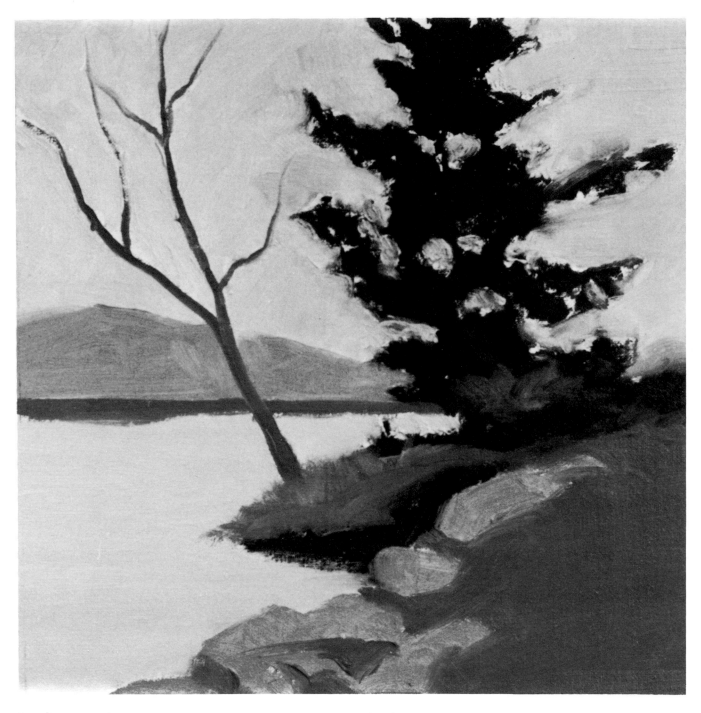

Step 3. For the dark green of the grass in the lower right-hand corner, the brown of the leafless tree and branches, and the dark strip of shadow beneath the distant shore, the artist chooses a *second* middletone that's further down on the value scale than the first middletone. He also decides that the patch of grass right under the trees isn't as light as he thought, so he repaints this area so that it's the same middletone that appears on the rest of the grass. Now the complete value scheme of the painting is clear. The darkest value appears on the big evergreen, on the shadow beneath it, and along the shadowy edge of the shore just beyond the rocks. The darker middletone appears on the grass, on the leaning shape of the tree, and on the shadowy strip under the distant shore. The lightest value appears in the sky and on the water that reflects the sky like a mirror. Notice how the light value of the sky reappears in the gaps between the foliage of the big evergreen. At this third stage, the painting looks like a poster, with flat, simple shapes that form a strong, bold design that we can enjoy for its own sake, even though the painting is still unfinished.

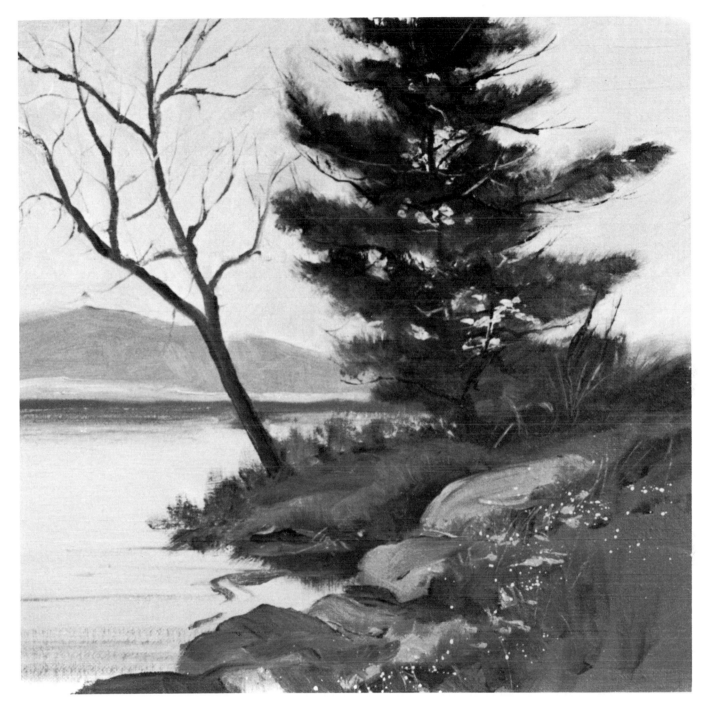

Step 4. Now the artist begins to make adjustments in the wet oil paint on the canvas. He blends various strokes of the darker middletone into the foliage of the evergreen, which is now painted in two values: the dark and also the darker middletone. For the shadows on the sides of the rocks in the foreground, he adds a few strokes of the dark. He uses the same dark to add shadowy areas to the trunk and branches of the leafless tree. With the point of a round, soft hair brush, he picks up the pale value of the sky to suggest light-struck branches that appear against the dark shape of the evergreen; small strokes and touches of this value appear in the foreground to suggest weeds and wildflowers. The rough texture of the grass beneath the leaning tree trunk is scrubbed in with the dark middletone. This same dark middletone is used for the single wiggly stroke that represents the reflection of the tree trunk in the water. Between the lighter middletone of the distant shore and the strip of darker tone beneath the shore, the artist paints a strip of sky value to suggest a band of light on the water. As he works over the surface of the picture, the artist gently blends the edges where the various values meet. The pale value of the water fuses softly into the dark strip at the edge of the distant shore. On the grassy mound beneath the trees, the lights and shadows also blur softly together. So do the two values that appear within the foliage of the evergreen. The four values of Step 3 are no longer as obvious; but if you half close your eyes, you'll see that they're still there after all.

Getting to Know Oil Colors. To work with oil colors successfully, you must learn how every color on your palette behaves when it's mixed with every other color. No two colors behave exactly alike, and their behavior can be unpredictable. For example, you've certainly been taught that you can make purple by combining red and blue. That *is* true when you mix phthalocyanine blue with alizarin crimson, but prepare yourself for a shock when you mix phthalocyanine blue with cadmium red. The result is a strange brown that has its own special kind of beauty, but it's certainly not purple! Rather than make surprising discoveries like this one in the middle of a painting, it's best to store up this information by conducting a series of tests and recording the results on color charts. These charts are fun to make and useful to tack on your studio wall.

Making Color Charts. Buy a pad of inexpensive, canvas-textured paper, or collect some old scraps of canvas and cut them to a size that's roughly that of the page you're now reading. With a sharp pencil, or perhaps a felt or fiber-tipped marker, plus a ruler, draw a series of boxes on the paper or canvas, forming a kind of checkerboard. The boxes should be 2″ to 3″ (50 to 76 mm) square. Each box should give you just enough space for a single color mixture. (Don't forget to write the names of the colors in the boxes.) The simplest way to plan these color charts is to make a separate chart for each color on your palette. If you draw a dozen boxes on each chart, you'll have enough boxes to mix ultramarine blue, for example, with white and with all the other colors on your palette. If you run out of room on one chart, continue your mixtures on a second chart.

Adding White. Because you'll eventually be mixing white with every other color on your palette, it's essential to find out how each tube color behaves when it's blended with white. Place a few broad strokes of color in its box on the chart. Then pick up a clean brush, dip it into pure white, and scrub the white into *half* of the tube color in the box. Now you've got a color sample that's divided into two halves: one half is the pure tube color and the other half is tube color blended with white. When you study the completed charts, you'll discover some fascinating facts. For example, while a touch of white brightens the blues and makes yellows even sunnier, it reduces the intensity of reds and oranges.

Mixing Pairs of Colors. Here's how to mix every color on your palette with every other color. Paint a thick stroke of each color, slanting the strokes in-ward so they converge. At the point where they converge, scrub the colors together to find out what kind of mixture they make. It may be necessary to add a touch of white to the mixture to bring out the full color. For example, a mixture of ultramarine blue and viridian will look dark and dull, but a gorgeous blue-green emerges when you add just a little white. On the other hand, cadmium red light and cadmium yellow light will produce a stunning orange without the aid of white. Once again, prepare yourself for some surprises. Although experienced oil painters normally avoid adding black to subdue another color, ivory black produces wonderful mixtures when it's used as a cool color, like blue or green. Thus, the combination of yellow ochre and ivory black will produce a lovely, subtle olive green or greenish brown that's useful in landscape painting. And cadmium orange joins with ivory black to produce lovely coppery tones.

Optical Mixing. When you blend two wet colors on your palette or directly on the painting surface, this is a *physical* mixture. But there's another way to mix colors that's been neglected by contemporary painters, although it was widely used by the Old Masters. In this method, the Old Masters often placed a layer of color on the canvas, allowed that layer to dry, then brushed on a second layer of transparent color (called a *glaze*) or semi-transparent color (called a *scumble*) that allowed the underlying color to shine through. The two colors mixed in the eye of the viewer to form a third color—an *optical* mixture. Glazing and scumbling produce color effects that are impossible to get through purely physical mixtures. Several of the demonstrations in *Color in Oil Painting* involve such optical mixtures. To see how optical mixtures work, you'll probably have to start a new chart. Paint a few strokes of tube color in its own box on the color chart. (Lighten some of the darker colors such as black, blue, green, and brown with white.) Leave some canvas bare at one end of the box. Let the strokes dry. Before you brush the second color over the dry paint, add some painting medium to make the tube color fluid and transparent. Then brush this glaze over the bare canvas and then carry the color *halfway* over the dried color. Now you can see how the underlying color looks by itself, how the transparent color looks by itself on the bare canvas, and how the two colors combine optically to create a third color. It's revealing to compare a physical mixture and an optical mixture of the same two colors: the optical mixture is sometimes more subtle and mysterious, sometimes more brilliant.

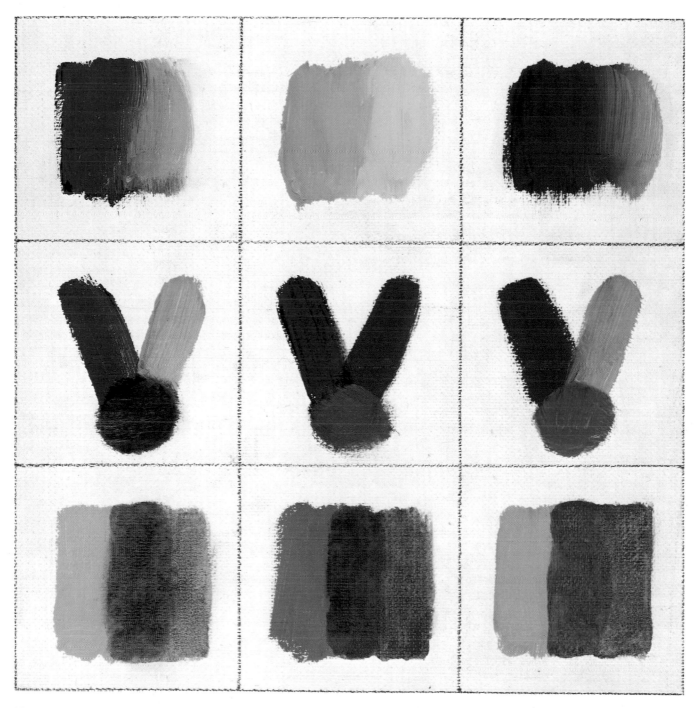

Exploring Color Mixtures. Here are some samples of the mixtures to test on your color charts. (Bear in mind that this isn't a typical chart but a selection of typical boxes from various charts.) In the top row, there are three primary colors, each taken straight from the tube *and* blended with white. Ultramarine blue (left) as it comes from the tube is fairly dark and subdued, but turns to a soft blue with a hint of warmth when you add white. Cadmium yellow (center) is bright and sunny from the tube, and even sunnier with white added. Alizarin crimson (right) is rather murky as it comes from the tube, but turns bright pink with a touch of white. In the second row, from left to right, a stroke of ultramarine blue and a stroke of cadmium yellow meet to form a subdued green; ultramarine blue and alizarin crimson produce a soft vio-let; and alizarin crimson and cadmium yellow make a hot orange. These six mixtures are all *physical mixtures*; that is, two wet colors are brushed together to produce a third. The third row shows *optical mixtures* in which one color is allowed to dry, and then a second color is diluted with painting medium to a transparent consistency that's brushed halfway over the first color. From left to right, ultramarine blue is brushed over cadmium yellow, alizarin crimson over ultramarine blue (lightened with white), and alizarin crimson over cadmium yellow. In a printed book, the differences between physical and optical mixtures are less obvious than they'll be when you paint your own color charts—so be sure to try optical mixtures for yourself.

Complementary Background. You can also control your colors by the way you plan color relationships—by carefully selecting the colors you place next to one another. The tones of this brilliant autumn tree are mixtures of cadmium yellow light, cadmium red light, and burnt sienna. But the red-golds look particularly bright because the autumn foliage is surrounded by the complementary colors of the trees in the background, which are deep green, punctuated by touches of blue. If you look back at your color wheel, you'll see that green is the complement of red and blue is the complement of orange. These two cool colors work together to intensify the warm autumn foliage by contrast.

Analogous Background. But what if you *don't* want that autumn tree to look quite so bright? The solution is to surround the tree with analogous colors—colors that are *near* each other on the color wheel—instead of the complementary colors at the *opposite* side of the wheel. Here, the artist has surrounded the red-gold tree with reds and browns that harmonize with the tree instead of contrasting with it. The brilliant tree begins to melt away into the background. However, that touch of blue sky (the complement of orange) helps to emphasize the general warmth of the entire landscape.

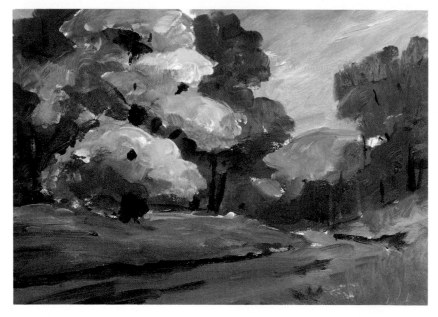

Neutral Background. What if you want to dramatize the brilliant color of the tree but you *don't* want to surround it with other bright colors? You can surround the bright colors with neutrals—with grays or browns or brown-grays that will stay quietly in the background. In this oil sketch, the bright autumn foliage is surrounded by subdued mixtures of ultramarine blue, burnt umber, and white. This is an overcast day, so the sky and foreground are also painted in quiet, neutral colors. The "rules" are simple: to make a color look brighter, surround it with complements or neutrals; to make a color look more subdued, surround it with analogous colors.

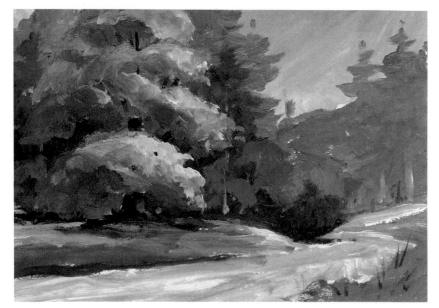

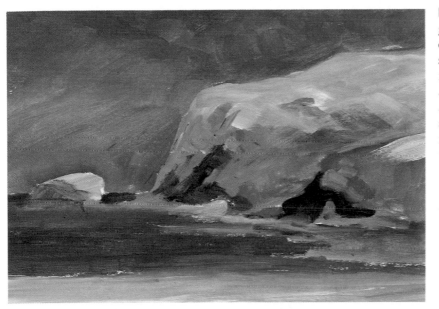

Dark Background. Just as the background colors can affect the intensity of a color, they can also affect its value. The sunlit top of this cliff—a mixture of cadmium yellow light, burnt sienna, viridian, and white—looks lightest and sunniest against a dark sky. The dark tone of the sky is reflected in the water, which also surrounds the cliff, giving further emphasis to the bright top of the small rock at the extreme left. The cool, dark tones are mixtures of ultramarine blue, burnt sienna, yellow ochre, and white.

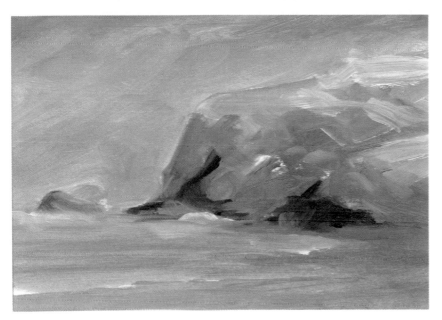

Middletone Background. Of course, there's no law that says you've got to emphasize the sunny top of the cliff and rock. You may prefer to let the cliff and rock stay quietly in the distance. For this purpose, a good strategy is to surround the cliff with a middletone that's not much darker or lighter than the value of the cliff itself. In this second oil sketch of the same subject, the sky is a paler mixture of ultramarine blue, viridian, burnt sienna, and more white, with the same mixture repeated in the water. There's less contrast between the values of the cliff, rock, sky, and water. The sunny tops of the cliff and rock are de-emphasized.

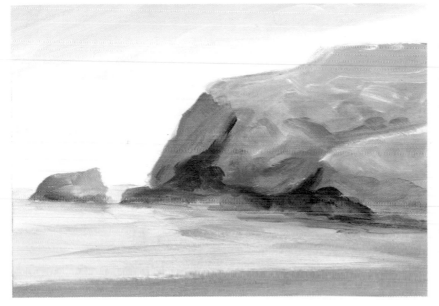

Light Background. Rather than emphasize the sunlit cliff against the dark sky, you may want to dramatize the *dark* silhouettes of the rocky shapes. In this case, your strategy might be to place the cliff against a pale sky. Now the value of the sky and water is much lighter, while the big cliff and the small rock look darker. Sky and water are both mixtures of ultramarine blue, viridian, yellow ochre, and lots of white. Once again, the "rules" are simple: to make a shape look lighter, place it against a dark background; to make it look darker, choose a light background; to de-emphasize the shape, choose a background that's roughly the same value.

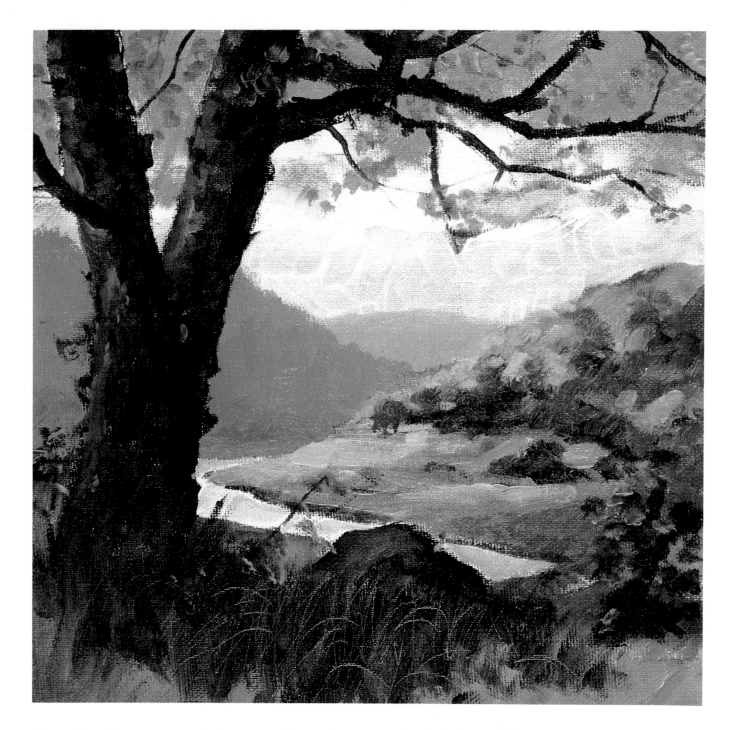

Sunny Day. To create a convincing sense of space in a painting—particularly in a landscape or a seascape—it's important to understand the "laws" of *aerial perspective.* According to these "laws," the colors closest to the viewer tend to be darker, warmer, and brighter than the colors in the distance, but as objects recede into the distance, their colors tend to grow cooler, paler, and less intense. In fact, that's what's happening in this landscape. The darkest colors are in the shadowy foreground, and the brightest colors are on the sunlit slope just beyond. As your eye moves to the slope in the middleground, just beyond the dark tree on the left, you see that the hill is paler and cooler. And the very distant mountain in the middle of the picture, just beneath the sky, is paler and cooler still. Warm colors dominate the mixtures in the foreground: burnt sienna, yellow ochre, and ivory black in the trees and rocks; cadmium yellow light, burnt sienna, and ultramarine blue on the sunny slopes. Beyond the sunny slopes, cooler colors begin to take command: phthalocyanine blue, viridian, burnt umber, and white for the hill in the middleground; ultramarine blue with a touch of alizarin crimson and a lot of white in the paler mountain at the horizon.

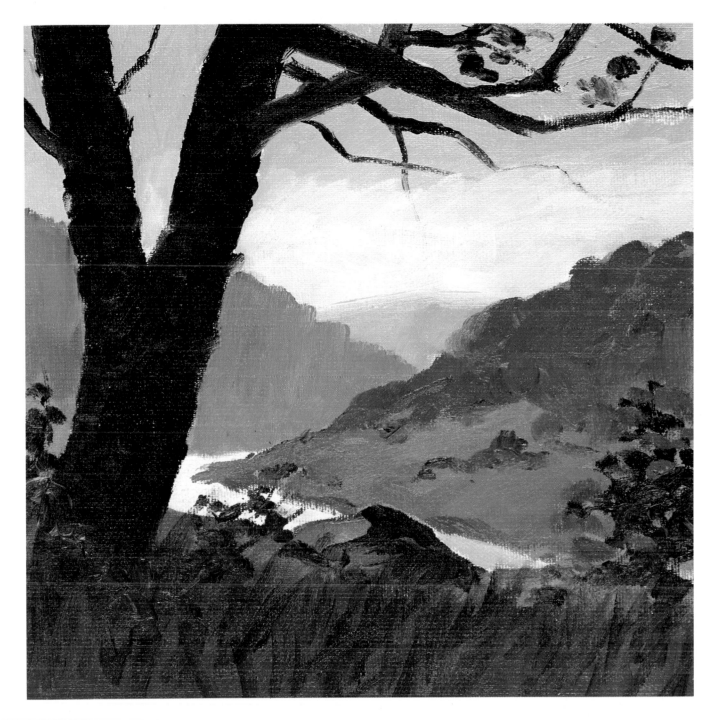

Overcast Day. Although the colors become a lot more subdued on an overcast day, the basic "laws" of aerial perspective still apply in any kind of weather. Typically, all the colors are cooler and more muted when the sun disappears behind a layer of clouds. But the tree, grass, and rock in the immediate foreground are still the darkest, warmest elements in this landscape; they're mixtures of burnt umber, yellow ochre, and ultramarine blue. The nearby slope is no longer sunny, but it's still brighter than the slopes in the distance; it's a mixture of phthalocyanine blue, yellow ochre, burnt sienna, and white. The hill in the middleground, just beyond the tree, becomes cooler, paler, and more subdued—painted with a mixture of ultramarine blue, burnt umber, yellow ochre, and white. And the remote mountain at the horizon is the palest mixture in the landscape: a little ultramarine blue and burnt umber, plus lots of white. Comparing these two studies of the same landscape, it's exciting to see how a change in weather can create two totally different pictures. As many great artists have done, you can set up your easel in the same place every day, discovering dramatic new possibilities in the subject as the weather and the seasons change before your eyes.

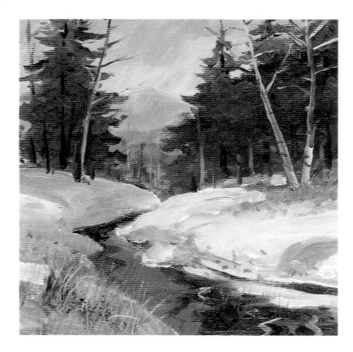

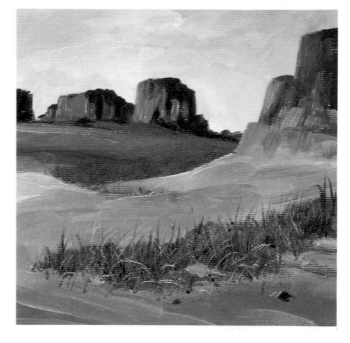

Cool Picture, Warm Notes. One good way to achieve color harmony is to choose *analogous* colors from one segment of the color wheel. Here, the artist works mainly with blues, greens, and blue-greens from one side of the wheel, then reaches across to the other side of the wheel to find a warm, complementary color for the dead weeds in the snow.

Warm Picture, Cool Notes. To reverse this strategy, you can choose your colors from a warm segment of the color wheel. In this desert landscape, most colors are chosen from the red, red-orange, orange, and yellow-orange part of the wheel. Then the artist jumps across the wheel to find a complementary, cool note for the foliage to provide a welcome note of contrast.

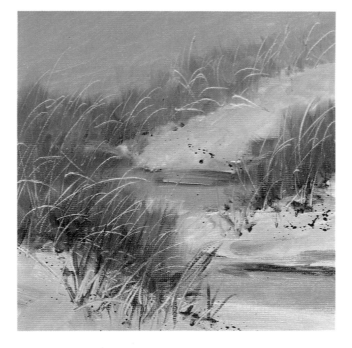

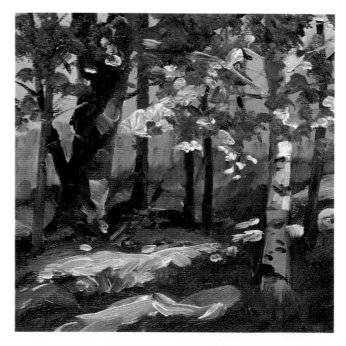

Repeating Colors. Harmony means unity. Another way to achieve unity is to interweave the same colors throughout the picture. The cool tone of the sky is repeated in the tide pools between the dunes, and is even reflected in the cool notes of color that appear in the sand. The sky colors alternate with the repeating bands of sand color. The cool color of the beach grass zigzags across the painting.

Repeating Neutrals. A subtle way to tie rich colors together is to interweave the bright colors with neutrals. Between the tree trunks, the artist has introduced warm and cool grays that reappear in the gaps between the foliage, on the foreground rocks and grass, and in the trunk of the birch at the right. The neutrals provide a unified setting for the diverse colors.

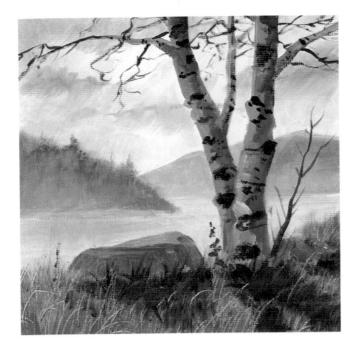

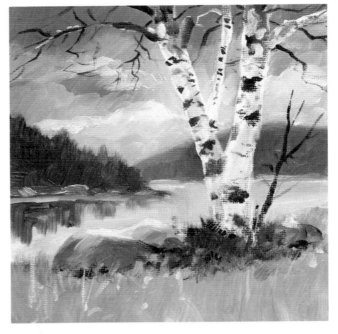

Early Morning. In the early morning, when the sun is low in the sky and the light hasn't reached its full brilliance, the landscape is often filled with delicate colors. You're apt to see soft yellows, yellow-greens, pinks, and violets. Here, the distant sun illuminates the lake and the far shore, while the tree and rock appear as dark silhouettes.

Midday. By the middle of the day, the sun has risen high in the sky, bathing the entire landscape in light and bringing out the full colors. The grass and foliage appear as rich yellows and greens. The early morning haze has disappeared, revealing the blues and whites of the sky and water. The sun brightens the top of the rock and illuminates the bark of the tree.

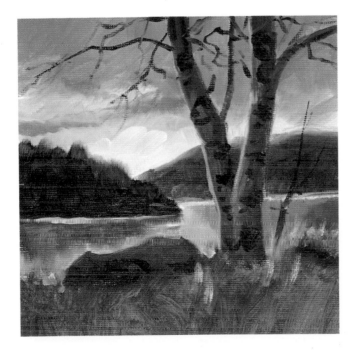

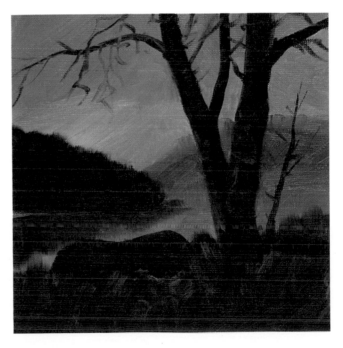

Late Afternoon. In late afternoon, the sun starts to sink behind the hills, throwing them into dark silhouettes. The tree and rock are also lit from behind and silhouetted. There's a strong contrast between the lights and shadows, as well as between the dark, upper sky and the brilliant sky at the horizon—repeated in the water.

Night. On a clear night, once your eyes become used to the darkness, you'll find that the moonlit sky can be filled with magical blues, greens, and violets. Similar colors can reappear in the landscape that receives the light of that sky. The moonlit sky is much lighter than the forms of the landscape, which are transformed into handsome silhouettes.

Step 1. To learn more about values, try a painting in which you work with just two colors, one warm and one cool, plus white. This *tonal painting* will depend heavily upon values, but this very limited palette can produce richer colors than you might expect. Here the artist places just burnt sienna, ultramarine blue, and white on the palette. Blending the two colors with turpentine, he outlines his composition on the canvas. Then with a large, flat bristle brush, he blocks in the sky with ultramarine blue and white, warmed with a touch of burnt sienna. As he works downward toward the horizon, he adds slightly more burnt sienna to the mixture to warm the sky color.

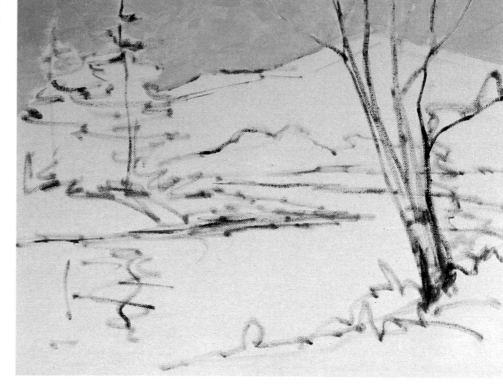

Step 2. The warm, but subdued color of the mountain is painted with the same three colors that appear in the sky, but now burnt sienna dominates. This time the mixture is cooled with a touch of ultramarine blue and lightened with white. Just as the sky contains some warm areas in which there's a bit more burnt sienna, the mountain contains some cool tones where the artist has added a bit more ultramarine blue to the mixture. Look at the sky and mountain closely: these areas contain lots of subtle variations, sometimes cooler and sometimes warmer, where the artist has varied the proportions of blue and burnt sienna in the mixtures.

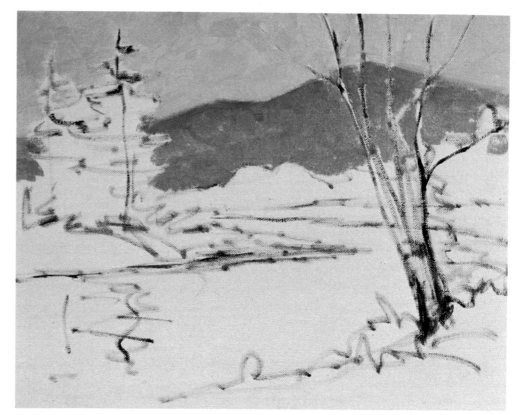

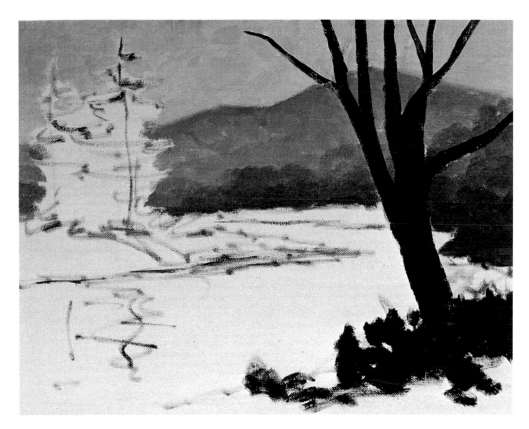

Step 3. Now the artist establishes the darkest note in the picture. Blending ultramarine blue and burnt sienna—without white—he picks up this mixture on a medium-sized bristle brush and paints the dark tree and the dark tone of the shore. Blending more white into this mixture and adding more blue, he suggests the dark trees at the foot of the mountain on the far shore. The artist has now established the four major values: the light value of the sky (to be repeated in the water), the dark value of the tree and nearby shore, the lighter middletone of the mountain, and the darker middletone of the distant trees.

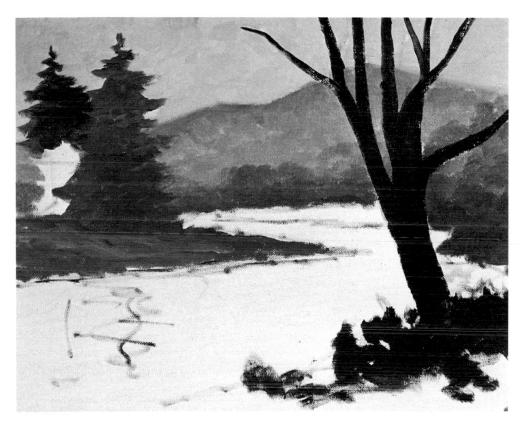

Step 4. So far, the artist has concentrated on the distance and foreground. Now he turns to the middleground. He blocks in the hot color of the dead evergreen and the shore beneath it with a mixture that's mainly burnt sienna, darkened here and there with a touch of ultramarine blue, and occasionally lightened with a hint of white. To the left, he begins to paint the shape of another evergreen with a mixture that's similar to the one he's already used for the trees at the base of the mountain. Half-close your eyes so that you see these two trees and the shore beneath them as values. They're the same dark middletone as the low trees on the distant shore.

Step 5. The artist finishes the dark tree at the extreme left, adding some of this color to indicate shadows beneath the trees and along the edges of the shore in the middleground. He carries the sky colors across the water. Because the water mirrors the sky, he places bluer mixtures in the foreground, gradually adding more white and a bit more burnt sienna as he moves into the middleground. The water in the center of the picture is mainly white—tinted with ultramarine blue and burnt sienna—to suggest the light of the sky shining on the bright water. The artist finishes blocking in the dark foreground with more of the color that he's already used on the dead evergreen.

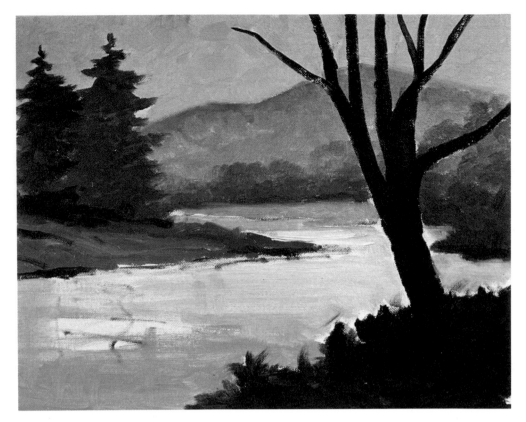

Step 6. The artist blocks in the foliage on the tree in the foreground. These dark, warm tones are mainly burnt sienna, darkened and cooled with ultramarine blue, and occasionally lightened with a touch of white. He uses a dark version of this same mixture to add another small tree trunk at the extreme right. Adding just a bit more white and an occasional touch of burnt sienna to the mixture, he blocks in the dark reflections of the trees in the water at the lower left. Notice how the reflection grows warmer beneath the hot color of the dead evergreen. With the same mixture used in the reflection, he adds a small evergreen to the middleground shore.

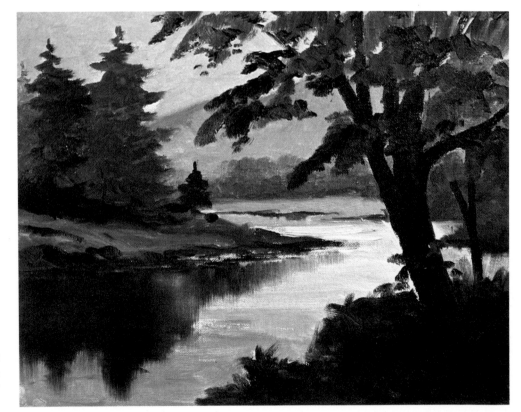

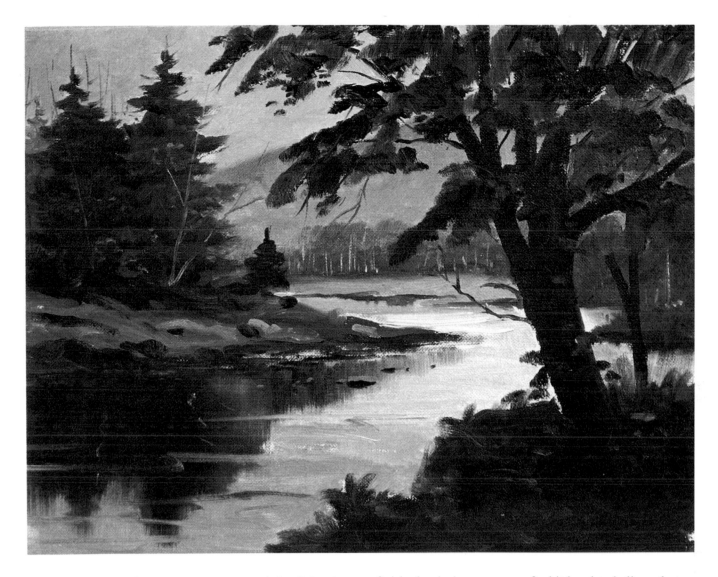

Step 7. It's always best to save texture and detail for the final step, as the artist does here. Working with the sharp point of a round, soft-hair brush, the artist adds more branches to the dark tree in the foreground and suggests a few individual leaves. He uses the same brush to indicate a few small rocks in the water and on the shore in the middleground. Rinsing the brush in turpentine and drying it on a scrap of newspaper, he picks up the pale mixtures used for the sky and the distant mountain and he adds lighter details, such as the ripples in the water at the lower left, the light-struck branches on the shore in the middleground, and the pale trunks of the trees on the distant shore. He also adds a few more branches to the evergreens at the extreme left, some touches of light on the shore beneath these trees, and even a few touches of light to the shadowy shore at the lower right. Looking at the finished painting, you may find it hard to believe that so much color was created with just ultramarine blue, burnt sienna, and white. Try such a limited palette for yourself and discover how many different mixtures you can make with the simplest possible means. You may even enjoy painting a series of pictures with different limited palettes, substituting the more brilliant phthalocyanine blue for the subdued ultramarine, or dropping blue altogether and switching to viridian, or putting aside burnt sienna in favor of the darker burnt umber. The whole secret of painting such a picture is to vary the *proportions* of all three tube colors in your mixtures. Thus, you not only create a full range of warm and cool mixtures, but you also produce a full range of values: dark, light, and two middletones, all carefully distributed throughout the painting for maximum variety.

Step 1. Blue, red, and yellow are called *primary colors* because they're the basic colors from which all other colors can be mixed—yet they themselves can't be mixed from other colors. Challenge yourself to see how many mixtures you can produce with a limited palette. It will turn out to be surprisingly versatile. This demonstration is painted entirely with ultramarine blue, cadmium red light, cadmium yellow light, plus white. The artist sketches the shapes of the basket and flowers with ultramarine blue, diluted with turpentine. He brushes in the background with a mixture of all three colors, plus lots of white, adding more blue for the shadowy tones at either side. The dark tone beneath the basket is just blue and red, with a hint of white.

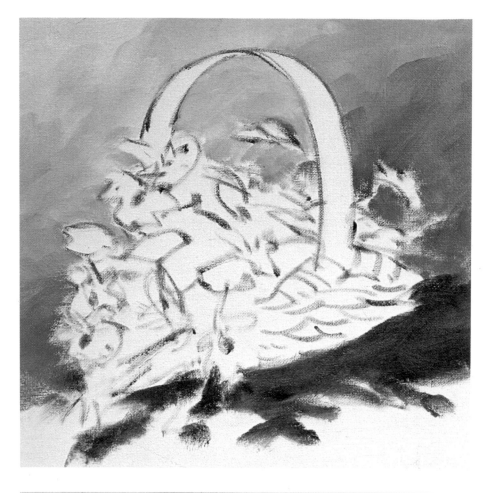

Step 2. The artist blends yellow and red, plus a bit of white, to create orange; then he subdues that orange with a hint of blue to create the color you see on the handle. More white is blended into the wet color for the lightest part of the curve. The dark underside of the handle is painted with the same shadow tone that appears in Step 1: blue and red. The two mixtures used to paint the handle are used again to paint the woven texture of the basket that emerges from the dark shadow in the lower right. Dark lines, suggesting the intricate detail of the woven basket, are painted with the shadow mixture and a small, pointed brush.

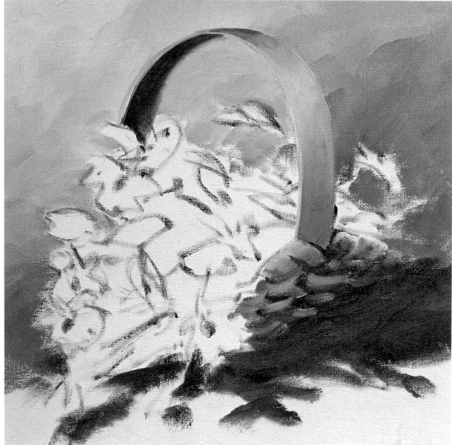

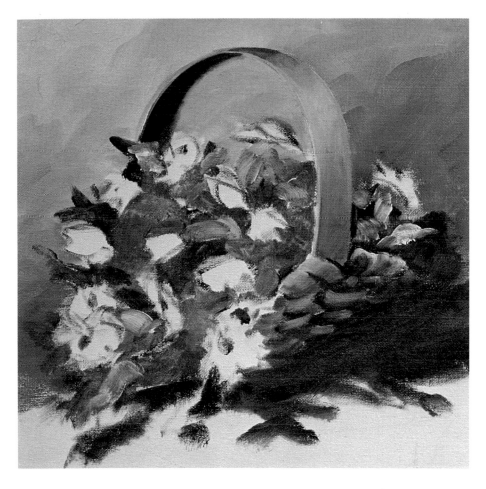

Step 3. The leaves, which are densely clustered within the basket, are blocked in with varying mixtures of blue, yellow, and white. Rather than use a smooth, even tone, the artist suggests the complex detail of the leaves by varied strokes that contain the blue-yellow mixture in different proportions. Some strokes contain more blue, while others contain more yellow. The darker strokes obviously contain less white, while the lighter strokes contain more. The artist works carefully around the shapes of the flowers, which, like the tablecloth, still remain bare canvas.

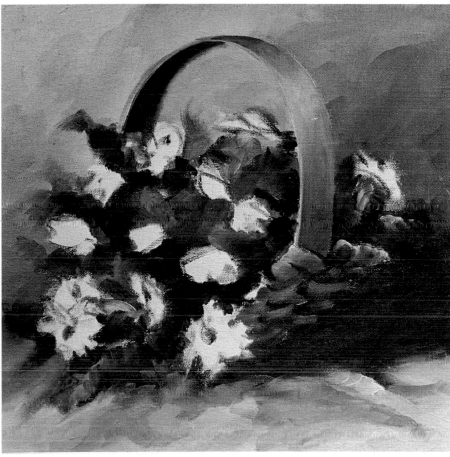

Step 4. Patches of shadow within the leaves are suggested by dark strokes of pure blue and yellow, occasionally warmed with a speck of red, but containing no white. To paint the tablecloth, the artist blends just a touch of the three primary colors with a lot of white for the paler areas. Then he adds more blue to this mixture for the shadows of the folds, which are occasionally warmed with an extra hint of red.

Step 5. The bright notes of the flowers are painted with thick strokes of pure yellow, plus a slight touch of red in the shadows. A few more touches of yellow are blended into the leaves to heighten their color here and there. At this stage, the only patches of bare canvas are the shapes of the white flowers.

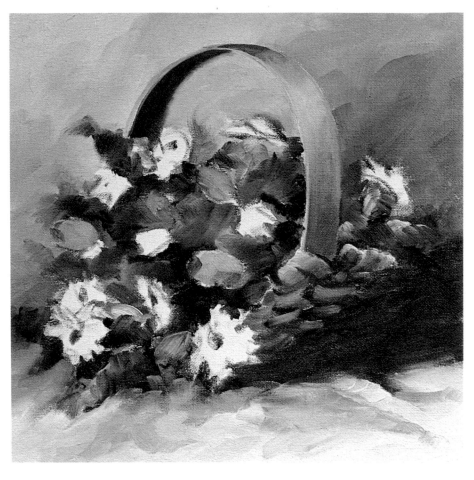

Step 6. The artist begins the white flowers with mixtures that may *look* like pure white, but actually contain just the slightest hint of all three primaries. The petals that catch the light are painted with thick white, slightly tinted with red and yellow. The petals in shadow are also painted with thick white, tinted with just a little blue and a speck of red. The brushstrokes radiate outward from the centers of the blossoms. The artist exploits the weave of the canvas to give his strokes a soft, ragged texture that matches the softness of the flowers.

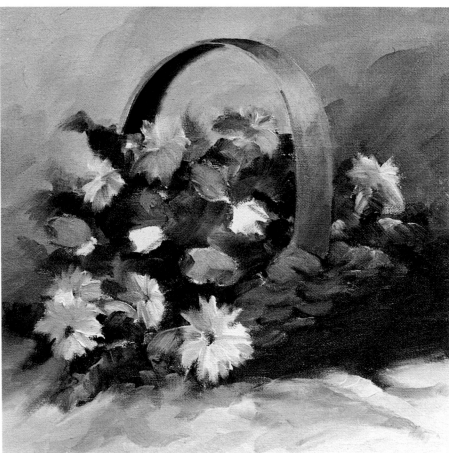

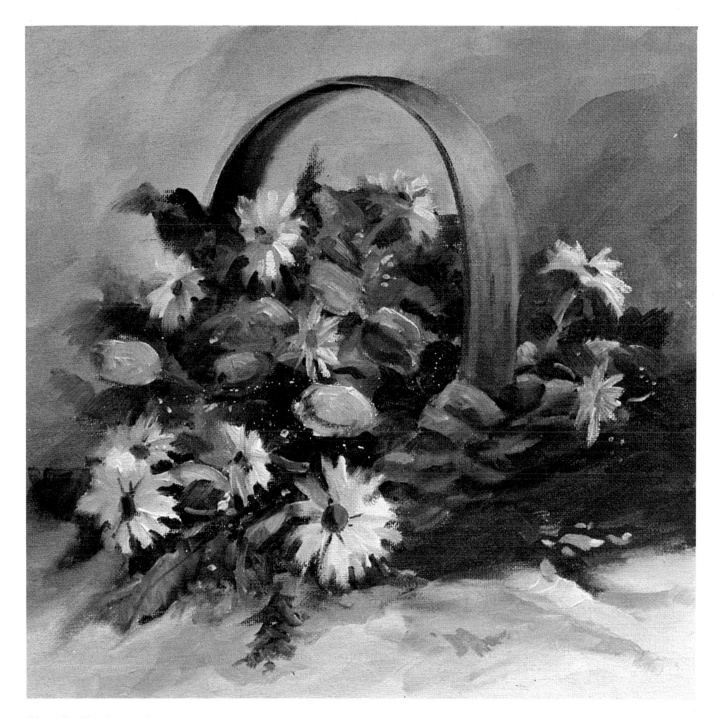

Step 7. The hot colors of the remaining flowers are painted with almost pure red, lightened with a touch of white and subdued by a hint of blue in the shadows. The warm centers of the white flowers are painted with red and yellow, with a touch of blue added for the dark notes. The artist completes the casual, sprawling bouquet by adding a few more white flowers and scattering some petals on the cloth that covers the table. He also reinforces the leaves with dark strokes of blue and yellow to strengthen the shadows, adding pale strokes of blue, yellow, and white to suggest more leaves caught in the light. With a small, round brush he picks up the dark shadow mixture of blue and red that appears beneath the basket to draw a few lines within the petals of the white flowers and to sharpen the edges of the flowers here and there.

The finished painting is ample proof that these three primaries—ultramarine blue, cadmium red light, cadmium yellow light, plus white—can create a full range of colors. Try painting a still life, then a landscape or seascape, with these three hues. Then try using other primaries. For example, a more brilliant primary palette might contain phthalocyanine blue instead of the subdued ultramarine blue, and you could substitute alizarin crimson for cadmium red light. You might also convert your subdued tonal palette—the ultramarine blue, burnt sienna, and white used for Demonstration 1—into a quiet primary palette by adding yellow ochre. Painting a series of pictures with various primary palettes is a wonderful way of learning how to mix colors.

Step 1. Now you're ready to try the full range of tube colors on your palette. But working with a full palette doesn't necessarily mean that you *must* paint a picture in brilliant colors. A full palette will work equally well for mixing the many muted colors in nature. In fact, it's a good idea to start out with a subdued subject, like this winter scene, to again force you to think about values. Here, in the first step, the artist brushes in the composition with ultramarine blue and a little burnt umber diluted with turpentine. Then he blocks in the sky with ultramarine blue, burnt sienna, yellow ochre, and white, blending in more yellow ochre and white as he moves to the right.

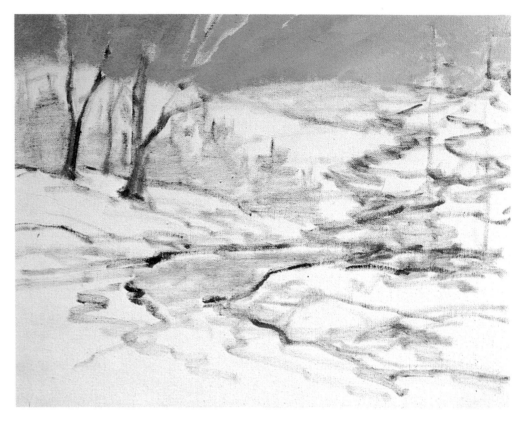

Step 2. The angular shape of the stream is painted with the same colors as the sky—ultramarine blue, burnt sienna, yellow ochre, and white—since the color of the water repeats the color of the sky. However, the artist changes the proportions of the mixture slightly, adding a bit more blue to the water and then adding more burnt sienna (but no white) to suggest the shadows at the edge of the shore. Blending more white into the water, he adds a few pale strokes that suggest the movement of the water. The distant mountain is painted with still another version of this mixture, now dominated by burnt sienna.

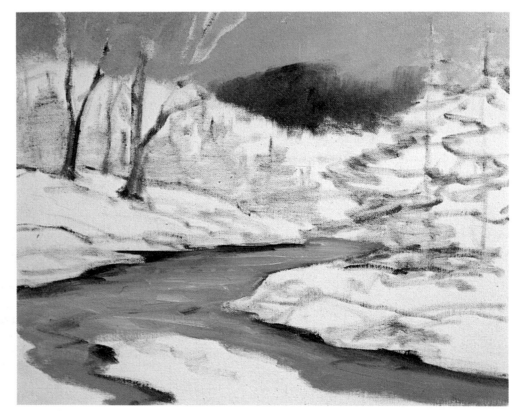

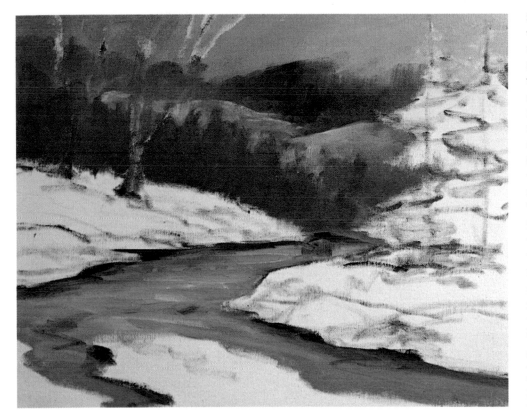

Step 3. The artist begins with the sky mixture—ultramarine blue, burnt sienna, yellow ochre, and white—to paint the strip of snowy slope beneath the distant mountain and above the diagonal row of shadowy trees. (Remember that snow is just another form of water, so it's also inclined to reflect the color of the sky.) Then he paints the shadowy row of trees, slanting down the snowy hill on the left, which is actually a combination of brilliant cadmium orange, subdued ultramarine blue, and burnt umber, plus white and an occasional touch of yellow ochre. This same mixture is used to paint the dark trees on the horizon, in the upper left-hand corner.

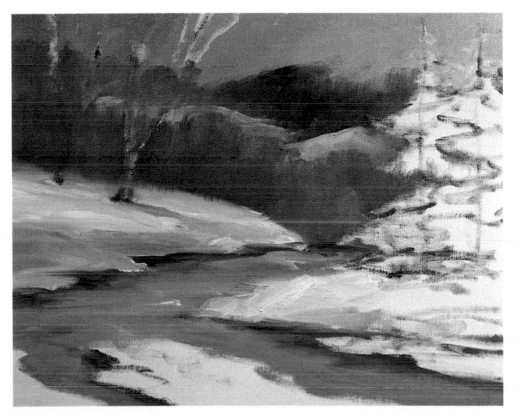

Step 4. The artist begins to work on the snow, starting with the triangular patch of shore in the middleground. He paints the sunlit top plane of the snow with a little cerulean blue and yellow ochre, mixed with a lot of white. (Cerulean blue is cooler and brighter than ultramarine blue.) Then he paints the shadows on the snow with ultramarine blue, a touch of alizarin crimson, burnt umber, and white. Although snow may *look* pure white, never paint it with solid strokes of white, used straight from the tube. The "white" snow is actually full of subtle color because it picks up so much reflected color from its surroundings and from the sky.

Step 5. The artist blocks in the rest of the snow with the same color combinations: cerulean blue, yellow ochre, and white for the sunlit top planes; and ultramarine blue, alizarin crimson, burnt umber, and white for the shadowy planes of the snowbanks. The dark tones of the evergreens are painted with another surprising combination of bright colors: cadmium orange and viridian, plus burnt umber for the darker tones and a touch of white for the lighter strokes. This color combination, carried downward into the stream, reflects the dark tones of the trees.

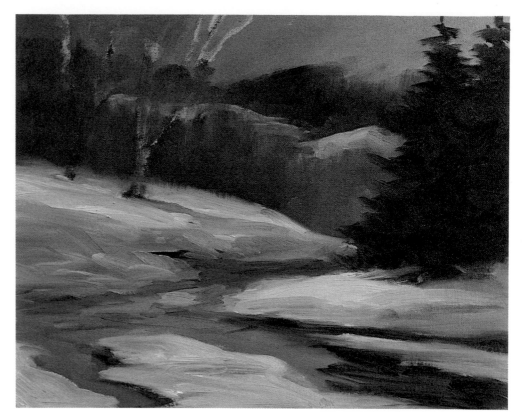

Step 6. At the left, the artist begins the dark trees with another interesting mixture of brilliant colors: cadmium red, viridian, burnt sienna, and a touch of yellow ochre. Adding a little white, he paints the distant tree trunks with a slender brush, varying the strokes by adding more white or yellow ochre. The dark rocks along the shore are the same mixture as the dark trees. Taking a second look, the artist decides that the water reflects its shadowy surroundings more than it reflects the sky. He repaints the stream with ultramarine blue, burnt umber, alizarin crimson, and a bit of white.

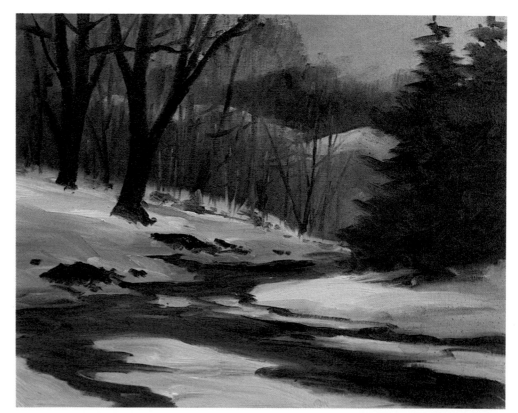

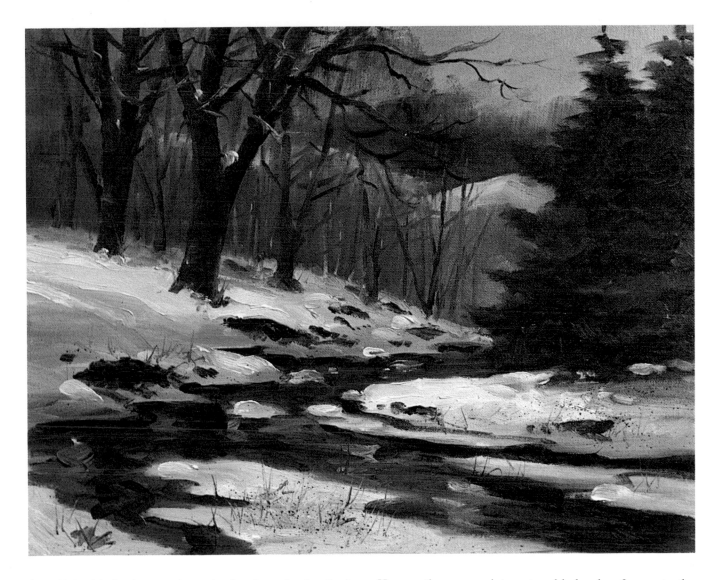

Step 7. In this final stage, the artist develops the detail of the foliage and branches, suggests some detail in the foreground, and builds up the darks and lights. Working with a slender brush, he adds more tree trunks, branches, and rocks with various combinations of brilliant colors that produce subtle darks: cadmium red, cadmium yellow, and phthalocyanine blue; cadmium orange, viridian, and burnt umber; cadmium orange, ultramarine blue, and burnt sienna. Minute changes in the proportions of these mixtures can produce interesting color variations. For example, a bit more cadmium orange adds a note of warmth to the mass of evergreens at the extreme right. An additional speck of cadmium red adds a hint of warmth to the shadowy mass of trees that moves down the distant slope at the left. To brighten the top planes of the snowbanks, the artist piles on thick strokes of white that's slightly tinted with cerulean blue and yellow ochre.

He uses the same mixture to add chunks of snow to the dark stream. And a few casual strokes of this mixture indicate the reflections of the snow in the dark water. The warm tones of the weeds, breaking through the snow in the foreground, are scattered strokes of yellow ochre, modified with a touch of burnt umber, and occasionally darkened with ultramarine blue. If you review the color mixtures used in this painting, you'll find that the artist has employed practically every color on his palette, from subdued hues like burnt umber and yellow ochre to the brilliant cadmiums, phthalocyanine blue, and viridian. Although the finished picture is a muted study of a snowy landscape on an overcast day, every one of these subtle mixtures contains interesting hints of rich color. Challenge yourself to paint a very quiet picture with mixtures of brilliant colors; it's one of the best ways to learn about color mixing.

Step 1. Painting an outdoor subject on a sunny day—perhaps a seascape like this one—will give you an opportunity to use your full palette to create richer colors. Try a gesso panel; your colors will look lighter and your strokes more distinct. Choosing a color that harmonizes with the overall color scheme, the artist draws the composition with ultramarine blue, subdued with a touch of burnt umber, and diluted with turpentine. He uses a big, flat bristle brush to block in the sky with ultramarine blue, cerulean blue, a hint of alizarin crimson, and white—adding more white for the cloud mass.

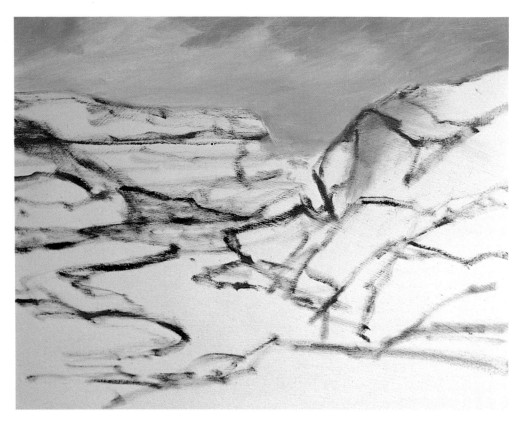

Step 2. The open sea normally reflects the color of the sky, and the water is often quite dark at the horizon. The artist indicates the dark, distant strip of ocean with the same mixture that he's used for the sky—but with less white. Where sunlight strikes the end of the headland at the horizon, he applies warm strokes of alizarin crimson and cadmium yellow, subdued with a touch of cerulean blue and lightened with white. The rest of the headland is cool and shadowy: the artist interweaves strokes of the warm, sunny mixture with cooler strokes of the sky mixture. Hints of warm color shine through the cooler tone of the shadow.

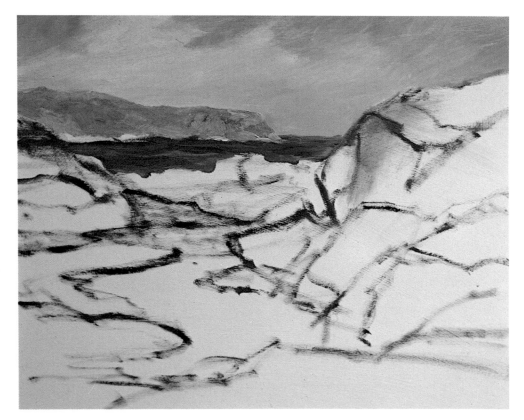

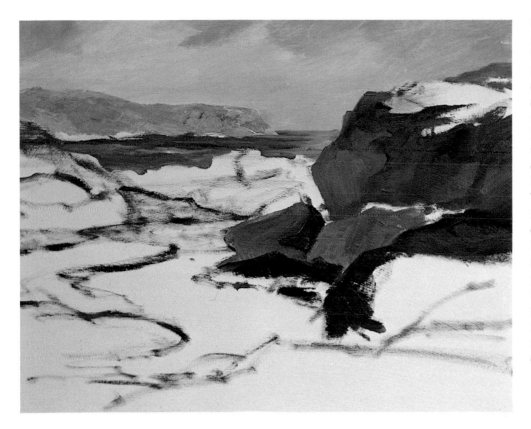

Step 3. Picking up his largest bristle brushes, the artist blocks in the dark tones of the foreground rocks. He concentrates on the shadowy areas, leaving bare canvas for the sunlit top of the largest rock. The strokes are various mixtures of alizarin crimson, ultramarine blue, burnt sienna, and white. The warmer strokes contain more crimson, while the cooler strokes contain more blue. On the seashore, the shadows of the rocks often pick up reflected colors from the water, which is why these shadows look so luminous. To increase their luminosity, the artist adds an occasional touch of yellow ochre.

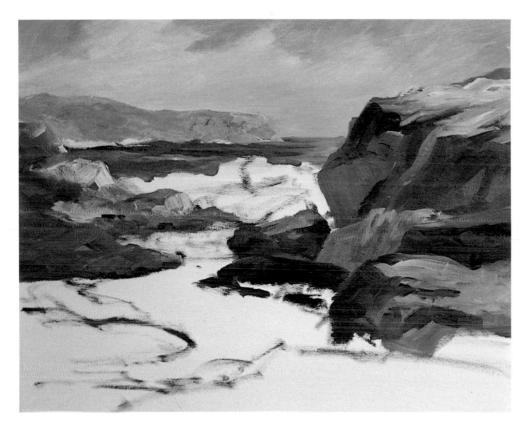

Step 4. The warmer colors of the rocks at the left are painted with various mixtures of cadmium red light, cadmium yellow light, burnt sienna, and yellow ochre, subdued by an occasional touch of ultramarine blue, particularly in the darks. The sunlit tops of the foreground rocks on the right are a mixture of cadmium red light and cadmium yellow light, which produces a stunning cadmium orange. This versatile mixture is easily subdued with a drop of cool color, such as ultramarine blue or viridian, and lightened with white—with an occasional cool note of the sky mixture.

Step 5. The bright, sunny tops of the rocks in the immediate foreground are again painted with cadmium red light and cadmium yellow light, subdued with a speck of ultramarine blue, and lightened with white. The darker tones on the foreground rocks contain more ultramarine blue. Now the entire panel is covered with wet color except for the foaming water between the rocks, which remains the bare, white surface of the gesso. As you look at the rocks—particularly those at the right—you can see how sharp and distinct the brushstrokes look on the smooth surface of the panel.

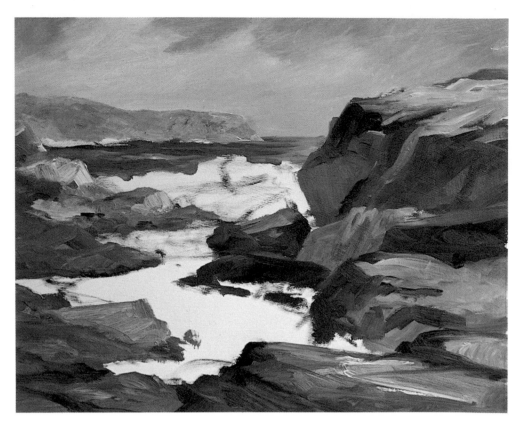

Step 6. Like snow, foam isn't pure white. Foam is water mixed with air, so it *behaves* like water, picking up reflected color. Therefore, under a blue sky, foam is apt to contain cool tones, as you see here. The artist paints the foam with big, rough strokes of white tinted with ultramarine and cerulean blues. Between the rocks, the foam also reflects the warm color of its surroundings, so the artist blends in delicate touches of the rock colors. With each stroke of foam, he varies the proportions of his mixtures, adding more or less white, so the strokes suggest light, shadow, and movement.

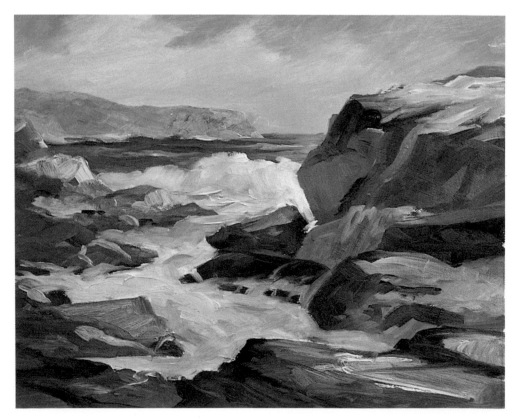

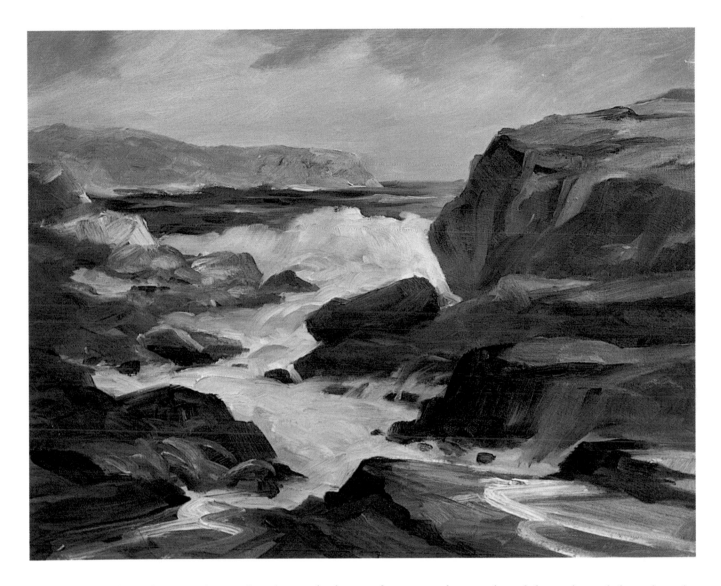

Step 7. The artist makes some interesting changes in the final stage of the painting. In the lower left-hand corner, he builds up and darkens the rocks, so now they're in shadow. He also strengthens the shadows on the rocks on both sides of the foaming water to dramatize the contrast between the dark rocks and the pale foam. These shadowy tones are various mixtures of cadmium red light, alizarin crimson, ultramarine blue, burnt sienna, and yellow ochre, plus white. Thus, there are warm strokes and cool strokes within the shadows, depending upon whether the mixture is dominated by cadmium red, alizarin crimson, or ultramarine blue. When the shadow tones become darker—as they do in the lower left—ultramarine blue and burnt sienna obviously take command. This mixture strengthens the shadow planes of the sunny rocks at the lower edge of the picture. Now the artist works with small bristle brushes to reshape the rocks and to modify the foam. Notice how he carries trickles of foam over the margins of the rocks and down into the lower left. He also uses the foam mixture to suggest the crests of the waves on the dark sea just below the horizon. Compare the finished rocks in Step 7 with the rocks in their unfinished state in Step 6. See how the rocks have become more shadowy, with the colors flowing more softly together. And study the subtle color mixtures within the rocks, which obviously reflect the cool tones of the surrounding water, while retaining the warm tones of the sun and the weathered stone. Although the artist has used a full range of rich colors in this seascape, he's carefully avoided the temptation to make every mixture equally bright. The picture is successful because there's a carefully planned interplay of bright and subdued colors. The muted (but still colorful) tones of the shadowy rocks dramatize the sunlit foam and the bright tops of the rocky slopes.

Step 1. The first four demonstrations show four methods of *direct* painting, which means painting in one continuous operation, and aiming for the final effect from the very beginning. But that's not the only way. The Old Másters often painted in separate operations that they called *underpainting* and *overpainting*. The simplest way to do this is to paint the entire picture in tones of gray or brownish gray, let this monochrome underpainting dry, and then add color in a separate overpainting. In this demonstration, the artist sketches his composition with a mixture of ultramarine blue and burnt umber. He uses the same combination, plus white, to paint the brick wall.

Step 2. The artist continues to work with ultramarine blue and burnt umber, adding more white for the big covered jar and the small jar on the left. He uses a dark value to paint the cucumber, its shadow, and the table edge. Then he adds white to the areas struck by light—the top of the cucumber and right side of the table—leaving the original dark tones in the shadow areas. To paint the drapery, he adds still more white. To make certain that the same tone appears throughout the underpainting, the artist has premixed a large quantity of it on his palette. To modify it, all he has to do is add different amounts of white.

Step 3. He completes the underpainting by executing the forms of the fruits and vegetables, the shapes and textures of the weathered wood, and such details as the strong touches of light and shadow on the jars, the drapery, and the other objects on the table. The finished underpainting is entirely a study in values, similar to a black-and-white photograph of the subject. When the underpainting is dry, the artist is ready to begin overpainting. The underpainting has been executed with just three tube colors—blue, umber, and white—diluted with the simplest painting medium: a 50–50 mixture of linseed oil and turpentine.

Step 4. Now the artist switches to one of the resinous painting mediums that you read about earlier. He blends cadmium red light, alizarin crimson, and burnt umber on his palette, and thins this blend with painting medium until the mixture is smooth and transparent. This *glaze* is brushed over the bricks with a flat, soft-hair brush. In the same way, the wooden table is glazed with a transparent mixture of yellow ochre, burnt sienna, a speck of alizarin crimson, and resinous painting medium. The monochrome underpainting of the bricks and wood shines through these glazes, which are like thin sheets of colored glass.

Step 5. The big, covered pot is now overpainted with a glowing glaze of cadmium red light, cadmium yellow light, and resinous painting medium. The monochrome underpainting, with its sharp, linear details and glowing highlights, still shows clearly through the transparent overpainting. Obviously, the brilliant colors of the overpainting become more subdued as they form optical mixtures with the monochrome underpainting. The artist can control the darkness or lightness of the overpainting by adding more or less medium. He can also brush more wet color onto the canvas to make the glaze darker. And he can wipe away some wet color with a rag—as he does here to accentuate the highlights on the jar.

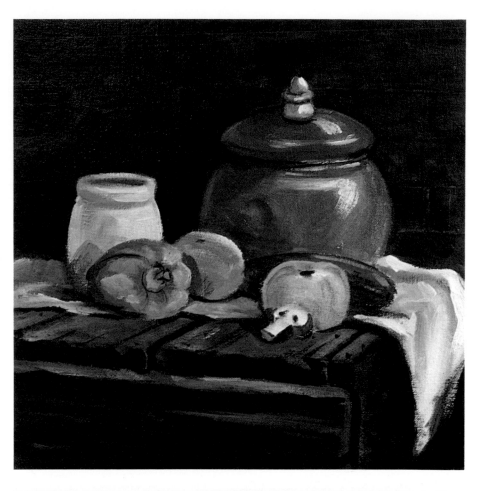

Step 6. The artist glazes the dark form of the cucumber with a transparent mixture of ultramarine blue and cadmium yellow light, diluted with resinous painting medium. To contrast with this subdued green, he mixes a bright glaze of cadmium red light and alizarin crimson on his palette, and brushes this mixture over the tomato. The cucumber has been underpainted in a dark monochrome, so the overpainting remains dark and subdued. But the tomato is underpainted in a pale monochrome that allows the bright glaze to sing out.

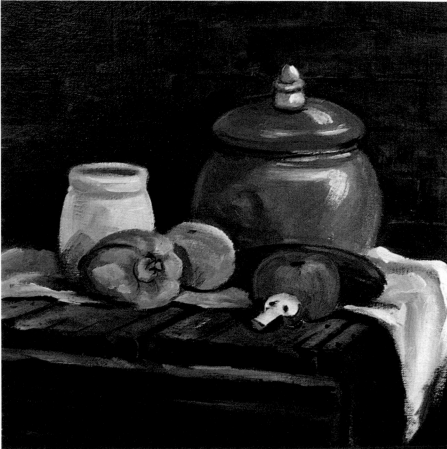

Step 7. The pepper is glazed with cadmium yellow light and ultramarine blue. The orange is glazed with cadmium red light and cadmium yellow light, plus a tiny hint of white that makes the glaze semitransparent rather than absolutely transparent. The small jar and the knob on the top of the big jar are both glazed with cerulean blue. The drapery is glazed with a delicate mixture of ultramarine blue and alizarin crimson, with lots of painting medium. The artist then adds a small amount of white to each of the glaze mixtures and adds more touches of light to each object. You can see these touches most clearly on the pepper, orange, and tomato. He brushes burnt sienna over the sliced mushroom in front of the tomato, wipes away some wet color from the lighted edge of the table, darkens the shadow side of the big pot and the round indentation on the side of the pot, and wipes away some of the glaze on the big pot to suggest cool reflections. This method of underpainting and overpainting has obvious advantages. You can concentrate entirely on difficult problems of form in the underpainting; then, when the underpainting is dry, you can concentrate entirely on the color. And this kind of color has a unique character, quite different from direct painting: transparent glazes give your picture a magical depth, atmosphere, and inner light.

Step 1. Having tried a monochrome underpainting followed by an overpainting in transparent color, you should certainly try a picture in which both the underpainting and the overpainting are in color. It's best to start with a limited color underpainting—a simple underpainting in just a few colors. The artist demonstrates a limited color underpainting in this study of dunes and beach grass beneath a cloudy sky with the sun breaking through. The preliminary brush drawing is executed in burnt umber, diluted with plenty of turpentine.

Step 2. The whole idea is to underpaint with colors that will form interesting optical mixtures with the overpainting. The artist underpaints the sky with yellow ochre and white, blending in more white as he approaches the horizon. He underpaints the shadowy side of the big sand dune with ultramarine blue and white. The top of the dune is underpainted with a dark mixture of ultramarine blue and burnt umber. He begins to darken the beach grass at the bottom of the dune with burnt umber, yellow ochre, ultramarine blue, and white. And he starts to brush a pale mixture of alizarin crimson and white over the sand.

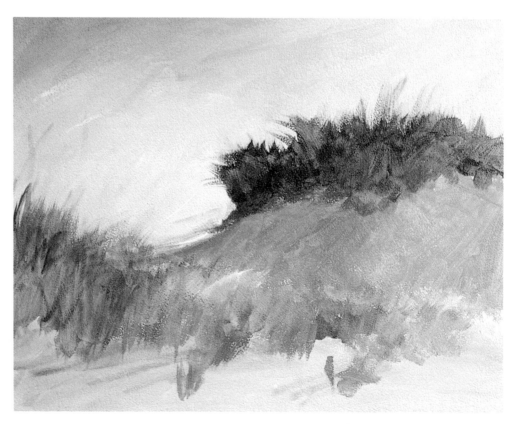

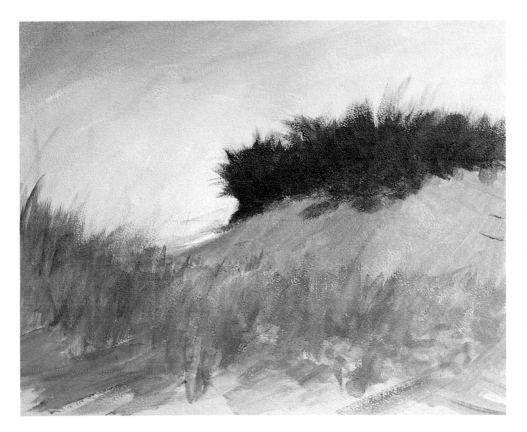

Step 3. The artist continues to build up the underpainting of the beach grass with alizarin crimson, cadmium yellow light, a little burnt umber, and white. Then he brightens the underpainting of the sand with a more vivid mixture of alizarin crimson and white. Moving up to the beach grass at the top of the dune, he darkens this with a dense mixture of ultramarine blue and alizarin crimson. The limited color underpainting is allowed to dry before the artist goes on to the overpainting. The underpainting has been executed with just a few colors, diluted with a 50–50 mixture of turpentine and linseed oil.

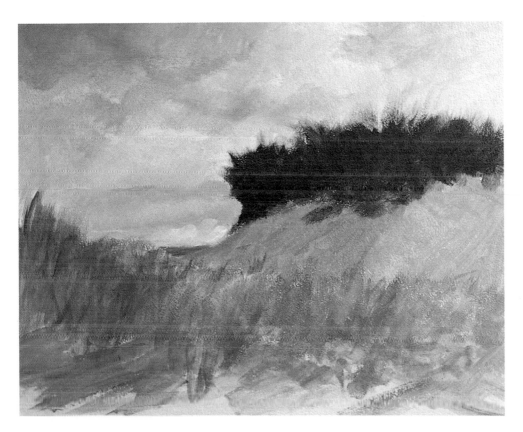

Step 4. The artist blends phthalocyanine blue with a touch of burnt umber and a fair amount of white. He then dilutes this mixture with a resinous painting medium. The result is not a transparent glaze, but a semitransparent mixture called a *scumble*. He brushes this mixture over the sky with a back-and-forth, scrubbing motion that creates a bluish haze over the warm underpainting. In some places, the artist brushes in more blue, more white, or more painting medium to make the scumble thinner. The result is a cloudy sky with patches of blue and warm sunlight shining through. The semitransparent scumble reveals the warm underpainting.

Step 5. A colorful haze of yellow ochre, alizarin crimson, and white is scumbled over the cool, shadowy underpainting on the dune. Thinned to a semitransparent consistency with resinous painting medium, the mixture is scrubbed on thinly to allow the cool undertone to come through. A thin, semitransparent mixture of cadmium red and cadmium yellow light is scumbled over the dark tone of the grass at the top of the dune. Then, a thick, opaque version of that same mixture (which really looks like cadmium orange) is picked up on the tip of a round, soft-hair brush to indicate blades of beach grass caught in bright sunlight.

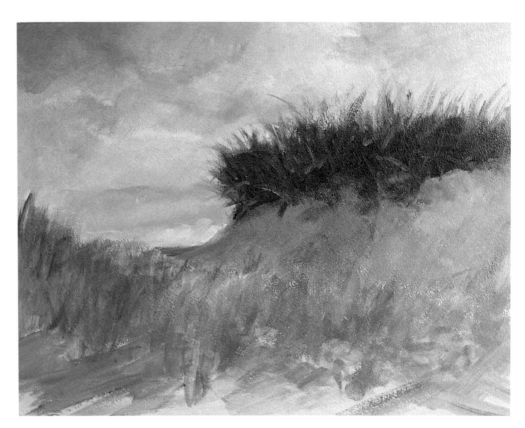

Step 6. Over the hot underpainting in the sandy foreground, the artist brushes a pale scumble of yellow ochre and white, forming an optical blend that expresses the sunny character of the sand. Over the warm underpainting of the beach grass in the foreground, the artist glazes a transparent dark mixture of cadmium yellow, cadmium red, and ultramarine blue, diluted with resinous medium to allow the vivid underpainting to shine through. A dense, opaque mixture of yellow ochre and white indicates the sunstruck blades of beach grass.

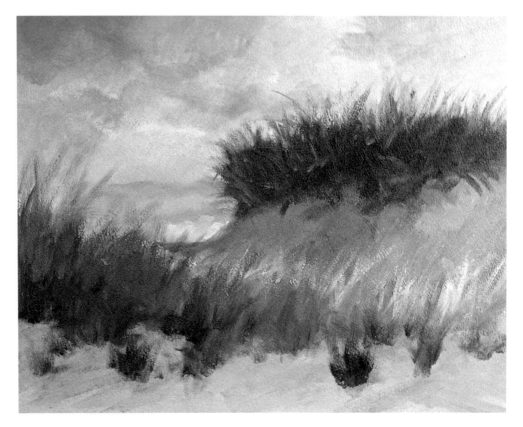

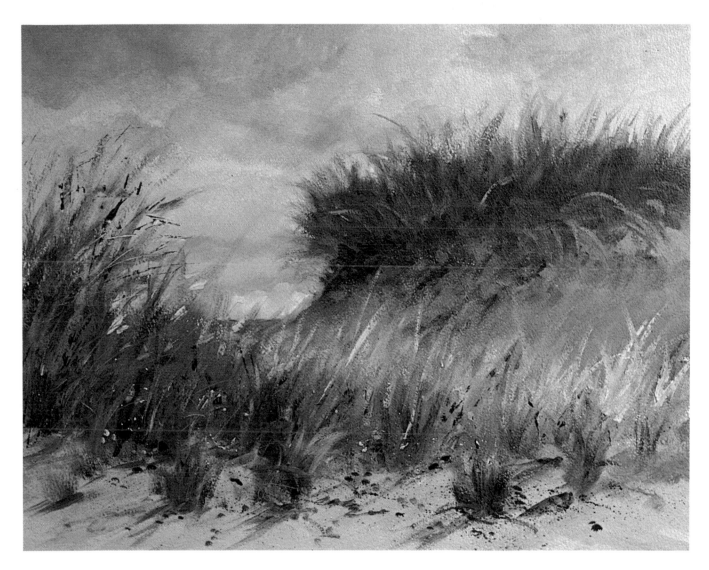

Step 7. While the overpainting is still wet, the artist adds the final details and textures with small brushes. He adds more blades of sunstruck beach grass with slender, opaque strokes of yellow ochre and white. With ultramarine blue and alizarin crimson, diluted to a liquid consistency with resinous painting medium, he adds the tiny dark touches among the beach grass in the foreground. Then he thins this mixture to transparency with more painting medium and brushes in the shadows that are cast by the beach grass across the sand. He blends some white into this mixture to add dark textures to the shadowy face of the big dune. Comparing the finished painting with the completed underpainting in Step 3, it's fascinating to see how the harsh colors of the underpainting gradually form optical mixtures with the overpainting to produce softer, more realistic colors. It's also important to learn the differences between glazes and scumbles. As you've seen in Demonstration 5, a glaze is like a transparent sheet of colored glass. A scumble, on the other hand, is more like a colorful haze. Each of these overpainting mixtures has a special way of forming optical mixtures with the underpainting—which you'll get to know by experience.

Step 1. One of the delights of underpainting and overpainting is that you can plan the underpainting as carefully as the artist did in Demonstration 6, or you can rely on your imagination, mixing your colors intuitively "just to see what happens." In this demonstration, the artist takes the intuitive route. He brushes in the lines of this autumn landscape with ultramarine blue, which will contrast, not harmonize, with the final colors in the painting. He also lets his imagination roam as he begins to block in the colors of the underpainting with broad, casual strokes.

Step 2. As this accidental-looking underpainting proceeds, a certain logic appears. The artist underpaints the dark tree trunks and foliage with colors that should produce interesting optical mixtures with a warm overpainting. And he paints the distant mountain with a warm color that should create an interesting optical mixture with a cool overpainting. Beyond the trees, there's a variety of warm patches that will reinforce the overpainting for the warm foliage. The sky is underpainted in warm colors that will enrich the cool overpainting of the sky.

Step 3. The colors of the finished underpainting certainly aren't those of an autumn landscape, but you now can see all the major pictorial elements. *Nothing* in the picture is really the final color, but all these strange underpainting mixtures are meant to stimulate the artist to invent overpainting colors that will create lively optical mixtures. Most of the warm tones here are blends of cadmium red, cadmium yellow, burnt sienna, and white. Most of the cool mixtures contain ultramarine blue, viridian, and burnt umber.

Step 4. When the underpainting is dry, the artist begins the overpainting. With a resinous medium he scumbles cerulean blue, yellow ochre, and white over the sky, permitting some of the underpainting to show through. He then scumbles cerulean blue and white over the warm underpainting of the mountain to produce a cool optical mixture. In the upper left, the artist begins to brush rough glazes and scumbles of cadmium red and cadmium yellow over the underpainting. The artist darkens the tree trunks by glazing burnt sienna over the cool underpainting.

Step 5. The artist scumbles cadmium red and cadmium yellow, blended with some white, over the foliage and it suddenly emerges in its true autumn colors. However, these colors are obviously enlivened by the under-painting, which still shines through. Some of the cool underpainting becomes patches of sky shining through the leaves. The dark underpainting of the foliage in the upper right forms a lively, irregular op-tical mixture with the over-painting, suggesting an in-tricate pattern of lights and shadows on the leaves.

Step 6. Over the generally cool underpainting of the foreground, the artist glazes and scumbles cadmium red, cadmium yellow, and burnt sienna—alternating trans-parent and semi-trans-parent strokes. Now it's ob-vious that the earth is covered with autumn leaves and other debris typical of the season. The tree trunks are solidified with glazes of phthalocyanine blue and burnt sienna. This mixture is diluted with more paint-ing medium and carried up-ward to suggest the cluster of shadowy leaves in the up-per left. More strokes of cad-mium red, cadmium yellow, and burnt sienna appear throughout the foliage.

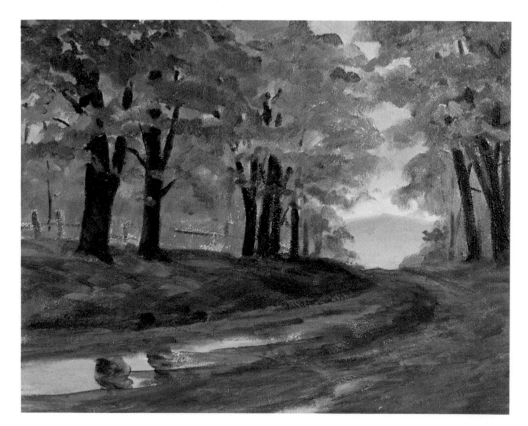

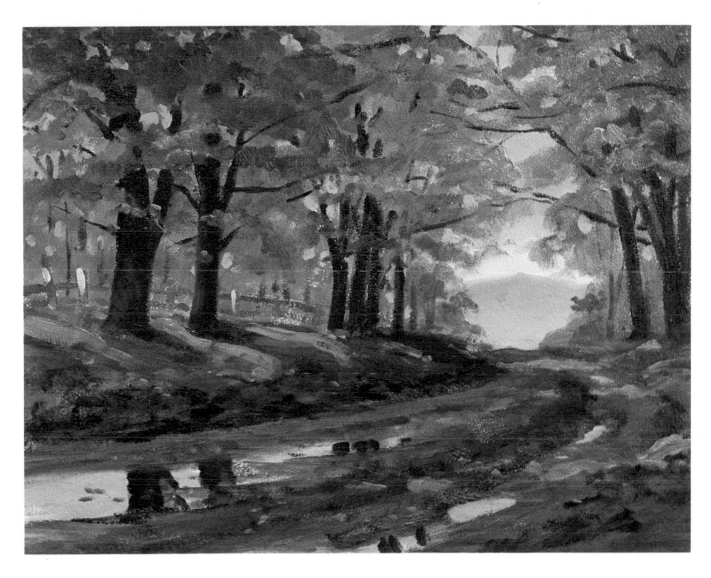

Step 7. The artist completes the painting by strengthening the darks and lights. With a fluid mixture of phthalocyanine blue and burnt sienna, he adds more branches to the trees, adds shadows along the edge of the road, and darkens the reflections of the trees in the puddles. With thick, opaque strokes of cerulean blue, warmed with a touch of yellow ochre and lightened with white, he punches more "sky holes" into the foliage and then brightens the puddles in the foreground. More opaque touches of cadmium yellow, with just a little cadmium red and white, add the sparkle of sunlight to the foliage and suggest patches of sunlight on the ground. Having seen the strange, unrealistic colors of the underpainting, you may be surprised to find that the finished painting is a realistic image of the colors of autumn. Look closely at the finished painting, and you'll see hints of the underpainting colors in almost every area of the canvas. Although the casual observer would never notice the underpainting, *you* know that it adds great vitality to the optical mixtures that produce these vivid color effects.

Step 1. So far, with the exception of one demonstration on a smooth gesso panel, these oil painting demonstrations have been done on canvas. Now this demonstration shows you an underpainting technique that takes advantage of a really *rough* painting surface. The artist coats a hardboard panel with thick, rough strokes of gesso that retain the imprint of the brush. When the gesso is dry, the artist draws the outlines of his composition with burnt sienna, diluted with turpentine. (His strokes obviously reveal the roughness of the painting surface.) He then blocks in the sky with cerulean blue, a little yellow ochre and a lot of white, gradually blending in more white as he nears the horizon.

Step 2. Thinning burnt sienna to a transparent consistency with plenty of turpentine, the artist washes this warm color over the tree trunk and branches. The purpose of this operation is to define the silhouette more clearly—preparatory to the next step. In the lower left-hand corner, the artist suggests a distant mountain with a mixture of ultramarine blue, alizarin crimson, yellow ochre and white. The rocky foreground remains bare gesso.

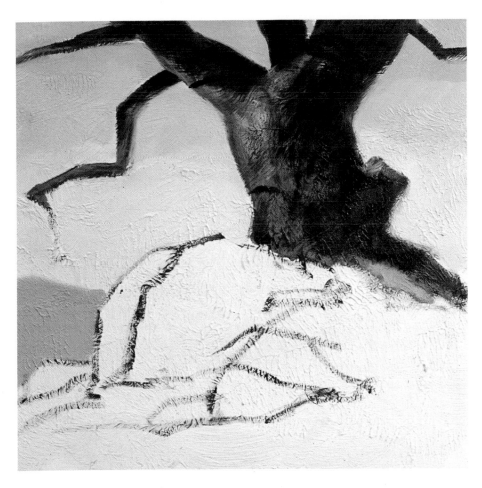

Step 3. With a dark mixture of burnt sienna and ultramarine blue, the artist uses a technique called *drybrush.* He holds his brush at an angle and moves it lightly back-and-forth over the trunk and branches. As the brush touches the raised texture of the rough gesso, liquid color is deposited on the irregular ridges of the painting surface. He gradually presses harder on the brush, depositing more color in certain areas to suggest dark shadows. Now the entire trunk and branches have the ragged texture of bark—which is why the artist has chosen this textured gesso panel. With a smaller brush he strengthens the branches and draws shadow lines on the trunk.

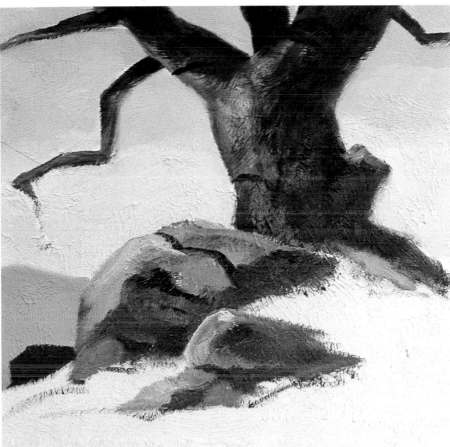

Step 4. With various mixtures of phthalocyanine blue, burnt sienna, yellow ochre, and white, the artist blocks in the lights and shadows of the rocks. The sunlit top planes contain more white and yellow ochre. There's more burnt sienna and phthalocyanine blue in the shadowy side planes . The cracks in the rocks are pure burnt sienna and phthalocyanine blue—as is the dark silhouette of the rock in the lower left. This is the finished underpainting. The artist lets the paint dry thoroughly before he goes on to the overpainting.

Step 5. Over the dried underpainting of the trunk and branches, the artist paints a glaze of burnt sienna with a hint of cadmium red light in the warmer areas and a little ultramarine blue in the cooler areas. (The color is thinned with resinous painting medium.) While this glaze is wet, the artist scrapes the trunk with his palette knife, taking color off the ridges to accentuate the ragged texture of the bark. The shadows on the snow are painted with ultramarine blue, alizarin crimson, yellow ochre, and white. Just a hint of this mixture is added to pure white for the lighted areas of the snow. The artist adds more shadows to the trunk and branches.

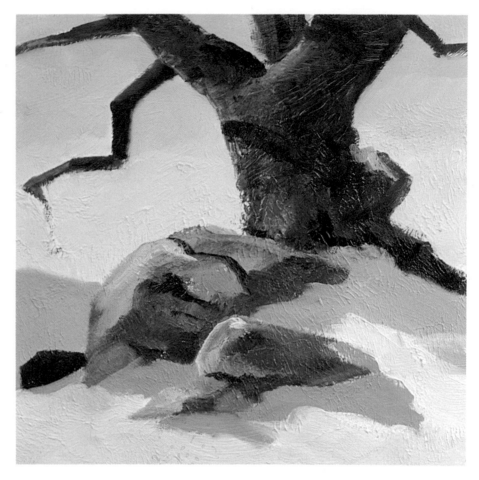

Step 6. The artist mixes a thick blend of cerulean blue, burnt sienna, yellow ochre, and white with his palette knife. Then he picks up this mixture with a painting knife—a knife with a specially designed, flexible, diamond-shaped blade—and carries the thick, pasty color over the lighted planes of the rocks. The color is caught by the rough texture of the gesso, so these strokes now have the ragged texture of the rocks themselves. Darkening this mixture with more cerulean blue and burnt sienna, the artist repaints the shadow planes with similar strokes. With a small, pointed brush he paints the cracks in the rocks with phthalocyanine blue and burnt sienna.

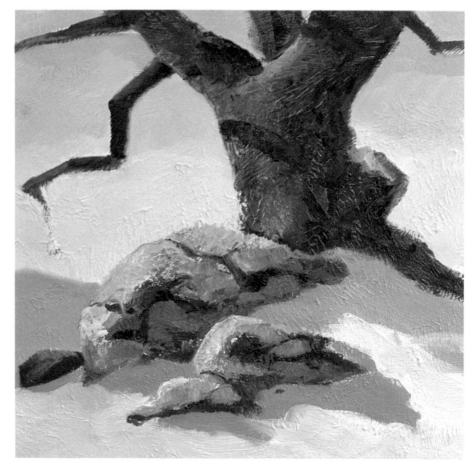

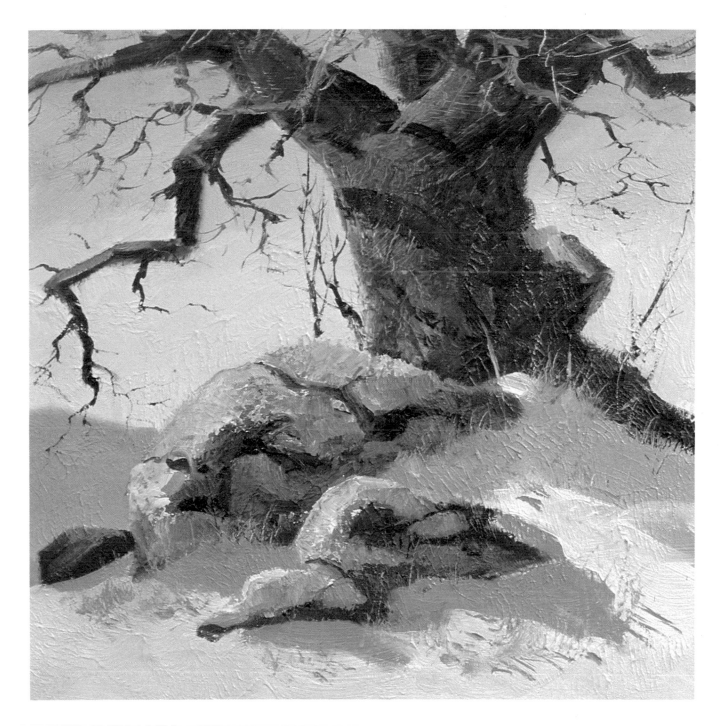

Step 7. To make the texture of the trunk even more obvious, the artist uses the side of his palette knife blade to scrape away more color from the ridges of the gesso panel. Picking up a very small amount of phthalocyanine blue and burnt sienna on a brush that's *damp*—not wet—with color, the artist strengthens the darks of the tree trunk with more drybrushing. He moves the damp brush lightly back-and-forth over the rough painting surface so that the bristles touch only the peaks and skip the valleys. Thus, the shadowy areas of the bark gradually grow darker and rougher. With a slender, pointed brush, he adds dark branches and twigs to the tree using a fluid mixture of phthalocyanine blue, burnt sienna, and paint-

ing medium. With a similar brush he adds lighter twigs and branches with cerulean blue, burnt umber, yellow ochre, and white. Wispy strokes of yellow ochre, burnt umber, and white are scattered across the foreground to suggest dead weeds in the snow. And the tip of a tiny brush is used to add the delicate shadow lines of the weeds with the same mixture used for the shadows on the snow: ultramarine blue, alizarin crimson, yellow ochre, and white. Studying the finished picture, you can see why the artist prepared this rough painting surface to suit the subject. He's used the irregular texture of the thick gesso to convey the weathered bark of the old tree and the granular surface of the rocks.

Step 1. In the first four demonstrations, you've seen how to mix colors on your palette. But another interesting approach is to start mixing colors on the palette and then continue to mix them on the canvas. Because the colors flow into one another on the painting surface, you achieve an almost instant color harmony. The artist begins with the usual brush drawing—in ultramarine blue and alizarin crimson. The brush lines will disappear as soon as the canvas is covered with wet paint, but the drawing stamps the design of the picture in the artist's memory.

Step 2. On the palette, the artist creates various mixtures of ultramarine blue, phthalocyanine blue, cadmium red, cadmium yellow, and yellow ochre, all softened with a great deal of white. He then brushes these tones over the entire canvas, letting all the colors fuse into one another. At first glance, the canvas seems like a haze of random strokes, but the strokes do follow some logic: the artist remembers that the cool tones of the water belong at the bottom of the canvas, while there's a brightly lit area in the center of the sky.

Step 3. Keeping the original drawing fixed firmly in his mind, the artist begins to blend more color into the wet surface of the canvas. He adds soft, blurred strokes of cadmium red and cadmium orange to the sky, and then he makes sure that these colors are reflected below in the area of the water. He darkens the water with more phthalocyanine blue—using this powerful color in very small quantities so that it won't obliterate the other mixtures. There are still no definite forms in the painting, but you begin to sense the presence of sky and water.

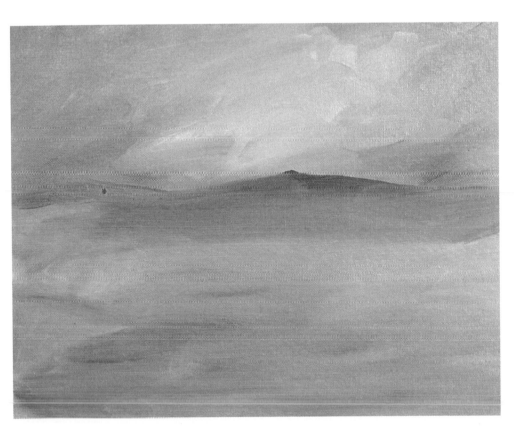

Step 4. At last, the first concrete form appears in the painting. It's the distant mountain that the artist has indicated in the original brush drawing. The shape is painted with ultramarine blue, alizarin crimson, and a little white, first mixed on the palette and then blended carefully into the wet color on the canvas. With long, horizontal strokes, the artists melts the lower edge of the mountain into the color below. That mountain makes us see the warm color above as sky, and the color below as misty water. Going over these areas with a big brush, the artist blends the colors more softly. Some of the harsh tones of Step 3 begin to fade.

Step 5. After combining burnt sienna, viridian, and a little cadmium orange on the palette, the artist brushes this into the middleground, just beneath the mountain, to create a wooded island. He carries a few strokes down into the water to suggest the reflection. He then picks up burnt umber, ultramarine blue, and viridian on his brush for the dark silhouette of the island on the left, its reflection, and the dark mass of foliage above. As each color is added to the picture, it mixes with the color that was placed on the canvas earlier. With a small brush he adds lines of yellow ochre and white to suggest shining white streaks in the water.

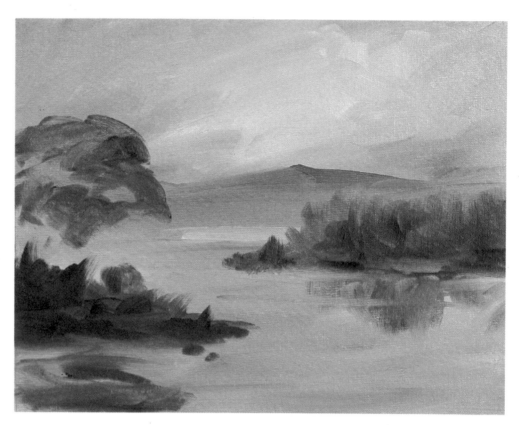

Step 6. The artist builds up the form of the big tree and the island at the left with thick strokes of ultramarine blue, viridian, and a touch of cadmium orange for warmth. The island is extended further into the water, and the tone of the land is darkened to match the tone of the tree. The reflection in the water is darkened for the same reason. A few streaks of cerulean blue, viridian, and white are carried across the reflection to suggest the light on the water. These dark tones in the left foreground are warmed by the underlying color that merges with the fresh brushstrokes.

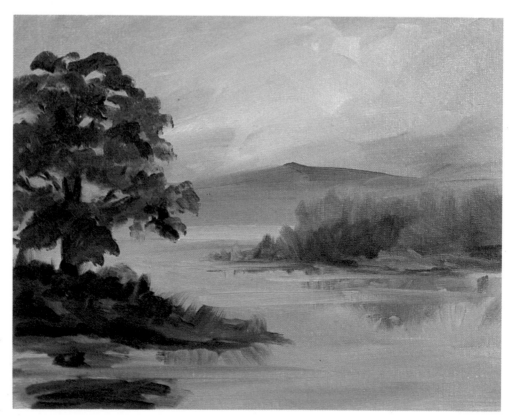

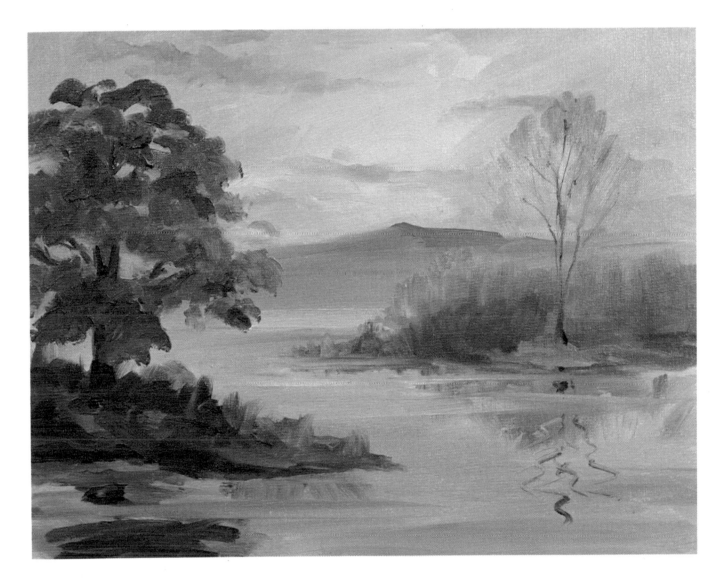

Step 7. To lighten the tone of the sky, the artist blends more yellow ochre and white into the wet, underlying color. Slightly darker, wispy clouds are brushed in with cerulean blue, alizarin crimson, and white. A touch of burnt umber is added to this mixture for the soft, almost transparent foliage of the slender tree on the right. Its twigs and the clouds merge with the underlying sky tone as the brush moves over the wet color. With a pointed, soft-hair brush, he draws the slender lines of the tree trunk with burnt sienna and ultramarine blue, then carries wiggly lines into the water for its reflection. After mixing cadmium red and cadmium yellow on the palette with a small bristle brush, he adds thick touches of this bright mixture to the edges of the tree on the left, the island below it, and the foliage in the central island to suggest warm sunlight on the dark shapes. Because of this special method of mixing color on the canvas, the final picture has a particularly lovely, delicate color harmony. The wet colors of Steps 2 and 3 flow through all the other colors that come afterward, creating the unified color scheme that's typical of this technique. If you study the individual brushstrokes, you'll see that they have a beautiful, soft quality because they're painted on a layer of wet color.

Step 1. For clarity of color, nothing equals painting with a knife. The polished, resilient, diamond-shaped blade of the painting knife deposits a smooth, dense stroke of color on the canvas—and that stroke always looks brighter and clearer than a brushstroke of the same color. After making a preliminary drawing on the canvas with ultramarine blue and turpentine, the artist knifes in the upper area of the sky with alizarin crimson, white, and a touch of ultramarine blue. He covers the lower sky with yellow ochre and white, warmed with a speck of alizarin crimson. With the knife, he scrapes the paint down to a very thin layer that will accept additional color.

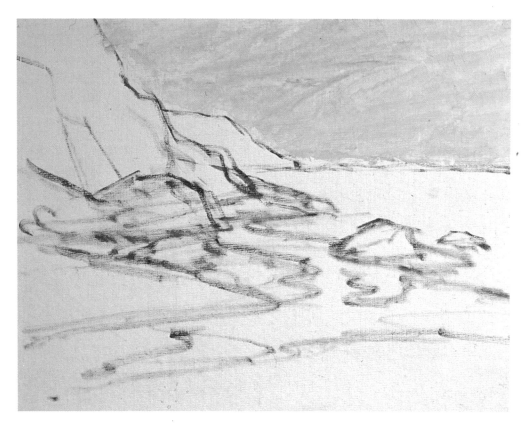

Step 2. The artist blocks in the dark cliff with strokes of ultramarine blue, burnt umber, yellow ochre, and white; the cool distant cliff with phthalocyanine blue, burnt umber, yellow ochre, and white; and the rocks' dark side planes with burnt sienna, ultramarine blue, and yellow ochre. The sunlit tops of the rocks are mixed with varying amounts of burnt sienna, yellow ochre, and white. The sand is yellow ochre, cadmium red, and white. The warm triangular shape on the sand at the left is burnt sienna and yellow ochre. The canvas is again scraped with a knife to force the color into the weave and expose its texture so the surface will grip additional strokes.

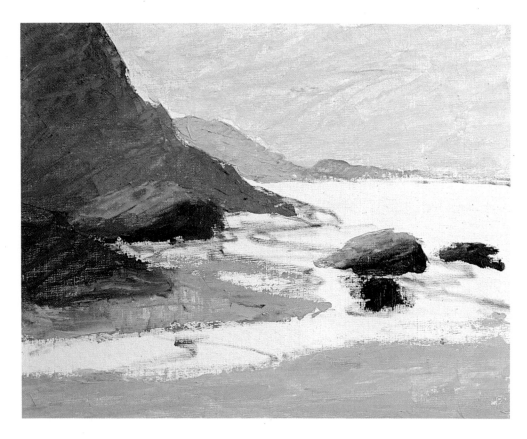

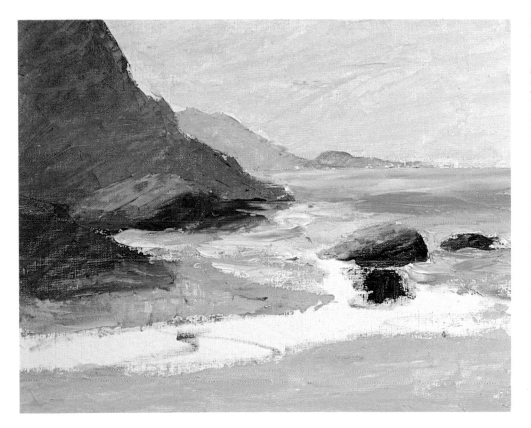

Step 3. Beneath the point of the dark cliff, a warm reflection is indicated with a few strokes of burnt sienna and yellow ochre. Then the water is laid in with long, horizontal strokes of phthalocyanine blue with some burnt umber, yellow ochre, and white. Obviously, more white is added to the paler strokes. At the edge of the horizon, just beneath the cool tone of the distant shore, the artist places a single, slender stroke of yellow ochre and white, warmed with a little alizarin crimson, to suggest the light of the sky shining on the surface of the water.

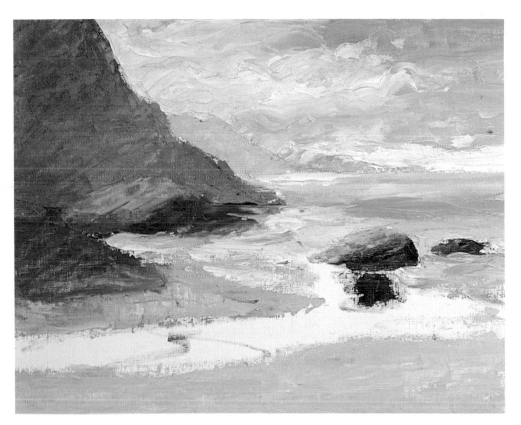

Step 4. On his palette, the artist blends several mixtures of phthalocyanine blue plus burnt umber and yellow ochre. He adds a little white for the cool patches of sky, more white for the pale tops of the clouds, and some yellow ochre for the warmer areas. Adding a touch of yellow ochre to enliven the white on his palette, the artist accentuates the sunlit tops of the clouds, and adds the strip of light just above the horizon. He varies the thickness of his strokes, sometimes applying the paint so thinly that the warm under painting comes through, suggesting sunshine breaking through the clouds.

Step 5. The artist strengthens the shape of the distant cliff with the sky color and a little burnt sienna. He knifes a low cloud over the top of the cliff. Then he blends ultramarine blue, burnt sienna, yellow ochre, and a touch of alizarin crimson for the warmer strokes in the dark cliff; and ultramarine blue and burnt sienna for the darker strokes in the cliff and rocks. Strokes of sky color suggest reflections among the wet rocks at the base of the cliff. Just beneath the cliff, observe how a few vertical strokes of rock color and sky color are softly blended together with the knife to suggest the reflection of the cliff.

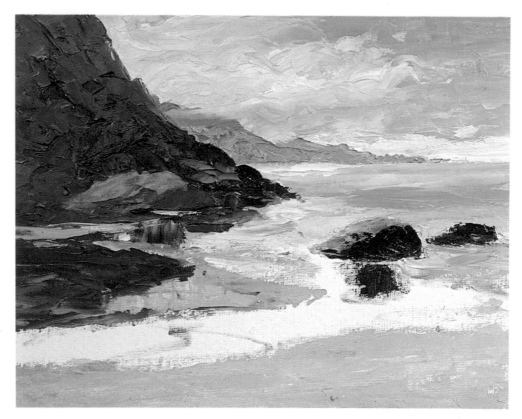

Step 6. The artist goes over the sand with thick strokes of yellow ochre, cadmium red, and white, plus a touch of cerulean blue. Then he blends a bit more blue into the foreground sand. He completes the water in the foreground with strokes of the various sky mixtures, accentuating the sparkling foam and the sunlight on the wet beach with thick strokes of white and yellow ochre. Picking up the dark rock mixture on his knife blade, he carries the reflection of the shadowy cliff down into the tide pool in the lower left. He uses thick strokes of the sand mixture to strengthen the sunlit tops of the rocks.

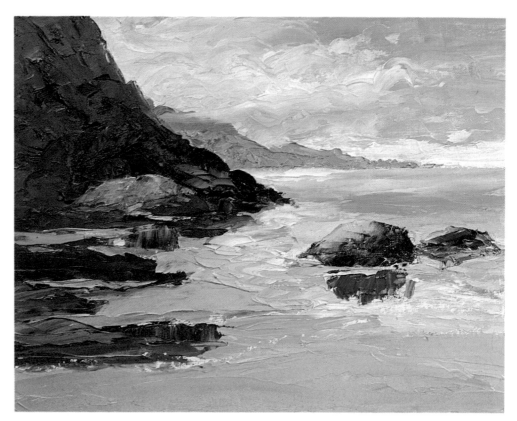

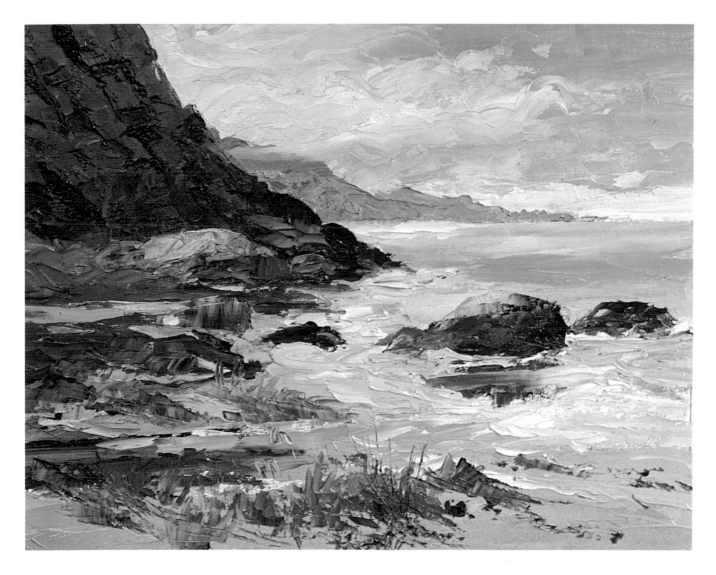

Step 7. Knife painting doesn't lend itself to intricate detail, but you *can* do more precise work than you might think. To strengthen the shadowy cracks in the dark cliff, the artist mixes phthalocyanine blue and burnt sienna. He adds the dark strokes by touching the side of the blade lightly against the canvas and then pulling the knife away. With this same mixture he adds more darks to the shore, including another rock at the edge of the beach. The artist also darkens the rock in the water at the extreme right. With the tip of the blade he adds quick, slender, curving strokes of sunlit foam (white tinted with yellow ochre) and he carries more sky reflections into the tide pool in the foreground. To suggest more movement in the foreground water around the rocks, he adds quick, choppy strokes of sky and cloud color. Finally, to indicate the scrubby grass on the sand, he uses the tip to paint short, irregular strokes of ultramarine blue, cadmium yellow, and a little burnt umber. These slender, linear strokes are again executed by pressing the sharp edge of the blade against the canvas and then pulling away. The finished painting looks delightfully rough and spontaneous, but the color has been carefully planned. The underpainting has *almost* disappeared beneath the heavy strokes of the overpainting, but not quite. You can still see the warm underpainting in the sky and in the shore. The color also has a freshness and purity that's unique to knife painting. To insure this purity, you must observe certain "rules" when you paint with a knife. Wipe the blade carefully and make sure that it's absolutely clean before you pick up a new color. Work with the absolute minimum number of strokes. Move your knife decisively across the canvas, and then pull the blade away without scraping back-and-forth—which will transform your bright color to mud. Mix your colors on the palette and be sure that the mixtures are right. Mixing colors on the canvas destroys their freshness. For knife painting, it's best to work on the woven texture of canvas, rather than on smooth, hard panels. If you really enjoy knife painting, you'll want to buy several painting knives with blades of different sizes and shapes.

Warm and Cool. If the strongest warm-cool contrast occurs at the center of interest—as it does in this mountainous landscape—the viewer's eye will go directly to that spot. The artist has planned this composition so that the center of interest is the group of sunlit rock formations surrounded by cool, shadowy cliffs on either side.

Bright and Subdued. Planning your contrasts of bright and subdued color is another way of directing your viewer's attention. The viewer's eye zigzags across the shadowy landscape, following the brightly lit water to the dark horizon and stopping at the patch of sunny sky. The artist reserves his most brilliant color for the sky just above the dark horizon.

Light Against Dark. Still another dramatic compositional device is the contrast of light against dark—the contrast of value. To focus your attention on the top of the rock, the artist places his lightest value right there, surrounding it with darkness. The artist has thrown a spotlight on the center of interest.

Leading the Eye. Color can provide a path for the eye. Here, the bright flowers carry you into the picture from the lower left, and then swing you gently around to the center of the picture, where the focal point is the break in the foliage at the horizon. The colorful path is accentuated by the dark patches in the meadow surrounding the flowers.

Cubical Form. To understand color, you must understand light and shade. Sunlight strikes these rocks as it would a cube. The top planes receive direct sun, while the side planes are in shadow. Where the light and shadow meet, there's a silvery halftone. And at the left side of each shadow, there's a hint of reflected light.

Rounded Form. Light from the sun curves around the puffy clouds very much as it would on a sphere. From right to left, you see the same four tones that you saw on the rocks: light, halftone, shadow, and reflected light. The reflected light bounces into the shadow from the sun on a nearby cloud.

Conical Form. This tall rock formation on a beach isn't exactly conical, but the light moves over the form as if it's a cone. Looking from right to left, you again see light, halftone, shadow, and just a bit of reflected light within the shadow, picked up from the mirror-like surface of the water.

Irregular Form. Not every form is geometric, of course, but once you've learned to recognize those four degrees of light and shade, you can see them on almost everything. Here, for example, on the twisted shapes of the dead tree, you can still see the same gradation—light, halftone, shadow, and reflected light—bouncing off the shining surface of the sunlit snow.

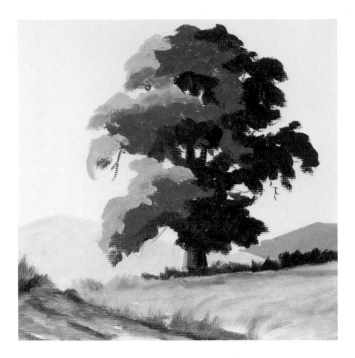

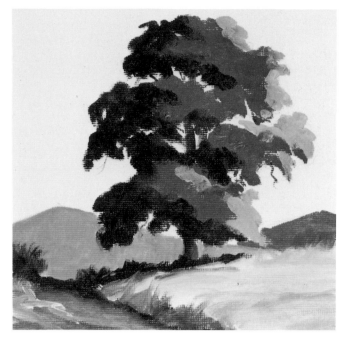

Side Lighting from Left. The direction of the light has a powerful influence on form and color. This tree receives the sunlight from the left. Thus, as you look from left to right, you see distinct zones of light, halftone, and shadow. In this case, there's no reflected light, but since the light comes from the left, the tree casts a shadow on the ground to the right.

Side Lighting from Right. The sequence of light, halftone, and shadow is reversed when the same tree receives the sunlight from the right. Once again, you see the three degrees of light and shadow, but in the opposite order. And because the light comes from the right, the cast shadow falls on the ground to the left of the tree.

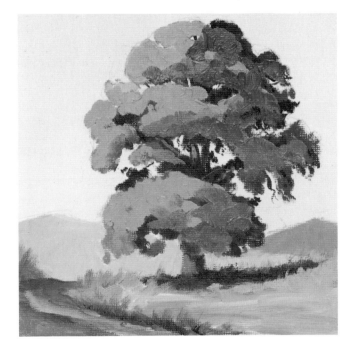

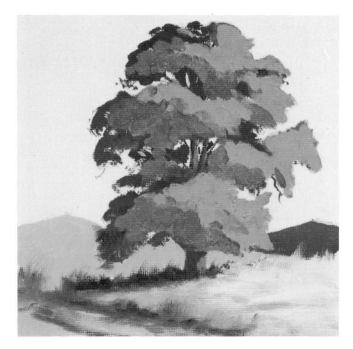

Three-Quarter Lighting from Left. Again the light comes from the left, but now it's moving over your left shoulder and striking the tree at an angle, rather than coming directly from the side. Thus, there's more light on the tree, somewhat less halftone, and just a bit of shadow at the extreme right. The cast shadow is at the right and slightly behind the tree.

Three-Quarter Lighting from Right. When the light comes diagonally over your right shoulder, the sequence of tones is reversed again and the cast shadow moves to the left. In both these examples of three-quarter light, notice that the sun is slightly above the tree, so the halftones and shadows tend to move under the leafy masses.

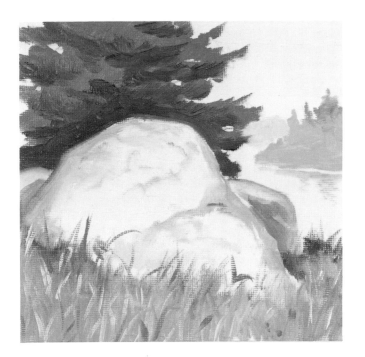

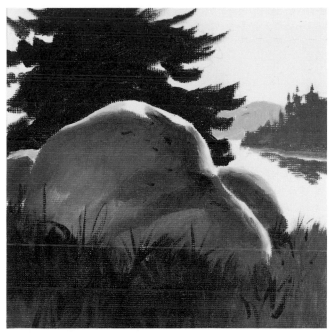

Front Lighting. When the sun is above and behind you, the light strikes the center of the form, and the halftones occur around the edges—as you see in this rock formation. Most of the rock is in bright sunlight, with so little darkness that there really are no true shadows, and the halftones create continuous strips of soft tone around the shapes.

Back Lighting. When the sun is behind the rock, the effect is exactly the opposite of front lighting. The face of the rock is almost entirely in shadow, with just a slender rim of light around the edge. However, there are strong reflected lights within the shadows, possibly bouncing off another rock or a pool of water that you can't see in the painting.

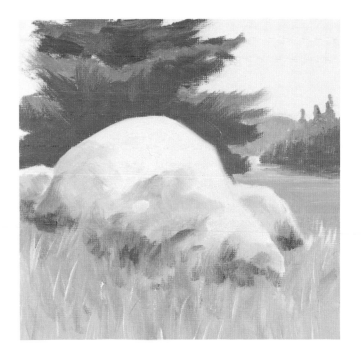

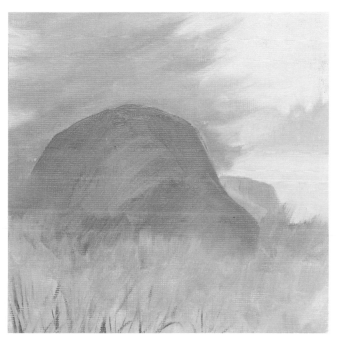

Top Lighting. At midday, the sun is directly overhead. The tops of the forms receive the strongest light, while the bottoms are in shadow, with the halftones somewhere in between. It's usually hard to see the reflected light within the shadow—and there may not be any.

Diffused Light. On an overcast, foggy, or hazy day, you may not see the usual gradation of light, halftone, shadow, and reflected light. You simply have to study your subject carefully and paint the pattern of light and shadow that you actually see. In this case, the rock contains a patch of soft light—perhaps from a break in the clouds—surrounded by soft shadow.

Sunny Day. Changes in the weather can completely transform the pattern of light and shade on your subject. On a sunny day, there are strong contrasts in this coastal landscape. You can see each tone very clearly: there are crisp lights and clearly defined shadows. Cast shadows, like the one to the left of the big rock at the center of the beach, may turn out to be surprisingly pale because they pick up reflected light from the sky or from nearby reflecting surfaces like the sunny sand or water. On the sunlit cliff in the upper half of the picture, it's easy to see distinct planes of light, halftone, and shadow, with hints of reflected light within the shadows.

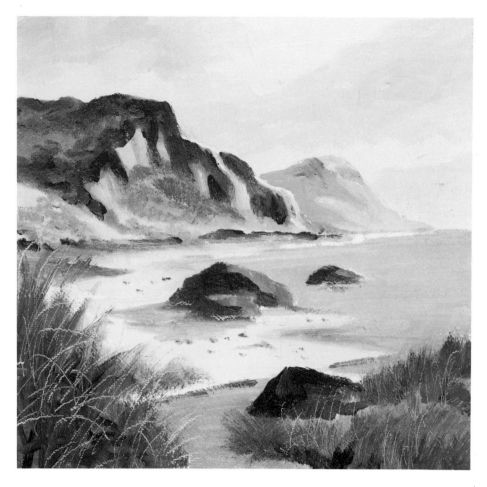

Cloudy Day. All the forms tend to become darker on a cloudy day, but you can still see the various degrees of light and shade if you look carefully. Surprisingly, a cloudy day can produce dramatic lighting effects if there are breaks between the clouds, allowing the sun to shine through and spotlight certain parts of the picture. That's what happens here, when the clouds open to allow a ray of light to illuminate the beach. At that one spot in the landscape, there are bold contrasts of light and shade, similar to those on a sunny day. In the foreground and on the cliffs, the clouds cast large, dark shadows. You can often create a powerful composition by placing cloud shadows on some parts of your picture, and spotlighting other areas.

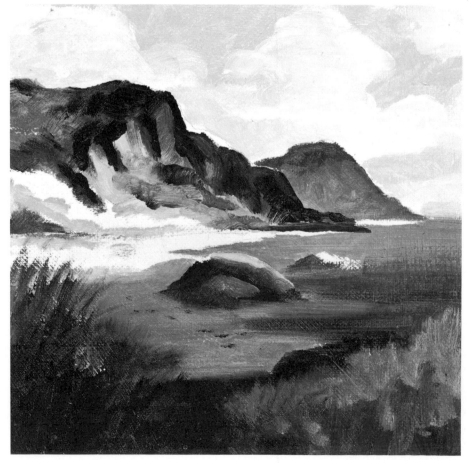

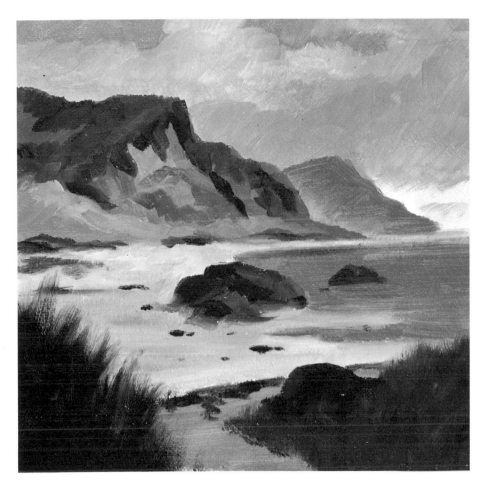

Overcast Day. When the light of the sky is screened by a layer of clouds, only a limited amount of light comes through, and all the values in the landscape move lower on the value scale. There are no really strong contrasts of light and dark, since the lights are all fairly dim. Sometimes there's a small break in the clouds, as you see along the horizon at the right. Such a break may allow a bit more light to fall on some particular part of the landscape, as it does here on the beach. But the total effect is still quite somber. This doesn't mean that an overcast day is a bad subject for a painting; on the contrary, many artists enjoy capturing this somber mood.

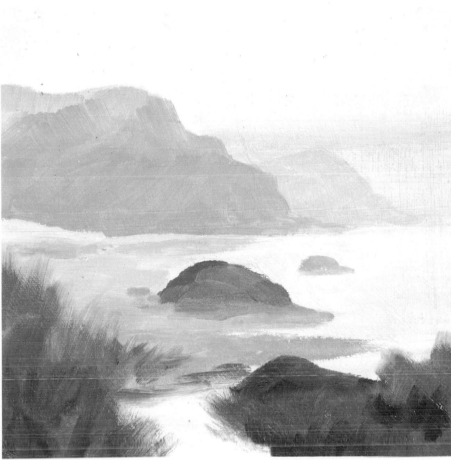

Hazy Day. At times, the entire landscape is covered with a haze that seems to drop a delicate veil over all your colors. Unlike overcast weather, when value differences may still be visible, haze makes it virtually impossible to see the distinction between light, halftone, shadow, and reflected light. The magic of a hazy day is that the weather reduces almost all the shapes to simple, mysterious silhouettes. To capture this magic, you must observe all the values carefully and match them accurately when you mix your colors.

High Key. As you study the values of your subject, it's often helpful to decide on the *key* of your picture. In a high-key picture like this one, *all* the values—including the darks—are fairly light. Nearly all your tones come from the upper part of the value scale. This means that the darkest tones of the picture are middle values, while everything else is lighter still. In this hazy winter landscape, with the snow falling, the darkest shapes are the evergreens, but see how pale they look in comparison with the two other studies of the same subject on this page.

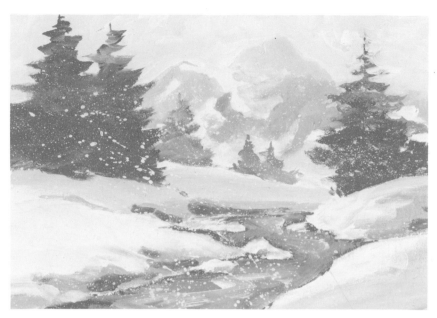

Middle Key. When the snow stops falling and the sun begins to come out through the haze, this winter landscape is transformed to a middle key. That is, most of the values come from the middle area of the value scale. The dark trees are slightly darker, but they're still not as dark as they'd be if the picture were in a low key. The stream grows darker and so do the shadows on the mountain. The snow is a little darker too, although you can still see some fairly bright patches of sunlight that come from the upper end of the scale.

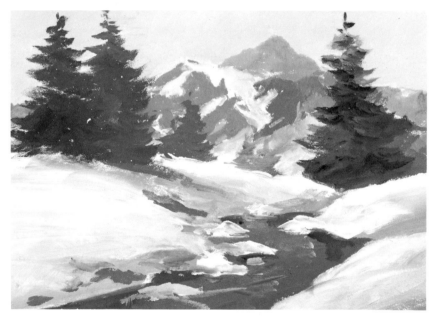

Low Key. When most of the tones in a landscape come from the lower part of the value scale, the picture is in a low key. The darks, like the evergreens and the stream, are apt to come from the very end of the value scale. The shadows on the snow and on the mountain come from slightly higher places on the value scale, while the sky and the lighted areas of the snow come from the middle area of the scale. In this low-key picture, the shadows on the snow are roughly the same value as the evergreens in the high-key picture. The best way to learn about high, middle, and low key is to go outdoors and paint some small oil sketches with mixtures of black and white tube color.

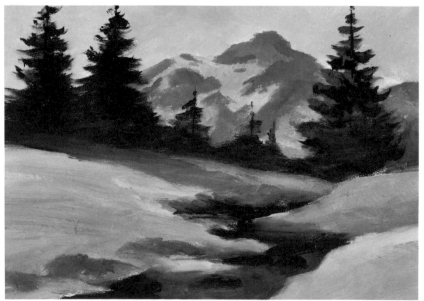

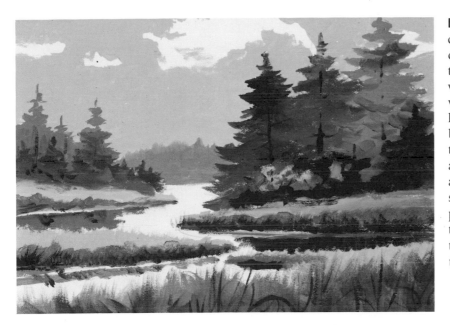

High Contrast. It's also important to decide whether you're painting a high-, medium-, or low-contrast subject. Examine the values you see on your subject. If the values are drawn from all parts of the value scale, you'll probably be painting a high-contrast picture. In this landscape in bright sunlight, the darkest notes among the trees and shore come from the lowest area of the value scale, the sunlit clouds and water come from the upper part of the scale, and the middletones come from places on the scale between the two extremes. A high-contrast subject has no particular key because the values come from the full range of the scale.

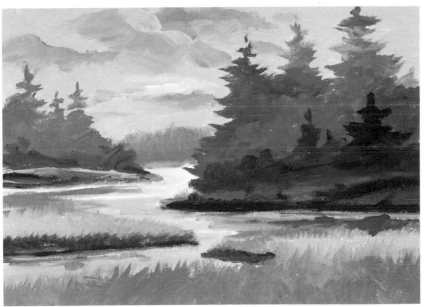

Medium Contrast. On a day that's partly cloudy or slightly overcast, with some sun breaking through, the same landscape is likely to become a medium-contrast subject. Now the darks turn somewhat lighter and the lights turn somewhat darker. But there's still a reasonable contrast between the lights (the sky and water) and the darker tones of the trees and shoreline. Only a few tones come from the far ends of the value scale—most of them come from the center of the value scale. This medium-contrast landscape is also in a middle key. But medium contrast and middle key don't always go together. The low-key landscape on the opposite page is also in the medium-contrast range.

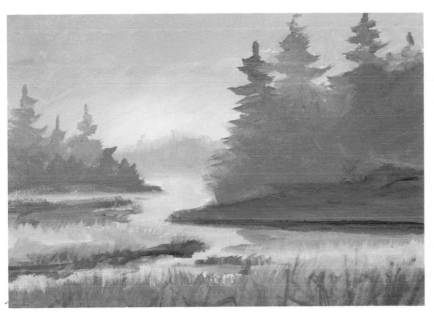

Low Contrast. On a hazy day, this landscape is transformed into a low-contrast subject. The lights grow darker and the darks grow lighter, so there's less contrast between them. Compare this with the high-contrast oil sketch, where the darks are deeper and the lights more intense. This hazy landscape is in a fairly high key, since most of the tones come from the upper part of the value scale. But, again, low contrast doesn't necessarily mean high key. As night falls, this landscape would still be in the low-contrast range, but it would fall into a low key. Make some more black-and-white oil sketches to explore these tonal contrasts.

Step 1. Here the artist shows how he paints a high-key landscape. Whether in black-and-white or in color, the technique is the same. After the usual brush drawing of the main shapes in the composition, the artist begins by blocking in the lightest and the darkest values in the painting. After indicating the rough shape of the dark foliage at the top of the rocks, and the palest tones in the sky, he then has a fairly accurate idea of the tonal range of the entire picture. In other words, he knows that nothing will be darker than the dense mass of foliage or lighter than the palest tone in the sky.

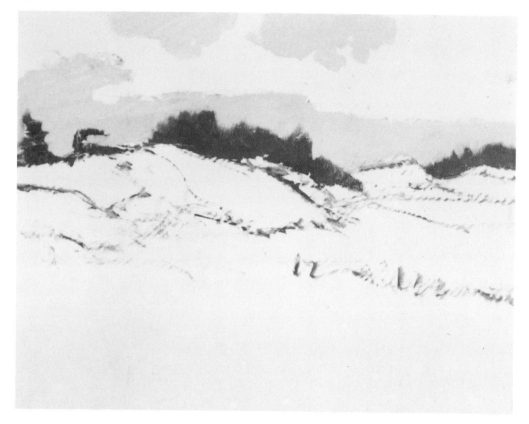

Step 2. The artist blocks in the dark shapes of the clouds with a value that's approximately midway between the palest tone in the sky and the dark tone of the foliage. He carries this middletone down over the landscape on either side of the sunlit rock formation. Then he paints the sunlit rocks in a flat tone that's approximately the same value as the pale tones in the sky. Thus by the end of Step 2, the artist has established the dark and light extremes of his painting, as well as an important middletone that falls somewhere in between.

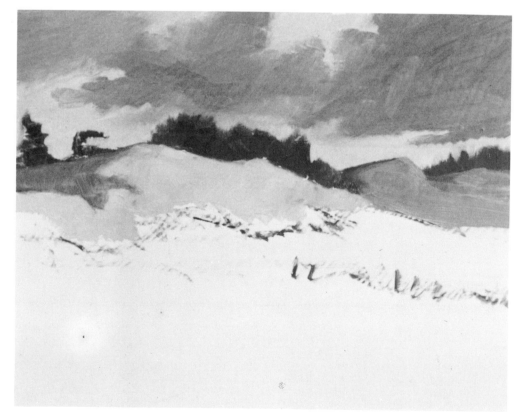

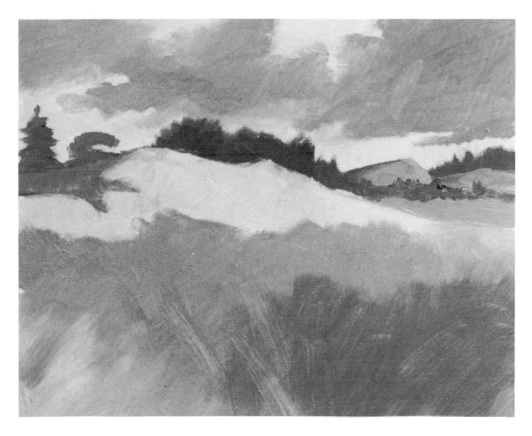

Step 3. Working now on the foreground, the artist covers the shadowy meadow with a middletone like that of the sky. In the lower right, he adds a second, darker middletone. He then adjusts the tree shapes at either end of the horizon, and darkens the land below the left-hand trees. Now he has a classic four-value landscape: dark, light, and two middletones.

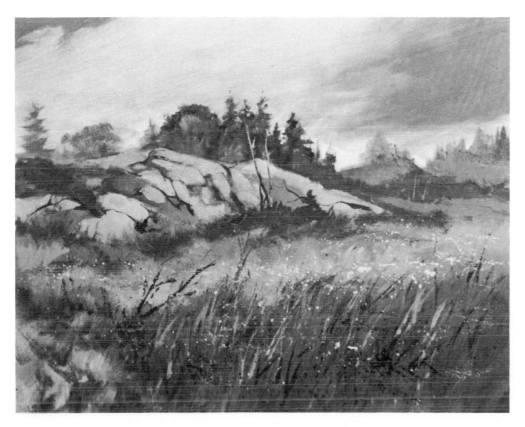

Step 4. The artist adjusts the tones and adds details. He makes one really important change: he paints out most of the middletone of the sky to re-establish the original light value, forming a pale setting for the dark trees. He adds the details on top of the dark trees in lighter values. The original dark tones showing through give depth and weight to the grouping. The shadows within the rocks are painted in middletones, while the cracks are painted with the same dark tone used in the trees. The artist completes the meadow by brushing in grasses and weeds with strokes of the lightest and darkest tones of the picture.

Step 1. The artist doesn't hesitate to execute the preliminary line drawing with dark brushstrokes, since the picture will be generally dark. He then blocks in the dark middletone of the distant mountain and the lighter middletone of the sky and water. He also paints the moon, which will be the lightest note in the picture. Thus, by the end of Step 1, he's established *almost* his full value range: the light and two middletones.

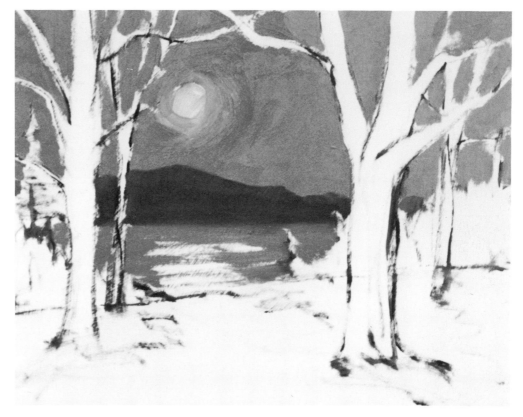

Step 2. At the edge of the lake, the artist paints the silhouettes of the evergreens with his darkest value. In the foreground, beneath the big trees, he repeats the two middletones that appear in the sky. The dark middletone is directly beneath the trees and the lighter middletone is on the curving road lit by the moonlight. Thus, by the end of Step 2, the artist has established the full value range of the painting, even though he hasn't completed the big trees and the moonlit water that are so important.

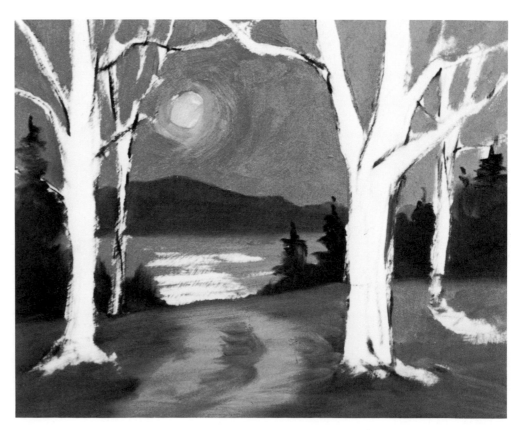

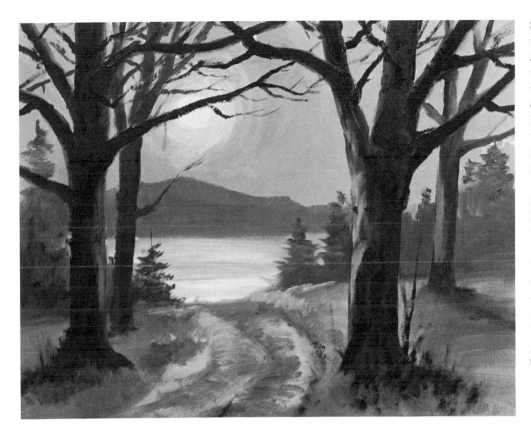

Step 3. The artist paints the trunks and branches, as well as a suggestion of shadow at their bases, with his darkest value. On the moonlit edges of the trunks, he places the lighter middletone. The water is lightened because it reflects the bright, pale moonlight, and the sky is lightened as well. The artist decides momentarily to lighten the evergreens along the shore so that they'll contrast with the dark trunks in the foreground. Now these evergreens are the same dark middletone as the mountains. The artist continues to develop the foreground with the two middletones: one light, one dark.

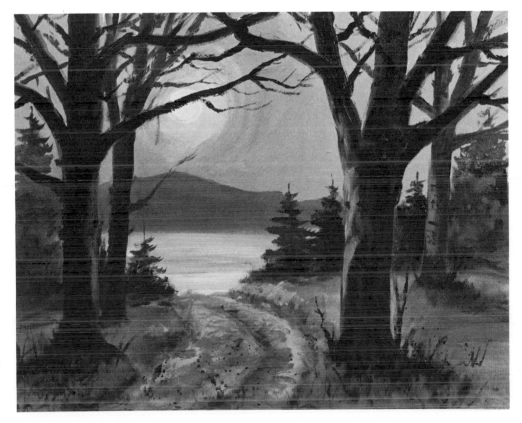

Step 4. The artist darkens the evergreens again to strengthen their contrast with the mountain. Working with the darkest tone, he adds more branches to the trees, textural detail to the trunks, and shadowy grasses on the ground. The finished painting is *essentially* low-key because the dominant tones are the darks of the tree trunks and evergreens, plus the dark middletones of the mountain and ground. But a low-key picture *can* have some bright areas to accentuate the darkness—such as the paler tones of the moon and water, and the lighter middletones of the sky and parts of the ground. Don't be surprised if a low-key picture is sometimes in the high-contrast range.

Step 1. It's important to maintain a clear idea of the placement of the light in a high-contrast picture. So the artist draws the shapes carefully with his preliminary brush lines, and then he blocks in the pale middletone of the sky, surrounding the dramatic rock formations on which the bright sunlight will fall. At the base of the mountains, he also indicates the placement of the light middletone on the tops of the trees.

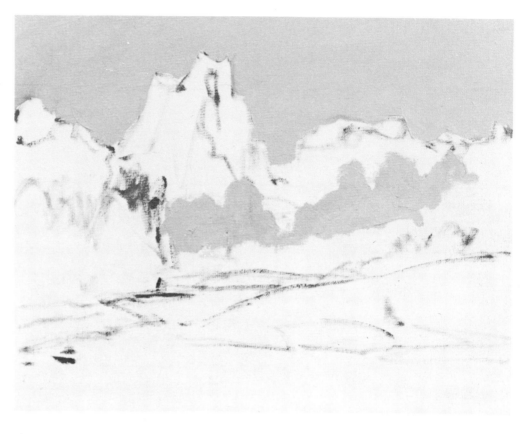

Step 2. The shadow sides of the looming, rocky shapes are actually a very dark middletone, falling just above the lowest end of the value scale. The artist blocks these in with decisive strokes. He then repeats this dark middletone along the shadowy undersides of the leafy masses of the trees along the shore. Even at this early stage, the canvas contains three of the four major values: the light on the mountains, represented by bare canvas at this stage; the pale middletone that appears in the sky and at the tops of the trees; and the dark middletone that appears beneath the trees and on the mountains. Only the dark is missing.

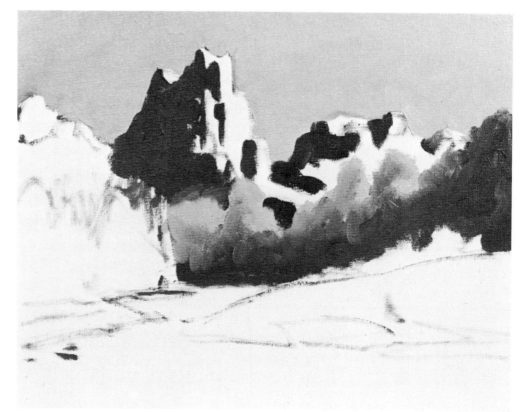

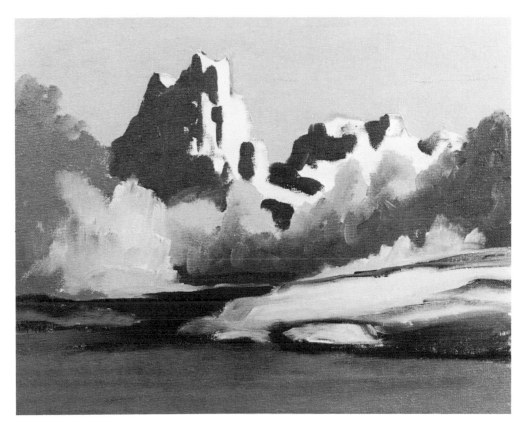

Step 3. The water in the lower third of the picture is now covered with a value that comes fairly close to the dark middletone that first appears in Step 2. Then the artist introduces the darkest notes in the picture—the deep shadows along the shoreline. He starts to add the lights: the blurred shape of the tree on the shoreline at the left; the low, sunlit trees on the shoreline at the right; and the sunlit tops of the low rocks in the water at the right. For the trees at the extreme left, he introduces a *third* middletone that's distinctly lighter than the dark middletone on the rocks.

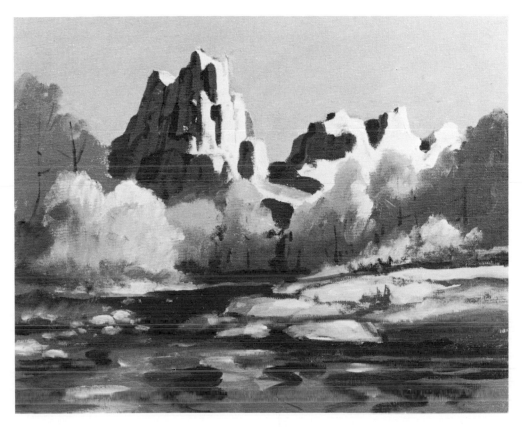

Step 4. Within the dark middletones on the sides of the big rock formations, the artist indicates the details of the rocks with the dark tone he's used in the water. He repeats this dark tone in the wiggly reflections in the pond and in the tree trunks along the shoreline. More detail is added to the water and to the low rocks with strokes of the middletones. As he develops the tones of the trees, you can see patches of light and two middletones among the shapes. This high-contrast picture demands a diverse range of values, so the artist has decided on five values rather than four: dark, light, and *three* middletones.

Step 1. As you've seen, the usual strategy in painting most pictures is to establish its tonal range as early as possible by blocking in the major values. You can paint them in any order—there are no rigid "rules." Working again with four values, the artist places the lightest value (which is actually rather dark) in the sky. He paints the clouds with the lighter middletone. Then he paints the trunk and branches of the tree with the darker middletone, and with the darkest tone—which appears at the base of the tree. Only half the canvas is now covered with wet color, but the four major values are already there.

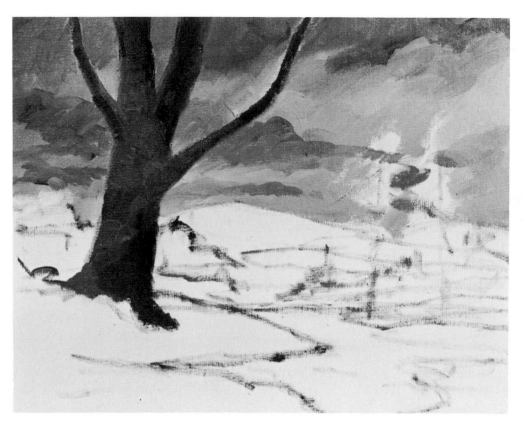

Step 2. Moving to the landscape beyond the tree, the artist paints the irregular bands of distant trees with the dark value and a middletone that's roughly comparable to the middletone in the sky. Between the rows of the distant trees, he indicates the snow with the light value that also appears in the sky. At this early stage, it's still difficult to decide what's sky and what's land, but that will become clearer in the next step.

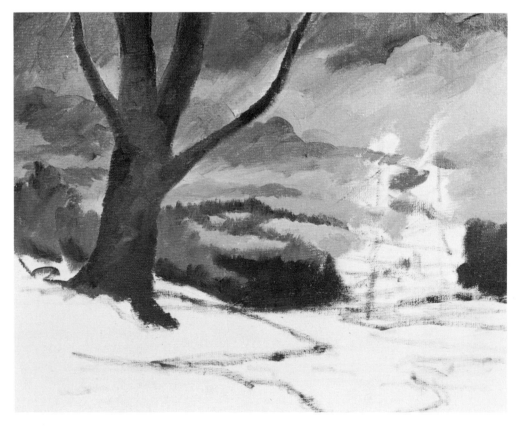

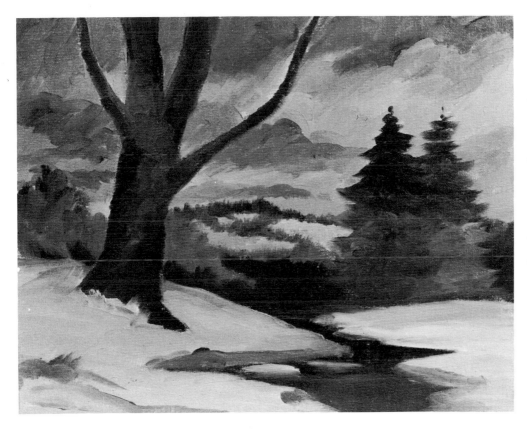

Step 3. In the foreground, the artist blocks in the lightest areas of the snow with the pale value that he used in the sky. He adds the strips of shadow on the snow with the lighter of the two middletones. The frozen stream is painted with two values: the darkest value and the dark middletone. Within the two evergreens at the right, you can see the two middletones and the dark. Now you can see that the sky ends at the dark strip of horizon halfway down the picture.

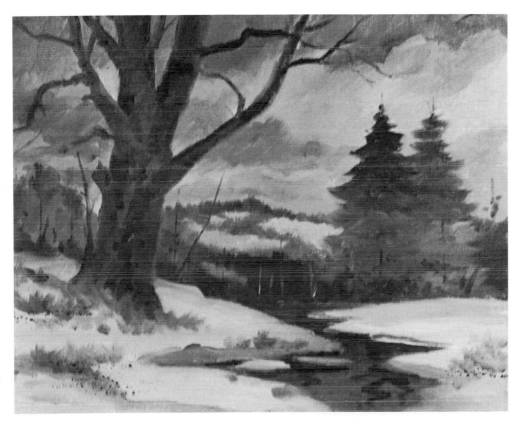

Step 4. In the final stage, the artist refines the values and adds details. He continues to develop the big tree at the left by adding touches of the two middletones, plus a few more darks. He adds trunks and branches to the distant trees. Irregular, dark strokes indicate reflections in the frozen stream. With touches of the lighter middletone, he adds frozen weeds and other debris to the snow in the foreground. In the finished picture, the four values flow softly into one another.. Most of the values come from the middle and lower parts of the value scale—and this is obviously a low-contrast picture.

Sketch for Demonstration 1. Because values are so important to the success of any painting, many artists do little value sketches in pencil or chalk before they begin a picture. In this way, they visualize the distribution of values to plan their composition and their color mixing. Here's the artist's value sketch for Demonstration 1—done in a couple of minutes with quick, scribbly pencil strokes. It's obvious that the strongest darks are in the foreground; the lightest areas are in the sky and water; while the two middletones are in the distant shore, the evergreens, and their reflection.

Sketch for Demonstration 3. In this value study for Demonstration 3, the artist records the dark values of the evergreens at the right and the zigzag pattern of the dark stream in the foreground. The lights are in the snow, while the middletones are in the upper half of the picture. In the demonstration painting, the artist has made certain changes, such as darkening the trees at the left. There's nothing sacred about a value sketch—you can always change your mind later. But it's useful to begin with such a sketch even if you improve upon it in the finished painting.

Sketch for Demonstration 4. The value sketch places the strongest darks on the shadowy rocks in the foreground; the palest lights in the sky and in the foamy water between the rocks; and the middletones in the immediate foreground, and in the rocks and sea in the middleground. But in the finished painting, the artist has changed his mind, darkening some of the rocks that appear as light middletones in the sketch. If you decide to alter your values midway through the painting, it's often helpful to make a few more value sketches to test out other possibilities.

Sketch for Demonstration 9. Although a wet-into-wet painting *looks* as if it happens by accident, such spontaneity is the result of careful planning. The value sketch shows a simple but effective strategy. Almost the entire canvas is a very pale tone from the upper part of the value scale. Just the dark tree and a bit of shore at the left represent a dark note from the lower end of the scale. The only middletones are the distant mountain and the wooded island at the center. The bold design is captured in the value sketch, although it looks like a mere doodle.

PART TWO

COLOR IN WATERCOLOR

Color in Watercolor Painting. Watercolor is unusual among painting mediums in that the color is essentially transparent. A brushstroke of watercolor consists mainly of pure water in which a small amount of color has been dissolved, so you're really painting with tinted water! When that water evaporates from the paper, a microscopic amount of color remains on the white painting surface, which shines through the color like sunlight through stained glass. For this reason, a watercolor painting can have extraordinary luminosity, a kind of inner light that no other painting medium can match. And because of this remarkable combination of transparency and luminosity, watercolor can produce color effects that are so varied and surprising that many artists have devoted their lives to this single medium. For everyone who's fascinated by watercolor, *Color in Watercolor Painting* has a twofold purpose: first it serves as an introduction to the basics of color as it applies specifically to watercolor painting; then it surveys the surprising range of watercolor techniques that artists have developed over the centuries.

Values. Oddly enough, one of the secrets of successful color is learning to think in black-and-white. To observe and paint the colors of nature with the greatest possible accuracy, you must be able to judge the comparative lightness and darkness of those colors. The best way to do this is to imagine that those colors are actually various shades of gray, which are called *values*. The first section of *Color in Watercolor Painting* teaches you how to do this. You'll learn to look at the colors of nature and convert them to values in your mind's eye. You'll find instructions for painting your own value chart in watercolor, which you can keep as a permanent reference. You'll then watch Ferdinand Petrie paint two demonstration watercolors, step-by-step, one in just three values and the other in four.

Color Control. To discover how your tube colors behave in various mixtures, you'll conduct a series of color tests and paint your own color charts in watercolor. You'll also learn how to plan the color schemes of your watercolor paintings so that specific colors look brighter or more subdued, darker or lighter. A series of colorful illustrations will reveal how to use transparent watercolor to create the illusion of perspective, to achieve satisfying color harmony, to render the subtle color changes that take place at different times of day and night, and to enhance your pictorial composition.

Demonstrations. The largest single section of

Color in Watercolor Painting is devoted to a series of ten step-by-step demonstrations in which Ferdinand Petrie shows you ten different ways to paint a watercolor. He begins with the simple, direct methods that are most widely used by contemporary watercolorists, and then introduces a variety of exciting methods that will be new and refreshing to many contemporary painters, although most of these techniques actually go back to eighteenth-and nineteenth-century masters of the medium. In each demonstration, you'll not only learn a specific watercolor technique, but you'll also see how this technique can produce its own particular color effects.

Ten Watercolor Techniques. Petrie begins by painting a picture with just two colors—a valuable exercise because it strengthens your understanding of values and also teaches you how much color you can actually create with a very limited watercolor palette. Then he paints a picture with the three primaries—red, blue, and yellow—to show you the rich variety of color mixtures you can achieve with just these three basic hues. The next two demonstrations show how the full watercolor palette can be used to paint one picture in subdued colors and another in brighter colors. The artist then demonstrates the classic technique of the British masters: a monochrome underpainting followed by an overpainting in full color. Petrie further explores the possibilities of multiple-phase watercolor techniques in two demonstrations: an underpainting in limited color followed by a full-color overpainting; and an underpainting and overpainting that are both in a full range of colors. To show how color and texture can enhance one another, you'll watch a demonstration of the drybrush technique. Then the artist shows how to mix watercolors directly on the paper in a demonstration of the wet-into-wet technique. Finally, Petrie shows how to achieve the vibrant color of the Impressionists.

Light and Shade. The transparency of watercolor makes this an ideal medium for capturing the effects of light in nature. And since there *is* no color without light, the final section of *Color in Watercolor Painting* is devoted to the subject of light and shade. You'll learn how to use watercolor to render the effects of light on geometric and nongeometric forms; how to capture the effects of light as it changes direction *and* changes with the weather; and finally, how to analyze the pattern of light and shade in your subject to paint high-key, middle-key, low-key, high-contrast, medium-contrast, and low contrast subjects, step-by-step.

Studio Setup. Whether you work in a studio or just a corner of a bedroom or kitchen, it's important to be methodical about setting up. Let's review the basic equipment and its arrangement.

Brushes for Watercolor. You'll need just a few brushes for watercolor painting—but you should buy the very best brushes you can afford. You can perform every significant painting operation with just four soft-hair brushes, whether they're expensive sable, less costly oxhair or soft nylon, or perhaps some blend of inexpensive animal hairs. All you really need are a big number 12 round and a smaller number 7 round, plus a big 1″ (25 mm) flat and a second flat about half that size.

Paper. The best all-purpose watercolor paper is moldmade 140-pound stock in the *cold-pressed* surface (called a "not" surface in Britain), which you ought to buy in the largest available sheets and cut into halves or quarters. The most common sheet size is 22″ x 30″ (55 x 76 cm). This paper has a distinct texture, but it's not as irregular as the surface called *rough*. Later you might like to try both rough and smooth paper or illustration board.

Drawing Board. The simplest way to support your paper while you work is to tack or tape the sheet to a piece of hardboard, cut just a little bigger than a full sheet or half sheet of watercolor paper. You can rest this board on a tabletop, perhaps propped up by a book at the back edge so the board slants toward you. You can also rest the board in your lap or even on the ground. Art supply stores carry more expensive *wooden* drawing boards to which you tape your paper. At some point, you may want to invest in a professional drawing table, with a top that tilts to whatever angle you find convenient. But you can easily get by with an inexpensive piece of hardboard, a handful of thumbtacks (drawing pins) or pushpins, and a roll of masking tape 1″ (25 mm) wide to hold down the edges of your paper.

Palette or Paintbox. Some professionals just squeeze out and mix their colors on a white enamel tray—which you can probably find in a shop that sells kitchen supplies. The palette made *specifically* for watercolor is white metal or plastic with compartments into which you squeeze tube colors, plus a mixing surface for producing quantities of liquid color. For working on location, it's convenient to have a metal watercolor box with compartments for your gear. But a toolbox or a fishing tackle box—with lots of compartments—will do just as well. If you decide to work outdoors with pans of color (more about these in a moment), buy an empty metal box that's equipped to hold pans, and then buy the selection of colors listed in this book. Don't buy a box that contains preselected pans of color.

Odds and Ends. You'll also need some single-edge razor blades or a knife with a retractable blade (for safety) to cut paper. Paper towels and cleansing tissues are useful, not only for cleaning up, but for lifting wet color from a painting in progress. A sponge is excellent for wetting paper, lifting wet color, and cleaning up spills. You obviously need a pencil for sketching your composition on the watercolor paper before you start to paint: buy an HB drawing pencil in an art supply store or just use an ordinary office pencil. To erase the pencil lines when the watercolor is dry, you'll need a kneaded rubber (or "putty rubber") eraser, so soft that you can shape it like clay and erase a pencil line without abrading the delicate surface of the sheet. You'll also need three wide-mouthed glass jars big enough to hold a quart or a liter of water (you'll find out why in a moment). If you're working outdoors, a folding stool is a convenience—and insect repellent is a *must*!

Work Layout. Lay out your supplies and equipment in a consistent way, so that everything is always in its place when you reach for it. Directly in front of you is your drawing board with your paper tacked or taped to it. If you're right-handed, place your palette and those three wide-mouthed jars to the right of the drawing board. In one jar, store your brushes, hair end up; don't let them roll around on the table and get squashed. Fill the other two jars with clear water. Use one jar of water as a "well" from which you draw water to mix your colors; use the other for washing your brushes. (Be sure to change the water when it gets really dirty.) Keep the sponge in a corner of your palette, with the paper towels nearby, ready for emergencies. Line up your tubes of color someplace where you can get at them quickly—possibly along the other side of your drawing board—when you need to refill your palette. Reverse these arrangements if you're left-handed.

Palette Layout. In the excitement of painting, it's essential to dart your brush at the right color instinctively. So establish a fixed location for each color on your palette. There's no one standard arrangement. One good way is to line up your colors in a row with the *cool* colors at one end and the *warm* colors at the other. The cool colors would be black, two or three blues, and green, followed by the warm yellows, orange, reds, and browns. The main thing is to be consistent in your arrangement, so you can find your colors when you want them.

Tubes and Pans. Watercolors are normally sold in collapsible metal tubes about as long as your thumb, and in metal or plastic pans about the size of the first joint of your thumb. The tube color is a moist paste that you squeeze out onto the surface of your palette. The color in the pan is dry, but dissolves as soon as you touch it with a wet brush. The pans, which lock neatly into a small metal box made to fit them, are convenient for rapid painting on location. But the pans are useful mainly for small pictures—no more than twice the size of this page—because the dry paint in pans is best for mixing small quantities of color. The tubes are more versatile and more popular. The moist color in the tubes will quickly yield small washes for small pictures and big washes for big pictures. If you must choose between tubes and pans, buy the tubes.

Color Selection. All the pictures in this book are painted with just a dozen tube colors. Once you learn to mix the various colors on your palette, you'll be astonished at the range of colors you can produce. Seven of these eleven colors are *primaries*—blues, reds, and yellows. (Primaries are colors you can't create by mixing other colors.) There are just two *secondaries*, orange and green. (Secondaries are colors you *can* create by mixing two primaries. For example, you can mix a rich variety of greens by combining various blues and yellows, plus many different oranges by combining reds and yellows, so you could really do without the secondaries. But it does save time to have them.) Finally, there are two browns, plus black.

Blues. Ultramarine blue is a dark, soft blue that produces a rich variety of greens when blended with the yellows, and a wide range of grays, browns, and brown-grays when mixed with the two browns on your palette. Phthalocyanine blue is a clear, brilliant hue that has tremendous tinting strength—which means that it must be used in small quantities because it tends to dominate any mixture. Cerulean blue is a light, bright blue that's popular for skies and atmospheric effects. It's an optional hue you might like to have available.

Reds. Alizarin crimson is a bright red with a hint of purple. It produces lovely oranges when mixed with the yellows, subtle violets when mixed with the blues, and rich darks when mixed with green. Cadmium red light is a dazzling red with a hint of orange, producing rich oranges when mixed with the yellows, coppery tones when mixed with the browns, and surprising darks (not violets) when mixed with the blues.

Yellows. Cadmium yellow light is bright and sunny, producing luminous oranges when mixed with the reds and rich greens when mixed with the blues. Yellow ochre is a much more subdued, tannish yellow that produces subtle greens when mixed with the blues and muted oranges when mixed with the reds. You'll find that both cadmiums tend to dominate mixtures, so add them just a bit at a time. Some watercolorists find cadmium yellow *too* strong—and just a bit too opaque—so they substitute new gamboge, which is bright, very transparent, and less apt to dominate a mixture.

Orange. Cadmium orange is a color that you really could create by mixing cadmium yellow light (or new gamboge) and cadmium red light. But it's a beautiful, sunny orange, and convenient to have ready-made.

Green. Viridian is another optional color—you can mix lots of greens—but convenient, like cerulean blue and cadmium orange. Just don't become dependent on this one green. Learn how many other greens you can mix by combining blues, blacks, and yellows. And see how many other greens you can make by modifying viridian with other colors.

Browns. Burnt umber is a dark, subdued brown that produces lovely brown-grays and blue-grays when blended with the blues, subtle foliage colors when mixed with green, and warm autumn colors when mixed with reds, yellows, and oranges. Burnt sienna is a bright orange-brown that produces a very different range of blue-grays and brown-grays when mixed with the blue, plus rich, coppery tones when blended with reds and yellows.

Black. This is a controversial color among watercolorists. Many painters don't use black because they can mix more interesting darks—containing a fascinating hint of color—by blending such colors as blue and brown, red and green, orange and blue. And blue-brown mixtures also make more interesting grays. However, ivory black is worth having on your palette if you use it as a *color*. For example, mixed with the yellows, ivory black produces beautiful, subdued greens for landscapes; and mixed with blues and greens, ivory black produces deep, cool tones for coastal subjects. If you find ivory black too strong, you might like to try Payne's gray, which is softer, lighter, and a bit bluer, making it popular for painting skies, clouds, and atmosphere.

No White. Your sheet of watercolor paper provides the only white you need. You lighten a color mixture with water, not with white paint.

Fruit. The best way to learn about values is to make a series of watercolor studies (like this one) entirely in black-and-white washes. When each color is seen as pure value, the green pear becomes a medium gray, the yellow apple is almost white, and the purple plums are a deep gray that turns black in the shadows.

Flowers. For these little watercolor studies, just squeeze ivory black onto your palette and add water to create different shades of gray. Leave the paper bare to get pure white. In this flower study, the yellow petals are bare paper, the oval blossoms at the top (which are actually orange) become a medium gray, and the green leaves are mainly black.

Winter. When you paint value studies outdoors, you'll often find that your subject consists of four major values. In this scene, the dark brown tree is a dark gray with blackish shadows. The distant evergreens are a slightly lighter gray. The blue sky and the bluish shadow on the snow are a pale gray. And the snow itself is the pure white paper.

Desert. Here's another outdoor value study in four values. The reddish brown of the rock formation is now a deep gray that's almost black. The tannish sand in the foreground is a medium gray. The blue patches of sky are rendered as a pale gray. And the white clouds are bare white paper.

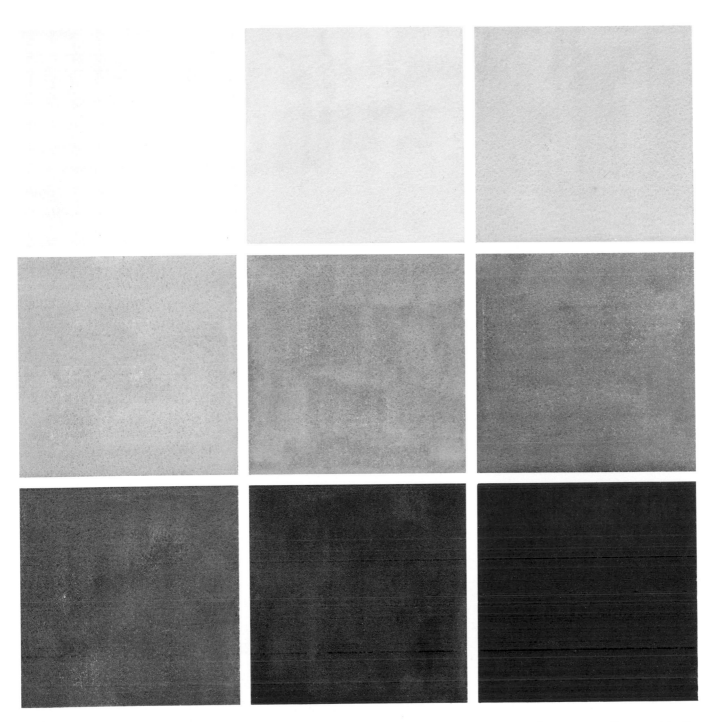

Classifying Values. You'll find it helpful to paint a chart of values to hang on the studio wall—and memorize. Then, when you see a color in nature and try to decide how light or dark the color mixture should be, you can find the right value on this chart or *value scale*. To make such a chart, draw a checkerboard pattern with nine squares on a sheet of watercolor paper, as you see here. The chart actually represents ten values, when the white of the bare paper is counted as your lightest value. To block in the values, add plenty of water to your ivory black to paint the palest square. Keep adding less water for each square until you get to pure black. You may find it easier to reverse the process, starting with the darkest square at the bottom of the value scale, then adding pro-gressively more water to each square until you get to the top of the scale. Don't be disappointed if you don't do well at first. It takes practice to learn just how much water to add for each value. And you must remember that watercolor lightens as it dries. You may find it simpler to paint each square on a separate scrap of paper, and save only the squares that turn out well. When you've got nine squares that seem right, you can paste them down. The watercolor washes in the squares don't have to be absolutely smooth. Just get all the values right. (To help you to remember the values, you may want to assign a number to each square.) Yes, nature *does* contain many more than ten values. But most artists find that these ten values come reasonably close to matching nearly every color.

Step 1. There's no point in trying to paint every value that you see in nature, particularly in a landscape where the number of values can be infinite and bewildering. In fact, many watercolorists find that they can paint a convincing landscape by simplifying the values of nature to just three different tones. In this three-value landscape, the artist begins with a simple but accurate pencil drawing on a sheet of cold-pressed watercolor paper. He draws the shape of the tree trunk with its roots and branches, the silhouette of the distant trees at the horizon, and the edge of the grassy field just beyond the big tree. Diluting ivory black with a great deal of water, he covers the entire sheet with a pale gray that represents the lightest tone in the picture. This is actually the delicate value of the sky. When this pale value is dry, he adds somewhat less water to the ivory black and covers the grassy field with a medium gray that comes from somewhere around the middle of the value scale. At this point, the picture contains two of the major values in the landscape.

Step 2. Next, mixing much less water with the ivory black on his palette, the artist creates a deep gray, found on the lower part of the value scale. He washes the gray over the tree trunk, roots, and branches. Then he places that same value on the clump of distant trees beyond the edge of the grassy field. Notice how he places thin, ragged brushstrokes along the lower edges of the roots and at the edge of the field to suggest pale blades of grass overlapping the darker shapes. When these darker washes are dry, the artist has a clear idea of the three main values in the landscape: the pale sky value, the somewhat darker value of the meadow, and the still darker value of the tree trunk in the foreground and the clump of trees over the brow of the hill at the right. So far, the painting contains practically no detail. It's just a kind of "poster" showing the three values as flat tones. But the basic pictorial design is there. Now the artist can go on to add the textures and details that convert the "poster" to a realistic watercolor.

Step 3. Within the two darkest shapes—the tree in the foreground and the clump of foliage in the distance—the artist begins to add texture and detail (such as twigs and branches) with slightly darker strokes. He suggests the ragged texture of the bark by employing a technique that's called *drybrush*. He dampens the brush with a small amount of darker color and moves the brush lightly over the paper. The paper's irregular surface breaks up the strokes to produce the rough marks you see here. To suggest the shadows within the distant foliage, he uses the same drybrush technique, but turns the brush on its side to make broader, rougher strokes. Although these shadows, textures, and details are darker than the original values of the tree and distant foliage, they don't really change the basic, three-value scheme of the painting. To check this, half-close your eyes and you'll see that the three basic values remain: the pale sky, the slightly darker field, and the still darker tree and distant foliage.

Step 4. With the tip of the brush, the artist continues to add texture and detail. Now he concentrates on the grassy field, where he adds slender strokes to pick out individual blades of grass and weeds. He also shakes the wet brush over the paper to spatter irregular droplets on the meadow, suggesting pebbles and other details. Like the texture and detail that were added to the tree and distant foliage in Step 3, these touches of detail don't change the basic value of the meadow. Half-close your eyes again, and look at the finished picture. You'll see that the three basic values are still there. There are two important reasons for learning how to simplify your subject to just

three values—a light, a dark, and a middletone. First, it's a lot easier to mix a color if you can ask yourself whether the color is a dark value, a light value, or somewhere in between. Second, a simplified value scheme produces a much bolder and more dramatic pictorial design. In the process of simplifying the values of nature to just three values in your painting, there's nothing wrong with lightening or darkening certain colors just a bit in order to make them conform to your design. Your goal, after all, isn't to create a camera image of what you see, but to organize and redesign what you see to make a satisfying painting.

Step 1. Faced with the infinite complexity of nature, most artists find it a relief to discover that they can create a solid, realistic picture by redesigning the colors of nature to a pictorial plan that's based on just three values. But three values aren't always enough to describe many complex subjects. Therefore, it's also important to learn how to simplify nature to *four* values—a dark, a light, and two middletones, one lighter and one darker. (Occasionally, a third middletone may have to be added to the four-value plan, but four values are usually enough.) As you can see in the preliminary pencil drawing in Step 1, this is a more complicated landscape than the preceding demonstration—one that will need four values. The artist begins with a pencil drawing that's deceptively casual. Actually, these relaxed, scribbly pencil lines indicate all the major shapes in the picture (except for the clouds and water). Over the entire sheet, he washes the lightest value—made with a lot of water added to a dab of black. This represents the delicate blue of the sky and its reflected color in the water.

Step 2. Adding slightly less water to the black on his palette, the artist brushes in the lighter of the two middletones. This value represents the clouds and their reflections in the water, the distant mountain peaks, and the wedge-shaped piece of shore at the extreme left. (That shore may look somewhat darker because of the heavier pencil strokes, but you'll soon see that it's the lighter of the two middletones.) Then he waits for the paint to dry. The artist has now painted two of his four major values on the watercolor paper.

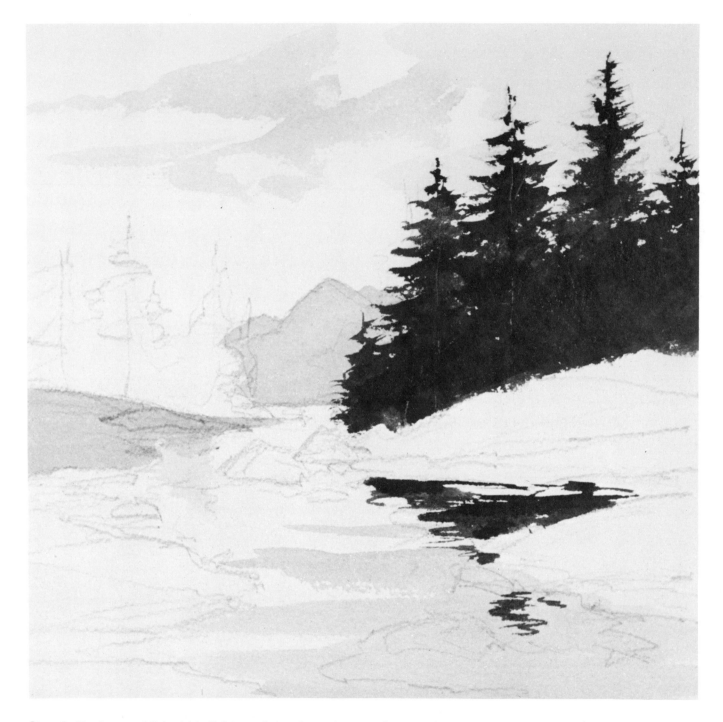

Step 3. Having established his lighter values, the artist now blocks in the darkest tone in the picture. This is the shadowy mass of evergreens on the right, probably a blackish green or a bluish green in nature, which becomes a deep gray that's almost black in this value study. The artist then repeats this dark value in the reflections in the stream. At this stage, the painting contains three of the four major values: the pale tone of the sky and water; the lighter of the two middletones in the clouds, peaks, shore, and water; and the dark tones of the evergreens and their reflections. By the way, notice the interesting brushwork in the evergreens. The artist suggests the characteristic shapes of the branches by pressing the side of a round brush against the paper at the center of the tree, and then quickly pulling the brush away to the right or left. Thus, the tree strokes are thicker at the center of the tree and thinner as they move out across the sky.

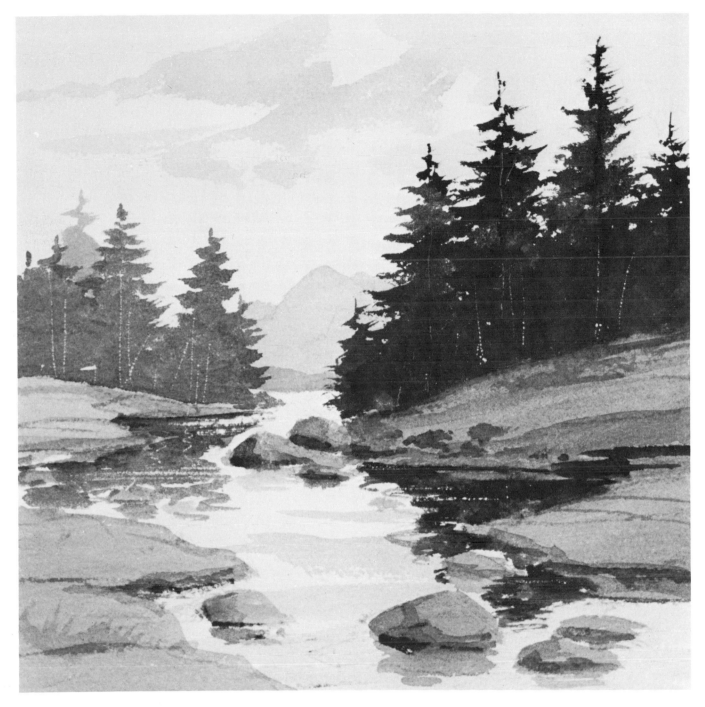

Step 4. By the end of Step 3, all that's missing is the darker of the two middletones. In nature, the more distant evergreens on the shore at the left are a soft, remote green. The artist interprets these as a dark middletone. He then carries the same tone down into the water to suggest the reflections of these trees beneath the shore at the left. Having placed all four values on the watercolor paper, the artist has thus established a "palette" of values that he can use throughout the picture. Now he paints the other shapes of the shore with his two middletones: the lighter middletone for the sunlit areas and the darker middletone for the shadows. The shapes of the rocks are more complicated, so he chooses to paint them in three tones: the lighter middletone for the sunlit planes; the darker middletone for the shadowy side planes; and the dark for the deepest shadow under the rocks. With the point of his brush, he adds a few more details that aren't necessarily drawn from that palette of four tones. You can see these strokes suggesting grass among the rocks in the lower left or shadow lines on the shore. When the painting is bone dry, he uses the corner of a razor blade to scratch a few trunks into the dark tones of the evergreens and a few streaks of light into the dark reflections in the stream. Despite the amount of detail, the picture still reduces itself to four major values when you look at it with half-closed eyes. If, by now, you're bored with painting value studies, just remember: when you begin to work with color, the job will be easier and more fun because you've learned to see color as value.

Getting to Know Watercolors. Watercolor dries so rapidly that you've got to make your color mixing decisions quickly and carry the color from palette to paper without a moment's hesitation. Thus, you must know the color so intimately that you instinctively reach for the right one, visualizing in advance how it's going to behave. The best way to learn what your colors can do is to conduct a series of mixing tests and record the results on simple color charts that you can study and memorize at your leisure.

Making Color Charts. To prepare your charts, buy an inexpensive pad of cold-pressed paper (called "not" in Britain) about the size of the page you're now reading. If you can save money by buying the paper in large sheets, cut up the sheets to make your charts. With an HB drawing pencil or an ordinary office pencil, draw a series of boxes on the paper with the aid of a ruler, to form a kind of checkerboard. Make the boxes 2″ to 3″ (50 to 76 mm) square, giving you enough room to paint a single color sample inside each box and to write the names of the colors. Make a separate sheet for each color on your palette, so you'll have enough boxes to mix that color with each of the others.

Adding Water. First you'll see how each tube color behaves when you add water. Water makes the tube colors fluid enough to brush across the paper, and also lightens the colors in the same way that white lightens oil paint. Now just make a few parallel strokes of each color, adding very little water to the first strokes at the left and adding a lot more water to the final strokes at the right. The darker area of the sample will show you how the color looks as it comes straight from the tube, while the paler area will show you how the color looks when it's diluted. Let the samples dry and study them carefully. You'll see that each color has its own special character. For example, phthalocyanine blue is so powerful that you'll need a great deal of water to dilute it—and even when you do add a lot of water, you'll still get a rich, vivid blue. On the other hand, the more subdued ultramarine blue has less *tinting strength*; you'll need much less water to produce a pale wash of ultramarine. You'll also discover that watercolor lightens as it dries, so remember to make your mixtures a bit "too dark."

Mixing Two Colors. Next, you'll mix each color on your palette with every other color. The best way is to make a few broad strokes in the left-hand side of your box. Then, while those first few strokes are wet and shiny, add some strokes of the second color in the right-hand side of the box, carefully bringing the second color over to meet the first and letting them flow together. At the point where they flow together, you'll get a third color, showing you how the two colors mix. If you do this carefully, the dried sample will contain three ragged bands of color: the original two colors at the right and left, and the mixture in the middle. Don't worry if the two colors flow together so swiftly that they disappear and all you've got left is the mixture. After all, it's the mixture that you're really trying to record. (Don't forget to write the names of the colors somewhere in the box.) Now analyze the dried chart to see what you can learn. Some colors, like cadmium red light and cadmium yellow light, flow together smoothly to form a soft, glowing mixture. Others, such as ultramarine blue and burnt sienna, may form a more granular, irregular mixture. Complements like viridian and alizarin crimson make lovely grays and browns. And some colors—like phthalocyanine blue again—are so powerful that they obliterate the other colors they're mixed with. So, the next time you add phthalocyanine blue, for instance, to alizarin crimson to make purple, add more crimson and just a *speck* of blue.

Optical Mixing. When you brush two hues together on your palette, you're creating a *physical* mixture. The two colors are physically combined to create a third color. But because watercolor is essentially transparent and quick-drying, experienced watercolorists often mix their colors in a different way: they brush one color over the paper, let it dry, and then brush a second color over the first. The two colors mix in the viewer's eye like two overlapping sheets of colored glass to create a third color—an *optical* mixture. Try a series of optical mixtures. Dilute each of your tube colors with a fair amount of water and brush a few strokes of color into the left-hand side of the box, leaving some bare paper at the right. When the first color is dry—*absolutely* dry—dilute a second color with water and brush over the dry color. Make the first few strokes of the second color on the bare paper at the right, and then carry some strokes halfway over the patch of dried color. When both layers of color are completely dry, you'll have three bands of color: the original, unmixed colors at either end, and a third band of color in the middle—the optical mixture. Compare physical and optical mixtures of the same two colors. The mixtures will be equally beautiful, but they'll often be different. The physical mixture tends to look bolder, stronger, but the optical mixture has a special kind of clarity, purity, and inner light.

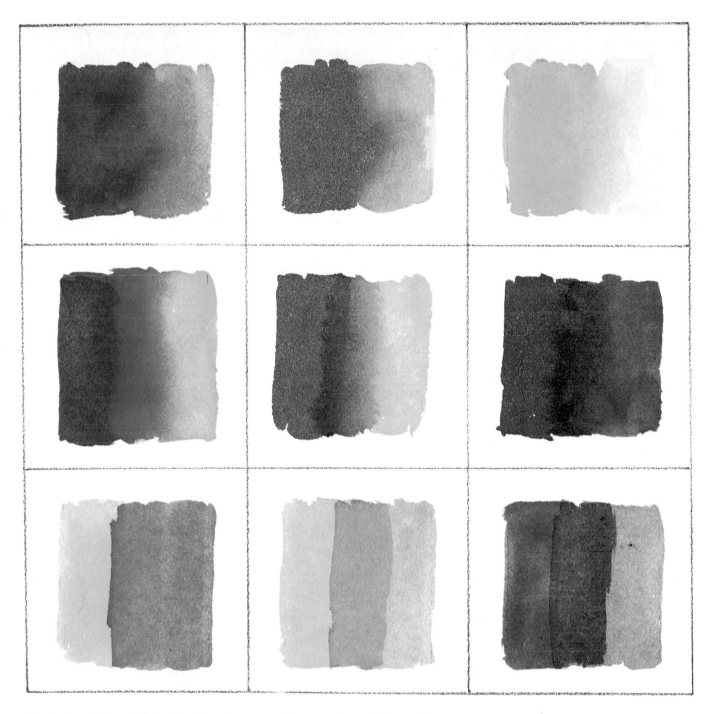

Exploring Color Mixtures. The chart on this page is actually a composite, showing typical boxes from the various color charts you should make. In the top row, from left to right, you can see how alizarin crimson, ultramarine blue, and cadmium yellow react when they're diluted with water. With a small amount of water, alizarin crimson is a bright, cool red that becomes a cool pink with more water. The dark, subdued ultramarine blue turns soft and atmospheric as you add more water. Cadmium yellow, which is bright and sunny, is so powerful that you need a great deal of water to produce a pale, delicate yellow. In the three samples in the second row, a wet stripe of one color is painted at the left, a wet stripe of another color is painted at the right, and the two stripes are then brushed together to create a third color. From left to right, you see that alizarin crimson and cadmium yellow meet to produce a bright orange, ultramarine blue and cadmium yellow produce a subdued green, and ultramarine blue and alizarin crimson produce a subdued violet. These three samples are all *physical* mixtures: that is, two colors are blended to produce a third. On the other hand, the colors in the third row are *optical* mixtures. To make an optical mixture, one color is painted across two-thirds of the box and allowed to dry. Then a second color is painted from right to left, partly overlapping the first color to create a third color. The overlapping colors are considered an optical mixture because the colors mix in your *eye*. Compare the optical mixtures with the physical mixtures, bearing in mind that the *same* tube colors are used in the second and third rows.

Complementary Background. From painting your color charts, you've discovered how to alter, adjust, and control colors by mixing them with water and with each other. But you can also heighten or subdue the intensity of a color by carefully planning color *relationships*. That is, a color can look brighter or more subdued, depending upon the color you place next to it. For example, these yellow apples look especially bright because the artist has placed them against a violet background. According to the color wheel that appears earlier in this book, violet is the complement of yellow. (Since complements brighten one another when they're placed side-by-side, *red* apples would look brightest against a *green* background.)

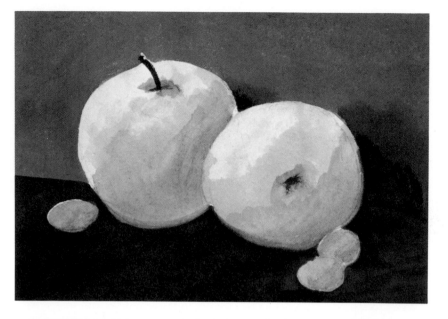

Analogous Background. To subdue a hue rather than brighten it, you can place that color against a background of a similar color. Now when the yellow apples are placed against an orange background, they don't look nearly as bright as they do against the violet background because orange is *analogous* to yellow. That is, orange is fairly close to yellow on the color wheel. If these apples were green, they could be subdued by placing them against a blue background, and if the apples were red, they could be subdued by placing them against an orange background. But look at the little green grapes on the table. They now appear brighter because they've been placed against a reddish background.

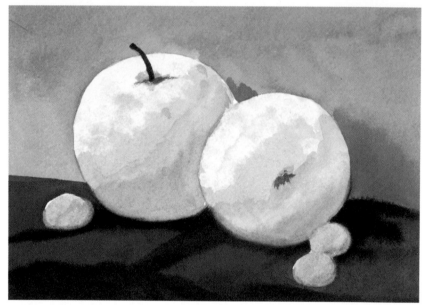

Neutral Background. Placing a color against a complementary background isn't the *only* way to increase intensity. If you'd rather not place two bright colors side by side, you can brighten one of these colors by surrounding it with a neutral color—a gray or a brown or a gray-brown. Thus, the gray wall heightens the intensity of these yellow apples, while the brown of the table brightens the green grapes. Remember two simple rules. To brighten a color, place it next to a complementary hue or a neutral. To subdue a color, place it against an analogous color.

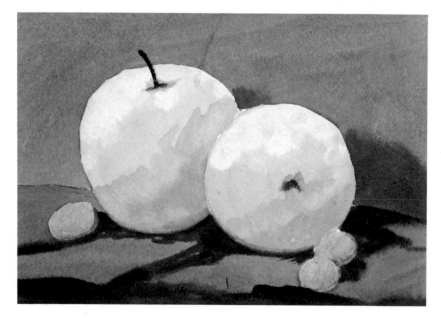

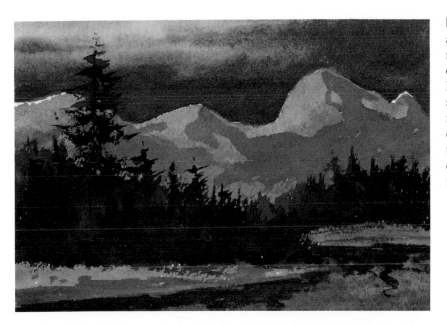

Dark Background. Just as the *intensity* of a color can be controlled by carefully planning your color relationships, so the *value* of a color can be altered by carefully selecting its surroundings. Against a dark, stormy sky, the lighted planes of these mountains look pale and dramatic. The dark value of the sky and the light value of the mountains actually strengthen one another. That is, the sky looks darker and the mountains look lighter.

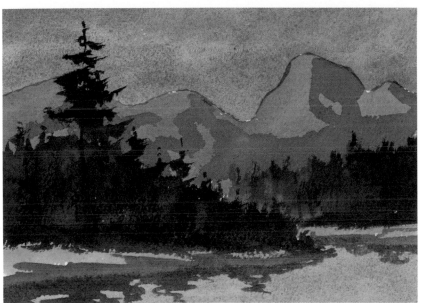

Middletone Background. If you lighten the sky to a middletone, both the sky and the mountain colors are roughly the same value. Thus the contrast between the two areas has been reduced. The reduced contrast makes the picture more benign and the landscape more friendly, as compared with the ominous, dramatic landscape above. Neither value plan is better than the other—they're just different.

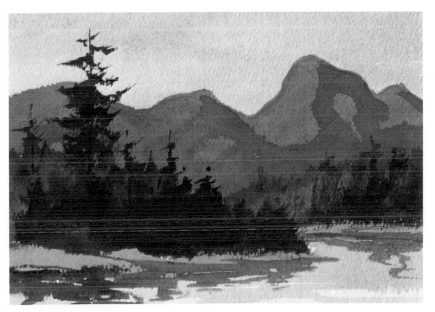

Light Background. The artist now places the mountains against a much paler value. Immediately, the shapes of the mountains become dark silhouettes against the pale sky, and the mood of the picture changes once again. The "rules" are obvious. To make a color look lighter, place it against a darker background. To make it look darker, place it against a lighter background. And if you want to call less attention to a color, place it against a background of roughly the same value.

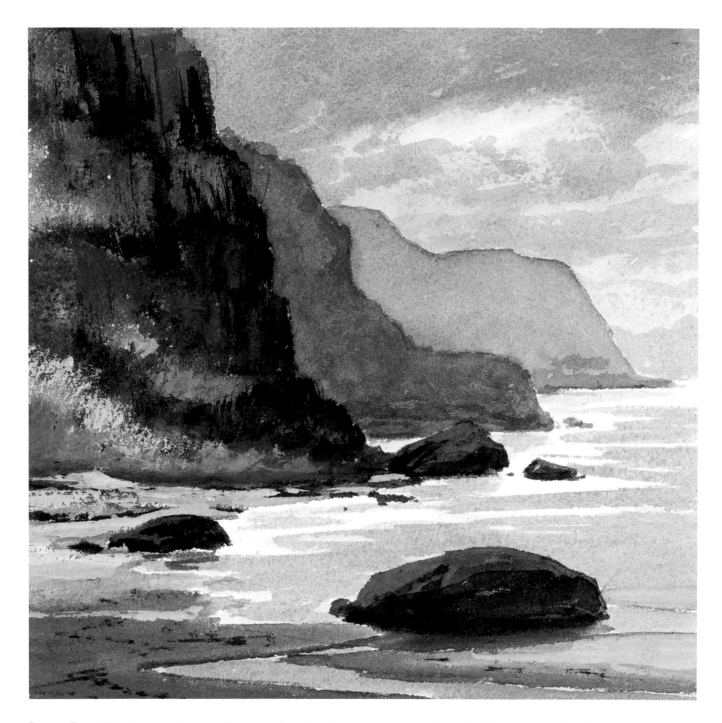

Sunny Day. Whether you're standing on a beach—like the artist painting this picture—in the woods, or on a mountain top, you'll find that the colors in the foreground tend to be brighter, darker, and generally warmer than the colors in the distance. As things move farther away, they tend to grow paler, more subdued, and cooler. In other words, color obeys the "laws" of *aerial perspective*. The effects of aerial perspective are particularly easy to render in watercolor, since the transparency of the medium is ideal for rendering the effects of light and atmosphere. In the foreground of this coastal scene, the artist places his strongest colors (diluted with a moderate amount of water). Thus, the headland at the extreme left is painted in dark, rich colors. When he paints the second headland in the middle distance, the artist adds more water and more cool color. To paint the third, most distant headland, the artist adds still more cool color and a lot more water to paint a delicate, highly transparent wash. Notice the same color effects in the sky and sea. The artist places his strongest colors in the sky that's directly overhead—at the top of the picture—and in the foreground water. Then, as he approaches the horizon, he dilutes his color to produce more delicate tints.

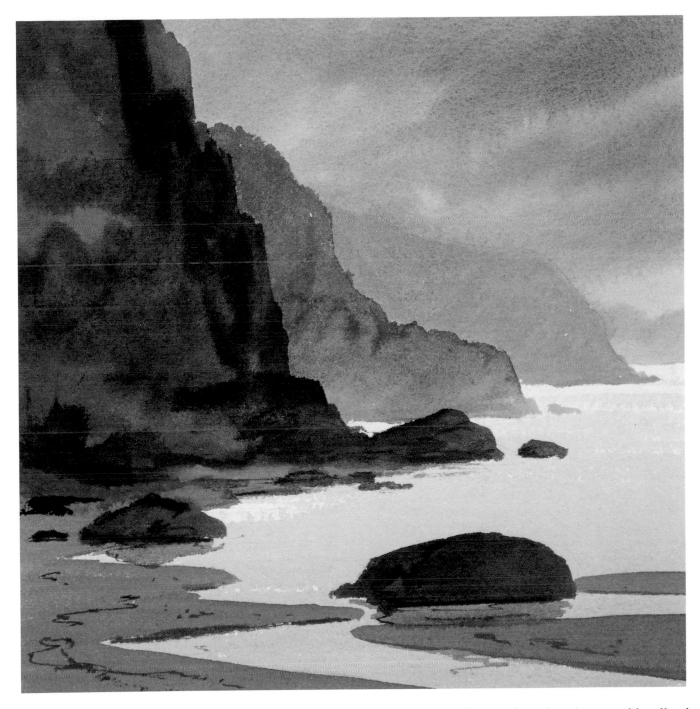

Overcast Day. Although colors are much more subdued on an overcast day, the same "laws" of aerial perspective *still* have a profound influence on a watercolor landscape or seascape. You can mix the subdued colors you'll need for an overcast day by combining a warm color like burnt sienna or burnt umber, and a cool color like ultramarine blue or cerulean blue. To paint the darker, warmer tones of the rocks and the headland in the foreground, the artist adds more warm color and less water. As he moves into the middle distance, he paints the second headland by adding more blue and more water to the mixture. The headland then becomes cooler, paler, and more remote. Finally, he places the third headland far in the distance by mixing a wash that's mostly water and just a hint of color. The sky is again painted in aerial perspective. It's darkest at the top of the picture—right over our heads—and palest at the distant horizon, where the color is mostly clear water.

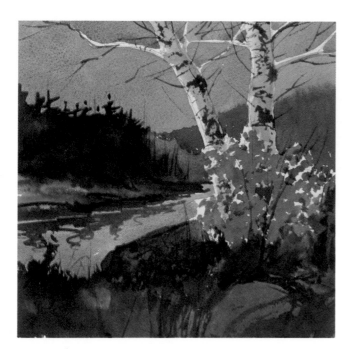

Cool Picture, Warm Notes. This landscape is painted mainly with cool mixtures on the blue-violet side of the color wheel. For contrast, the artist looks across the wheel for the complement of blue, and he adds an orange shrub. To accentuate this cool harmony, he paints a delicate blue wash over the entire picture, leaving only the birches and orange shrub untouched.

Warm Picture, Cool Notes. To paint a picture that's predominantly warm, the artist finds a cluster of analogous hues on the orange side of the color wheel. For a cool note of contrast—which is always welcome—he looks across the wheel to find the complement of orange, and adds some patches of blue sky.

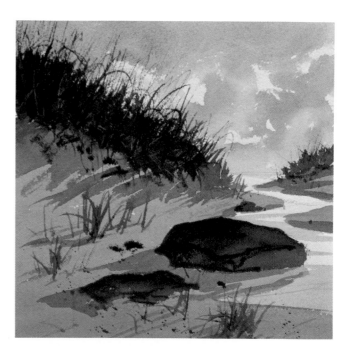

Repeating Colors. Another way to create harmony is to repeat certain colors throughout the picture. The warm tone of the foreground weeds is echoed among the distant trees, on the sunlit edge of the mountain, and at the horizon. The cool tone of the sky is repeated in the cool shadows on the snow.

Repeating Neutrals. Those quiet, inconspicuous colors called *neutrals*—grays, browns, brownish grays, and grayish browns—can be enormously helpful in designing a harmonious picture. Here, the warm neutral shadows move back and forth across the sand, accentuating the warmth of the sunny spots. The cool neutrals in the lower sky are repeated in the water.

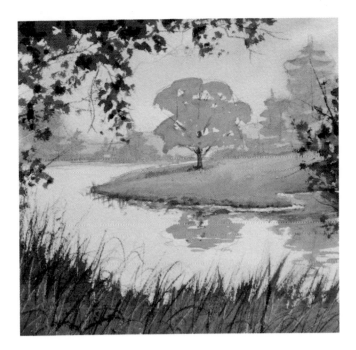

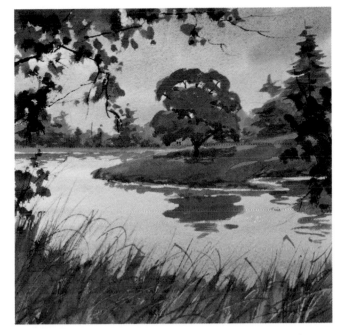

Early Morning. The same scene is gradually transformed into a series of different pictures as the sun rises, travels across the sky, and finally descends again, to be replaced by the moon. In the early morning, colors tend to be soft and delicate. The artist uses his brightest tube colors, but adds a fair amount of water to produce luminous, transparent washes.

Midday. In late morning, at noon, and in early afternoon, the sun is directly overhead and the landscape is bathed in strong light. This is when colors are strongest. The artist now works with pure, bright colors. He adds enough water to make his mixtures flow freely, but paints the midday landscape with much richer and brighter washes than the landscape of early morning.

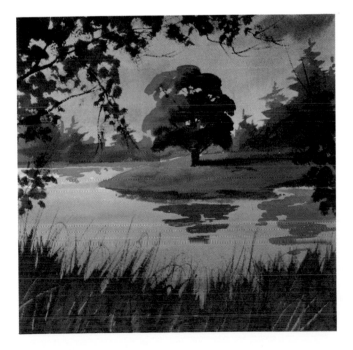

Late Afternoon. Toward the end of the day, when the sun moves downward toward the horizon, colors become more subdued and values become darker. The sun's rays begin to turn orange or red, and the shadows become heavy and somber. There's strong contrast between the lights and the darks in the landscape, such as the dark tree partially silhouetted against the luminous sky.

Night. On a moonlit night, the landscape contains much more color than you might expect, and there are also strong value contrasts. The colors are predominantly cool, with lots of rich blues, greens, and purples. The sky and water reflect a good deal of moonlight. You can see the dark trees and surrounding landscape silhouetted against the lighter sky and water.

Step 1. An excellent way to learn how to see color and value at the same time is to paint a watercolor with a *tonal palette*. This means just two colors, one warm and one cool, intermixed in various proportions to produce a variety of warm and cool tones, and diluted with water for a full value range. This landscape is painted in ultramarine blue and burnt sienna on cold-pressed paper. Over a simple pencil drawing of the main shapes, the artist wets the sky with pure water. Into the wet sky, he brushes ultramarine blue, softened with a touch of burnt sienna. As he moves toward the horizon, he adds more water. With a few dark, wavy strokes, he suggests low-lying clouds.

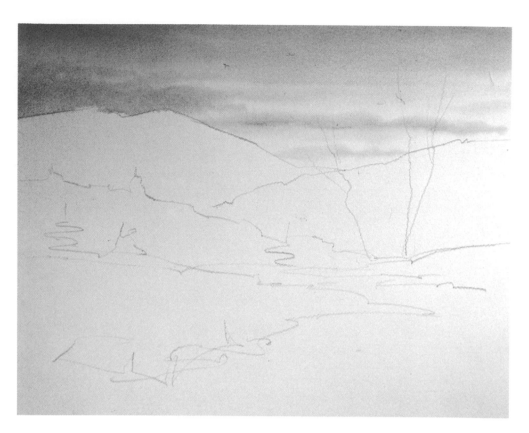

Step 2. After the sky is thoroughly dry, the artist blocks in the dark mountain with a grayer tone than the sky—produced by adding more burnt sienna to the ultramarine blue. As he moves down to the pale base of the mountain, he adds more water. Still more water is added to this mixture for the small, pale shape of the distant mountain. On the snowy slope to the right, the warm, ragged shapes of the trees are painted mainly with burnt sienna, softened with a touch of ultramarine blue, and diluted with less water than the sky and mountains. Because the paint is thick, containing little water, the wash isn't smooth and even, and the texture of the sheet roughens the strokes.

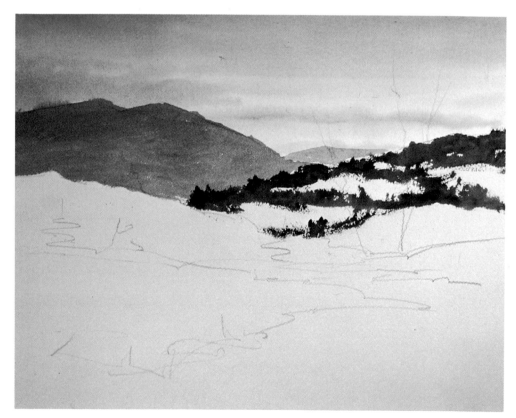

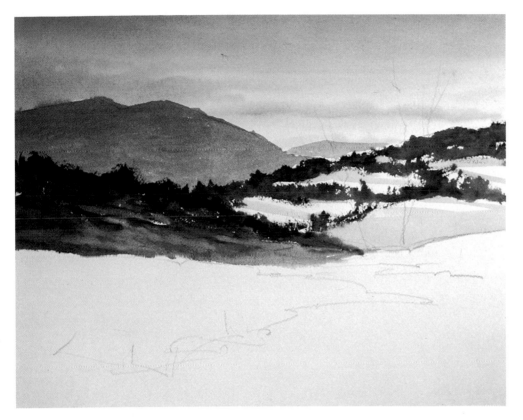

Step 3. The artist mixes a pale version of the wash he's used for the dark mountain—adding much more water—for the delicate shadows on the snow. By now, the dark mountain is dry, so he can paint the overlapping darks of the shadowy slope at the left. To paint the shrubs on top of the slope, he begins with thick strokes of burnt sienna, darkened with ultramarine blue, and diluted with very little water. He adds more blue and more water as he works downward into the paler, cooler tone of the snow in shadow. Where the dark, warm-colored shrubs meet the cool, pale tones of the snow, he adds dark strokes to suggest shadows.

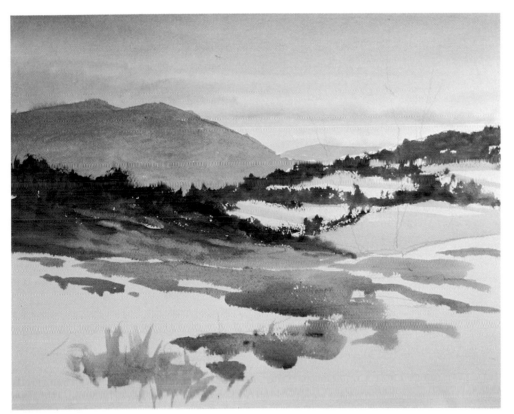

Step 4. In the foreground, the snow partly covers the soil and weeds of a frozen field, which are exposed in warm patches. The artist paints the exposed areas of the field with almost pure burnt sienna, softened by the slightest hint of ultramarine blue and diluted with varying quantities of water, so that some strokes are darker than others. He also decides that the shadowy slope of Step 3 is too dark and too warm. So he wets a bristle brush with pure water, lightly scrubs the dark area, and blots away some of the wet color with a cleansing tissue. When the corrected area is dry, he covers it with a pale wash of ultramarine blue, subdued by a little burnt sienna.

Step 5. The artist mixes a very dark wash—almost black—in which the ultramarine blue and burnt sienna are used almost straight from the tube, diluted with just enough water to make the paint flow smoothly. With his smallest soft-hair brush, the artist paints the evergreens and the bare trees on the shadowy slope. He adds rough strokes of the same mixture among the warm-toned shrubs on the sunny slope at the right, suggesting shadows. Adding more water and a bit more burnt sienna to this dark mixture, he adds dark patches to the big mountain at the left, suggesting clusters of trees among the snow.

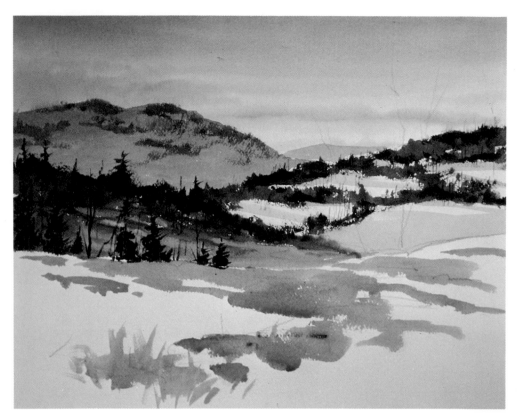

Step 6. Continuing to work with the blackish mixture he's used for the evergreens, the artist draws the slender lines of the leafless trees and their wispy branches. Adding a little more water to the dark evergreen mixture, and warming it with slightly more burnt sienna, he paints the rocks in the foreground field. He adds more water for the scrubby weeds at the far end of the field—and for the rough strokes that suggest the trees just beyond that field.

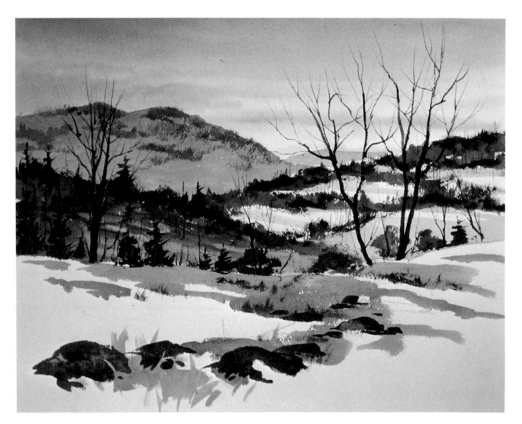

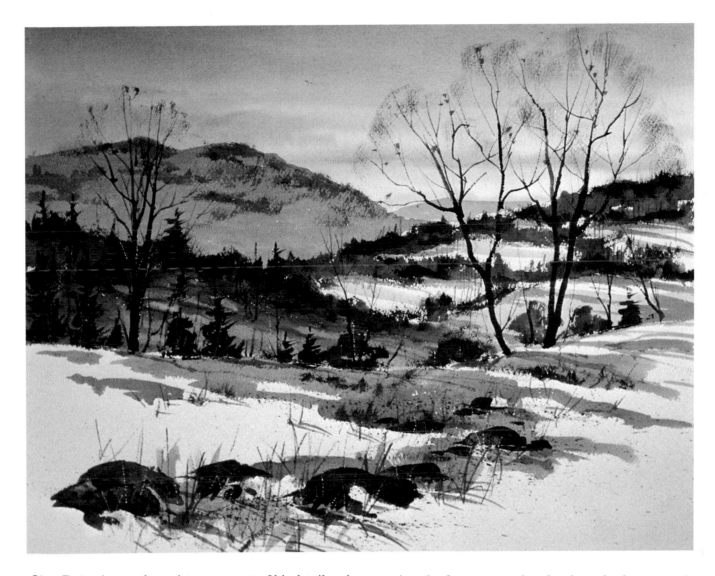

Step 7. As always, the artist saves most of his detail and texture for the final stage. With the tip of his smallest round brush, he adds the cracks and other details in the foreground rocks with the dark mixture he's already used for the tree trunks and the evergreens in the middle distance. Adding a little burnt sienna and slightly more water to this mixture, he dips a medium-sized brush into this blend, and wipes the brush on a paper towel so that the hairs are moist rather than sopping wet. Pressing the hairs of the brush gently against the palm of his hand, he separates them slightly to paint the small blurs of tone that suggest the lacy texture of the dead leaves on the branches of the trees against the sky. Adding more water to make this mixture flow smoothly, he wets the brush thoroughly with this dark, warm tone and brings the brush back to a point by rolling it gently in his hand. With the tip of the brush, he adds the warm blades of grass that come through the snow in the foreground. Darkening the mixture with more ultramarine blue, he loads the brush with wet color. He extends his index finger over the painting and strikes the handle of the brush against the finger, scattering droplets of color across the foreground to suggest bits of debris on the snow. With the same cool, shadowy mixture that he's used to paint the distant mountain, he draws the shadow lines of the grass across the snow in the lower half of the painting. He draws similar shadow lines across the slopes in the middleground to suggest the shadows of the trees on the snow. These shadows are mainly ultramarine blue with just a hint of burnt sienna. The completed painting hardly looks as if it's painted with just two colors. Although the color range is limited, you feel that all the colors of a winter day are really there. Try a painting like this in just two colors. You'll enjoy the challenge and you'll also learn a lot about color mixing. One of the most important lessons you'll learn is that just a slight change in the proportions of a mixture—just a bit more warm or cool color—will make a tremendous difference. Look over the colors on your palette and consider some other combinations of two colors. For example, phthalocyanine blue will work well with either burnt sienna or burnt umber—and so will viridian.

Step 1. The most important colors on your watercolor palette are the primaries: the reds, yellows, and blues. These are the colors you can't do without. Every color on the color wheel can be made with some combination of primaries, but there's no way of mixing other colors to make a primary. To learn more about color mixing, try painting a picture with just the three primaries. This field of wildflowers is painted entirely with ultramarine blue, cadmium yellow, and cadmium red. The artist begins with a simple pencil drawing. Then he covers the shapes of the flowers with a masking liquid available at art supply stores. (Later on, you'll find out why.)

Step 2. Starting at the top of the picture, the artist paints the sky with ultramarine blue, warmed with a very slight touch of cadmium red, and diluted with various amounts of water. Obviously, there's less water in the darker areas and more water in the lighter strokes toward the horizon. When the sky is dry, he paints the dark shape of the mountain with ultramarine blue and a little cadmium red, barely diluted with any water. Notice how he carefully paints the dark tone of the hill around the intricate shapes of the fallen tree trunk and the two evergreens at the right.

Step 3. When the dark hill is absolutely dry, the artist fills in the shapes of the two evergreens at the right with *almost* pure cadmium yellow, subdued very slightly by specks of both cadmium red and ultramarine blue. It's important to remember that the three primaries, mixed together, will produce a variety of muted colors in the brown-gray range. So a single bright primary can be softened by the slightest mixture of the other two. In the upper left, the artist does, in fact, mix all three primaries for the pale, neutral tones of the distant evergreens.

Step 4. When the pale evergreens are dry, the artist blends another dark mixture on his palette for the evergreens in the upper left. Ultramarine blue and cadmium yellow produce a deep, subdued green, which turns even darker when the artist adds a slight touch of cadmium red. He paints this strong dark right over the pale tone of the more remote evergreens. For the warm shadows on the sunstruck trees at the right, he again mixes the three primaries, this time adding less blue and more water for a lighter, more transparent tone. He covers the sunny grass of the foreground with a mixture that's mainly cadmium yellow, warmed with a touch of cadmium red, then subdued with just a hint of ultramarine blue.

Step 5. At the end of Step 4, the tree trunk on the horizon remains bare paper. Now the artist mixes a rich brown that's mainly cadmium red and cadmium yellow, darkened with a few drops of ultramarine blue. He brushes this color carefully along the underside of the tree trunk, leaving bare paper for the sunlit edges of the wood. Moving up from the bottom edge of the picture, he warms the foreground with that same mixture, lightened with more water. While the warm foreground mixture is still wet, he mixes a subdued, cool tone with ultramarine blue and cadmium yellow, brushing this across the middleground and allowing the cooler mixture to flow into the wet, warm color of the foreground.

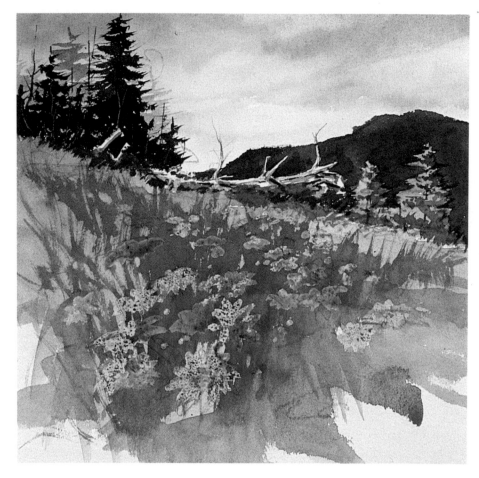

Step 6. After allowing the foreground colors to dry thoroughly, the artist creates two new mixtures on his palette, one warm and one cool. With ultramarine blue and cadmium yellow, plus a few drops of cadmium red, he mixes a dark, subdued green that he carries across the meadow with slender, erratic strokes to suggest blades of grass. The warm grass color is cadmium red and cadmium yellow, darkened with a touch of ultramarine blue. This mixture is loosely brushed across the foreground to warm the tone of the meadow.

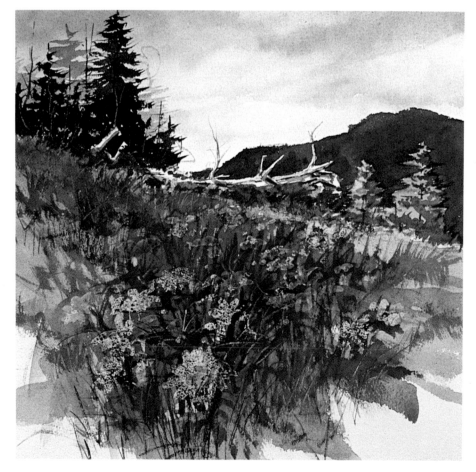

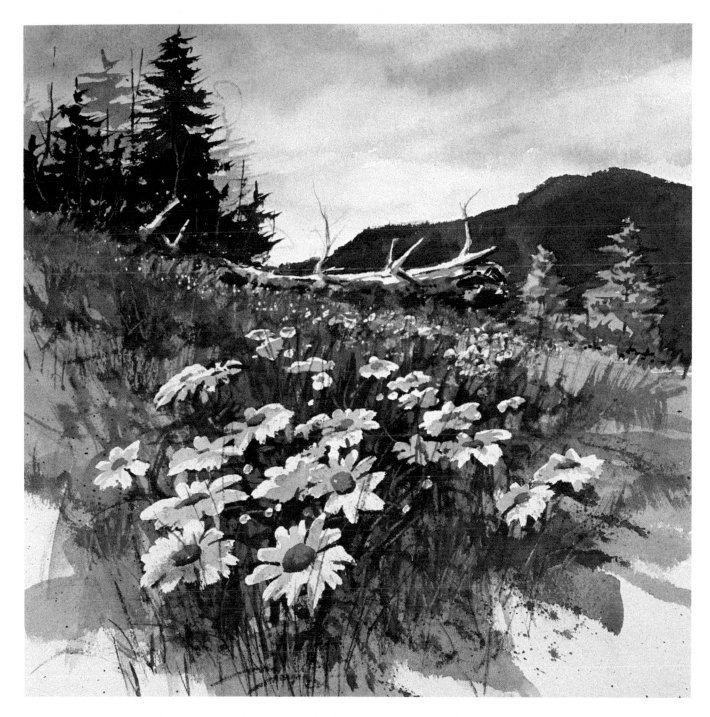

Step 7. Now you'll see the purpose of the masking liquid that covered the flowers in Step 1. The rubbery, water-resistant fluid dried and formed a protective skin over a part of the painting that was to be kept pure white. Now the "skin" peels off easily. When the artist removes the dried masking liquid from the flowers, their shapes are brilliant white paper. To paint the pale shadows on the petals, the artist mixes all three primaries to make a neutral tone, and then he dilutes this tone with plenty of water. He applies this tone sparingly to preserve the brilliant white of the petals. Then, at the center of each blossom, he places a bright mixture of cadmium red and cadmium yellow, softened by just the slightest hint of ultramarine blue. He completes the painting by creating a dark mixture of ultramarine blue and cadmium red, plus just a little cadmium yellow, for the strokes of strong shadow that he places on the tree trunk and beneath the flowers in the foreground. (The shadows beneath the flowers intensify the whiteness of the petals.) The fascinating thing about this picture is that almost every mixture contains the three primary colors—yet the mixtures are varied because the artist keeps changing the proportions of the three primaries. It's also interesting to see that these three rich colors can produce such subtle mixtures. There's no law that says that bright tube colors must produce bright mixtures. The artist can make the bright colors do whatever he wants them to do—as you'll see in the next demonstration.

Step 1. Before trying out the full range of colors on your watercolor palette in a *bright* picture, challenge yourself to paint a *subdued* picture with all those brilliant tube colors. This demonstration will show you how to use a full palette of colors to produce a subdued painting of a coastal landscape. The artist begins with the usual pencil drawing. Then he wets the sky with clear water, stopping at the headland and the horizon. On the wet, shiny paper, he brushes various mixtures of ultramarine blue and burnt sienna, some warmer and some cooler, depending upon the proportions of the colors in the mixture. The strokes fuse softly on the wet paper.

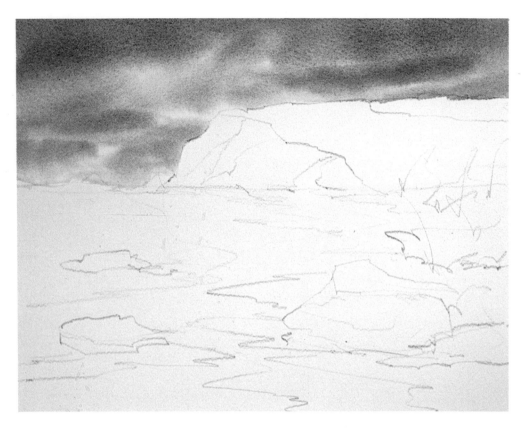

Step 2. The artist lets the sky dry thoroughly. (If you own an electric hair dryer, a blast of hot air will speed the drying process.) For the warm top of the headland, the artist mixes alizarin crimson, yellow ochre, and ultramarine blue. He adds more water for the paler area at the lower edge of the wash. The cooler side plane is painted with various blends of cerulean blue, yellow ochre, and burnt sienna. When the warm top plane of the headland is thoroughly dry, the artist adds a few darker strokes of viridian and alizarin crimson to suggest lines of distant trees. A few strokes of clear water blur the end of the headland to indicate foam breaking against the rocks.

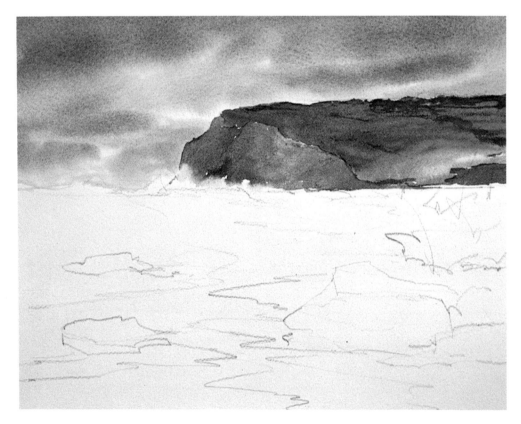

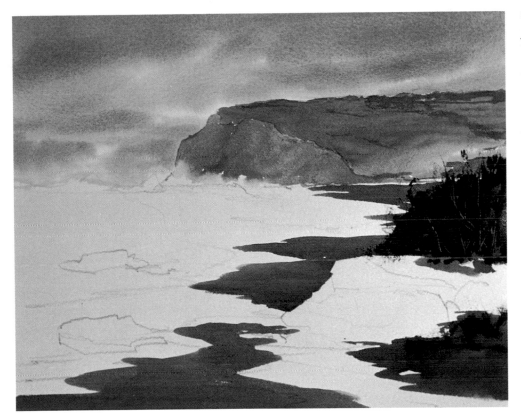

Step 3. For the warm, dark, jagged shapes of the beach, the artist combines three primaries on his palette: the bright, clear cerulean blue; the brilliant alizarin crimson; and the more subdued yellow ochre. The dark bushes at the right are painted with phthalocyanine blue, yellow ochre, and the slightest touch of cadmium red to produce the powerful, mysterious dark that you see here. While the color is still damp, he scratches away a few branches with the pointed end of his wooden brush handle.

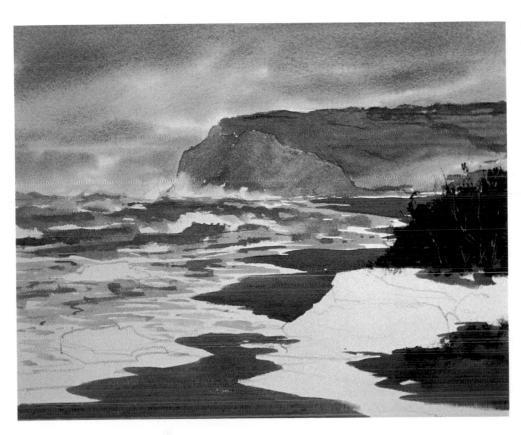

Step 4. On this moody, overcast day, the color of the waves is subdued, like the surrounding landscape. First, the artist paints the paler tones of the water with cerulean blue, new gamboge, a little burnt umber, and lots of water. Then, for the shadowy edges of the waves and the dark patches under the pale foam, he adds more cerulean blue and burnt sienna. The foaming tops of the waves—as well as the foam that spills up the beach—remain bare white paper.

Step 5. The dark rocks in the foreground are first covered with a flat wash of cerulean blue, burnt sienna, and new gamboge. When this mixture dries, the artist blends a rich dark—phthalocyanine blue and burnt umber—to paint the shadows and cracks in the rocks. Across the sand in the foreground, the artist washes a soft, cool mixture of ultramarine blue, alizarin crimson, and burnt sienna to unify the color of the beach. With a darker, warmer version of this mixture—less water and more burnt sienna—he darkens the edge of the beach and adds the reflection beneath the big rock in the lower left.

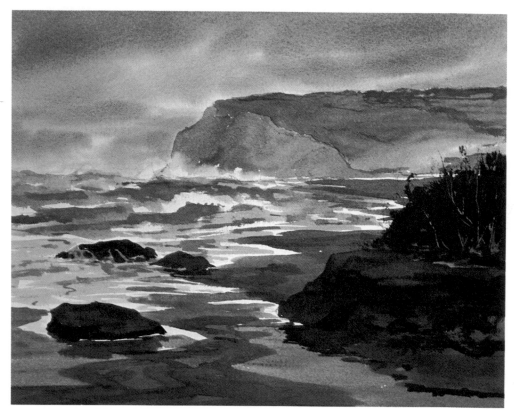

Step 6. The artist begins to build up the detail in the foreground with small, dark strokes. He uses the sharp point of a small brush to place crisp, dark touches of phthalocyanine blue and burnt umber on the rock formation in the lower right, to add two more dark rocks to the edge of the beach—one in the foreground and one in the middle of the picture—and to add other inconspicuous details like the reflection in the lower right corner and the tiny touches of darkness that suggest pebbles, seaweed, and other coastal debris at the water's edge.

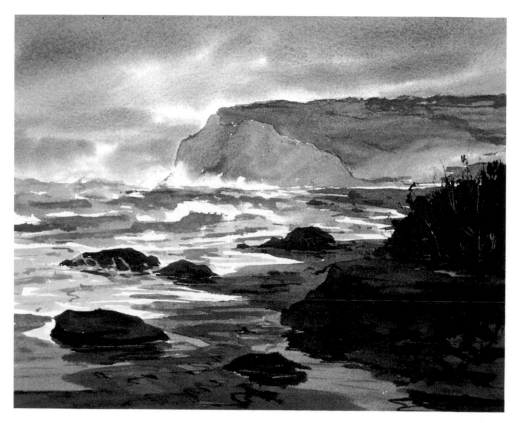

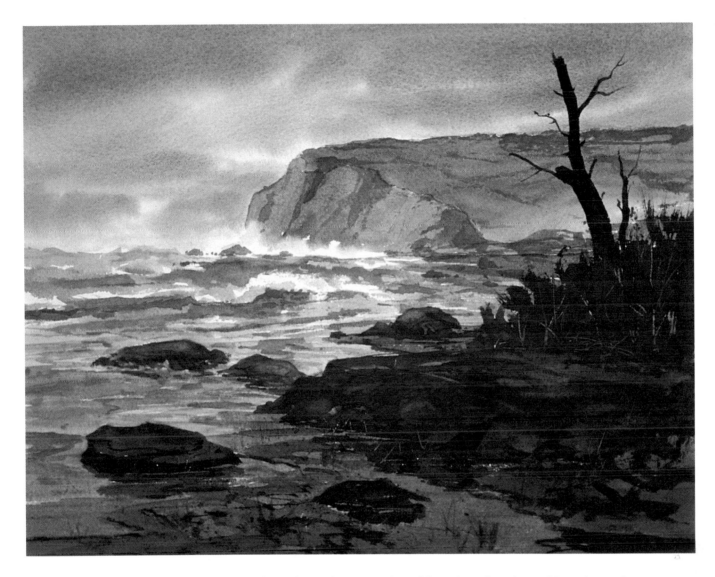

Step 7. In the final stage of the picture, the artist makes an important change. He decides to strengthen and simplify his composition by extending the rocky foreground from the right-hand corner into the center of the picture. For this dark shape, he uses the same mixtures he's already used in Steps 5 and 6. He also decides to darken and unify the tone of the beach by carrying a cool wash across the sand in the immediate foreground. This is a mixture of cerulean blue, alizarin crimson, and burnt sienna. Now the entire foreground seems cool, wet, more shadowy, and more luminous. To strengthen the contrast between the dark foreground and the paler headland in the distance, the artist places the sharp silhouette of a broken tree in the upper right with a mysterious dark mixture of phthalocyanine blue and burnt sienna. With this same mixture, he adds strong shadows to the lower edge of the foreground rock formation, more reflections in the wet beach, and small, scattered strokes that suggest additional shoreline debris in the lower left. Moving into the middleground, he scrubs the tops of the rocks with a wet bristle brush and then blots away some of the wet color with a cleansing tissue. Now the rocks seem wet, and their wet surfaces appear to reflect the light in the sky. Mixing cerulean blue, burnt umber, and yellow ochre, the artist creates a shadowy tone that he places selectively on the side of the distant headland. Now you have a clear sense of lights and shadows on the side plane of that massive rock formation. With ultramarine blue, yellow ochre, and a little burnt umber, the artist adds more darks to the waves, strengthening their shapes and creating stronger contrasts between the lights and darks in the water. Beneath the foam of the breaking wave at the center of the picture, he adds a few touches of shadow with cerulean blue, burnt umber, and plenty of water to make sure that the shadow isn't *too* dark. Finally, he adds a few strokes of beach grass with a pointed brush, and scratches some light lines into the shadowy foreground with the sharp corner of a razor blade. The finished picture is subdued, but full of color. Many of the brightest colors on the palette have been combined to produce all these muted tones, which turn out to be surprisingly rich when you look at them closely.

Step 1. Painting a colorful landscape in bright sunlight will give you an opportunity to learn more about the range of color mixtures you can produce with your full palette. But remember, bright color doesn't mean *garish* color! You'll also have to learn how to subdue each brilliant mixture just enough to prevent its leaping out of the picture. After sketching the composition, the artist begins this tropical landscape by painting the sky a brilliant phthalocyanine blue. To make that stunning blue hold its place in the distant sky, he softens the pure color with a touch of burnt umber. For the shadows on the clouds, he adds more burnt umber and a speck of alizarin crimson.

Step 2. For the tone of the distant mountain, the artist again mixes two brilliant colors on his palette: phthalocyanine blue and alizarin crimson. Then, to keep the mountain far back in the picture, he adds a speck of burnt umber and plenty of water. When this wash is dry, he paints the nearer, tree-covered slope with small strokes that flow softly together: ultramarine blue and cadmium yellow for the cooler tones; new gamboge, alizarin crimson, and a hint of ultramarine blue for the warmer tones. When the slope is dry, the artist paints the low, shadowy cluster of foliage with ultramarine blue, alizarin crimson, and yellow ochre.

Step 3. The water is painted with a mixture of phthalocyanine blue—the same brilliant blue that's used in the sky—softened with yellow ochre and a touch of burnt umber, plus plenty of water, since a little phthalocyanine blue goes a long way. Note that the water isn't painted to the edge of the sand, but stops just short of the beach so that the bare paper suggests foam. Then the artist carefully blocks in the curving shape of the beach with yellow ochre and burnt umber, adding less water in the foreground and more water as the beach winds around into the middle distance.

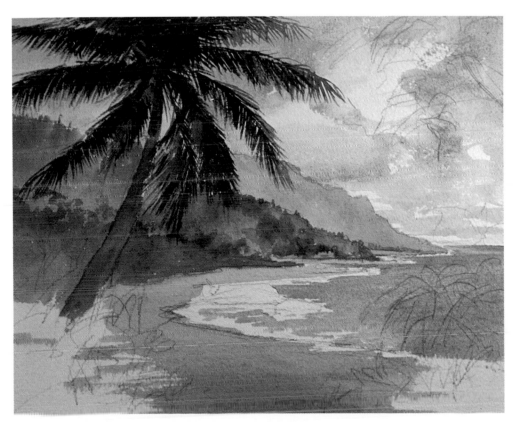

Step 4. When the sky, distant mountain, and wooded slopes are absolutely dry, the artist begins work on the big palm tree. First he paints the warm tone of the trunk and the warmer foliage—which you can see under the darker foliage—with ultramarine blue and cadmium orange. He uses a medium-sized, round brush for the trunk and then switches to a smaller, sharply pointed brush for the foliage. When this warm tone is dry, he mixes a darker, cooler tone with phthalocyanine blue, new gamboge, and burnt umber. Then, with the sharp point of the small brush, he paints this dark mixture over the warm undertone of the foliage.

Step 5. Now the artist covers the lower edge of the picture with a greenish mixture of ultramarine blue and new gamboge, warmed with alizarin crimson. He works upward, carrying this mixture over the beach and water with slender, curved strokes that suggest tropical grass, silhouetted against the sunny sand and water. At the left of the palm tree, he adds a few strokes of dark, cool foliage with the same mixture he's used for the dark foliage of the palm in Step 4. These dark strokes blur softly into the wet color of the beach grass at the foot of the tree. Strokes of phthalocyanine blue and burnt sienna suggest shadows and textures on the trunk of the big palm.

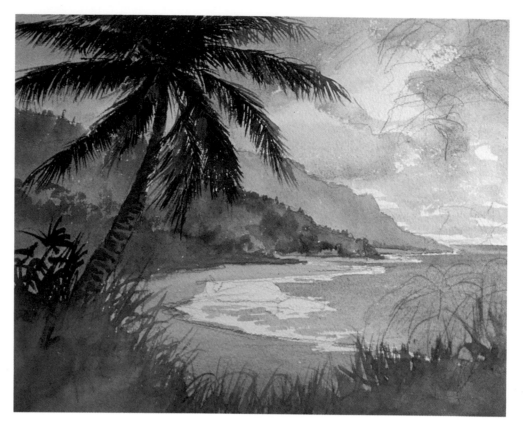

Step 6. When the warm foreground tone is dry, the artist blends phthalocyanine blue, yellow ochre, and burnt sienna on his palette to produce a dark, shadowy mixture. Slender, curving strokes of this mixture are built up over the dark undertone of the foreground to suggest dense tropical growth. At the right, the artist adds a cluster of tropical plants with this mixture. Notice how he adds more water for the paler foliage at the top. Just under the big palm, the artist places a few spots of cadmium red, softened with a speck of burnt umber, to indicate tropical flowers along the beach.

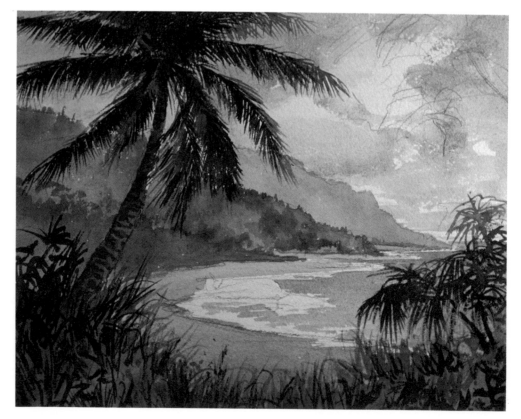

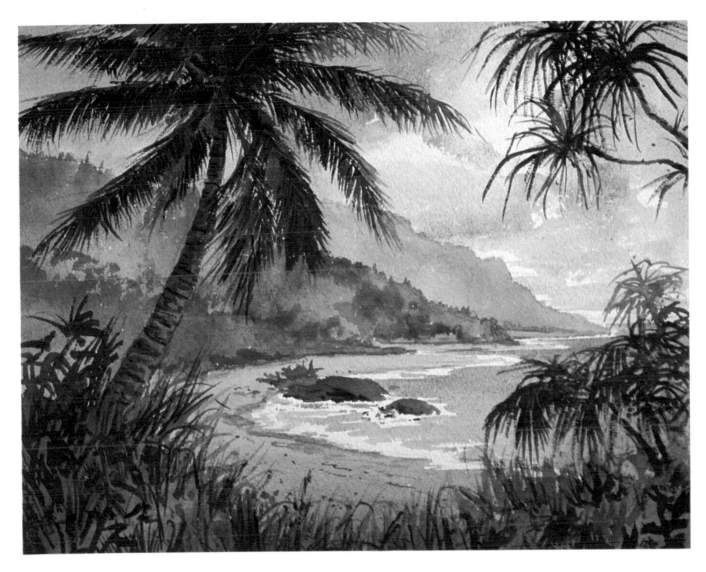

Step 7. To complete the "frame" of dark foliage around the sunny beach, the artist adds more branches in the upper right corner. These are painted in the same way as the beach grass in the foreground. The artist starts with a paler, warmer mixture of ultramarine blue, cadmium yellow, and burnt sienna, lightening this tone with water. When these first strokes are dry, he completes the branches with a darker, cooler mixture of phthalocyanine blue, new gamboge, and burnt sienna. With this same dark mixture, he thickens the shadowy foliage of the big palm and adds more dark strokes to accentuate the texture and detail of the trunk. The dark shapes of the rocks in the water are finally painted with ultramarine blue, new gamboge, and a little cadmium red—with more ultramarine blue for the small strokes of shadow. The artist dilutes this mixture with water to strengthen the edge of the beach where it meets the ocean. Tiny strokes and dots of the rock mixture are scattered along the beach to suggest shoreline debris like pebbles and seaweed. A few more wildflowers are added among the foreground foliage with cadmium red and a slight touch of burnt umber. If you study the final painting, you'll make an interesting discovery. The artist has used the full range of brilliant colors on his palette to capture a sunny tropical shore—but his mixtures are much more subtle than you might expect. The brilliant tube colors have been carefully softened so that they hold their place in the picture and don't compete with one another. The strong contrasts of sunlight and shadow, typical of the tropics, have been created mainly by differences in value, rather than by brilliant color. The pale tones of the beach, the sea, and the wooded slope look sunny not only because the artist has chosen the right color mixtures, but because these paler tones are surrounded by the strong darks of the palm and the tropical growth in the foreground.

Step 1. The first four demonstrations have shown the *direct* technique, where each color is mixed separately on the palette and applied directly to the paper in a single operation. But in the eighteenth and nineteenth centuries, the British Old Masters of watercolor perfected a different method, one that starts with a monochrome underpainting. To demonstrate that technique, the artist begins with a precise pencil drawing that defines the light and shadow planes. He then mixes a warm, neutral tone with burnt umber and ultramarine blue, plus plenty of water. This tone is then brushed over everything except the lightest planes, and is left to dry. Now we have the lights (the white paper) and the pale middletones.

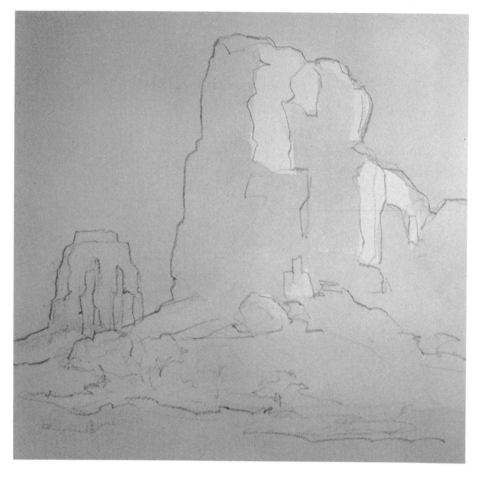

Step 2. The artist locates the darker middletones. He covers these areas with a second wash of the same mixture he's used in Step 1. Because these areas now contain two separate washes, they're twice as dark as the tone that covers the paper in the first step. When the second wash is absolutely dry, he then locates the darks and blocks in these areas with a third wash that's identical in tone to the first two washes—or perhaps just a bit darker. When the third wash is dry, the artist has a complete rendering of the pattern of light and shade on his subject in four values: light, two middletones, and dark.

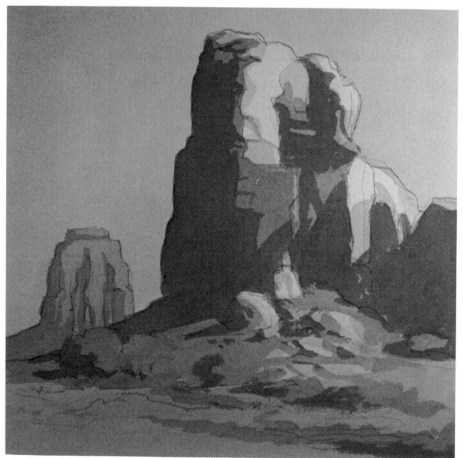

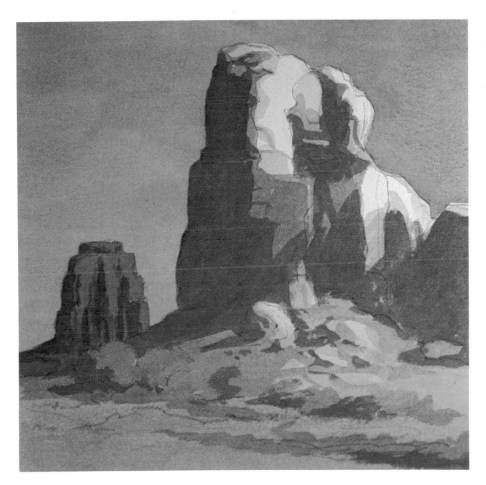

Step 3. By the end of Step 2, the artist has established the forms and has indicated light and shade. Now he can concentrate primarily on color. He washes pure ultramarine blue over the sky, carrying this cool mixture over the rocky shadow shapes to cover just the darks and the darker middletones. This cool wash also covers the distant rock formation at the left. When the blue wash is dry, he runs a warm wash of cadmium red, burnt sienna, and yellow ochre over the distant rock formation. He reinforces the shadows with ultramarine blue and alizarin crimson. The artist works with washes of bright, clear color because these mixtures become more subdued as they travel over the monochrome underpainting.

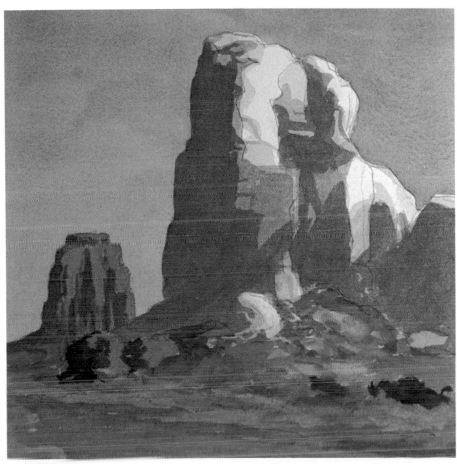

Step 4. The artist begins to warm the foreground with a pale wash of new gamboge and cadmium red. When this golden tone dries, he enriches parts of the foreground with a stronger, brighter version of the same mixture, containing more cadmium red and a touch of burnt sienna. On the dried washes that cover the foreground, the artist begins to suggest some desert plants with dark patches of ultramarine blue and cadmium orange.

Step 5. The artist carries the warm foreground tone—new gamboge, cadmium red, and burnt sienna—up over the big rock formation with rough, irregular strokes that suggest the texture of the rocks. This tone immediately warms the lights, middletones, and darks on the rock. In the foreground, the artist develops the desert growth with a series of pale strokes of ultramarine blue and cadmium orange. When these strokes are dry, he adds darker strokes of the same mixture.

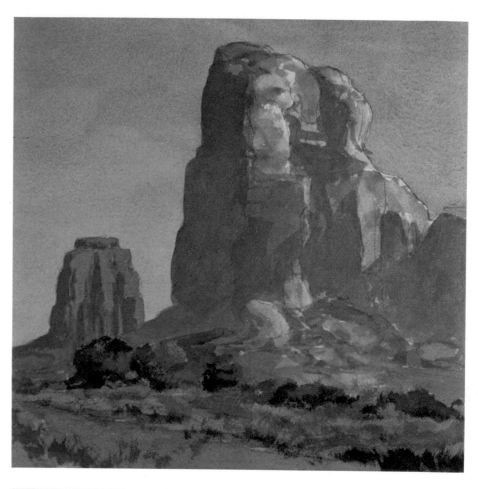

Step 6. Mixing a dark wash of ultramarine blue and burnt sienna on his palette, the artist deepens the shadows on the big rock formation and on the slope, with bold, decisive strokes. Smaller strokes of this same dark mixture are used to suggest cracks in the rocks, and to indicate boulders on the ground. A few more touches of warm color are added to the lighted planes of the massive rock formation with new gamboge, cadmium red, and burnt sienna. The color of the slope at the foot of the rock is also intensified by a few strokes of this mixture.

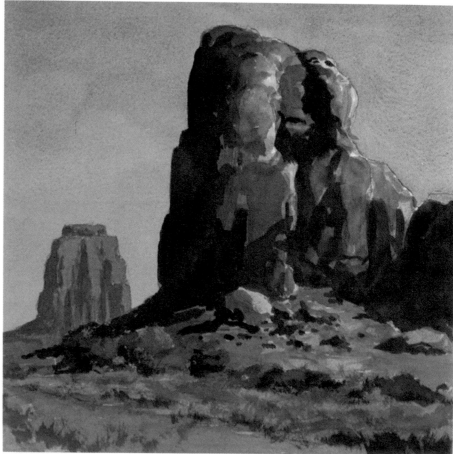

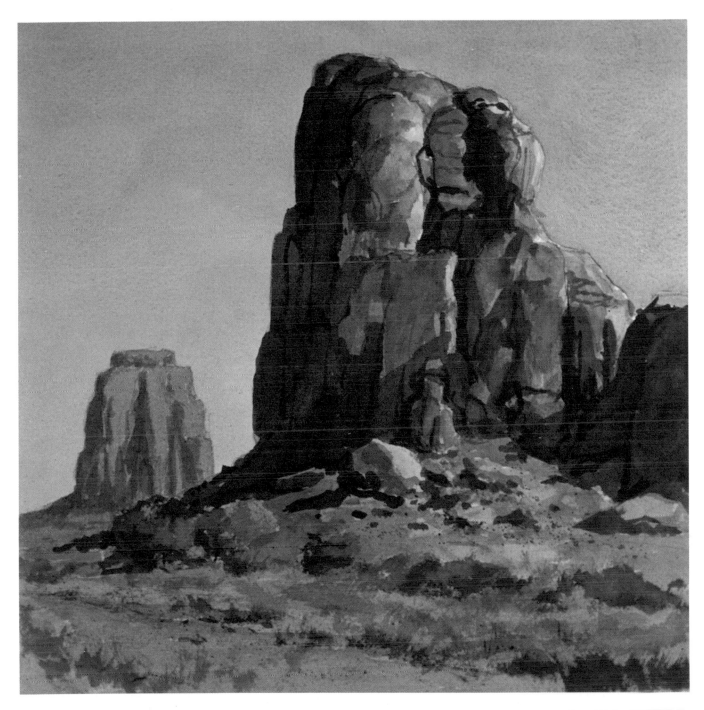

Step 7. With a dark mixture of ultramarine blue and burnt sienna, the artist adds more cracks and other details within the big rock formation. These slender strokes appear not only in the lighted areas, but also within the shadows. He cools some of the middletones in the rocks with a pale wash of ultramarine blue. He suggests more boulders and pebbles with tiny, dark touches of ultramarine blue and burnt sienna. He spatters some of these dark flecks onto the paper with a wet brush that's shaken over the surface. With this mixture, he strengthens the shadows beneath the desert plants in the foreground. At the last minute the artist decides that the ragged strip of desert plants needs to be cooler, so he brushes them with a pale wash of ultramarine blue and new gamboge. The shadows of the distant rock formation are accented with darker strokes of ultramarine blue, alizarin crimson, and burnt sienna. Looking back over this demonstration, you can see the logic of this classic technique. The painting is built up in gradual stages, wash over wash. First, the artist builds up the forms by working gradually from light to dark. When the pattern of light and dark is completed, the artist builds up the color in a series of washes, each more intense than the wash before. The final watercolor has a particularly strong, three-dimensional feeling because of the monochrome underpainting. In contrast with the direct technique, this method of painting a watercolor depends primarily on optical, rather than physical, mixtures.

Step 1. When you work with a monochrome underpainting, your optical mixtures are always a bit subdued. To discover how to create brighter optical mixtures, try underpainting in color. In this demonstration, the artist works with just three color mixtures to create a limited-color underpainting. He draws the rocks, tide pools, headland, and horizon carefully so that he has a clear idea of where each underpainting color will go. Then he brushes a wash of yellow ochre over the sky and the tide pools, leaving gaps in the sky to suggest clouds. This first underpainting wash is allowed to dry.

Step 2. The headland at the left is blocked in with a wash of alizarin crimson and just a hint of ultramarine blue. Then the artist covers the two big rock formations, the patches of beach between the tide pools, and the strip of receding beach with pure ultramarine blue—adding much more water for the distant beach. Thus, the forms in the foreground are darkest, obeying the "laws" of aerial perspective even in this simple underpainting.

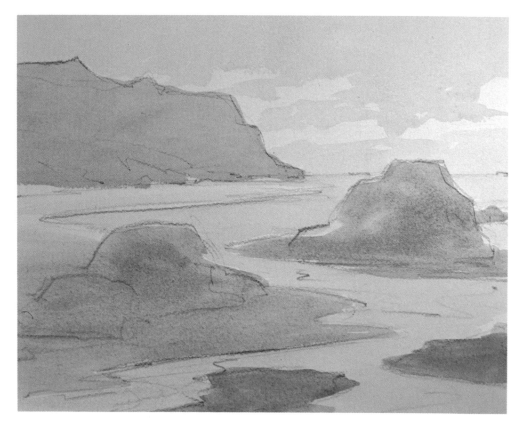

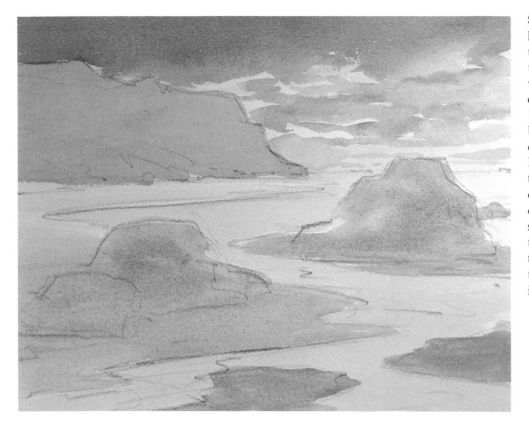

Step 3. Over the warm yellow ochre underpainting of the sky, the artist brushes ultramarine blue, modified with just a hint of alizarin crimson and burnt umber. He adds more water to his brushstrokes as he works down toward the horizon. He also leaves gaps between the strokes, allowing patches of white paper and yellow ochre underpainting to shine through. Thus, we see the scattered clouds above the horizon, and a suggestion of warm sunshine glowing throughout the sky.

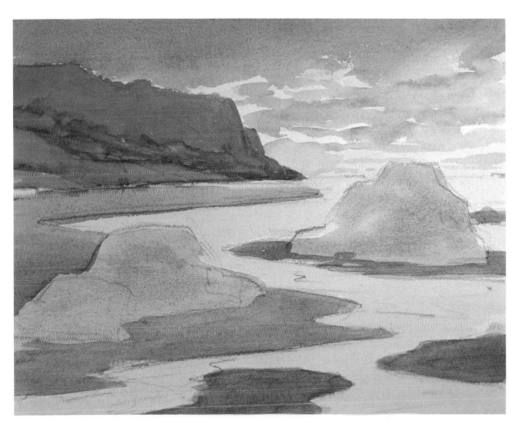

Step 4. Over the top half of the headland, the artist brushes ultramarine blue, which is warmed by the alizarin crimson underpainting. Along the lower part of the cliff, the artist brushes strokes of burnt sienna, which forms a luminous optical mixture with the alizarin crimson underpainting. The artist washes a paler burnt sienna tone over the beach beneath the cliff. He carries this wash around to the foreground sand. In the distance, the beach looks sunnier because the blue underpainting is paler, while the sand in the foreground looks shadowy because the cool underpainting is darker.

Step 5. Over the ultramarine blue underpainting of the foreground rocks, the artist brushes broad strokes of burnt sienna and cadmium red. This brilliant mixture is cooled and softened as it forms an optical mixture with the underpainting. (The artist purposely leaves a few gaps between his strokes on the rocks.) When the rocks are dry, the artist carries a pale wash of cerulean blue over the yellow ochre underpainting of the water. Notice how he again leaves gaps in his strokes to let the sunny tone of the yellow ochre underpainting come through. To suggest sunlight on the water at the horizon, he leaves the warm underpainting untouched.

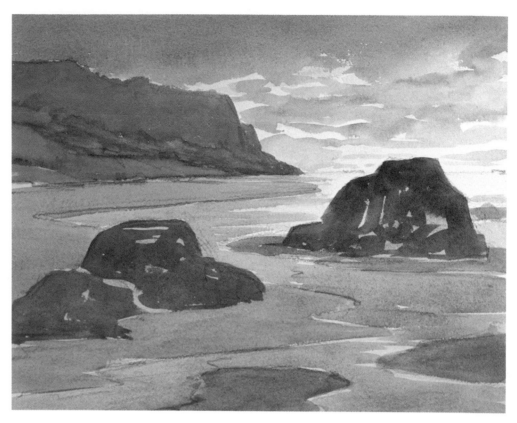

Step 6. Working with straight strokes to accentuate the blocky shapes, the artist paints the shadows on the rocks with ultramarine blue—forming a dark, optical mixture with the warm, underlying tone of Step 5. Where the underlying burnt sienna tone remains untouched, we see sunlit planes on the rocks. The artist mixes burnt sienna and ultramarine blue, and brushes this into the tide pools to indicate the reflections. To darken the shadowed patches of sand in the foreground, the artist blends ultramarine blue, alizarin crimson, and a little burnt sienna, which he brushes across the sand in long, horizontal strokes.

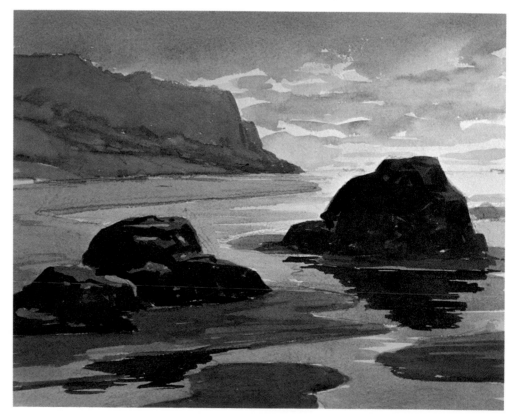

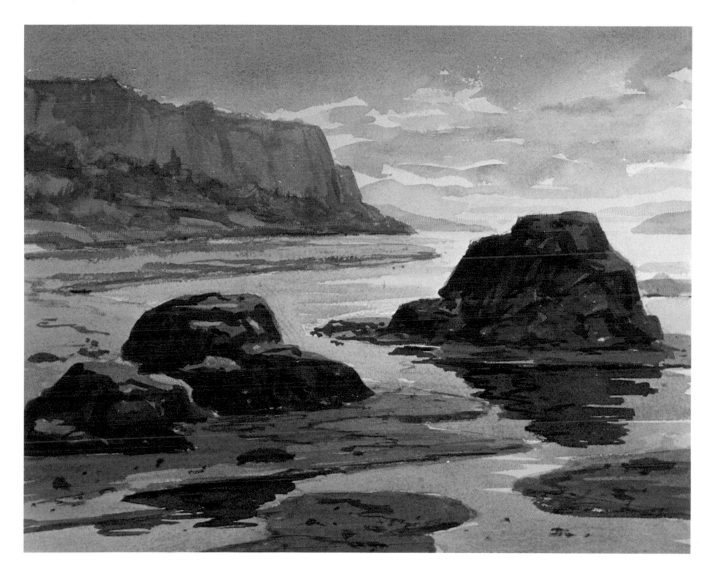

Step 7. By the end of Step 6, virtually the entire painting has been covered with optical mixtures. Now the artist can concentrate on details. With ultramarine blue, alizarin crimson, and burnt sienna, he paints the shadows and the crevices on the face of the distant headland. These strokes form a new optical mixture with the underlying color. The foliage on the warm slope at the foot of the headland is added with small strokes of ultramarine blue and cadmium yellow—warmed and subdued by the underlying tone. The shape of the distant strip of beach is strengthened with slender, horizontal strokes of the same mixture that's used to paint the shadows on the cliff. To paint the cracks within the shadows on the foreground rocks, and to add darker strokes to the reflections in the tide pools, the artist mixes a particularly powerful dark with phthalocyanine blue and burnt sienna. Small dots and dashes of this dark mixture are scattered over the sand in the foreground to suggest pebbles. The artist also strengthens the edges of the sandy patches with dark strokes of this mixture. As you look at the finished painting, it's worthwhile to go back and analyze each optical mixture. Every area of the painting—except for the pale patches above and below the horizon—contains at least two separate washes that mix in the viewer's eye. And many areas—such as the sunny slope at the foot of the headland, the foreground rocks, and the patches of sand between the tide pools—contain three separate washes, plus additional strokes for detail. Like the watercolors of the British Old Masters, the picture is gradually built up, wash over wash. But it's underpainted in *color*, rather than in monochrome.

Step 1. Now that you've had experience building a watercolor over a monochrome underpainting and a limited color underpainting, you'll enjoy working with an underpainting in full color. This can be a splashy, spontaneous way of working. The artist begins with a loose pencil drawing, indicating the trees, mountain, and stream quickly and simply. Then he brushes a rough, irregular wash of cerulean blue over the distant mountain, stopping at the trees and letting his brushstrokes show. When the cool underpainting of the mountain is dry, he paints a strip of new gamboge, softened with yellow ochre, over the distant shore.

Step 2. Above the warm strip of the distant shore, the artist brushes in short, irregular strokes of ultramarine blue and a little alizarin crimson to underpaint the dark trees. On either side of this cool, dark underpainting, he brushes new gamboge and a little burnt umber to underpaint the big masses of foliage. He uses this same warm mixture to underpaint the shore in the foreground, carrying the warm tone into the water to suggest reflected color. While the water area is still wet, he brushes in a strip of cerulean blue; the two wet colors fuse softly. The artist underpaints the foliage in the lower left with a warm wash of ultramarine blue and alizarin crimson.

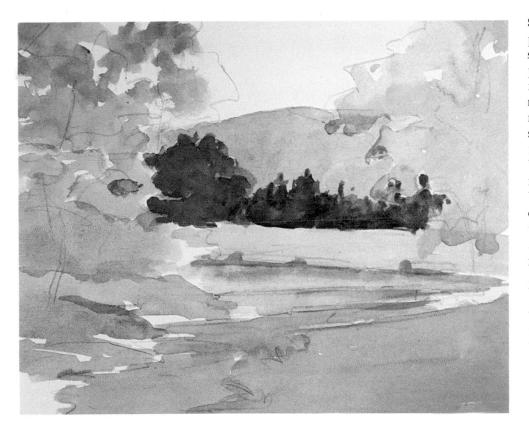

Step 3. The artist runs a pale wash of alizarin crimson over the cool underpainting of the distant mountains. The two washes merge to form an optical mixture that's warmer, but still remote. When the mountain is dry, the artist brushes rough strokes of new gamboge and a little burnt sienna over the dark, cool underpainting of the trees on the far shore. He adds just a touch of cadmium orange to the mixture for the big, dark tree in the background. Both the cool and warm overpaintings merge to form a dark, warm, optical mixture that seems to contain cooler shadows.

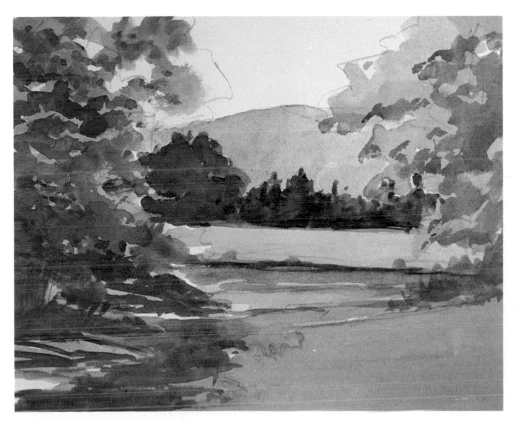

Step 4. The complex form of the tree at the extreme left is overpainted with irregular strokes of alizarin crimson, softened by ultramarine blue and burnt sienna. This dark mixture is carried down into the water to suggest the reflection of the tree. The mixture is deepened and subdued with a little more ultramarine blue and diluted with more water to overpaint the distant trees. Diluted with still more water, this warm mixture is carried into the stream—to form optical mixtures with the tones that are already there. The shadowed leaves on the right-hand tree and its dark base are defined with alizarin crimson.

Step 5. In the lower left, the artist builds up the shadows in the foliage—and the reflections in the stream—with dots and dashes of burnt sienna and ultramarine blue. Along the sunny shore beyond the stream, bushes are added with ultramarine blue and cadmium orange—repeated in the water to indicate reflections. The artist begins to develop the grass in the lower right with short, scrubby strokes of pale cerulean blue, followed by pale, warm strokes of alizarin crimson and burnt sienna. A few strokes of this warm mixture suggest pale middletones on the tree at the right.

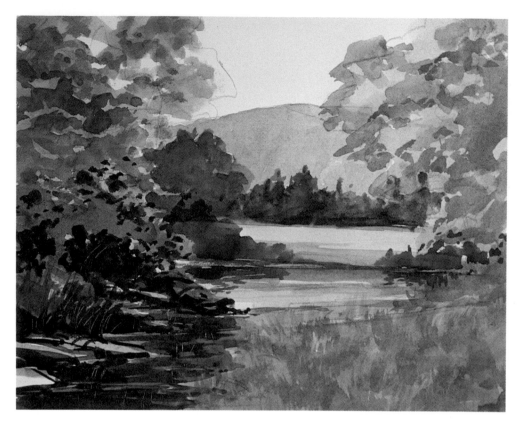

Step 6. Cerulean blue is brushed over the sky, stopping short of the mountain to let the undertone come through. The artist darkens the bushes on the far shore and their reflections with ultramarine blue and burnt sienna. The stream is cooled with pale cerulean blue that's carried down into the left-hand corner. The artist darkens this corner with ultramarine blue and burnt sienna, and then scrubs out the flat rocks with a wet bristle brush. He warms the big trees at either side, plus the grassy field in the foreground, with alizarin crimson softened with ultramarine blue and burnt sienna. Then he scratches weeds out of the wet color with the brush handle.

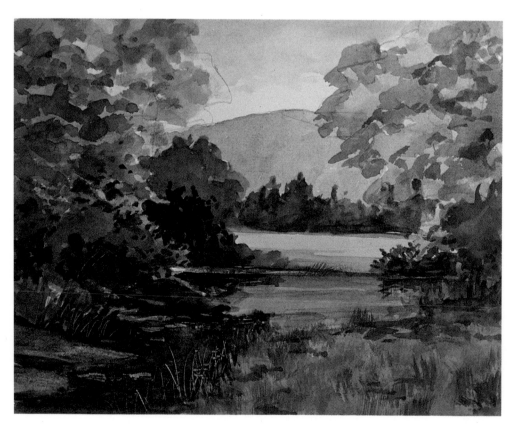

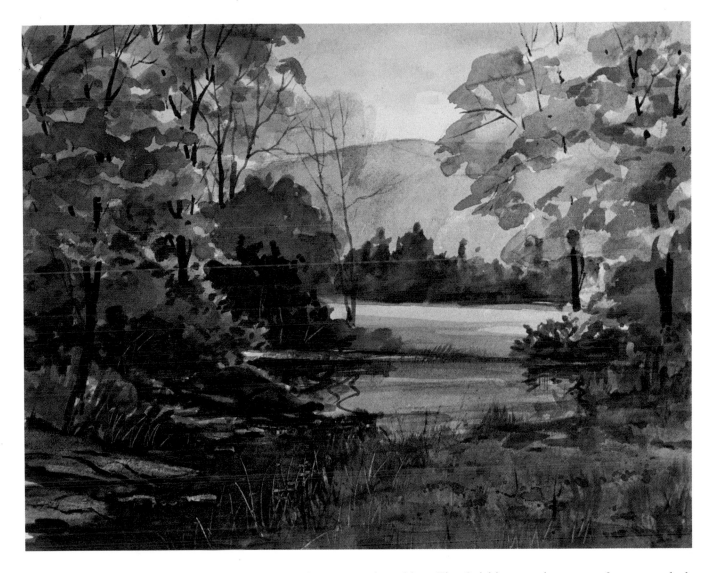

Step 7. Mixing a rich dark of viridian and burnt sienna, the artist places trunks and branches within the foliage at either side of the picture. These trunks and branches are painted with short strokes, interrupted by the clusters of leaves. He adds one more tree on the far shore with slender strokes of ultramarine blue and cadmium orange. This is diluted with lots of water to make a few broad, scrubby strokes that indicate foliage at the top. He then strengthens the foliage in the upper left with strokes of burnt sienna and alizarin crimson, subdued by a hint of viridian. He builds up the detail of the grass in the foreground with this same mixture. But he decides that the foreground is becoming too warm. So he tones down the grassy field with a pale wash of cerulean blue that mixes with the warm undertone to create a particularly fascinating, shadowy optical mixture. Where the wet bristle brush has scrubbed out the shapes of the rocks in the lower left, the artist delineates the cracks on these flat rocks with strokes of ultramarine blue and burnt sienna. To suggest the cool tone of the water running over these rocks, he tints them with the palest possible wash of cerulean blue. The finishing touches are a few more dark strokes for the wiggly reflection of the slender tree in the water, and more pale scratches to indicate foreground weeds and branches among the bushes on the far shore. Comparing the completed painting with the underpainting in Step 2, you may be surprised to see how those splashes of pure color have been transformed into subtle optical mixtures. Every area of the painting contains at least two washes of color: the underpainting and at least one overpainting. But *most* of the picture contains three or more layers of transparent color that blend in the viewer's eye to create complex and magical optical mixtures. This method of building up a watercolor—in a series of washes—is ideal for capturing the subtleties of light and atmosphere. The complex shadow tone in the lower right, for example, would be impossible to duplicate by the direct technique. So would the stream in the center of the picture, and the trees at the left, where multiple colors shine through one another to produce optical mixtures that defy description.

Step 1. Still another way to paint a watercolor is to exploit the texture of the paper when you apply liquid color—and when you remove that color. A sheet of rough paper has a pronounced *tooth* that's ideal for textural painting techniques, as demonstrated here. The artist chooses rocks, a fallen tree, and white water as subjects that are particularly suitable for this painting method. He begins by painting the sky with a smooth wash of phthalocyanine blue, softened with burnt umber and a little yellow ochre. He then adds the mountains with ultramarine blue, burnt sienna, and a few drops of alizarin crimson, and the warm tone of the distant trees with cadmium orange and a bit of ultramarine blue.

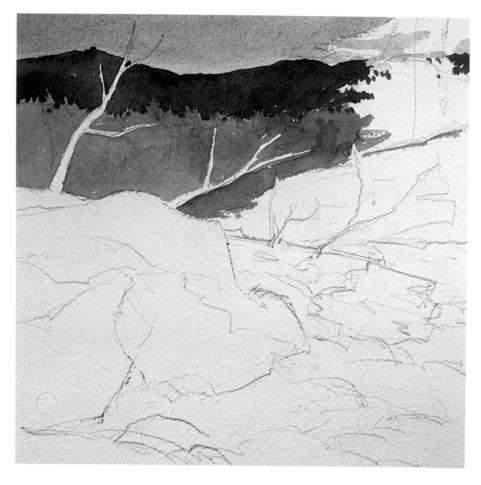

Step 2. In the upper right-hand corner, the artist underpaints the big, dark tree with burnt sienna, a touch of cadmium red, and ultramarine blue. When this warm tone is dry, he brushes in the dark branches of the tree with phthalocyanine blue and burnt sienna. Moving to the left, he paints the smaller evergreens in exactly the same way, beginning with the paler, warmer mixture for the more distant trees, letting these washes dry, and then overpainting them with the darker mixture to render the nearer trees. Notice how he uses the pointed wooden handle of the brush to scratch a few lines into the wet color, indicating tree trunks. In Steps 1 and 2, the artist works carefully around the branches of the dead tree, which remain bare white paper.

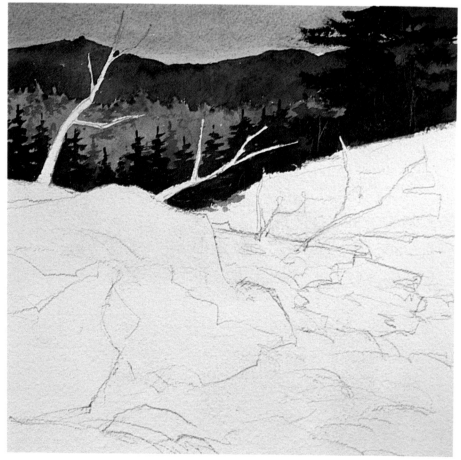

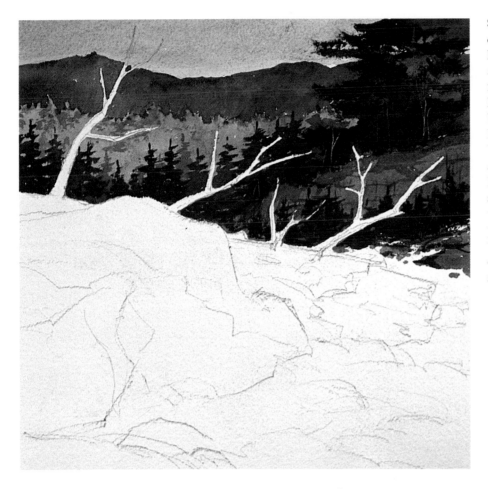

Step 3. The artist completes the dark background by extending the landscape down to the water's edge at the right. First he brushes in a flat wash of burnt sienna with a little ultramarine blue, tracing the brush carefully around the silhouetted shapes of the sunlit branches. When this tone is dry, he adds more ultramarine blue—and less water—to paint the warm shadow beneath the big tree in the upper right-hand corner. Now he paints the dark evergreens along the shore with the familiar mixture of phthalocyanine blue and burnt sienna.

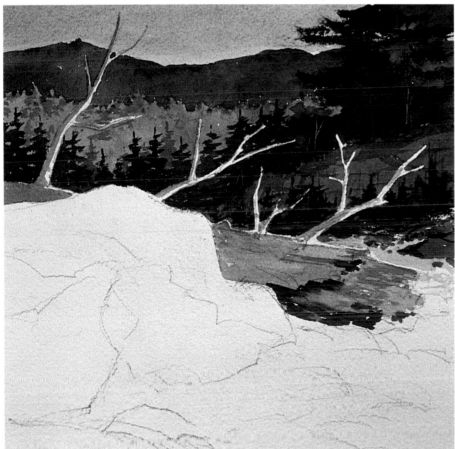

Step 4. Beginning work on the foreground, the artist paints a warm tone at the broken end of the tree with a pale wash of burnt umber, yellow ochre, and a little ultramarine blue. While the wash is still damp, he adds darker strokes of burnt umber and ultramarine blue to indicate the shadow edges, which melt softly away into the pale, wet color. The cooler tone of the bark is painted with the same three colors, but in different proportions: more ultramarine blue, less burnt umber and yellow ochre. He adds a crack in the bark with burnt umber and ultramarine blue, repeating this mixture on the broken end of the tree. The artist carefully leaves slender strips of bare paper along the sunlit edges of the shapes.

Step 5. Now the textural painting begins. Turning a flat brush on its side and gliding lightly over the painting surface, the artist blocks in the tone of the rocks with erratic strokes that are broken up by the tooth of the rough paper. The rock tone is burnt umber, ultramarine blue, and yellow ochre, diluted with varying amounts of water. To enhance the rough texture, the artist blots parts of the rock with a crumpled paper towel. Picking up a darker version of the same mixture on a small brush, the artist draws the cracks in the fallen tree. The brush is damp, not wet, and the texture of the paper roughens the strokes. The corner of a razor blade, skipping lightly over the painting surface, creates ragged strips of light on the bark.

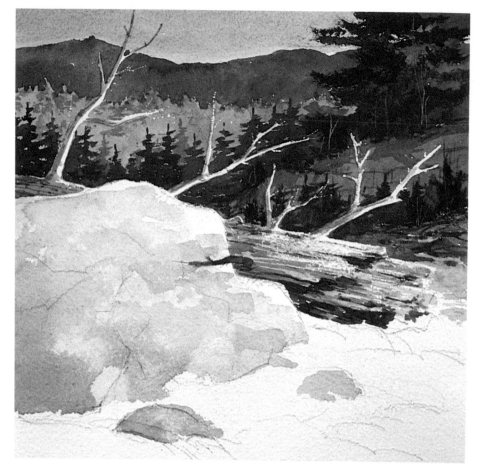

Step 6. Again working with the side of a big, flat brush, the artist blocks in the dark shadows on the rocks with burnt sienna, yellow ochre, and ultramarine blue. He moves the brush lightly over the paper so that the rough texture of the painting surface breaks up the strokes. He blots away some of the shadow tones with a rough, crumpled paper towel. When the shadow tones are dry, he spatters the rocks with droplets of ultramarine blue and burnt umber, shaken from a wet brush. After waiting for the rocks to dry thoroughly, he scrapes away the lights with the flat edge of a razor blade, moving it gently across the paper.

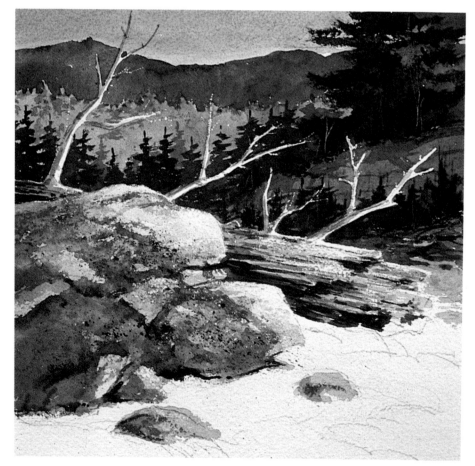

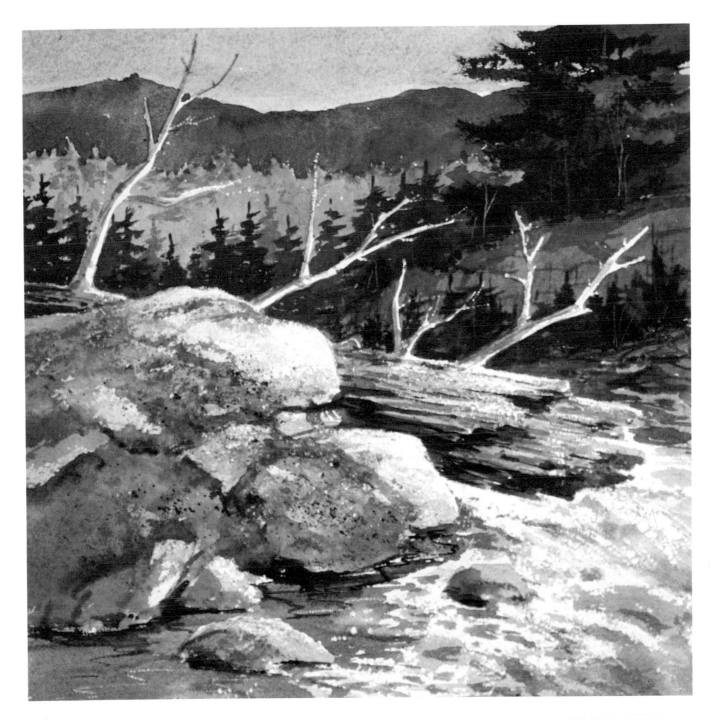

Step 7. By holding the side of the damp brush against the rough paper to make a ragged stroke that's broken up by the texture of the painting surface, the artist paints the water with strokes that follow the movement of the stream. These drybrush strokes are applied with light movements that allow flecks of bare paper to show through, suggesting the white water. When the water is absolutely dry, he uses the flat edge of a razor blade to scrape away more patches of white. (The artist doesn't dig the blade into the paper, but gently shaves away the high points of the irregular painting surface.) He drybrushes more color over the shadow sides of the rocks, allows the color to dry, and scrapes the lights again. The water, like the rocks, is essentially ultramarine blue,

burnt umber, and yellow ochre—cooled by adding more blue. As you examine the finished painting, you can see that its entire lower half—the rocks, fallen tree trunk, and water—has been executed by drybrushing and scraping. The granular surface of the sheet breaks up the brush-strokes to suggest the grain of the rocks, the ragged character of the fallen tree, and the sparkle of the foam on the water. When the razor blade is carried gently across the rough paper, the sharp blade strikes only the high points of the painting surface, removing tiny granules of paper to reveal flecks of white. The secret of textural painting is not only knowing how to apply color, but knowing how to remove it!

Step 1. There are many ways to mix color. In the direct technique, you mix colors on the palette. In the various underpainting and overpainting techniques, you mix colors on your palette and then mix them again, in a sense, when you apply one wash over another. As you'll now see, there's still another way to mix colors—by doing it directly on wet paper. Completing the pencil drawing, the artist sponges the entire sheet with clear water. To suggest sunlight seen through the forest, he brushes yellow ochre into the center of the wet sheet, and surrounds this warm tone with cerulean blue. The strokes blur and blend on the wet painting surface.

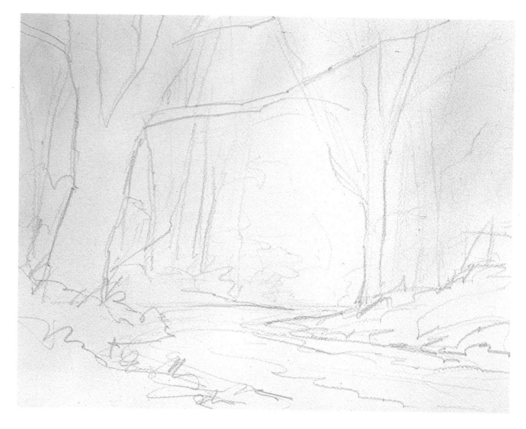

Step 2. While the paper is still wet, the artist mixes a slightly darker tone of cerulean blue and yellow ochre on his palette. He quickly brushes broad strokes of this mixture across the wet sheet to suggest the silhouettes of the pale, distant trees. Like the strokes of Step 1, these new strokes blur and blend as they strike the wet paper. However, the paper isn't quite as wet as it was before, so the new strokes don't disappear altogether, but retain a slightly more distinct shape. One important caution about the wet-into-wet technique: wet paper tends to dilute your colors, so make your strokes darker than you want them to be. They'll dry lighter.

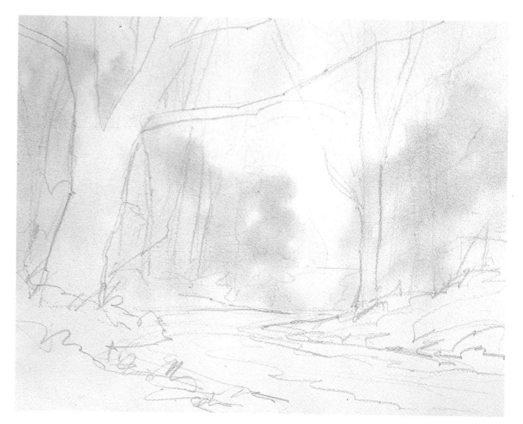

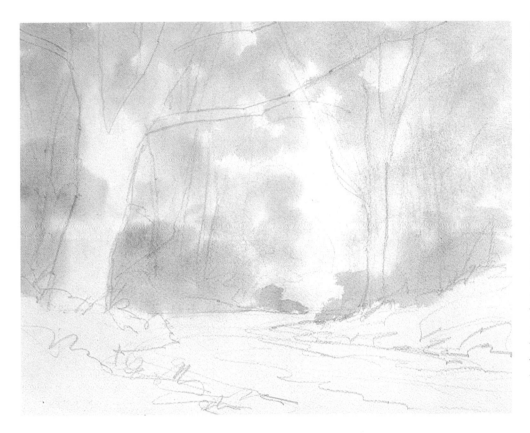

Step 3. The paper is drying rapidly, but the surface still hasn't lost its shine. The artist quickly adds broad strokes of foliage with cerulean blue and burnt umber. Warming the mixture with more burnt umber, he brushes darker strokes along the bases of the trees. The paper is dryer than it was in Steps 1 and 2, so the strokes are more distinct now, although there are still soft edges where the strokes melt into the damp, underlying color. By the end of this step, the paper has lost its shine. This means that it's still moist, but not wet enough to take strokes of fresh color without marring the mixtures that are already there.

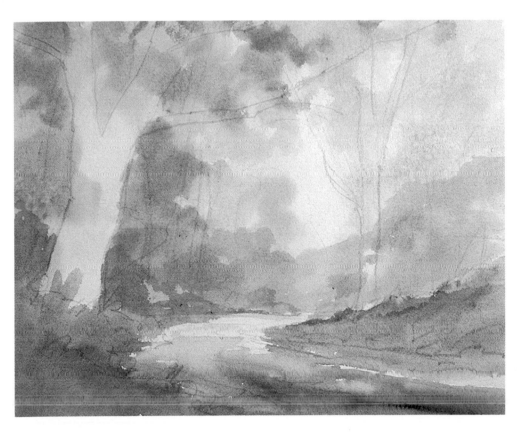

Step 4. The artist waits for the paper to dry thoroughly. Then he rewets it with a large, flat, soft-hair brush, carrying the clear water down to the edge of the road and the bases of the trees. Letting the water sink in and dry slightly so that his strokes won't be too blurred, he builds up the shadowy masses of foliage with darker mixtures of burnt umber, cerulean blue, and yellow ochre. He blocks in the warm tone in the lower left with burnt sienna and yellow ochre. Then he paints the rest of the foreground with strokes of burnt umber and ultramarine blue, allowing the strokes of the road to run softly into the wet tones of the grasses on both sides.

Step 5. When the entire painting is thoroughly dry, he paints the dark trunk and branches at the right with ultramarine blue, burnt umber, and a little new gamboge in the lighter area. Adding more water to this mixture, he indicates the more distant trunks and branches. Because they're painted on bone dry paper, these strokes are sharper and more distinct than the wet-into-wet mixtures of Steps 1 through 4. However, the dark tree at the left contains a wet-into-wet mixture of another kind: the artist has placed the light and dark strokes side-by-side and the wet colors run together.

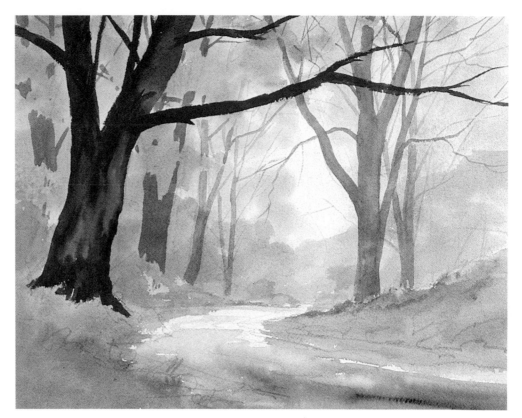

Step 6. Still working on the dry paper, the artist develops the tones and textures of the foreground. With a moist (not dripping wet) brush, he indicates the warm grasses and weeds in the lower left with cadmium orange, burnt sienna, and ultramarine blue. The rough texture of the paper breaks up the strokes. Lightening this same mixture with more water, he paints the opposite side of the road in the same way. Then he adds dark ruts to the road with strokes of burnt umber and ultramarine blue—some strokes have more water and some less—letting the wet strokes flow together and mix "accidentally."

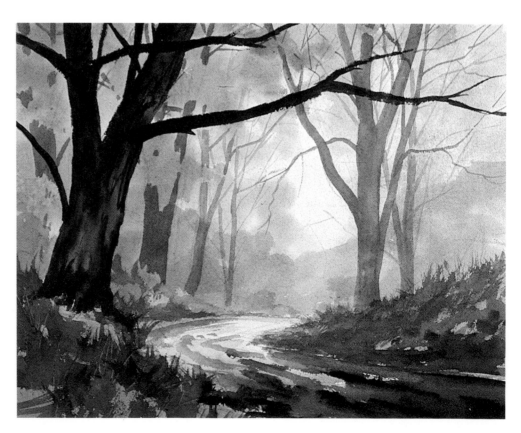

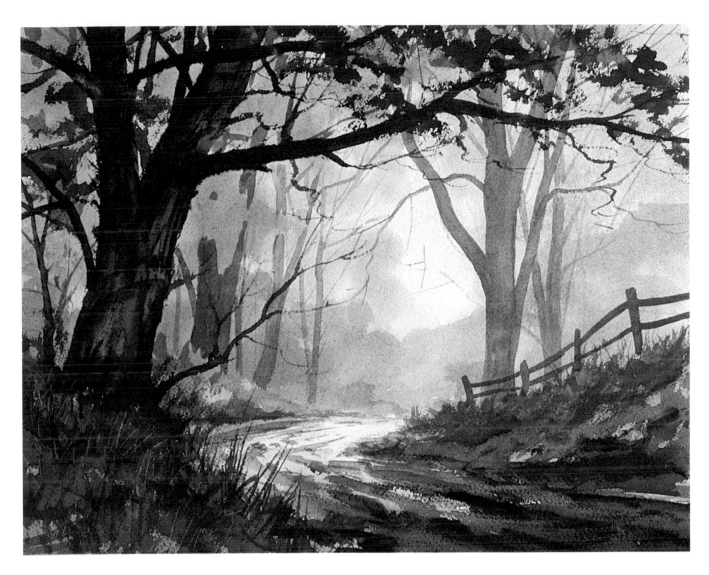

Step 7. When the foreground is thoroughly dry, the artist adds the details of the dark grass in the lower left with crisp strokes of ultramarine blue and burnt sienna. With the corner of a razor blade, he scratches out the pale blades of grass that catch the light. He darkens the opposite side of the road with drybrush strokes of burnt umber and ultramarine blue, and then adds more drybrush strokes to darken and accentuate the rough texture of the road itself. Moistening a round brush with a dark, fairly dry mixture of ultramarine blue and burnt sienna, the artist turns the brush on its side and drybrushes ragged strokes across the top of the picture to suggest clusters of foliage on the dark tree. Adding more water to make this mixture more fluid, he draws slender lines to indicate more twigs and branches. Then he uses this warm mixture to add small trees along the left-hand edge of the painting. The entire paper is covered with color now, except for the pale patch at the center of the road, which is spotlit by the light that comes through the overcast sky. Reviewing the sequence of steps in the execution of this painting, you'll recall that all the wet-into-wet mixing was done in Steps 1 through 4. By the end of Step 4, the painting was covered with large, soft masses of color. Over these blurred, wet-into-wet mixtures, the artist completed the picture with crisp, distinct strokes. It's rare for an artist to paint an *entire* picture wet-into-wet. Such a picture tends to have a vague, monotonous, fuzzy look. It's far more effective to combine wet-into-wet mixing—or the wet paper technique as it's sometimes called—with more distinct brushwork on dry paper, as you've seen in this demonstration.

Step 1. The Impressionist and Post-Impressionist painters of the late nineteenth century created vibrant optical mixtures. They built up their paintings with individual strokes, placed next to *and* over one another, to produce a mosaic of shimmering color. The *stroke technique*, as it might be called, is demonstrated here. The artist begins with a fairly precise pencil drawing so that he can plan the placement of his strokes accurately. Then he brushes a delicate tone of phthalocyanine blue, burnt umber, and yellow ochre across the sky, gradually adding more water and yellow ochre as he moves toward the horizon. Strokes of this mixture are carried into the water.

Step 2. The artist has chosen a sheet of smooth watercolor paper on which the strokes will be sharp and distinct. He begins to build up the warm tones of the trees with an underpainting of new gamboge, yellow ochre, and alizarin crimson, applied in bold, clearly defined strokes. By varying the proportions of the colors in the mixture, he makes some strokes brighter and others more subdued. Paler strokes of this mixture are carried down to the ground beneath the trees. And the low foliage on the far shore is indicated with strokes of ultramarine blue, warmed with a little burnt sienna and yellow ochre, diluted with lots of water.

Step 3. The tree trunks on the right are underpainted with warm strokes of alizarin crimson, burnt sienna, and yellow ochre. This mixture reappears in the branches and the ground at the bases of the trees. The darker, cooler tones of the tree at the center of the picture are rendered with strokes of ultramarine blue, burnt umber, and yellow ochre—repeated in the water to suggest a reflection. The cool tones in the lower left and in the distant water are strokes of cerulean blue with a hint of burnt umber. The artist begins to add cool strokes to the grass and its reflection on the right with greenish tones of ultramarine blue and new gamboge.

Step 4. The artist continues to darken the thick tree trunk at the right with strokes of alizarin crimson, burnt sienna, and a little ultramarine blue. He adds much more ultramarine blue to this mixture to darken the shadowy trunk at the center. With a brighter mixture of alizarin crimson, new gamboge, and a touch of burnt sienna, he builds up the color in the lower left foreground. He adds more water to this blend for the warm strokes that enrich the foliage of the trees and suggest the warm reflection in the water at the lower right.

Step 5. The shadows within the foliage are crisp strokes of ultramarine blue, warmed with a hint of alizarin crimson. To vary the density of the shadows, some strokes are made darker, while others are made paler with more water. Notice that the strokes are gradually becoming smaller. The artist has begun with his biggest, boldest strokes. Then, as he makes the forms of the landscape more distinct, he works with smaller brushes. It's also interesting to see how he leaves spaces between the strokes so that each new layer of brushstrokes allows the underlying colors (and white paper) to shine through.

Step 6. The artist continues to enrich the shadows with darker, denser strokes of ultramarine blue and alizarin crimson. Now there are strong darks not only in the foliage, but on the shadow sides of the trunks and on the ground. The artist uses the same dark mixture to define the branches more precisely, adding more branches among the foliage, and building up a strong shadow beneath the low mass of trees on the far shore—and darkening its reflection in the water. He also begins to place small, distinct strokes of ultramarine blue over the warm undertone of the foliage. The two colors mix to create the cool colors of the leaves and shadows.

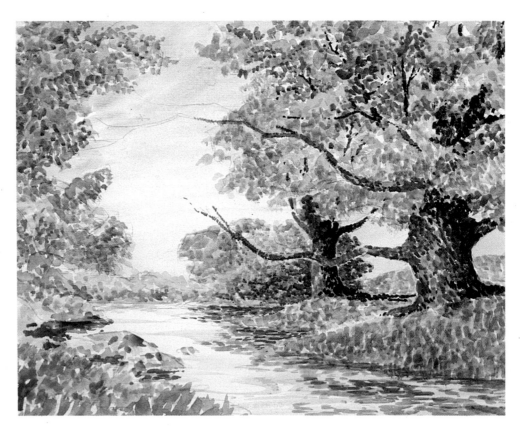

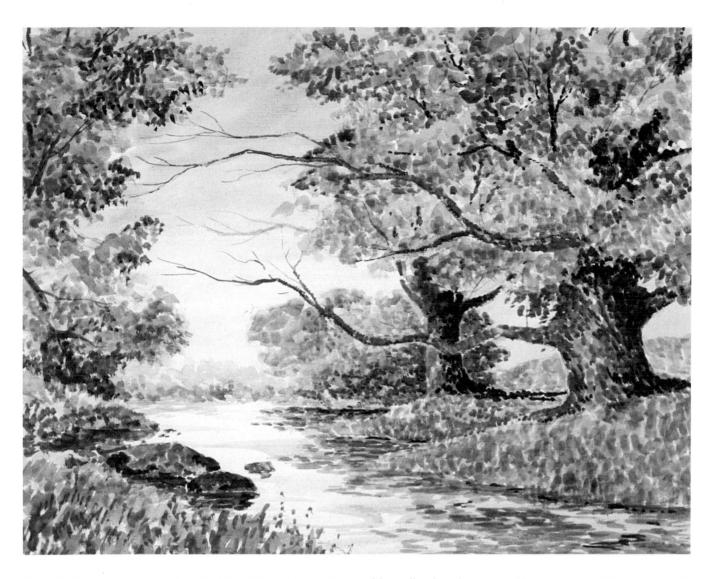

Step 7. Concentrating on the left side of the picture, the artist strengthens the darks among the foliage with small, precise touches of ultramarine blue and alizarin crimson. He also uses this mixture to strengthen the cool reflections of the trees in the water. The rocks at the lower left are darkened with strokes of new gamboge, alizarin crimson, and burnt sienna. The watery shadows beneath the rocks are accented with touches of ultramarine blue and alizarin crimson. Then the sunny grass in the lower left is strengthened with touches of alizarin crimson and cadmium orange, cooled with viridian. The artist adds more detail to the trees on the right, carrying several branches across the open sky with strokes of burnt sienna, alizarin crimson, and ultramarine blue. He adds more branches to the trees on the left with this mixture. Stronger darks are also added to the trees on the right with ultramarine blue, alizarin crimson, and burnt umber. When you work in the stroke technique, it's important to know when to stop—before you build up so many layers of strokes that the clear colors begin to turn muddy and indistinct. Since the artist feels that the colors are now as luminous as he can make them, he stops. There are several points to remember about the stroke technique. First, this intricate buildup of strokes looks particularly effective when it's combined with areas of smooth, unbroken color like the sky and water in this picture. Second, you must remember to let each layer of strokes dry thoroughly before you apply the next layer. Third, you build up your colors gradually, working with fairly pale and transparent tones until the very end, when you can pile up strong colors and rich darks.

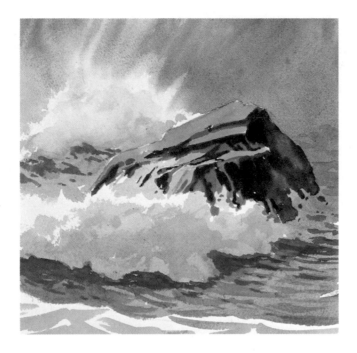

Warm and Cool. Contrast is always the most effective way to call the reader's attention to the focal point of your picture. Here, the viewer's eye goes directly to the warm, sunlit top of the rock because it's surrounded by the cool tones of the sky, foam, and water.

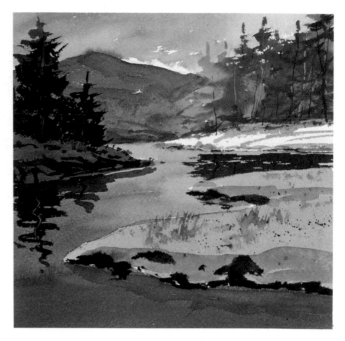

Bright and Subdued. Another way to direct the viewer's eye to your picture's center of interest is to plan a contrast of bright and subdued color. Here, the sunlit tone of the tree is surrounded by the subdued colors of the sky, mountain, and icy water.

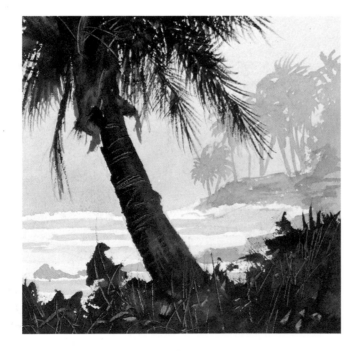

Light Against Dark. When you're working with subdued colors, a contrast of values is particularly effective. Here, the pale, windblown palms in the distance are framed by the dark shape of the palm and the grass in the foreground.

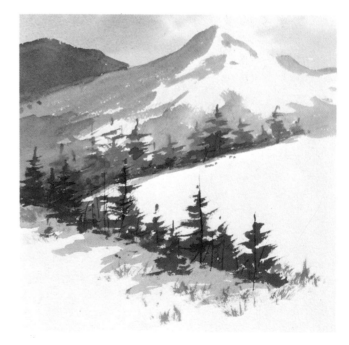

Leading the Eye. Color and value can be used to create a path for the eye to follow into the picture. The dark, warm line of trees, silhouetted against the snow, zigzags from the foreground into the middle distance, carrying the viewer's eye to the snowy peak of the mountain.

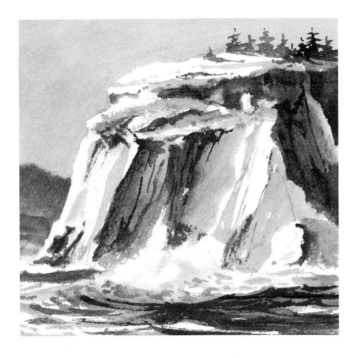

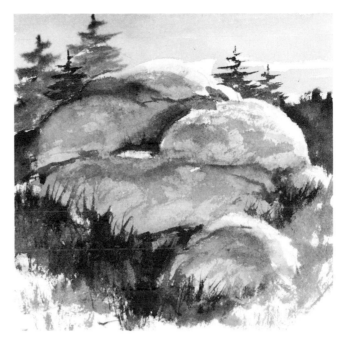

Cubical Form. To paint the forms of nature, you must learn about light. If you visualize this cliff as a couple of irregular cubical forms, you can divide these forms into lighted top planes, a left side plane that also receives the light, and big frontal planes that are in shadow. The shadow planes pick up reflected light from the water.

Rounded Form. Study the gradation of light and shade on the round rock in the lower right. First there's the *light*, which is bare paper. Then there's a pale *halftone*, falling between the light and shadow. As the rock turns away from the light, there are dark strokes for the *shadow*. Then, toward the bottom of the shadow there's a lighter tone called the *reflected light*.

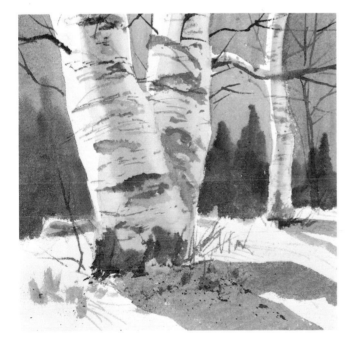

Cylindrical Form. Running your eye over the cylindrical trunk from left to right, you can see the light (bare paper), the halftone between the light and shadow, the shadow itself, the reflected light at the edge of the shadow, and the darker cast shadow on the ground. The light comes from the sun, while the reflected light bounces off the snow, which acts like a mirror.

Irregular Form. This irregular clump of snow on a branch shows the same gradation of light and shade. Looking from top to bottom, you see the light (represented by the bare paper), the pale wash of the halftone, the darker strokes of the shadow, and finally the paler tones of the reflected light within the shadow.

Side Lighting from Left. The light hits the rocks from the upper left, so those four familiar tones move from left to right. The artist has left bare paper for the lights, indicated the halftones with pale washes (scraped lightly with a razor blade), drybrushed the shadows, and scraped in the reflected lights.

Side Lighting from Right. Now the light comes from the right, so the sequence of four tones is reversed. The artist has painted light, halftone, shadow, and reflected light wet-into-wet, so they flow together. He's used a cleansing tissue to lift wet color from the lights, and blotted away some reflected lights.

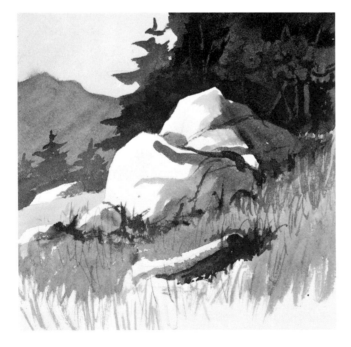

Three-Quarter Lighting from Left. When the light comes over your left shoulder, the lighted planes are bigger and there's less shadow. The halftones are painted first and allowed to dry, then the shadows are added. The artist lightens his last few shadow strokes with water to suggest reflected light.

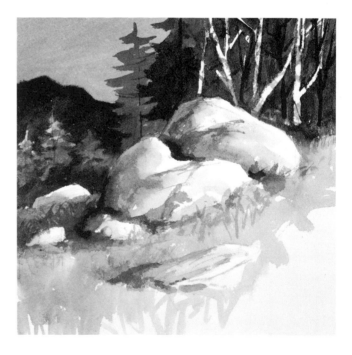

Three-Quarter Lighting from Right. The sequence of tones is reversed again when the light comes from above your right shoulder. The lighted planes are bare paper. The artist covers the rest of the rock with a pale halftone. He brushes in the shadows while the halftone is wet. He reinforces the shadows when those tones are dry.

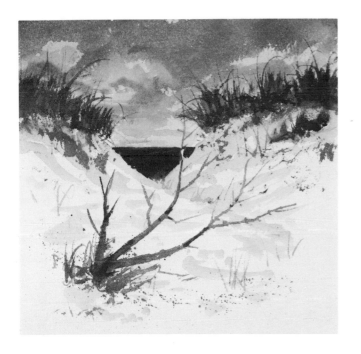

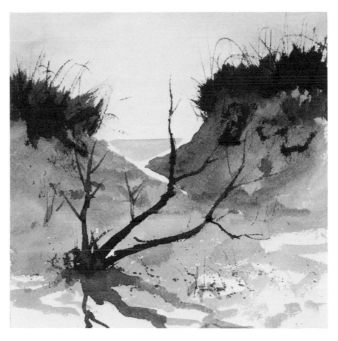

Front Lighting. In this monochrome watercolor study, the sun is above and behind your head, striking the front of the dunes. Thus, the dunes are almost completely bathed in bright light, with just a few halftones and no shadows, except for the cast shadows beneath the grass and under the branches in the foreground.

Back Lighting. Now the sun has moved behind the dunes, which become dark silhouettes against the pale sky. Just the edges of the dunes catch the bright sunlight. There's no halftone between the light and shadow. Each dune is almost entirely in shadow, but these shadows are filled with reflected light that's picked up from the sky, and perhaps from nearby tide pools.

Top Lighting. When the sun is overhead, the upper parts of the dunes catch the light and the lower areas are in shadow. The artist starts with darker strokes at the bottom of the picture, adding more water as he works upward, and leaving the paper bare for the sunny areas. The sun is directly above the patches of beach grass, so there are strong cast shadows beneath them.

Diffused Light. On a hazy or overcast day, the light is blurred, so there's no predictable sequence of light, halftone, shadow, and reflected light. Since there's also not much distinction between them, you must study your subject and paint what you see. Here, the artist paints the indistinct tones on wet paper, letting one tone blur softly into another.

Sunny Day. Just as the landscape is transformed by the changing position of the sun in the sky, so your subject will also be transformed by the weather. As you see in this sketch, on a sunny day, there are strong contrasts of light and shadow—like the contrast between the shadowy slope at the right and the sunny slope in the middle of the picture, or between the light and shadow planes of the rocks in the foreground. The strong light creates sharply defined shadows that cross the landscape, like those in the grass at the lower edge of the picture. There may be clouds in the sky (which may also cast shadows on the land), but there are plenty of spaces between the clouds for the sun to shine through.

Cloudy Day. When clouds cover the sky and block most of the sun's rays, a lot of the landscape tends to be in shadow. There are also fewer strong contrasts between light and shadow. However, there's often a break in the clouds, allowing a few rays to come through and spotlight some part of the landscape—like the sunlit slope at the right and the bright edge of the shore in the center of the picture. It's interesting to see that the artist has painted this dark sky wet-into-wet, while he's painted the sunny sky—in the previous picture with distinct washes.

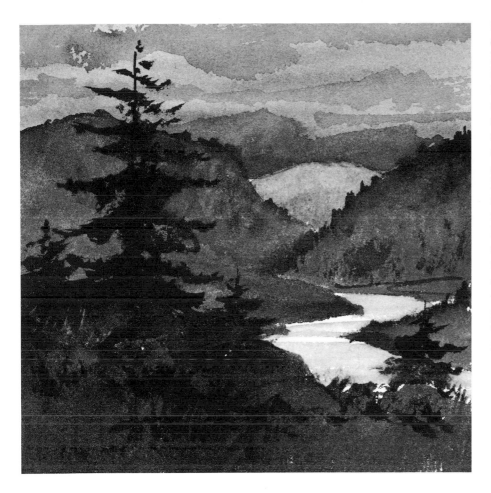

Overcast Day. When the sky is completely covered by a cloud layer, the entire landscape tends to be overcast with a shadowy tone that minimizes contrasts. In this study of the same landscape on an overcast day, most of the shapes are dim silhouettes with virtually no indication of light, halftone, shadow, or reflected light. A shiny surface like the water seems brighter than the rest of the landscape because the mirror-like surface bounces back whatever light is available. On each shadowy slope, the artist lets the various tones melt into one another, wet-into-wet. In the same way, the dark silhouette of the evergreen at the left fuses softly into the wet tone of the dark slope in the foreground.

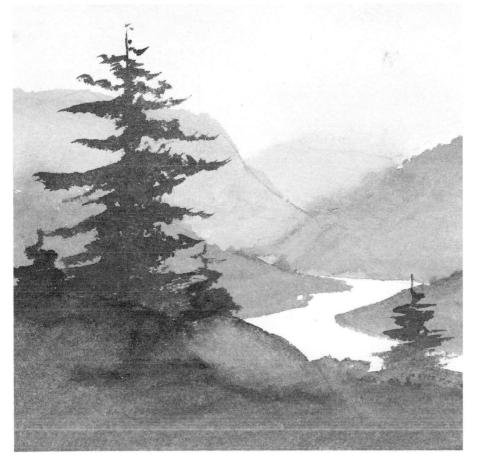

Hazy Day. When a thin haze veils the sun, more light is apt to come through. But that light is soft and diffused, so the landscape tends to be simplified to pale silhouettes. The artist works mainly with flat, delicate washes, letting one wet wash run into another in the distant mountains. Once again, the dark evergreen is a silhouette that fuses with the wet tone of the slope in the foreground. The shiny surface of the stream reflects the soft light and is again the brightest note in the picture. To learn about values in different kinds of weather, it's worthwhile to spend time making monochrome watercolor sketches outdoors.

High Key. Before you touch your brush to the watercolor paper, it's important to examine your subject carefully and decide whether that subject has a definite *key*. If most of the tones are fairly pale—coming from the upper part of the value scale—you're going to paint a high-key picture. In a high-key subject like this coastal landscape, not only the lights, but the halftones, shadows, reflected lights, and cast shadows will be quite pale. To create a high-key effect, the artist has left a lot of bare paper and has added a great deal of water to nearly all of his washes. The only strong darks are in the foreground.

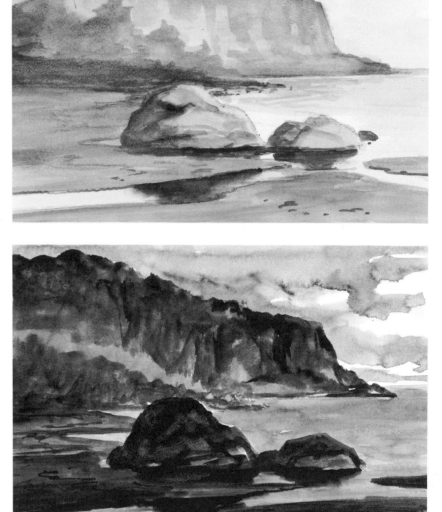

Middle Key. With a change in the light and weather, the same landscape may be transformed to a middle-key subject. Although there are strong darks in the foreground and a few bright lights in the sky, most of the tones come from the middle part of the value scale. There are also more tonal contrasts in this middle-key landscape than there are in the high-key landscape above. In general, you'll find that most subjects are in the middle key.

Low Key. As the light begins to fade toward the end of the day, this same landscape becomes a low-key subject. That is, most of the tones come from the lower part of the value scale, although there are a few bright lights in the sky and on the edge of one rock in the foreground. Not all subjects fall neatly into one of these three categories—high, middle, or low key—but if you *can* identify a specific key, this will help you plan your values more accurately and you'll capture the mood with greater sensitivity.

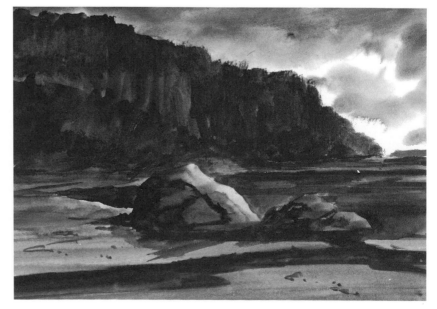

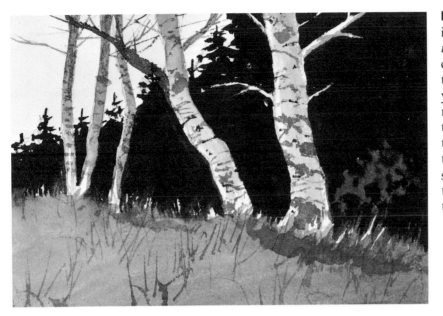

High Contrast. As you plan a watercolor, it's also important to determine the *contrast range* of your subject. If the tones come from all over the value scale—from the palest values to the darkest ones then you've got a high-contrast picture. In this monochrome watercolor sketch, there's the bright tone of the sky, the dark tone of the woods, and the middletones of the trees and grass. You can't really identify a specific key in this picture, but you *can* determine the contrast range before you start to paint.

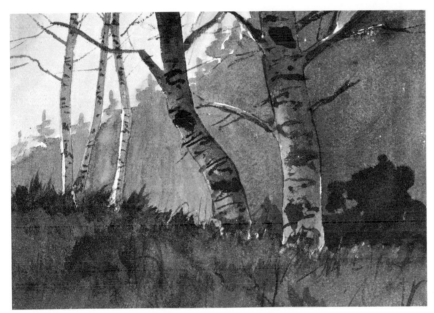

Medium Contrast. As the light fades or becomes diffused by a cloudy sky, the pattern of light and shade changes. This same landscape becomes a medium-contrast subject. Now the tones fall closer together on the value scale. They don't come from the extremes of the scale as they do in a high-contrast subject. Instead, the lights become a bit darker, while the darks become somewhat paler. This particular watercolor study happens to be in the *middle key*, as well as the *medium contrast* range. But that's not always true. A *high-* or *low-key* subject can also be in the medium contrast range if there's reasonable contrast in a few areas—which is true of all the studies on the opposite page.

Low Contrast. On a misty day, this pale landscape becomes a low-contrast subject because there's very little distinction between light, halftone, and shadow. But remember that mist isn't the only thing that creates a low-contrast subject. This would also be a low-contrast painting if a rainy day darkened the landscape so that all the values came from the middle of the scale, or if nightfall darkened the landscape so that all the values came from the lower end of the scale. To record these changes in key and contrast, choose some familiar outdoor subject that's close to home, and make a series of monochrome watercolor sketches under different conditions of light and weather.

Step 1. To demonstrate how to paint a high-key subject, the artist chooses a sunny desert landscape in which all the colors appear to be "bleached" by the brilliant light. He brushes clear water over the sky and then brushes pale strokes onto the wet surface, where they soften and blur. When the sky is dry, he blocks in the shadow planes of the distant mountains with strokes that are approximately the same value as the soft clouds. By the end of Step 1, he has established two of his major values: the lightest value, represented by the bare paper, and a pale middletone that appears both in the sky and in the shadow planes of the mountains.

Step 2. Moving into the middleground, the artist blocks in the shadowy face of the low ridge with a darker middletone. Actually, he paints this with strokes that vary in value, but they blend, wet-into-wet. In the immediate foreground, the artist paints the delicate tone of the water with the same pale middletone that appears in the sky; but at the edge of the water, he introduces a strong, dark shadow, which blurs softly into the wet tone of the water. Now, at the end of Step 2, the picture contains a relatively strong dark, two middletones, and the light tone of the bare paper.

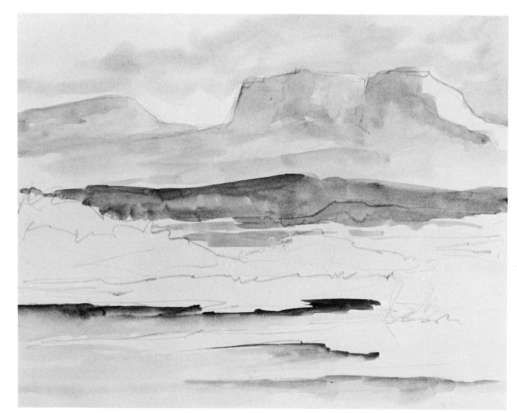

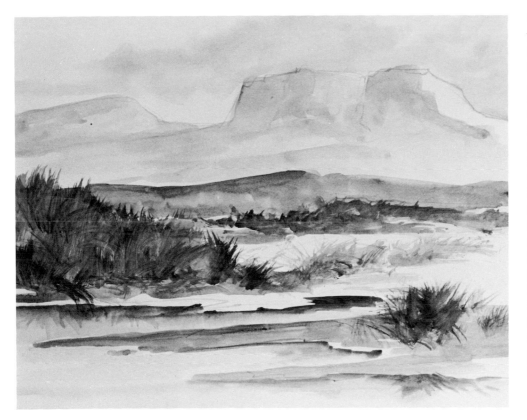

Step 3. With scrubby, erratic strokes that jut in various directions, the artist indicates the clumps of desert plants with a mixture that's approximately the same value as the dark shadow at the edge of the water. He indicates the slender, horizontal strip of sand that moves out into the water in the foreground with a dark middletone—similar to that of the shadowy middleground ridge. Although most of the tones in the landscape are pale, the artist remembers the "laws" of aerial perspective: the darkest tones and the strongest contrasts are in the foreground, while things grow paler, with less contrast, in the distance.

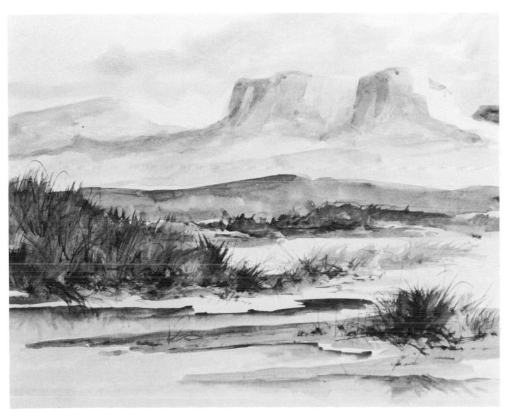

Step 4. The artist completes this high-key landscape by introducing a few touches of the darker middletone on the shadowy crags of the distant mountains, and on the slope at the foot of the mountain to the left. He reinforces the tropical plants and foreground shapes with slightly darker touches. Although there *are* a few strong darks, most of the tones come from the upper part of the value scale—and this is mainly a high-key subject. Try painting a subject like this first in monochrome—on a small scale—and then paint it again in color when the values are fixed firmly in your mind.

Step 1. The artist brushes the upper part of the picture with clear water, and then he adds strokes that represent two middletones—one light and one dark. He blots away the clouds with a crumpled cleansing tissue, exposing the white paper to establish the lightest value in the picture. While the paper is still slightly damp, he blocks in the mountain, which is similar to the dark middletone that appears at the center of the sky. Notice how he adds more water to his strokes to suggest that the lower slopes of the mountain fade away into a pale mist. By the end of Step 1, you can already see the lightest value in the picture and the two middletones.

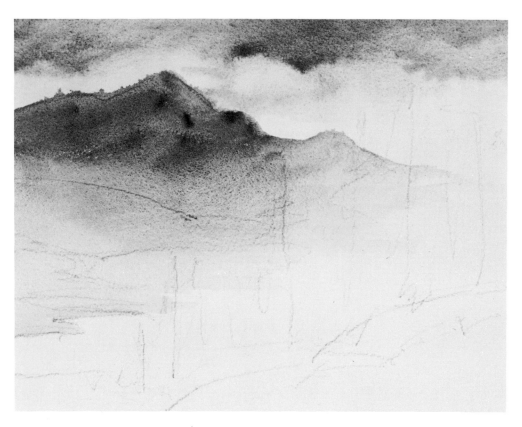

Step 2. At the left, the artist paints the silhouettes of the evergreens and their shadows with the darker middletone that already appears in the mountain and the center of the sky. The shadowy land at the edge of the frozen stream in the lower left is painted with a faintly darker version of this same middletone. Finally, to establish the darkest value in the picture, the artist paints the nearby evergreens with dense tones, with just enough water to make the color flow smoothly. While the color is still damp, he uses the point of his wooden brush handle to scratch away the light trunks.

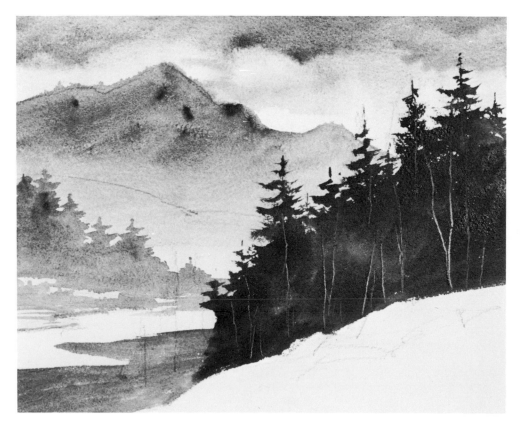

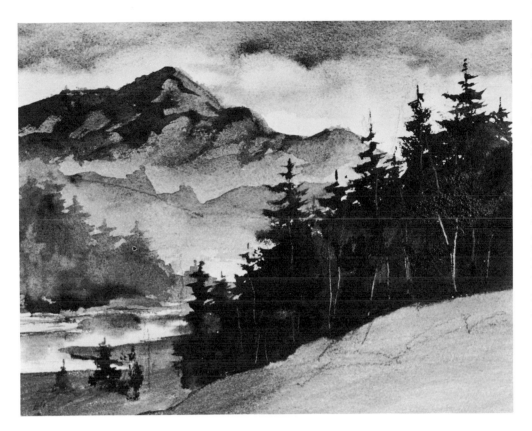

Step 3. As the artist paints the shadowy side planes with a dark value that's similar to that of the trees, the mountain becomes more solid and three-dimensional. Notice how he leaves gaps between the dark strokes to expose the middletone that he's painted in Step 1. He darkens the evergreens at the left—and suggests another clump of evergreens in the lower left-hand corner with dark strokes. Halfway down the mountain, the artist adds the misty outline of a lower ridge.

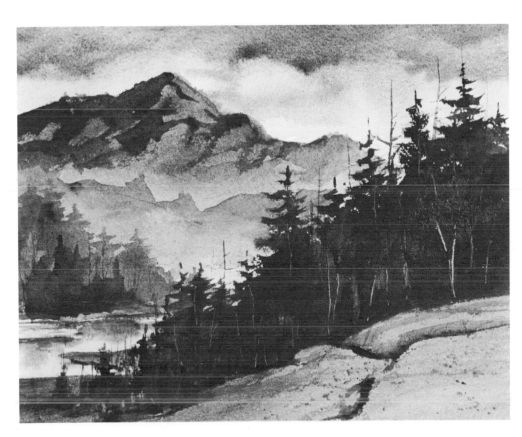

Step 4. The artist finishes the landscape by adding more dark evergreens on both sides of the stream in the lower left. He also adds dark cracks in the rocky slope at the lower right and drybrushes some texture over the rocky surface. He scratches in more trunks and branches among the dark evergreens. Although there *are* some strong darks and one strong light among the clouds, most of the tones come from the central area of the value scale, so this is *predominantly* a middle-key picture. However, because of the strong darks and lights, it's also a high-contrast subject.

Step 1. To paint a high-contrast picture, it's a good idea to define your lights and shadows very clearly so that the tonal contrasts are as distinct as possible. Thus, the artist begins with a pencil drawing that's simple, but *precise*. His lines define the exact contours and angles of the trees. He also traces the contours of the snowbank with exact pencil lines. If he was dealing with the vague tones of a foggy, low-contrast landscape, he might have done a looser drawing—but high contrast means sharp definition of forms and values.

Step 2. Brushing clear water across the top half of the picture, the artist wets the paper down to the lines that define the tops of the snowbanks. As the water sinks in and the paper begins to dry, he adds the soft tone of the distant hill just before the wet paper loses its shine. The strokes melt softly into the wet surface, but the paper is just dry enough for the hill to retain a distinct shape. (One important tip about using the wet paper technique: if a form begins to blur beyond recognition, you can sharpen the edges by blotting around the contours with a paper towel or a cleansing tissue.)

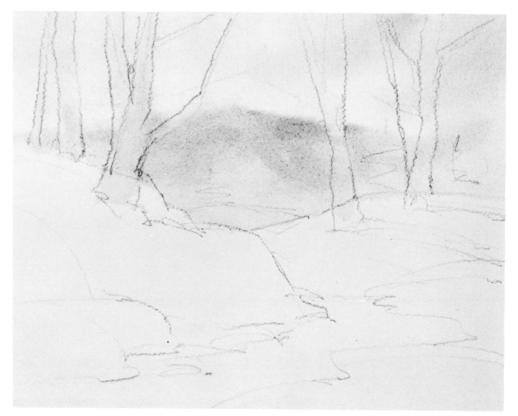

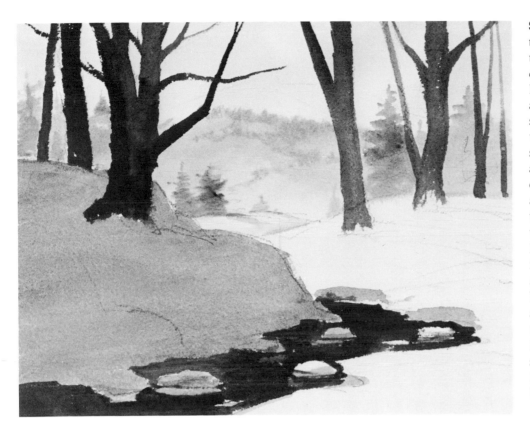

Step 3. The artist blocks in the shadowy snowbank in the left foreground with a darker tone than the distant hill. He suggests the foliage at the top of the hill, plus some distant evergreens, with the same tone as the shadowy snowbank—adding a few dark touches to the evergreens. When these tones are dry, he paints the dark trees and the jagged stream with strong, dark strokes, leaving gaps in the stream for the rocks—to which he adds touches of shadow. Notice how the distant trees at the right are slightly paler than the nearer trees at the left, which are also in shadow. By the end of Step 3, all the major values have been established.

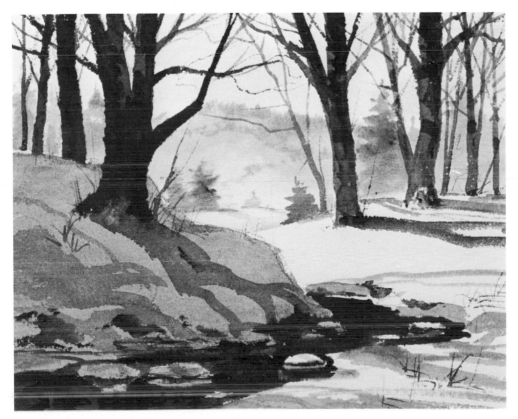

Step 4. The big trees at the right are darkened. The artist adds more trees and branches in the upper right, and a few more branches to the trees in the upper left. Strong, distinct lines of shadow are swept across the sunny snow at the right and down the shadowy snow on the left. More shadow lines are added in the lower right, and a few blades of grass complete the picture. The finished landscape is obviously a high-contrast subject: the lights and darks come from the two extremes of the value scale, while the halftones fall between these two extremes. The contrast is heightened by the hard-edged, distinct character of the brushwork.

Step 1. Most watercolors are in the medium-contrast range, which means that the lightest tones fall just below the top of the value scale, while the darks stop just above the lower end of the scale. In this medium-contrast demonstration, the artist decides not to render the complex detail of this· wooded landscape branch by branch in the preliminary pencil drawing. Instead he indicates the main shapes with casual lines. He locates the tree trunks, the near and far edges of the lake, the evergreens on the distant shore, and the overall shapes of the leafy masses. That's enough to guide him when he applies loose, fluid washes.

Step 2. The artist begins with the pale middletone of the sky, letting the wash run down the smooth paper to create an "accidental" streaky texture. Although the sky will later disappear behind the foliage, the irregular brushwork will lend vitality to the strokes that go over the sky. Just above the horizon, he lightens the wet sky with a crumpled cleansing tissue and adds a low, distant hill in the same value. He blocks in a dark middletone to indicate the evergrccn on the far shore, and then he repeats the paler middletone of the sky in the water, adding a strip of shadow along the shoreline. He begins to cover the tree trunks with the two middletones.

Step 3. Working mainly with the darker middletone, he begins to add some of the strong darks. He lets the brush wander over the foliage, depositing free, fluid strokes that are mainly the darker middletone, with an occasional strong dark. Then he darkens the tree trunks, adds a few evergreens along the near shore with approximately the same value, and indicates the fallen tree trunk along the shore in the center of the picture. This particular kind of brushstroke is typical of a watercolor painted on smooth paper. The stroke is fluid, yet has a sharp edge.

Step 4. With the same casual, wandering brushstrokes, the artist adds darks among the foliage to indicate shadows within the leafy masses. He continues to darken the trunks, adding more branches. Finally, middletones and a few darks appear on the ground to suggest shadows, grasses, and other details around the bases of the trees. The artist has worked gradually from light to dark, covering most of the painting with middletones, eliminating the white paper almost completely, and stopping after he adds just a few strong darks. The finished picture is in the medium-contrast range. It's also in a middle key.

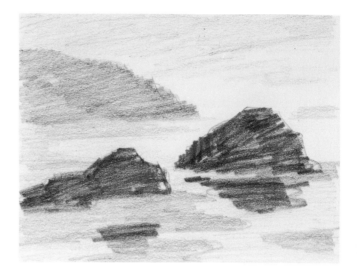

Sketch for Demonstration 1. Watercolor dries so quickly—and *everything* happens so quickly—that you've got to do a lot of advance planning. Therefore, many watercolorists do little value sketches in pencil or chalk before they start to paint. The value sketch can just be a scribble, like this tonal plan for Demonstration 1. The artist locates his strongest darks on the slope at the left, on the top of the slope at the right, and in the foreground rocks. He places the middletones on the distant hill and in the zigzag shape of the dark field that breaks through the snow in the foreground.

Sketch for Demonstration 6. This small tonal plan took no more than a couple of minutes, but it gave the artist a clear idea of the location of his darks, lights, and middletones. The strongest darks appear in the rocks and in their reflections. The distant headland represents the darker middletone. The lights and the paler middletones are in the sky and water. When you look back at the finished painting, you'll see that the artist changed his mind about a few things. But these changes were easier to make because he started out with a clear-cut value plan.

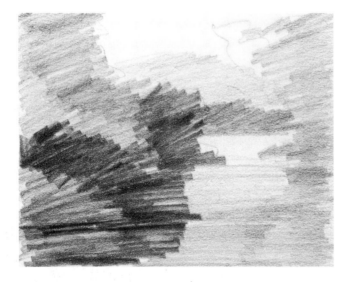

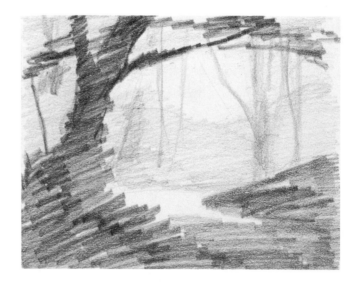

Sketch for Demonstration 7. At first glance, the tonal sketch for Demonstration 7 looks so scribbly that you can't recognize anything. But when you compare it with the finished painting, the sketch turns out to be surprisingly accurate in its rough way. Such a sketch doesn't have to look pretty—and it doesn't matter if no one understands the sketch but you. If it visualizes the main values accurately and fixes them firmly in your *mind*, it's a good tonal plan.

Sketch for Demonstration 9. The painting was executed in a rather limited, subdued color scheme. Thus, the power of the pictorial design depended less on color than on precise control of tonal contrasts. For this reason, the tonal sketch for Demonstration 9 is more precise than the usual scribbles. Actually, the artist made a *series* of two-minute value sketches, selecting the one you see here because it gave him the most accurate image of the dark foreground shapes, the lighted middleground road, the dim shapes in the distance, and the luminous sky.

PART THREE

COLOR IN ACRYLIC

Color in Acrylic Painting. In comparison with oil and watercolor, which go back to earlier centuries, acrylic is still quite new, the product of twentieth century chemical research. Acrylic is so new that artists are still discovering new ways to use the medium. What's particularly fascinating about acrylic is that it can be applied in so many ways: with brush and knife like thick, opaque oil paint; blended with acrylic painting medium that makes the color behave like transparent or semitransparent oil paint; or simply diluted with water to behave like transparent watercolor. This wide range of technical possibilities can produce an equally wide range of color effects—and that's what *Color in Acrylic Painting* is really about. In the pages that follow, you'll find a brief survey of color fundamentals as they apply specifically to acrylic; then you'll learn the many ways of using acrylic to capture the colors of nature. These techniques will range from the simplest and most basic—familiar to the experienced painter in acrylic—to a variety of methods that many painters is to broaden your command of the medium and encourage you to try new ways to get fresh, exciting color.

Values. Developing a "color sense" really means developing your ability to observe, analyze, and record the colors of nature. Many experienced painters and teachers say that the most important element in "color sense" is the ability to judge the lightness or darkness of colors—that is, the ability to judge *values*. So the first section of *Color in Acrylic Painting* will teach you to look at nature as if the world contained no color at all, just shades of black, white, and varied grays. After learning to analyze the values in a variety of outdoor subjects, you'll learn how to paint your own value chart in acrylic. Then you'll be encouraged to do a series of acrylic paintings entirely in black and white—and you'll watch well-known painter Ferdinand Petrie paint two acrylic demonstrations, step-by-step, one in just three values and the other in four. Thus, you'll learn that an effective acrylic painting doesn't simply record the values of nature, but simplifies them to create an effective pictorial design.

Color Control. Each acrylic tube color has its own special way of behaving, which you'll learn by conducting a series of color mixing tests, thus producing a series of acrylic color charts that you can post on your studio wall. Having learned how acrylic colors behave in mixtures, you'll then see how they behave when you place them side by side in a painting. You'll also learn how to organize the colors in an acrylic painting so that one hue enhances another, making specific colors look brighter or more subdued, lighter or darker. Other illustrations will show you how to use acrylic color to create the feeling of three-dimensional space or color perspective; how to create color harmony; and how to capture the changing colors of morning, midday, late afternoon, and night.

Demonstrations. Too many painters find just one way of applying paint to canvas or paper, and they stick to it! Thus, they overlook the vast range of painting techniques that *could* produce far greater vitality and variety in their color. In ten step-by-step demonstrations, Ferdinand Petrie shows how to use acrylic to get a variety of color effects. These demonstrations will open your eyes to the many different ways of handling this versatile medium to produce lively color in your acrylic paintings.

Ten Acrylic Painting Techniques. Petrie begins by demonstrating what you can do with just two acrylic tube colors, plus white, to produce a range of subtle colors. The second demonstration also reveals the possibilities of a limited palette, showing how to paint a colorful picture with just the three primaries (red, yellow, blue) and white. Petrie then paints two more demonstrations that explain how to use a full palette of acrylic colors to paint a subdued picture and a richly colored picture. The next four demonstrations show the remarkable possibilities of underpainting and overpainting in acrylic: a monochrome underpainting followed by a full-color overpainting; an underpainting in limited colors followed by an overpainting in full color; a full-color underpainting followed by a full-color overpainting; and a roughly textured underpainting followed by a full-color overpainting. Then a demonstration of the wet-into-wet technique shows how to mix acrylic colors directly on the painting surface. The final demonstration shows how to use acrylic in the technique of the Impressionists, building stroke over stroke for vibrant light and color.

Light and Shade. You can't understand the behavior of color without understanding the behavior of light, so the final section of *Color in Acrylic Painting* is devoted to capturing the effects of light and shade in acrylic. You'll learn how to use acrylic to render light and shade on geometric and non-geometric forms in nature; how to render the light as it strikes the subject from different angles; how to capture the light on sunny, cloudy, overcast, and hazy days; and how to paint the various lighting effects that artists call high key, middle key, low key, high contrast, medium contrast, and low contrast.

Brushes for Acrylic Painting. Because you can wash out a brush quickly when you switch from one color to another, you'll need very few brushes for acrylic painting. Two large, flat brushes will do for covering big areas: a 1″ (25 mm) bristle brush, the kind you use for oil painting; and a soft-hair brush the same size, preferably soft nylon or oxhair. Then you'll need another bristle brush and another soft-hair brush, each half that size. For more detailed work, add a couple of round soft-hair brushes—a number 10, which is about ¼″ (6 mm) in diameter, and a number 6, which is about half as thick. If you find that you like working in very fluid color, where acrylic paint is thinned to the consistency of watercolor, it might be helpful to add a big number 12 round, soft-hair brush, either nylon or oxhair. Since acrylic painting will subject brushes to a lot of wear and tear, few artists use their expensive sables.

Painting Surfaces. If you like to work on a smooth surface, you can use illustration board, which is white drawing paper with a stiff cardboard backing. You can also use watercolor paper; the most versatile watercolor paper is moldmade 140-pound stock in the cold-pressed surface (called a "not" surface in Britain). Acrylic handles beautifully on canvas, but make sure that the canvas is coated with white acrylic paint, not white oil paint. Your art supply store will also sell inexpensive canvas boards—thin canvas glued to cardboard—that are usually coated with white acrylic, which is excellent for acrylic painting. You can create your own painting surface by coating hardboard with acrylic gesso, a thick, white acrylic paint that comes in cans or jars. For a smooth surface, brush on several thin coats of acrylic gesso diluted with water to the consistency of milk or thin cream. For a rougher surface, brush on the gesso straight from the can so that the white coating retains the marks of the brush. Use a big nylon housepainter's brush.

Drawing Board. To support your illustration board or watercolor paper while you work, the simplest solution is a piece of hardboard. Just tack or tape your painting surface to the hardboard and rest it on a tabletop—with a book under the back edge of your board so it slants toward you. You can tack down a canvas board in the same way. If you like to work on a vertical surface—which many artists prefer when they're painting on canvas, canvas board, or hardboard coated with gesso—a wooden easel is the solution. If your budget permits, you may like a wooden drawing table, which you can tilt to a horizontal, diagonal, or vertical position just by turning a knob.

Palette. One of the most popular palettes is the least expensive—a white enamel tray, which you can probably find in a shop that sells kitchen supplies. Another good choice is a white metal or plastic palette (the kind used for watercolor) with compartments into which you can squeeze your tube colors. Some acrylic painters like the paper palettes used by oil painters: a pad of waterproof pages you can tear off and discard after painting.

Odds and Ends. For working outdoors, it's helpful to have a wood or metal paintbox with compartments for tubes, brushes, bottles of medium, knives, and other accessories. You can buy a tear-off paper palette and canvas boards that fit neatly into the box. Many acrylic painters carry their gear in a toolbox or a fishing tackle box, both of which also have lots of compartments. Two types of knives are helpful: a palette knife for mixing colors; and a sharp one with a retractable blade (or some single-edge razor blades) to cut paper, illustration board, or tape. You'll also find paper towels and a sponge useful for cleaning up. Then you'll need an HB drawing pencil or just an ordinary office pencil for sketching in your composition before you start to paint. To erase the pencil lines, get a kneaded rubber eraser (called a "putty rubber" in Great Britain), which is so soft that you can shape it like clay and erase a pencil line without hurting the surface. Then, to hold down that paper or board, get a roll of 1″ (25 mm) masking tape and a handful of thumbtacks (drawing pins) or pushpins. Finally, to carry water when you work outdoors, you can take a discarded plastic detergent bottle (if it's big enough to hold a couple of quarts or liters) or buy a water bottle or a canteen in a store that sells camping supplies. For the studio, you'll need three wide-mouthed glass jars, each big enough to hold a quart or a liter.

Work Layout. Before you start to paint, lay out your supplies and equipment in a consistent way, so everything is always in its place when you reach for it. Obviously your drawing board or easel is directly in front of you. If you're right-handed, place your palette, those three jars, and a cup of medium to the right. In one jar, store your brushes, hair end up. Then fill the other two jars with clear water: one for washing your brushes and the other for diluting your colors. Also, establish a fixed location for each color on your palette. One good way is to place your *cool* colors (black, blue, and green) at one end and the *warm* colors (yellow, orange, red, and brown) at the other. Put a big blob of white in a distant corner where it won't pick up traces of the other colors.

Color Selection. The acrylic paintings in this book are all done with about a dozen colors and fewer than a dozen in many cases. Although the leading manufacturers of acrylic colors will offer you as many as thirty inviting hues, few professionals use more than a dozen, and many get by with eight or ten. The colors listed below are really enough for many years of painting. You'll notice that most colors are in pairs—one bright and the other subdued—to give you the greatest possible range of color mixtures. The list also includes a number of optional colors you can easily do without, but which are convenient to have on hand.

Blues. Ultramarine blue is a dark, rather muted blue that seems to have a hint of violet. The second blue, phthalocyanine blue, is cooler, far more brilliant, and so powerful that it's apt to dominate any mixture with another color—so it's important to add it in tiny quantities until you get the mixture you want. A third blue—in the optional category is cerulean blue, a lovely, airy hue that's a favorite for skies and atmospheric effects.

Reds. Cadmium red light is a fiery hue that contains a hint of orange and has tremendous tinting strength—which means that a little goes a long way when you mix it with another color. So add it cautiously. Naphthol crimson is a darker red with a slightly violet cast. When you blend these two reds, you get the most vivid mixture your palette makes.

Yellows. Cadmium yellow light is a luminous, sunny yellow with the same terrific tinting strength as the other cadmiums. In contrast, yellow ochre (sometimes called *yellow oxide*) is a soft, tannish tone that produces lovely, subdued mixtures.

Green. Since you can mix so many different greens by combining the blues and yellows on your palette—or black and yellow—a tube green is really optional. However, phthalocyanine green is a clear, brilliant hue that many acrylic painters include in their palettes. Like phthalocyanine blue, the green has great tinting strength and tends to dominate mixtures, so add it very gradually.

Orange. It's so easy to mix a variety of oranges—by combining reds and yellows—that a tube of orange is really optional. But if you feel the need for a bright orange on your palette, get cadmium orange.

Browns. Burnt umber is a dark, subdued brown that appears on practically every artist's palette. Burnt sienna is a coppery brown so bright and warm that it's almost an orange.

Black and White. The paintings here contain ivory black, which has slightly less tinting strength than Mars black. But you can buy either one. Titanium white is the standard acrylic white.

Gloss and Matte Mediums. Although you can simply thin acrylic tube color with water, most manufacturers produce liquid painting mediums for this purpose. Gloss medium will thin your paint to a delightful, creamy consistency; if you add enough medium, the paint turns transparent and allows the underlying colors to shine through. As its name suggests, gloss medium dries to a shiny finish like an oil painting. Matte medium has exactly the same consistency and will also turn your color transparent if you add enough medium, but it dries to a satin finish with no shine. Try both mediums and see which you prefer. It's a matter of taste.

Gel Medium. Still another medium comes in a tube and is called gel because it has a consistency like thick, homemade mayonnaise. The gel looks cloudy as it comes from the tube, but dries clear. Blended with tube color, gel produces a thick, juicy consistency that's lovely for heavily textured brush and knife painting.

Modeling Paste. Even thicker than gel is modeling paste, which comes in a can or jar and has a consistency more like clay because it contains marble dust. You can literally build a painting ¼″ to ½″ (6 to 13 mm) thick if you blend your tube colors with modeling paste. But build gradually in several thin layers, allowing each one to dry before you apply the next, or the paste will crack.

Retarder. One of the advantages of acrylic is its rapid drying time, since it dries to the touch as soon as the water evaporates. However, if you find that it dries *too* fast, you can extend the drying time by blending retarder with your tube color.

Combining Mediums. You can also mix your tube colors with various combinations of these mediums to arrive at precisely the consistency you prefer. For example, a 50–50 blend of gloss and matte mediums will give you a semi-gloss surface. A combination of gel with one of the liquid mediums will give you a juicy, semi-liquid consistency. A simple mixture of tube color and modeling paste can sometimes be a bit gritty; this very thick paint will flow more smoothly if you add some liquid medium or gel. To create a roughly textured painting surface, you can combine acrylic gesso with modeling paste, and brush the mixture over a sheet of hardboard with a stiff housepainter's brush.

Wildflowers and Tree. Before you start to paint in color, try making a series of little paintings in black-and-white. This will teach you to judge *values*—the comparative lightness or darkness of the colors of nature. Seen as values, this green grass is a medium gray, the dark brown tree trunk is almost black, and the pale yellow wildflowers are white.

Palms. In the brilliant light of the tropics, value contrasts are particularly strong. In this monochrome painting, the sunny sky is virtually white, the silhouettes of the palms are almost black, and the distant shore is a medium gray. Note that all four paintings on this page are done in just three values—yet they easily communicate the tones of the subject.

Meadow and Pond. The pale blue sky and its reflection in the water are practically white. The silhouettes of the dark green foliage and the dark brown rocks become practically black—and so does the reflection at the edge of the water. The green of the meadow and the darker tone of the water are both medium gray.

Rock and Waves. When you view this coastal subject as if you're looking at a black-and-white snapshot, you see the purplish brown of the rocks as blackish gray, the bluish shadows on the foam and water become light gray, while the pale blue sky and the pale blue water in the lower left seem almost white.

Classifying Values. Painters usually begin mixing a color by looking carefully at the subject and determining its precise value. Thus, it's enormously helpful to have a value scale on your studio wall. To paint such a chart, draw a checkerboard of nine squares on a sheet of illustration board, or on smooth, heavy drawing paper. Then mix the various tones with ivory black and titanium white. Paint the nine values as you see them here, starting with the palest tone at the upper left and gradually darkening each square until you get to pure black at the lower right. (Actually, this scale includes ten values if you include the white surface of the illustration board.) Com-

pared with the diversity of nature, you may wonder if these ten values are enough—but you'll find that every color in nature comes *reasonably* close to one of the ten values on the scale. The job of painting those nine squares looks easy, but it isn't. You'll probably have to paint and repaint most of the squares several times, adding a bit more white or black to each mixture until you get the values exactly right. Don't worry if the chart isn't absolutely neat. (The edges of some of these boxes are a bit ragged.) The main thing is to get the values right—and commit them to memory.

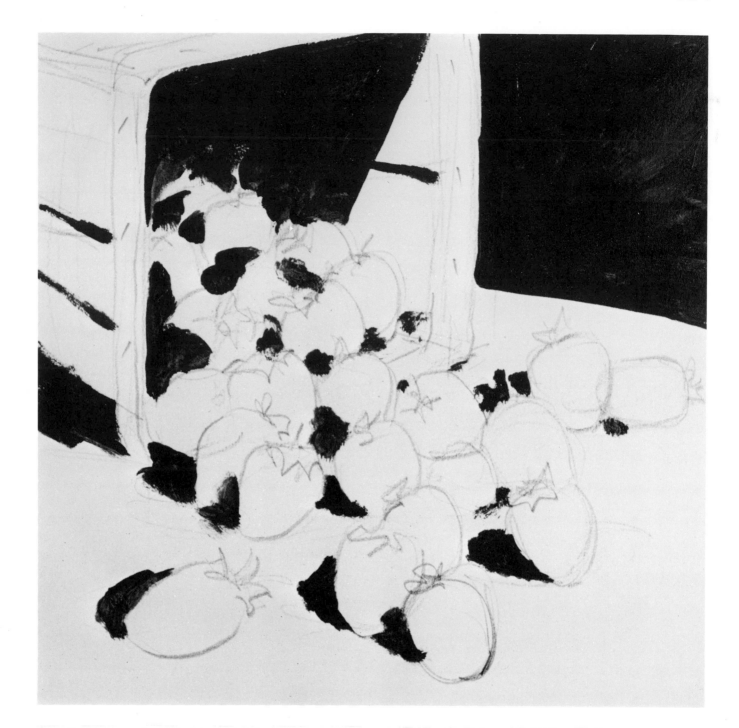

Step 1. When you looked at those first four value studies, you saw that each little painting contained just three tones: a light, a dark, and a middletone. And you may have been surprised to find that just three tones were enough to create a convincing picture. Actually, professional painters *always* simplify the values of nature. And many professionals find that they can do the job with just three values, as you'll see in this still-life demonstration of strawberries and a basket. The artist begins by making a pencil drawing of the strawberries, the basket, the edge of the table, and the shapes of the shadows—both within the basket and to the left of each strawberry. Because this is a monochrome painting, the artist begins by blocking in his darkest tones with a mixture that's mainly ivory black, with just a touch of titanium white. When the artist has painted the dark background tone in the upper right, the shadows inside the basket, the dark cracks in the basket, and the small shadows on the table, he's clearly established two of the three major values in the picture. The bare, untouched surface of the illustration board represents the lightest tone, while all the other areas represent the darkest tone in the painting. When you paint your "practice studies" in monochrome, it's often best to begin this way—by defining the two extremes of dark and light in the picture.

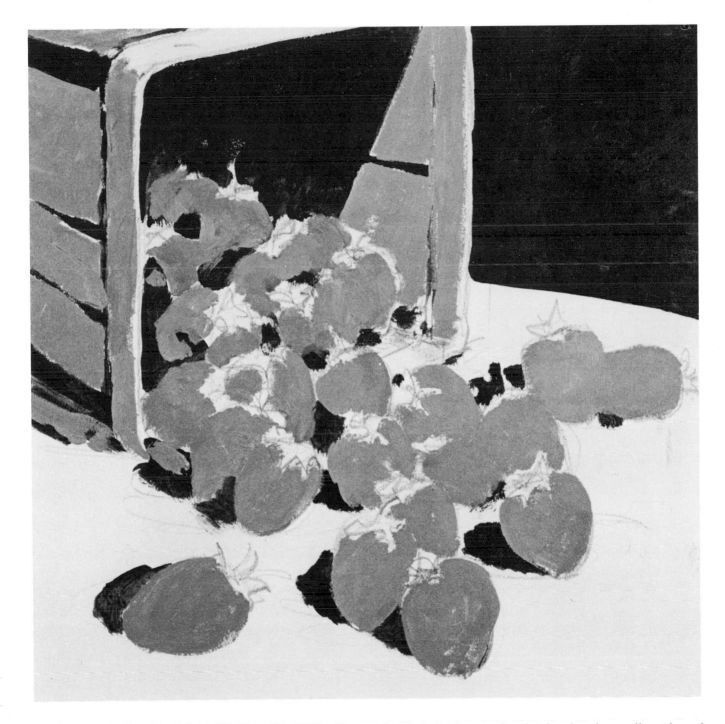

Step 2. The third and remaining value is a middletone. The artist studies the basket and the strawberries carefully, and then he mixes ivory black and titanium white on his palette to produce a middletone that seems closest to the colors of the subject. He brushes this mixture loosely over the basket, working carefully around the patches and strips of darkness, and also leaving the lighted edges of the basket untouched. In the same way, he blocks in the strawberries, leaving the small patches of shadow untouched, and also leaving bare illustration board for the stems of the berries. By the end of Step 2, the artist has established all three of his major values: a dark from the lower part of the value scale, a light from the upper part, and a middletone from the central area of the scale. The basic design of the picture is there, and he can now concentrate on details.

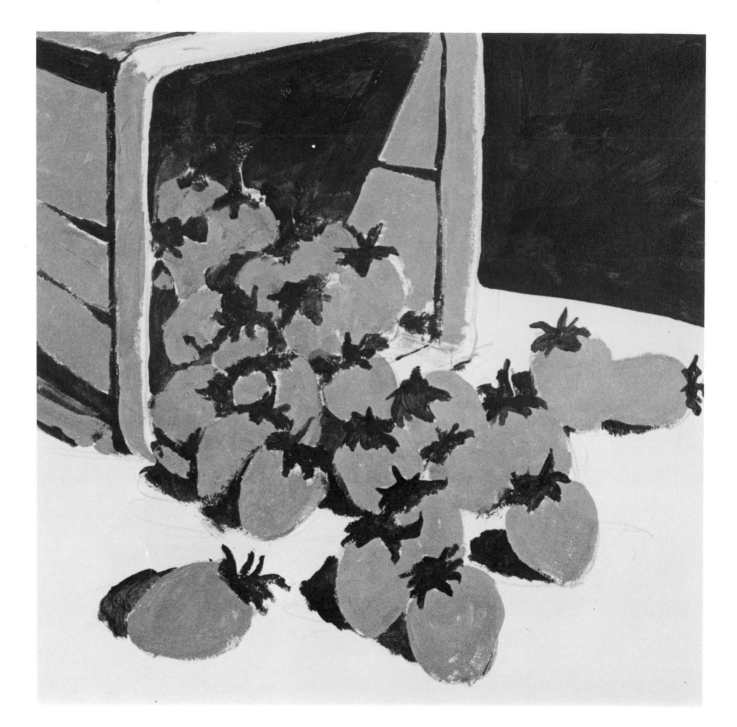

Step 3. Since he's decided to simplify his subject to just three values, the artist uses the same dark value to paint the stems of the strawberries. Like the dark he's already used in Step 1, this is mainly ivory black with just a little titanium white, and with enough water to make the paint flow smoothly. In the actual subject, the darks of the wall in the upper right, the shadows on the basket, the smaller shadows on the table, and the stems of the strawberries are all different colors and aren't *exactly* the same value. But all of these areas are close to one another in value, so the artist knows that he can make a convincing picture by simplifying them *all* to the same dark tone. In the same way, the basket and the berries are actually different colors and may not be exactly alike in value, but they're close enough to be painted the same middletone.

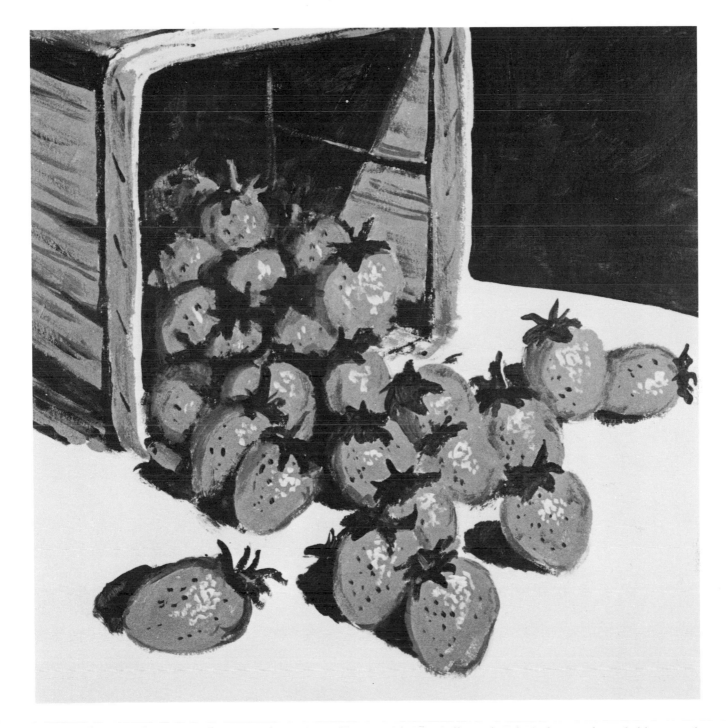

Step 4. To add the final details and textures, the artist works mainly with the three values that already appear on the illustration board in Step 3. He picks up his darkest value to add slender lines that suggest the texture of the basket. He uses tiny touches of the same dark value—plus little dots of the palest value—to indicate the texture of the berries. Then, along the edges of the berries, he introduces just a few strokes of a second, slightly darker middletone to model the forms and make them look more three-dimensional. A few strokes of this second, slightly darker middletone also appear on the basket. However, all these strokes of a second middletone are so inconspicuous that the basic, three-value scheme remains unchanged. Looking at the finished study with half-closed eyes, you'll see that virtually the entire picture is painted with the three original values: a dark, a light, and one dominant middletone.

Step 1. So far, all these monochrome acrylic studies have been painted in three values. But there are many times when *four values* will do the job more effectively—when the colors of nature really demand a dark, a light, and *two* middletones. That's what happens in this demonstration painting of a mountainous landscape in black-and-white acrylic. The artist begins with a pencil drawing that defines the shapes of the mountains, the slopes below, the mass of trees below those slopes, and the strip of water at the bottom of the picture. Within the shapes of the mountains, the pencil lines also define the shapes of the light and shadow planes. The sky is the lighter of the two middletones. The artist blocks in the sky with ivory black, plenty of titanium white, and water. This same middletone is reflected in the lake at the bottom of the picture. The artist blocks in the lake with the same mixture.

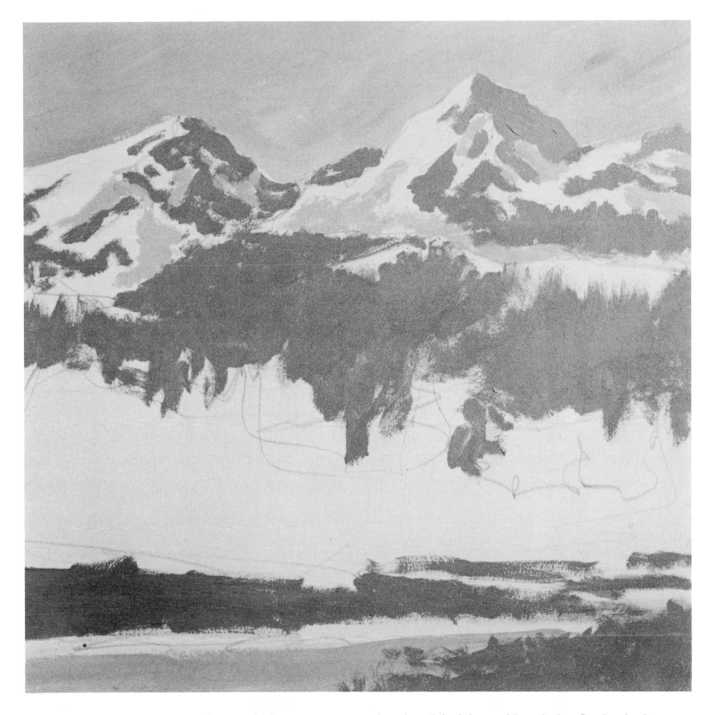

Step 2. Because he's working with two middletones—one lighter and one darker—the artist decides that it's important to establish a distinction between these two values as early as possible. With a mixture that contains more ivory black and less titanium white, he blocks in the shadow planes on the mountains and on the tree-covered slopes below. This same tone reappears on the shore at the edge of the lake, and in a dark reflection in the water at the lower right. (These last few strokes turn out to be too dark, but the artist easily corrects them with additional strokes of opaque acrylic when Step 2 is dry.) Finally, the artist adds some strokes of the lighter middletone to suggest paler shadows within the snow on the mountains.

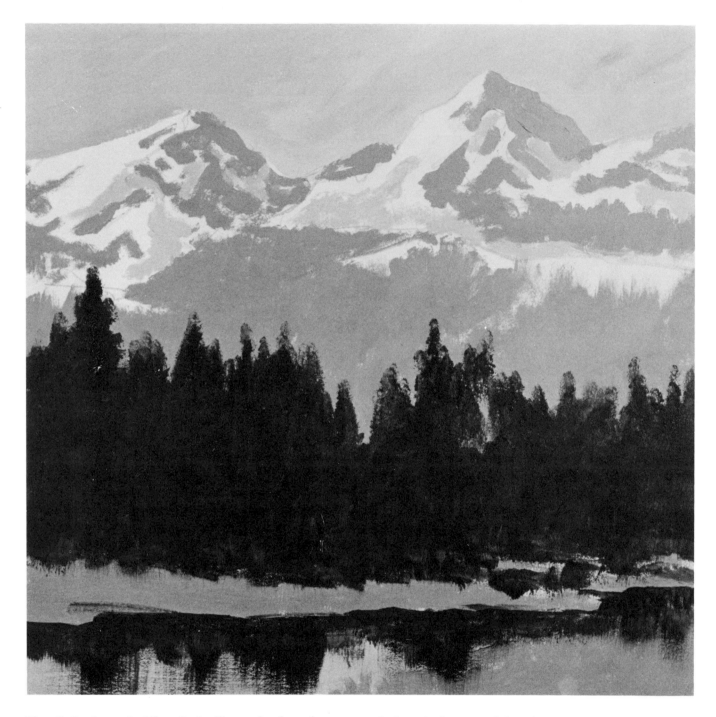

Step 3. By the end of Step 2, the illustration board contains three of the four major values: the bare illustration board, representing the lightest tone that comes from the upper part of the value scale, a pale middletone that's only a bit farther down on the value scale, and a darker middletone from the central area of the scale. Now the artist completes the four-value scheme by painting the trees and their reflections with a dark tone that comes from the lowest part of the value scale. (Notice that the artist has corrected the dark middletones that were *too* dark at the bottom of the picture in Step 2.) These dark masses—the trees and their reflections—are almost pure ivory black with just the slightest hint of titanium white. The artist adds less water to this mixture than he's added to the lighter tones, so the brushstrokes have a rough texture that you can see most clearly at the tops of the trees and in the reflections at the lower left. Now that the value scheme of the painting is stated, the artist can develop the final details in the last step.

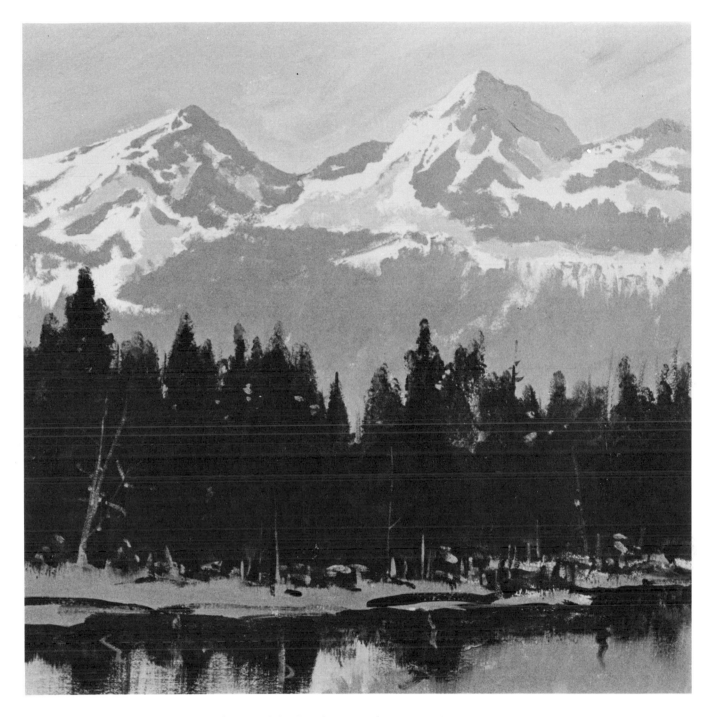

Step 4. Up to this point, the artist has used flat brushes, both medium and large, to paint in broad strokes. Now he picks up the darker middletone on the point of a slender, round brush to suggest a few trunks among the dark mass of the trees, and to add the pale reflections of these trunks within the dark reflections in the water. Rinsing the brush, he uses it again to add a few dark branches above the trees, some dark trunks and shadows beneath the trees, and the dark reflection of a trunk in the water at the lower right. Moving up to the mountains, the artist adds more shadow planes—the darker middletone—on the snowy slopes with a small, flat brush. These additional strokes are most obvious on the peak in the upper left. With the tip of a round brush, he adds tiny touches of the darker middletone to indicate more shadows on the upper slopes. The finished painting, executed entirely in mixtures of ivory black and titanium white, is a dramatic example of the way that just four values can be used to render a rich, highly complex pattern of light and shade, while creating a strong sense of space and atmosphere. Because the values are right, such a painting hardly needs color at all!

Complementary Background. The hot color of the melon is a mixture of cadmium red light and naphthol crimson. (The two bright reds on your acrylic palette make an even brighter red when you blend them.) The color of the melon *starts* out looking brilliant, of course, but it will look even more brilliant if you place it against green, the complement of red on the opposite side of the color wheel. The cool background color is a mixture of phthalocyanine blue and cadmium yellow light, and just a bit of burnt umber.

Analogous Background. On the color wheel, the colors on each side of any color are called analogous colors. Therefore red-orange and yellow-orange are both analogous to red—*related* to red—for the obvious reason that they *contain* red. Placed against an analogous background color, the hot color of the melon doesn't stand out as strongly as it did against the complementary background of the previous example. Instead, the melon and the background harmonize, rather than contrast. The warm color of the background is a mixture of cadmium red light and cadmium yellow light, softened with just a little burnt umber.

Neutral Background. Still another way to make the hot color of the melon sing out is to place it against a subdued color, called a *neutral*. When placed against neutrals—grays, tans, blue-grays, browns, and gray-browns—every bright color looks dramatic. Here, the background is a blend of ultramarine blue, burnt umber, and white. Remember, there's no "ideal" background for this melon or for any other color. Your choice of background color depends on what you want to accomplish in the picture. To make a color look brighter, place it against a complementary or neutral background. To make a color appear more subdued, place it against an analogous background.

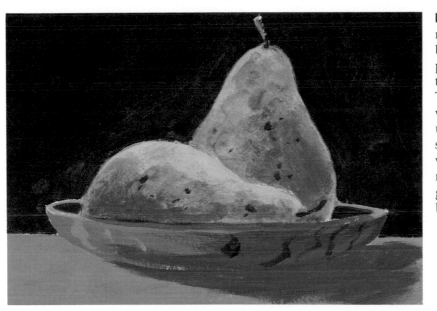

Dark Background. Value, like color, is a matter of *relationships.* These pears look both light and bright because the artist has placed them against a dark background that dramatizes the paler tones of the fruit. The lighted areas of the pears are painted with cadmium yellow light, just a speck of ultramarine blue, and lots of white. The shadowy areas of the pears are painted with the same mixture, but it contains more ultramarine blue. The dark background color is phthalocyanine blue and burnt sienna.

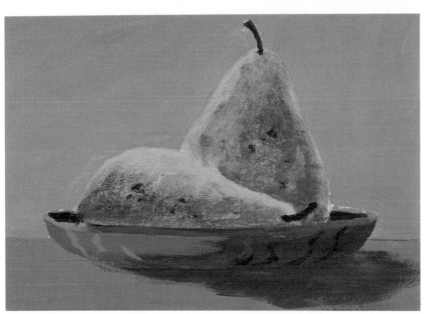

Middletone Background. The same pears don't look as light *or* as bright when the artist places them against a background that's much closer in value to the pears. In fact, the pears look slightly darker against the middletone background than they look against the dark background in the picture above. The color mixtures in the pears are exactly the same. The background mixture is ultramarine blue, burnt umber, and white. The neutral table, by the way, is also the same mixture as the background, but with more burnt umber.

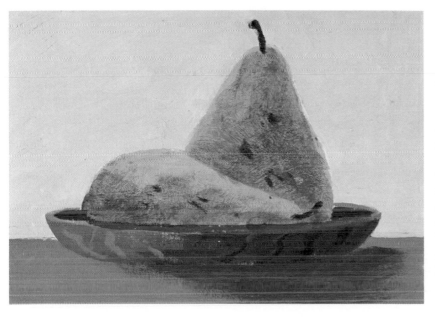

Light Background. When the artist places the pears against a pale value, they also stand out against the background. But now they stand out because they look *darker* than the background. The color mixtures in the pears are still the same, but now the background is ultramarine blue and lots of white, with just a hint of burnt sienna. Look at these three studies of the pears with half-closed eyes and you'll see the "rules" for controlling value relationships. To make a color look lighter, place it against a dark background. To make a color look less prominent, place it against a background of similar value. And to make a color look darker, place it against a lighter background.

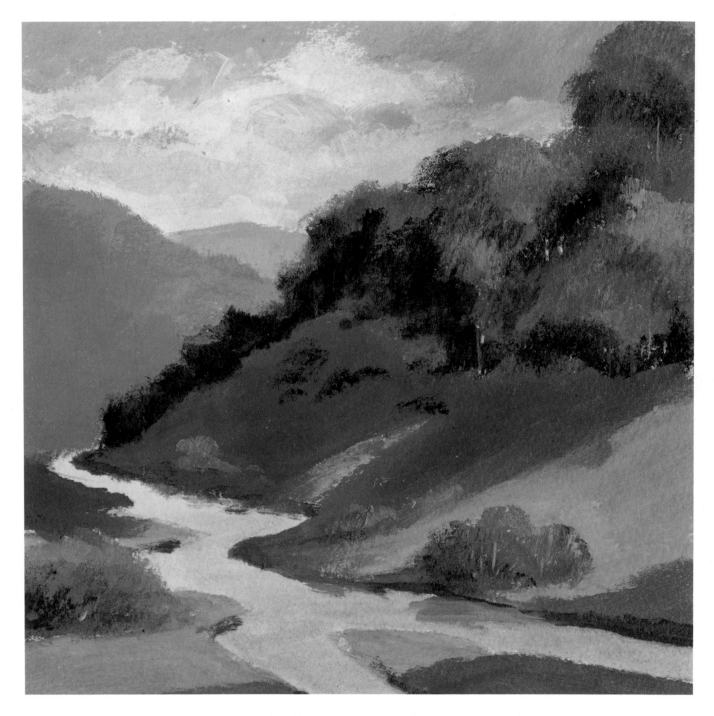

Sunny Day. You've probably seen perspective diagrams that show how parallel lines tend to converge as they recede toward the horizon. That's what's happening with the zigzag shape of the stream, whose banks move closer together as the stream moves away from the foreground. But *color* also creates a strong feeling of perspective. In a sunny landscape like the one you see here, colors tend to be brighter and warmer in the foreground, where there are also stronger tonal contrasts. As objects become more distant, their colors gradually become paler and cooler, with less contrast. Thus, warm, sunlit patches contrast with strong, rich shadows in the foreground of this landscape. But on the more distant slope at the left, the color is paler, cooler, and more subdued, with just a subtle value change to suggest the contrast between light and shadow. And the tiny, distant peak at the center of the picture is still paler and cooler—there are no lights and shadows on the mountain at all. The sky obeys the same "rules" of *aerial perspective.* Directly overhead, at the top of the picture, the sky is both darker and brighter than the more distant sky at the horizon. This acrylic painting is executed on cold-pressed watercolor paper. You can see the texture of the paper in the trees. The sunlit slopes and foliage in the foreground are all mixtures of phthalocyanine blue, cadmium yellow light, burnt sienna, and white, with more yellow in the sunlit areas, and more blue and burnt sienna in the shadows.

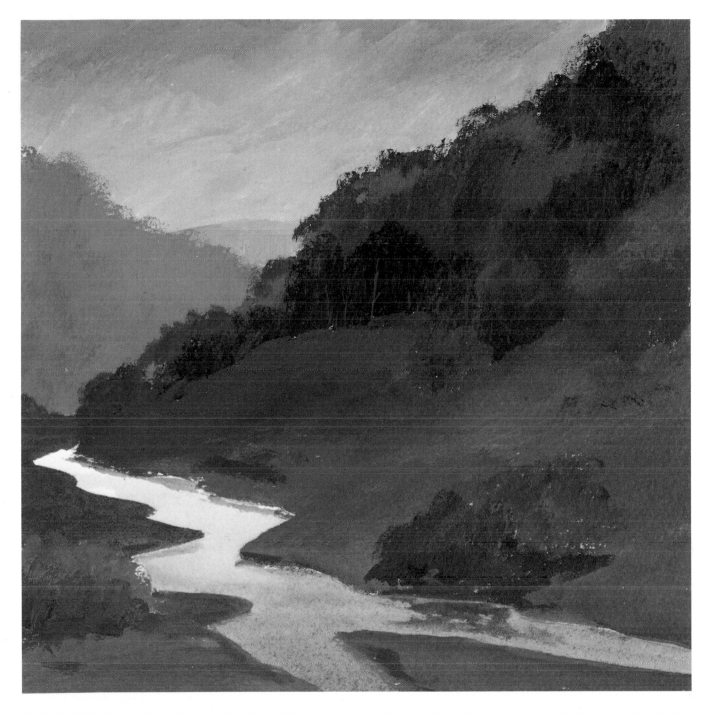

Overcast Day. Although the colors of this landscape are more subdued on a gray day, the colors still obey the same "rules" of aerial perspective. The strongest, darkest colors are in the foreground, where you can still see *some* contrast between light and shadow, particularly in the trees and bushes. The more distant slope at the left is distinctly lighter and cooler, with almost no suggestion of contrast between light and shadow. And the distant peak is much paler and cooler, just as it was on the sunny day. The sky is no longer colorful, but it's still darker directly overhead, gradually growing paler toward the horizon. This study of an overcast day is also painted on a sheet of cold-pressed watercolor paper, and it's painted with the same mixtures as the study of the sunny day. The lighter tones of the slopes and trees contain less cadmium yellow and white, of course, while they contain more phthalocyanine blue and burnt sienna. The patches of shadow beneath the trees on the slope and beneath the bushes along the shoreline are *mainly* blue and burnt sienna, with just the slightest hint of yellow. It's worth noting that the stream in both paintings is painted with transparent color, diluted with pure water, to capture the transparency of the subject.

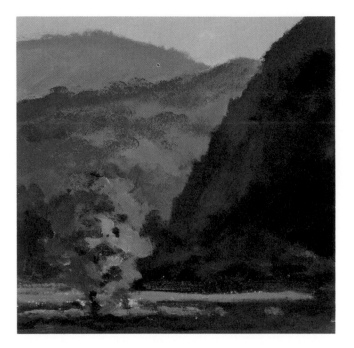

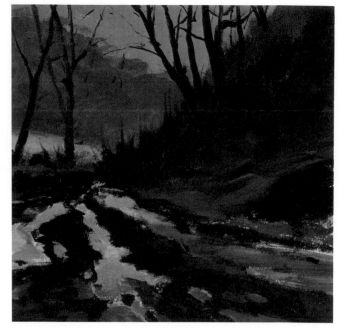

Cool Picture, Warm Notes. A simple way to create cool, harmonious color is to work with analogous colors like these blues, violets, and greens. (They're analogous because they all contain some blue.) And for a note of contrast in a picture that might look too cool, you can reach across the color wheel for the warm complement of one of these cool tones, like the color of the sunlit tree.

Warm Picture, Cool Notes. You can reverse this strategy by working mainly with warm, analogous colors like yellows, oranges, and coppery browns. And for contrast, you can find the cool complement of one of those warm mixtures on the opposite side of the color wheel. Here, the warmth of the landscape is enhanced by those few patches of cool color in the foreground.

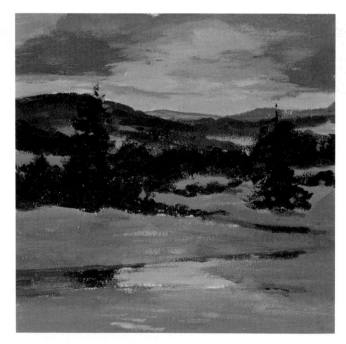

Repeating Colors. Another way to achieve color harmony is to interweave one particular color through all the others. This tropical landscape is unified by the repetition of a similar color in the clouds, on the distant shoreline, and in the shadows on the foreground. The cool shadows on the sand accentuate the warmth of the sunny areas of the beach.

Repeating Neutrals. Another way to unify a picture is to interweave neutrals through the other colors. In this winter landscape, the dark neutrals of the sky are repeated in the snow on the ground. The neutrals also surround and accentuate the brilliant colors that appear along the lower edge of the sky and then reappear as reflections in the land.

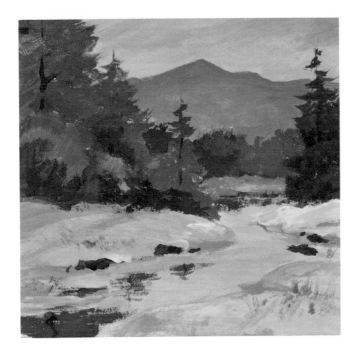

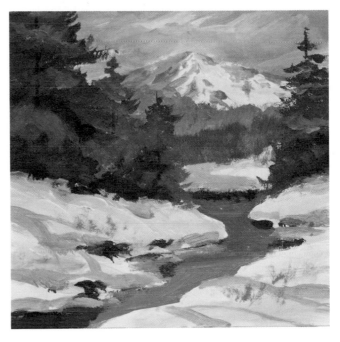

Early Morning. It's fascinating to paint the same subject at different times of the day, recording how the color changes from hour to hour. In the early morning, this snowy landscape is filled with warm, delicate color. The warm sky is reflected in the snow and water. The distant mountain, seen through the morning haze, is a flat, warm shape with no detail.

Midday. A few hours later, bathed in full sunlight, colors are stronger and contrasts more definite. The tones of the trees are deeper and more intense. There are stronger shadows on the snow, while the deep tone of the water reflects the sky color. The morning haze is gone, so you can see the details of the mountain, with its contrasts of sunlight and shadow.

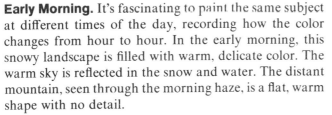

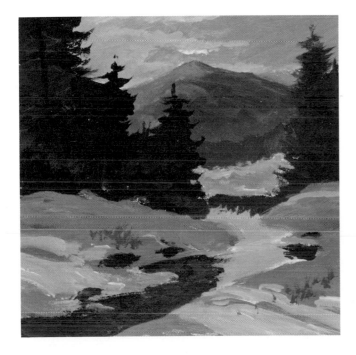

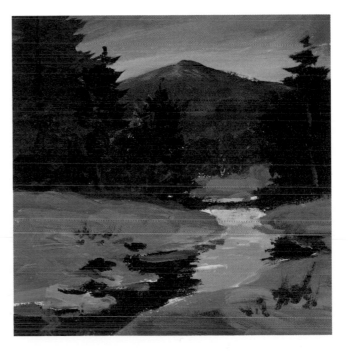

Late Afternoon. As the sun begins to drop toward the horizon, the sky turns warmer, and this warm light is reflected in the stream. The sun throws a reddish light on the mountain. The trees, silhouetted against the sun, are dark shapes that cast deep shadows on the snow and somber reflections in the water.

Night. At nightfall, colors are stronger than you might expect. The moonlight in the sky reappears in the water. The snow still reflects light and is full of subdued color. There's just enough light to see some color in the dark trees. When the moon rises higher, the sky, mountains, and trees will contain rich, dark colors.

Step 1. These two rich colors—phthalocyanine blue and burnt sienna (plus white)—will give you a surprising range of warm and cool mixtures, and a full range of values. When you paint with this kind of limited palette, you're forced to create a *tonal* picture that depends heavily on accurate observation of values. The artist begins by making a pencil drawing on a sheet of illustration board. Then he blocks in the sky with a mixture that's mainly phthalocyanine blue and white, softened with a bit of burnt sienna. Toward the horizon, the artist adds more white to his strokes. He quickly blends the strokes of the sky into one another before the color dries.

Step 2. When the sky is dry, he paints the palest, most distant mountain with the same mixture that appears in the sky, with less white. He paints the darker, slightly warmer mountain at the left, with a mixture that contains less white and more burnt sienna—adding an extra touch of burnt sienna for the darker foliage at the top. Obeying the "laws" of aerial perspective, the nearer mountain at the right is distinctly darker, mainly blue and burnt sienna, with very little white. The artist adds less water when he paints the two darker mountains, so the color is less fluid and the strokes look rougher.

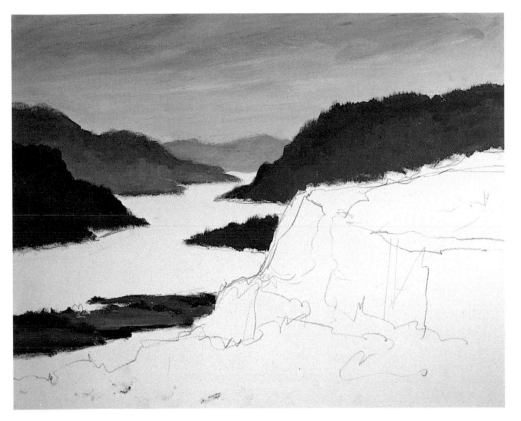

Step 3. Moving farther toward the foreground, the artist paints the darker, warmer cliff at the left with a mixture that contains more burnt sienna and less white than any of the earlier mixtures, although it still contains plenty of blue. The low triangle of land at the center of the picture is darker and cooler, so the artist adds more blue to this last mixture. When he paints the low strip of land in the lower left, the artist indicates the dark lines of the trees with the same cool, dark mixture he's used for the small triangle above. But then he adds more burnt sienna and white for the lighter patches.

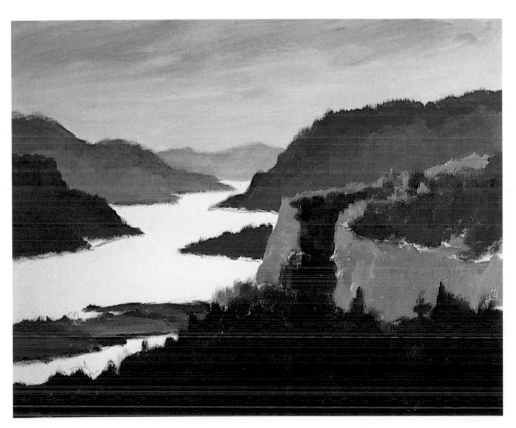

Step 4. The warm, sunlit sides of the cliffs in the foreground are covered with strokes of burnt sienna and white, cooled with a very small amount of blue. The dark, warm foliage along the tops of the cliffs is mainly burnt sienna, subdued by blue and lightened with just a touch of white. This same mixture, containing almost no white, is used to block in the warm, shadowy mass of trees in the foreground. By the end of Step 4, the landscape clearly obeys the "laws" of aerial perspective: the warmest, darkest tones—and the strongest contrasts of light and shadow—are in the foreground, while the colors grow cooler and paler in the distance.

Step 5. The water is painted with a series of straight horizontal strokes. To express the movement of the water and the shimmer of the light on its surface, the artist avoids blending the strokes smoothly into one another, but allows each stroke to retain the imprint of the brush. The darker strokes obviously contain lots of blue, just the slightest hint of burnt sienna, and a moderate amount of white. The artist lightens his strokes with more white as he follows the stream into the distance, where it catches the sunlight. He adds very little water to the paler strokes, so that the thick, rough texture of the white will accentuate the sparkle of the light.

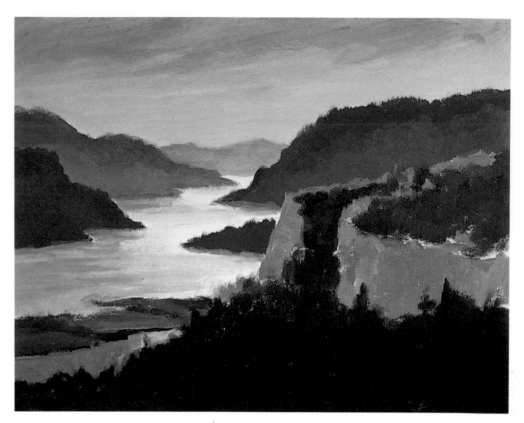

Step 6. The artist begins to develop the foliage along the tops of the cliffs and in the immediate foreground with small, rough strokes. These strokes are varied mixtures of all three tube colors, with more blue in the cooler strokes and more burnt sienna in the warmer strokes. He adds just a little water to these mixtures so that the paint will be thick enough to produce rough, irregular strokes. He applies the color with short, scrubby movements of a stiff bristle brush. The strokes have a ragged quality, like the foliage. He begins to suggest the craggy texture of the cliffs with similar rough strokes.

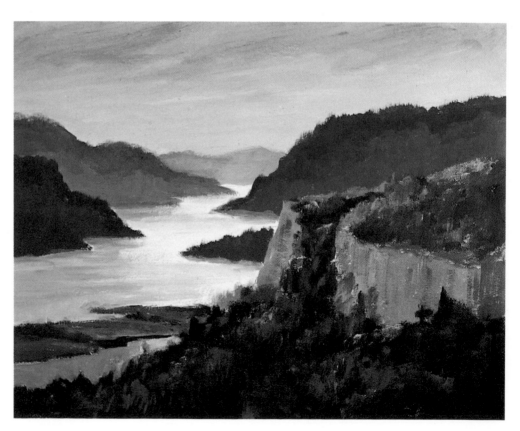

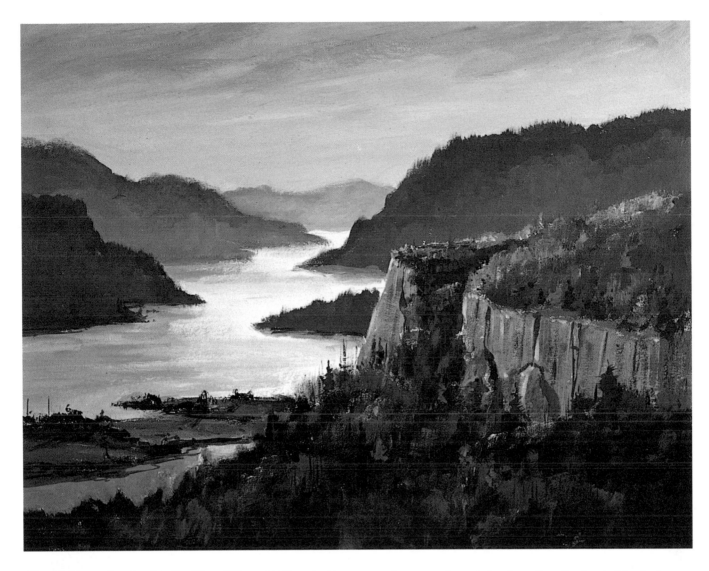

Step 7. To render the detail of the cliffs and foliage in the foreground, the artist switches to a small, round, soft-hair brush. Slender strokes of dark color suggest trunks and branches among the trees, and deep cracks in the sides of the cliff. These very dark strokes are phthalocyanine blue and burnt sienna, without white, but diluted with lots of water to produce a liquid paint consistency that lends itself to precise strokes. For the touches of light on the sides of the rocky cliffs, the artist rinses this small brush and dips it in white that's tinted with the slightest amount of blue and burnt sienna, again diluted with plenty of water for exact brushwork. In the lower left, the artist adds a few more dark strokes to suggest detail among the trees on the low strip of land. He also adds some shadow lines at the near edge of the shoreline. In the finished picture, the colors are subdued, but they're full of warm and cool variations. The values have been carefully observed and accurately recorded to create realistic light, atmosphere, and space in the landscape. To strengthen your command of values, try other tonal palettes, such as phthalocyanine blue and burnt umber, ultramarine blue and burnt umber or burnt sienna, or phthalocyanine green with burnt umber or burnt sienna. When you work with opaque color, you'll add white to lighten your mixtures. But you may also want to try working in a transparent watercolor technique, lightening and diluting your colors with pure water. (For the transparent technique, switch from illustration board to watercolor paper.)

Step 1. Now, to learn the basics of color mixing, you'll use just the three primary colors—blue, red, yellow, plus white—to discover how many different mixtures you can make with just these four tubes! This demonstration is painted with ultramarine blue, cadmium red light, cadmium yellow light, and titanium white on a canvas board. As usual, the artist starts with a pencil drawing. Then he paints the cool sky at the top with blue, plus a drop of red and white. He adds more white to this mixture for the lighted areas of the clouds. For their shadowy undersides, he adds a touch of yellow to the sky mixture to produce a warm neutral that he lightens with white.

Step 2. The artist carries the shadowy tone of the clouds across the lagoon, since water normally reflects the sky colors. When this pale tone is dry, he mixes a darker tone with lots of blue, a hint of red and yellow, plus white. He picks up a small amount of this color on a big bristle brush, which he holds at an angle and passes *lightly* back-and-forth over the rough surface of the canvas. The weave of the canvas breaks up the strokes to produce an effect that's called *drybrush*. The ragged drybrush strokes produce an irregular gradation from dark to light, suggesting the shimmering play of light on the lagoon.

Step 3. The primaries tend to subdue one another when they're all in the same mixture. For the dark, soft tone of the wooded headland, the artist blends blue, yellow, and white to create a rich, subdued green—and then he adds a hint of red to make it more neutral. Along the top of the headland, drybrush strokes suggest the ragged texture of the foliage. The darker shapes of the trees along the bottom of the slope are mainly blue and red, with a hint of yellow. The warm sand is blocked in with red, yellow, and white, softened with a speck of blue. A few touches of this warm mixture appear on the wooded slope.

Step 4. When the colors of Step 3 are completely dry, the artist paints the rich, warm, dark shapes of the leaning trunks with red and blue. In the warm areas, red dominates the mixture, while the darker markings on the trunks are dominated by blue. With a round, soft-hair brush, the artist paints the hanging foliage with blue and yellow, muted with a slight hint of red. The paler leaves at the right are modified with white, while the darker leaves at the top contain no white at all.

Step 5. Switching to a smaller, round brush, the artist paints the foreground foliage with a dense network of little strokes. He works with thick yellow and blue, diluted with some acrylic painting medium to produce a rich, buttery texture. He mixes the colors not on his palette, but directly on the canvas board, painting blue strokes over yellow and yellow strokes over blue to create a lively, irregular tone. Mixed on the canvas board in this way, the colors suggest variations of sunlight and shadow.

Step 6. The artist continues to develop the foreground foliage by overlapping strokes of yellow and blue. He works with small strokes, sometimes letting the yellow break through to suggest sunshine and sometimes letting the dark strokes suggest shadows. Then he adds more foliage to the palms with warm strokes that are mainly red and yellow, slightly subdued with a speck of blue. He uses the same warm tone to build up the detail of the trunks, lightening some of the strokes with white. Now there are lights and shadows on the trunks and in the hanging foliage.

Step 7. Blending blue, yellow, and lots of white on the palette, the artist adds more pale, sunlit leaves to the clusters of foliage that dangle from the trunks of the palms. He adds a few strokes of the same pale mixture to the tangled foliage in the foreground to suggest sunlit leaves. Then, with the very tip of a round brush, he adds tiny touches of this color throughout the foreground foliage—plus touches of red and yellow, sometimes pure, and sometimes tinted with white. Now the foreground foliage is filled with tropical wildflowers, produced by the spatter technique. To make the wildflowers, the artist picks up very liquid color on a soft-hair brush, holds one hand a few inches above the painting surface, then smacks the handle of the brush against his outstretched hand. Droplets of liquid color spatter across the picture. The artist completes the picture by sharpening the edge of the beach with slender strokes that suggest foam. These strokes are almost pure white, faintly tinted with blue, and diluted with water to a fluid consistency for precise brushwork. The final picture proves the versatility of a palette that consists of just three primaries, plus white. Not only do you see a variety of subtle color mixtures, but you also see strong darks that are produced by mixing bright colors, without the aid of black. It's worthwhile to spend more time painting several pictures with different groups of primaries. The most brilliant combination would be cadmium red light and cadmium yellow light again, but with the dazzling phthalocyanine blue instead of the more subdued ultramarine blue. Another interesting combination would be phthalocyanine blue, cadmium yellow light, and naphthol crimson. Many artists enjoy painting with a subdued primary palette that consists of ultramarine blue, yellow ochre, and burnt sienna. By painting a series of pictures with different primary palettes, you'll develop an intimate knowledge of the behavior of the most important colors that are on your palette.

Step 1. When you paint with the full range of bright colors on your palette, you're *not* obligated to paint a brilliantly colored picture. On the contrary it's good experience to paint a *subdued* picture with these brilliant hues and force yourself to make subtle mixtures. In this demonstration, the artist paints a somber winter landscape with a full palette. He begins with a brush drawing on canvas in phthalocyanine blue, naphthol crimson, and white. Then he blocks in the sky with ultramarine blue, naphthol crimson, yellow ochre, and white—blending in more white as he moves toward the right.

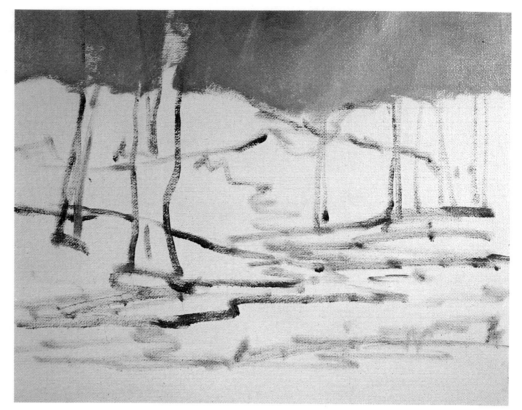

Step 2. The artist scrubs in the rough, dark bands of distant trees with short, vertical strokes of ultramarine blue, naphthol crimson, burnt umber, and white—adding more white for the paler trees on the snowy slope at the right. Tinting a batch of white with this mixture, he blocks in the snow between the dark rows of distant trees. Then he carries the mixture down the snowy slope at the center of the picture. Looking closely at the painting, you can see that the dark color of the trees has been drybrushed over the grain of the canvas to suggest the texture of the masses of distant foliage.

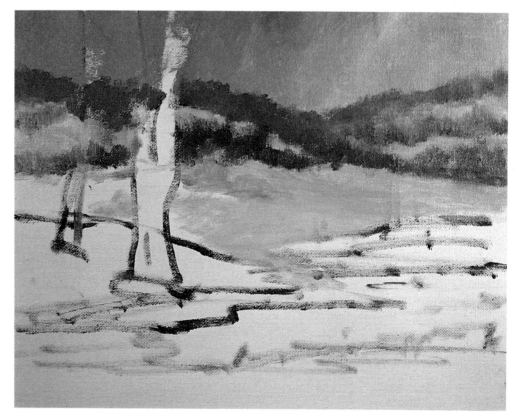

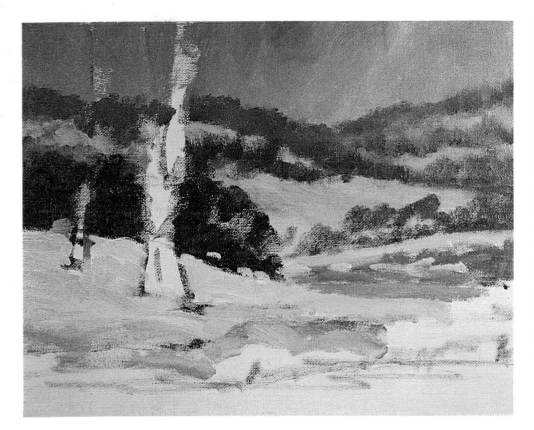

Step 3. The artist blocks in the dark tone of the thick foliage on the slope behind the two trees at the left. This tone is a mixture of phthalocyanine green, burnt sienna, and a touch of ultramarine blue. On the slope to the right, he blocks in the cooler foliage with phthalocyanine green and ultramarine blue, warmed with a speck of naphthol crimson and lightened with white. He blocks in the foreground snow with thick white, tinted with cerulean blue, cadmium orange, and burnt sienna. The shadows on the snow are burnt umber, yellow ochre, cerulean blue, and lots of white.

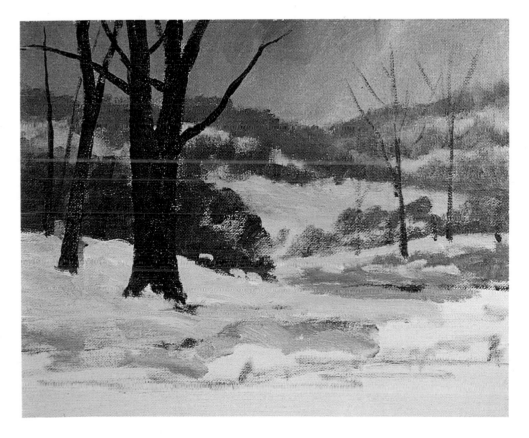

Step 4. The dark trunks and branches of the trees, with their subtle hints of color within the darkness, aren't black, but a mixture of phthalocyanine blue, burnt sienna, and a drop of naphthol crimson. The artist dilutes the mixture with liquid acrylic medium and a little water, so the consistency of the paint is creamy, but fluid enough for precise brushwork. For the dark trees at the left, the artist adds no white to this glowing, dark mixture. But to paint the slender, more remote trees at the right, he lightens the dark mixture with a little white. He paints the trees with a slender bristle brush.

Step 5. Blending phthalocyanine blue, naphthol crimson, and burnt umber, the artist uses a slim, rounded bristle brush, called a *filbert*, to drybrush masses of leaves over the trees in the upper right. He deposits such a thin film of color that the distant sky and landscape shine through the foliage. He brushes thick, ragged strokes of yellow ochre, burnt umber, and a hint of naphthol crimson, plus white over the foreground to suggest clumps of dead, frozen weeds in the snow. The thick color is softened with a drop of liquid medium, so the brush drags the dense mixture over the canvas, leaving ragged patches of color.

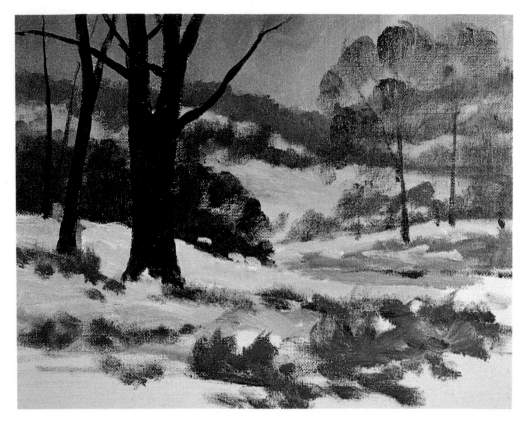

Step 6. The artist enriches the warm patches of color in the foreground with short, scrubby strokes of yellow ochre, burnt sienna, ultramarine blue, and white— and cooler mixtures of cerulean blue, burnt umber, yellow ochre, and white. These warm and cool strokes are blended into one another while the color is wet. The artist covers the remaining foreground with a snow mixture that's mainly thick titanium white, tinted with a drop of the cooler mixture that appears among the weeds. The thin, horizontal band of the stream at the right is cerulean blue, burnt umber, and white.

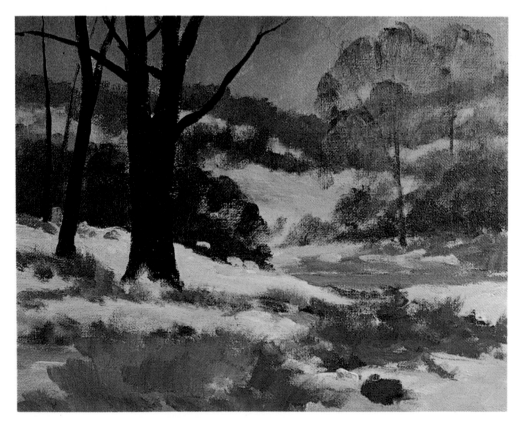

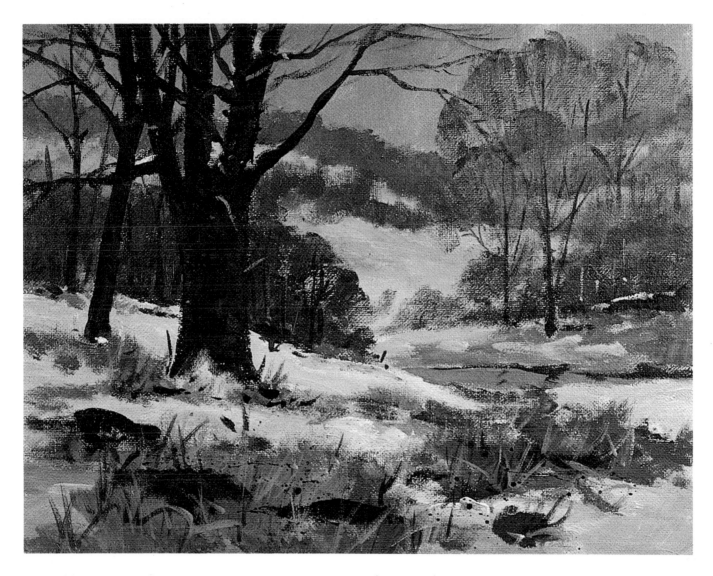

Step 7. The artist completes the picture by adding small strokes to suggest the details that convert the broad masses of color into a realistic landscape. He blends phthalocyanine blue, burnt sienna, and a little naphthol crimson on his palette, thinning this dense mixture with acrylic medium and water, to add more branches to the dark trees at the left. The dark trees need some strokes of warmer, lighter color, so he adds thick strokes of ivory black, burnt sienna, and yellow ochre. Now there's a subtle suggestion of light and shade on the dark trunks. Within the shadowy mass of foliage behind the dark trees, the artist adds thin strokes of ultramarine blue and burnt sienna to indicate trunks and branches. He adds a little more ultramarine blue, plus white, to this mixture to place additional branches on the pale trees at the right. A few strokes of this mixture appear in the stream to suggest the reflections of these trees. Among the weeds in the foreground, the artist adds several dark, flat rocks with ivory black, burnt umber, and yellow ochre. This same mixture is used to place dark weeds at the base of the big tree and to scatter other dark weeds across the foreground. The artist also adds paler weeds in the foreground with a blend of cadmium yellow light, burnt umber, a little cerulean blue, and white. Finally, he adds lots of water to the mixture of ivory black, burnt umber, and yellow ochre that remains on his palette—and then he spatters this liquid color across the foreground. Reviewing the variety of color mixtures in this subdued winter landscape, you'll find that the artist has used many of the most brilliant colors on his palette, as well as the more subdued colors. Thus the finished picture is far from monochromatic, but is actually filled with color. These muted mixtures are colorful because they contain many of the brightest colors on the palette.

Step 1. Now the artist demonstrates how to use the bright colors on your palette to paint a sunny landscape. On a sheet of thick illustration board that he's coated with acrylic gesso, the artist draws the main shapes in pencil. He draws the surrounding rocks with special care, since these shapes define the outer edges of the stream. With a big bristle brush, he blocks in the cool tones of the upper sky with cerulean blue, yellow ochre, and white. He places warm shadows beneath the clouds with strokes of yellow ochre and white, plus a speck of cerulean blue. For the sunlit areas of the clouds, he uses *almost* pure white, tinted with the shadowy mixture.

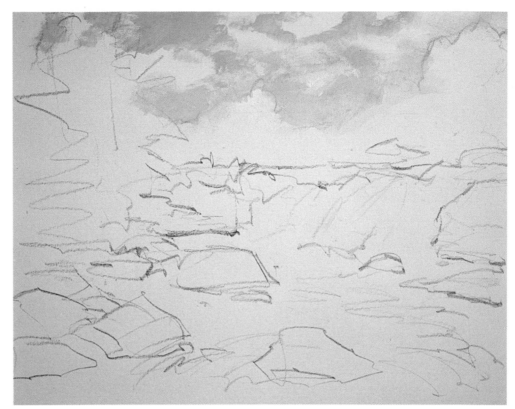

Step 2. The artist paints the deep tones of the trees at both sides of the painting with a thick mixture of phthalocyanine blue, burnt sienna, and yellow ochre, with just enough water to produce a pasty consistency. He then drags the bristle brush across the painting surface with ragged strokes that suggest the texture of the foliage. On the far shore, between the two masses of dark trees, the artist paints the pale trees with cadmium yellow light, cerulean blue, and lots of white—with a dark patch of cerulean blue, cadmium yellow light, burnt umber, and white to indicate the tone of the shadow beneath the trees.

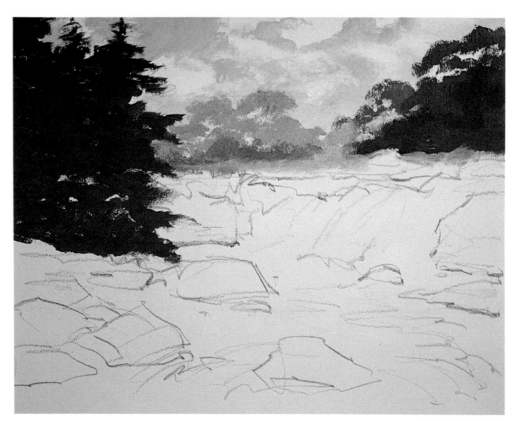

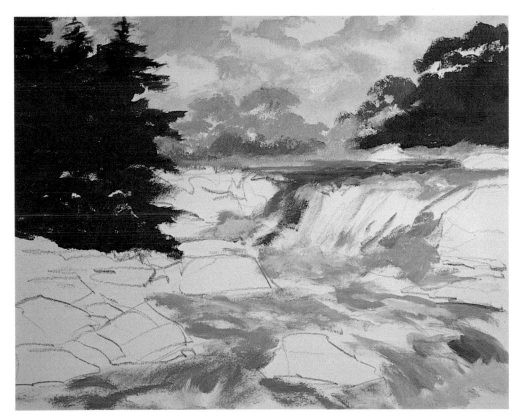

Step 3. With a slender bristle brush, the artist begins to paint the cool tones of the water with varied mixtures of ultramarine blue, cerulean blue, a little naphthol crimson, and white. The darkest blue strokes contain more ultramarine blue, the paler blue strokes contain more cerulean blue and white, and the warmer strokes contain more crimson. The colors are diluted with enough water to produce a thin, milky consistency and are scrubbed thinly over the illustration board to suggest the lively, foaming action of the water. Notice how the direction of the strokes follows the movement of the water.

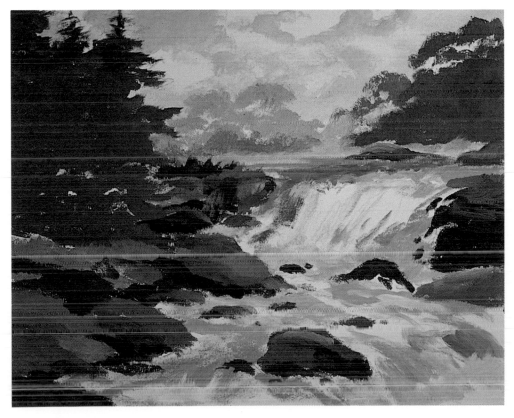

Step 4. Having preserved the pencil outlines of the rocks, the artist now blocks in their color. The sunlit tops of the rocks are mixtures of cadmium red light, cadmium yellow light, burnt sienna, and white. The warm shadows on the sides of the rocks are burnt sienna, cadmium red light, ultramarine blue, and white, with an occasional touch of yellow ochre. And the strong darks along the lower edges of the rocks are phthalocyanine blue, burnt sienna, and the slightest hint of cadmium red light. The paint is thinned with acrylic medium and water to a smooth, creamy consistency that lends itself to broad, solid strokes.

Step 5. Now the artist works on the water with strokes of white, blended with acrylic gel medium to produce thick strokes that will stand up slightly and retain the imprint of the brush. He tints the thick white with small amounts of cerulean blue and an occasional touch of ultramarine blue to vary the values of his strokes. Where the foam is most dense, the white is thickest and the brush-strokes are roughest. The strokes follow the move-ment of the water down the waterfall and over the rocks toward the lower right. The original blues still shine through.

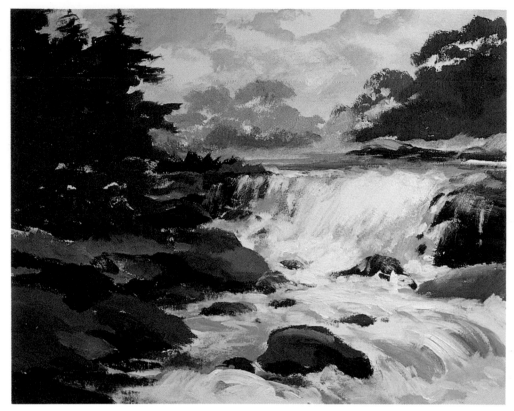

Step 6. Within the dark mass of foliage at the left, the artist adds deep shadows with phthalocyanine blue, burnt sienna, and a speck of cadmium red light. He dips a pointed, soft-hair brush into this mixture—adding a bit of white—to draw pale trunks and branches against the dark foliage on either side of the stream. Beneath the dark trees at the left, the artist places a shadow on the rocks by repainting the tops with phthalocyanine blue, yellow ochre, and burnt sienna. Beneath the far shore, the artist drybrushes a thick stroke of white, faintly tinted with cerulean blue, to suggest sunlight on the water.

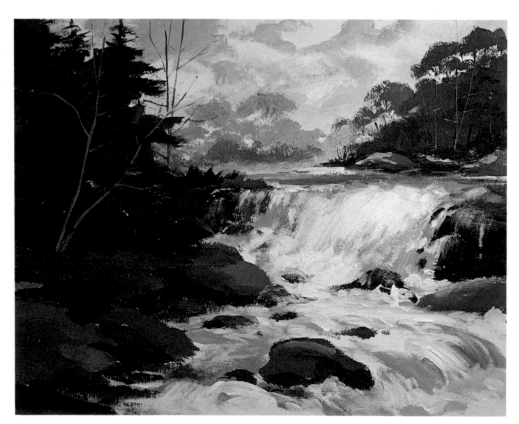

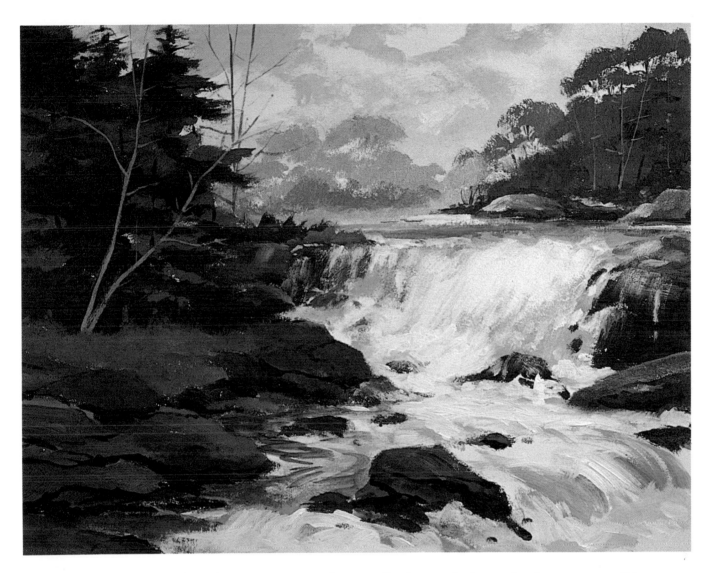

Step 7. In this final stage, the artist concentrates on the details of the rocks and the water in the foreground. With a sharply pointed soft-hair brush, he draws the dark divisions between the rocks and the cracks in the rocks themselves with precise strokes of phthalocyanine blue and burnt sienna, diluted with liquid painting medium and water to produce the right consistency for precise brushwork. Suddenly, the broad masses of color in Step 6 are transformed into realistic rocks. Beneath the warm shapes of the rocks, the artist places strokes of this dark mixture to reinforce the shadowy edges of the rocks in the water. In the foaming water beneath the rocky shore at the left, the artist places thin, swirling strokes of phthalocyanine blue, warmed with burnt sienna and lightened with a touch of white, to suggest the reflections of the trees, the erratic brushwork indicating that these reflections are broken up by the movement of the stream. The artist brightens the foam in the foreground with carefully placed, thick strokes of white—faintly tinted with cerulean blue. As you review the seven steps in this demonstration, you'll see that the mixtures contain most of the bright *and* subdued colors on the palette. The completed painting is filled with color and with sunlight, but no garish mixtures leap off the painting surface. Each color stays in its place, as it does in the natural landscape. The sunlit water *looks* sunlit not because it was painted with brilliant colors, but because the bright tones of the water are surrounded by more subdued, shadowy colors. As you've already learned, colors look *brighter* when they're surrounded by subdued colors, and *lighter* when they're surrounded by dark colors.

Step 1. In the first four demonstrations, the artist mixed colors on his palette and applied them directly to the painting surface in a single operation. This method is called direct or *alla prima* painting. But you should also try other methods of painting for effects that are quite different from direct painting. This demonstration shows the simplest method, called *underpainting* and *overpainting.* After the usual pencil drawing on a gesso-coated illustration board, the artist blocks in the background with a warm neutral made with ultramarine blue, burnt umber, yellow ochre, and white. In the upper right, he lightens the mixture with more white.

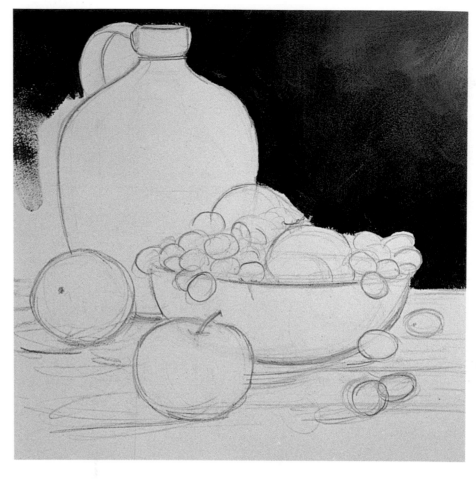

Step 2. All the artist has on his palette is a big mound of this dark mixture—ultramarine blue, burnt umber, and yellow ochre—which he modifies with different amounts of titanium white. Thus, he paints the lights, halftones, shadows, and reflected lights on the jug and fruit with this same basic mixture, and simply blends in more white as he needs it. As you can see, the entire still life is painted in the same warm monochrome that was used in the background of Step 1.

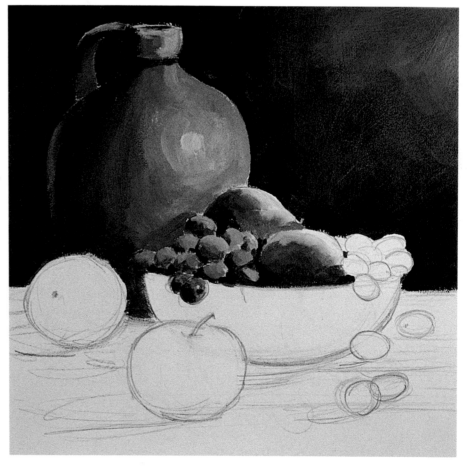

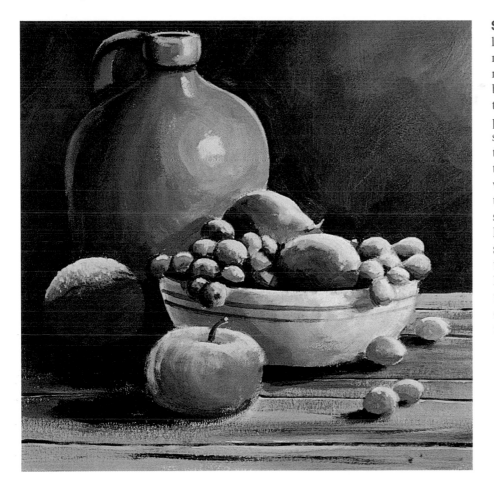

Step 3. As the artist works on the lower half of the picture, he adds much more white to the basic monochrome mixture to paint the brighter shapes of the fruit bowl, the table, and the fruit. When he paints the darkest details—the shadows on the table, the cracks between the wooden boards, and the texture of the wood—he adds no white to the mixture. Notice the interesting lighting effect on the shape of the orange at the extreme left. Most of the orange is in the shadow of the fruit bowl, while only the top of the sphere catches the light. The artist renders the lighted top with tiny dots of pale color that express the characteristic texture of the thick skin of the fruit.

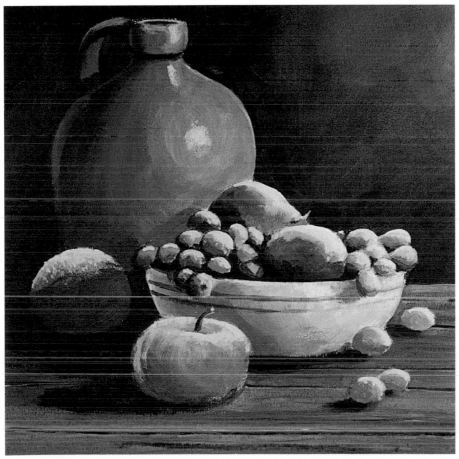

Step 4. By the end of Step 3, the artist has completed the entire picture in values, without color. This is a monochrome underpainting—the first phase of the painting process. When the underpainting is dry, he can begin the overpainting, working in transparent color that allows the values of the underpainting to shine through. He dilutes all his colors with liquid acrylic medium and water to produce fluid, transparent *glazes*. First he brushes a glaze of burnt sienna over the background. Then he glazes the large jug with burnt sienna and yellow ochre. The color of the wood emerges as he glazes the table with a warm mixture of burnt sienna and burnt umber.

Step 5. Blending cadmium red light with a little naphthol crimson on his palette, the artist adds liquid acrylic medium and water, and he glazes this bright mixture over the apple. On the smaller, oval forms of the grapes, he glazes a pale tone of cadmium yellow light. The colors are lightened with acrylic medium and water—not with white, which would reduce their transparency. Normally, a glaze should be as clear and transparent as a sheet of colored glass!

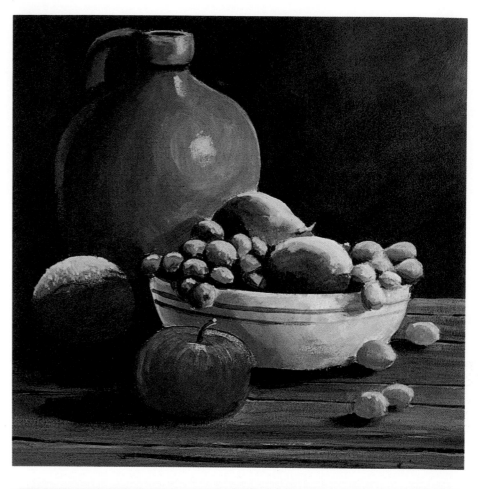

Step 6. When the cadmium yellow glaze on the grapes is dry, he glazes them again with a mixture of phthalocyanine green and cadmium yellow light, leaving the lighted tops of the grapes untouched. The softer tone of the pear is glazed with phthalocyanine green and yellow ochre. The warm tone of the apple in the bowl (like the one on the table) is a glaze of cadmium red light and naphthol crimson. A glaze of cadmium red light and cadmium yellow light is brushed over most of the orange, with just a bit more yellow at the very top. The artist brushes a delicate glaze of cerulean blue over the fruit bowl. And then he darkens the shadows around the fruit—both in the bowl and on the table—with transparent touches of ultramarine blue.

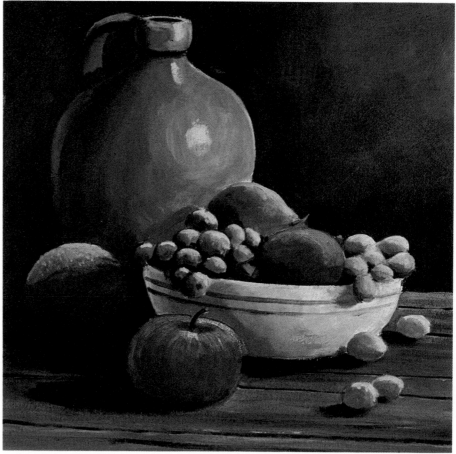

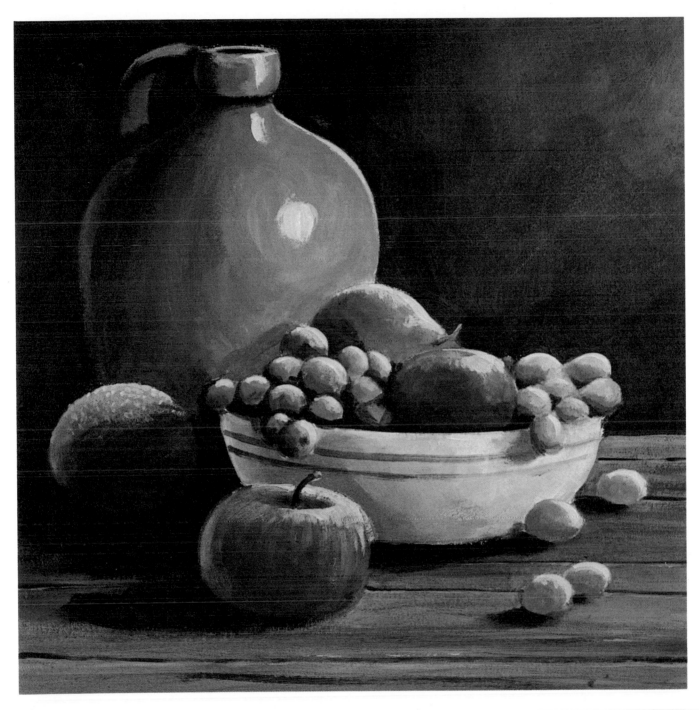

Step 7. In the final stage of the painting, the artist strengthens the lights in the still life with small touches of white, warmed with a hint of yellow ochre, and diluted with liquid acrylic painting medium. He brightens the highlights on the jug and then strengthens the lighted edge of the jug on the right-hand side. Moving a small brush deftly over the lighted tops of the various pieces of fruit, he adds a few touches of white to each shape—just enough to make these forms look more luminous and three-dimensional. Notice how the strokes of white curve down the sides of the apple. The brush merely touches the top of the orange with pinpoints of light to accentuate the shining texture of the skin. As you can see, a painting executed in transparent glazes on a monochrome under-painting has a very different character from a direct (or *alla prima*) painting that's done in opaque color. The monochrome underpainting gives the picture a much stronger feeling of light and shade traveling over three-dimensional forms. And the glazes have a glow—a feeling of inner light—that's possible only with transparent color. This technique is also a practical solution when you're painting a subject that has complicated forms and an intricate play of light and shadow. You can solve the problems of form and light and shade in the monochromatic underpainting, without dealing with the problems of color. Then you can concentrate entirely on color when you get to the overpainting.

Step 1. Now experiment with underpainting in color. The purpose of this technique is not to render light and shade in the underpainting, but to provide undertones that will produce interesting optical mixtures with the overpainting. The artist draws a desert landscape in pencil on a sheet of canvas-textured paper. Then he underpaints the sky with a thin layer of naphthol crimson, titanium white, and plenty of water. He leaves the painting surface bare to indicate the lighted areas of the clouds. Although the sky will be overpainted in cool colors, this warm, contrasting underpainting will add depth and richness to the cool tones of the sky and clouds.

Step 2. Unlike the underpainting of the sky—which will *contrast* with the overpainting—the land is underpainted with a warm tone that will *harmonize* with the overpainting. This underpainting is a thin, washy tone of yellow ochre and white. Then he underpaints the rocky shapes on the horizon with a cool tone—ultramarine blue and white—that will enrich the warm overpainting. The completed underpainting is applied in thin layers of color—with lots of water—to retain the canvas texture, which will enliven the brushwork of the overpainting.

Step 3. The artist blends ultramarine blue, cerulean blue, a little yellow ochre, and white on his palette. From this point on, he dilutes his mixtures with liquid painting medium and water. He begins to overpaint the sky with variations of this mixture, adding more ultramarine at the top and more white toward the horizon. He moves his brush with a back-and-forth scrubbing motion—called *scumbling*. Scumbling deposits the color in a thin, semi-opaque layer that allows the warm tone of the underpainting to shine through. He also leaves occasional gaps in the underpainting. You can see such gaps in the upper left-hand corner and at the right.

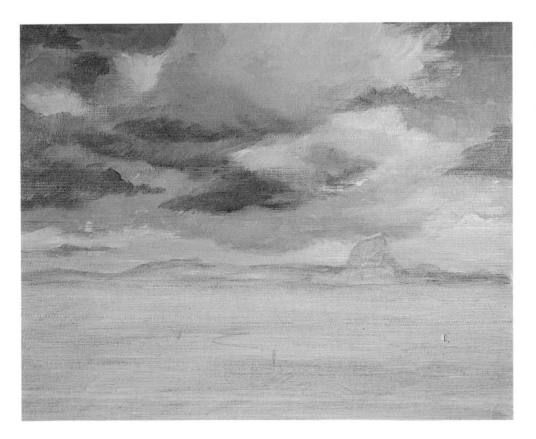

Step 4. The artist darkens the shadowy undersides of the clouds with a warm mixture of burnt sienna, ultramarine blue, and a touch of cadmium red light, plus white. Then he adds a little more ultramarine blue and lots of white to this mixture to paint the paler tones of the clouds—varying the amount of white so that some clouds are lighter and others are darker. Adding yellow ochre and white to the pale cloud mixture, he brushes a warm tone along the horizon, beneath the clouds. The entire sky is painted with scumbling strokes that spread the paint so thinly that the underpainting shines through, adding a subtle hint of warmth.

Step 5. Over the cool underpainting of the distant mesas at the horizon, the artist glazes cadmium red light, cadmium yellow light, and burnt umber. The tall, dark rock formation is overpainted with thick strokes of phthalocyanine blue, burnt sienna, and yellow ochre, with more blue on the dark side. These thick strokes are semitransparent because the color is blended with acrylic gel medium. The foreground is first glazed with cool mixtures of ultramarine blue, cadmium yellow light and yellow ochre, followed by warm scumbles of cadmium red light, cadmium yellow light, and burnt umber in various proportions, so some strokes are warmer and others are cooler. The ragged strokes, broken up by the painting surface, suggest coarse desert plants.

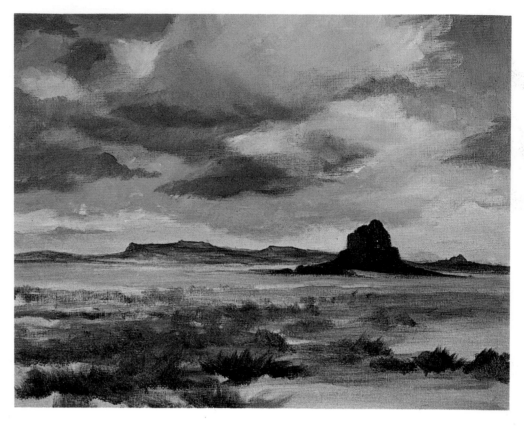

Step 6. The artist scumbles the lighter, brighter areas of the clouds with titanium white that's tinted with cerulean blue, yellow ochre, and a drop of naphthol crimson. He scumbles phthalocyanine blue, burnt umber, and white on the shadowy undersides of the clouds. Then he builds up the cool tones of the sky with phthalocyanine blue, a little burnt umber and yellow ochre, plus white. He draws a few streaks of this mixture across the lower sky, near the horizon. And he brightens the horizon with white, tinted with yellow ochre. All these strokes are thin scumbles. The underlying warm tones show through and create optical mixtures with the overpainting.

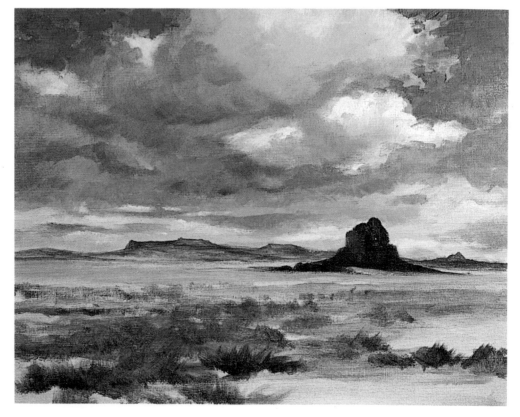

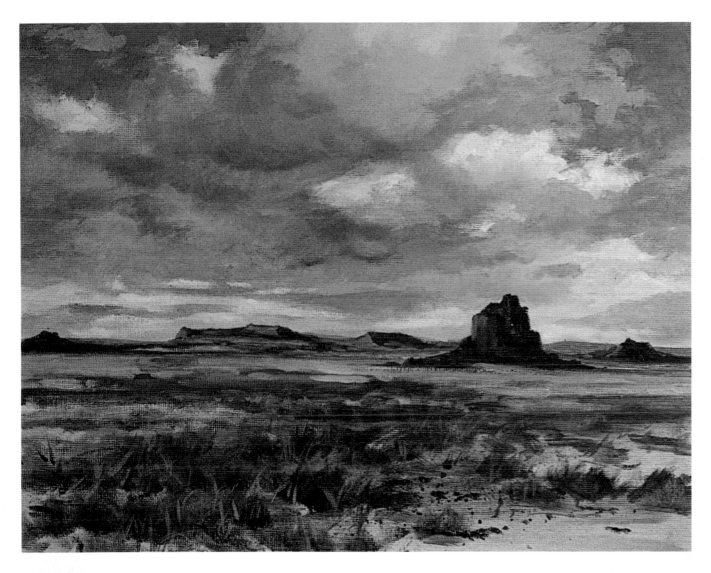

Step 7. At the extreme right and left of the horizon, the artist adds dark rock formations with liquid, transparent glazes of cadmium orange, burnt sienna, and phthalocyanine blue. He uses the same dark glaze to add detail to the tall rock formation. Then he lightens his glaze with water to add shadows and dark edges to the low mesas along the central horizon. Across the flat landscape just beneath the horizon, the artist glazes a warm, shadowy mixture of ultramarine blue and alizarin crimson. He carries a few strokes of this warm tone into the foreground. The coarse desert growth in the foreground becomes more realistic as the artist adds scrubby, transparent vertical and diagonal strokes of ultramarine blue and cadmium yellow light for the shadowy patches, cadmium orange and burnt sienna in the brighter areas to the left, and burnt sienna and phthalocyanine green for the warm neutrals. When these glazes dry, the artist goes over them with slender strokes of yellow ochre and white to suggest individual plants caught in the sunlight. The artist adds water to some of the darker mixtures on the palette and spatters droplets across the foreground to suggest a few stones. Finally, the artist brightens the bare desert just below the horizon with horizontal strokes of yellow ochre and white, darkened with a speck of burnt umber. In this landscape, the underpainting is very simple—just three colors applied thinly over most of the painting surface. At first glance, the underpainting seems to disappear beneath the overpainting, but those undertones are still there. Because the overpainting consists almost entirely of thin scumbles and transparent glazes, virtually every color in the finished painting is an optical mixture that's strongly influenced by the underpainting. Study the sky, for example, where the warm underpainting creeps through, lending depth and subtlety to the cooler colors of the overpainting. In the same way, the cool underpainting of the rocky shapes adds depth and complexity to the warm overpainting. And the analogous underpainting tone of the land adds unity to the complex colors of the overpainting. As you can see, the color of the underpainting may *contrast* or *harmonize* with the overpainting. You should experiment with underpaintings that work both ways.

Step 5. The tree trunks are scumbled with burnt sienna, ultramarine blue, yellow ochre, and white—with more burnt sienna and ultramarine in the shadows. The shadowy reflections in the water are a dark mixture of burnt sienna, phthalocyanine green, and a little ultramarine. At the top of the picture, the sunny underpainting of the foliage is glazed with cadmium yellow light and cadmium red light. At this stage, the artist is beginning to work with slightly thicker color, so the glazes are diluted with liquid painting medium and a bit of water—rather than the pure water he's used in the first four steps.

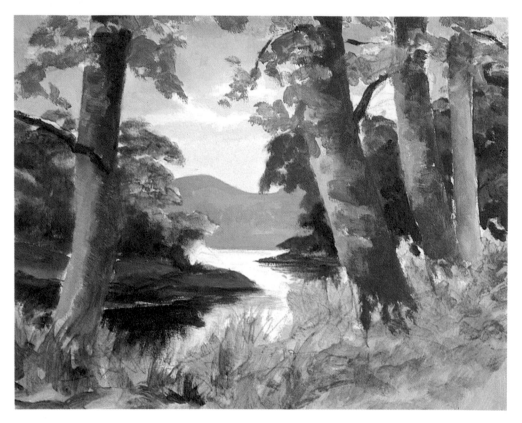

Step 6. The artist adds trunks, branches, and touches of shadow to the distant foliage with a dark, transparent mixture of phthalocyanine blue and burnt sienna. He also uses this tone to sharpen the edges of the shoreline. Then he scumbles a pale tone of cerulean blue and white over the water, drybrushes ultramarine blue and burnt sienna over the shadow areas of the trunks, and builds up the lights with drybrush strokes of yellow ochre and white. The same mixture of yellow ochre and white reappears in the slender strokes that suggest sunstruck branches on the foreground trees and sunstruck leaves on the distant foliage.

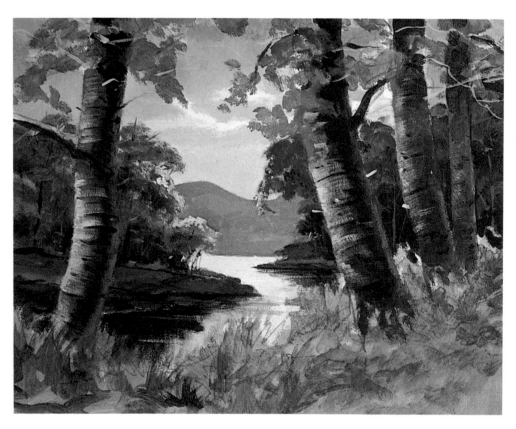

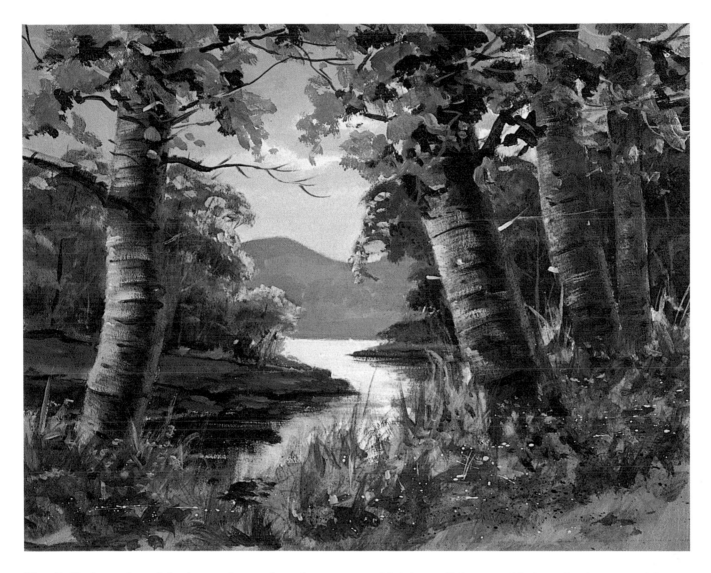

Step 7. Dark touches of shadow and more branches are added to the sunny foliage at the top of the picture with strokes of phthalocyanine blue and burnt sienna. Then the artist concentrates on the texture and detail of the foreground. The dark strokes among the tangled grass are made with glazes of ultramarine blue and cadmium yellow light, with an occasional touch of burnt sienna, diluted with plenty of acrylic medium so that the color remains transparent and allows the sunny underpainting to shine through. The artist uses two different brushes for the foreground: a small bristle brush for the thicker, more irregular scrubs of color, and a slender, soft-hair brush for the individual blades of grass. The bright grass—caught in the sunlight and silhouetted against the dark background—is painted with cadmium yellow light and white, plus a drop of ultramarine blue. A few touches of bright sunlight are added to the foreground leaves with carefully placed strokes of cadmium yellow light and cadmium orange. Now compare the completed picture with the underpainting to see how these optical mixtures work. Notice how the warm undertone of the sky and the distant trees shines through the cool overpainting. The warm underpainting of the foreground also creates the feeling of sunlight among the cooler strokes of the overpainting. Especially obvious is the way the warm underpainting of the foreground foliage reinforces the warm overpainting. It's only in the tree trunks that the underpainting seems to disappear. But even there the cool shadows of the underpainting still influence the gradation of light and shade in the final picture.

Step 1. Acrylic is particularly effective for a kind of underpainting that depends upon texture, rather than on color. Acrylic modeling paste—a ready-made mix of acrylic medium and marble dust—can be blended with color or used alone to create a rough textured surface that's wonderful for painting subjects like these rocks and driftwood. The artist begins with a pencil drawing on canvas board. Then he spreads acrylic modeling paste on the rocks and driftwood with a palette knife, patting the paste on the rocks with the flat blade to build up their texture. On the driftwood, he applies the paste with long strokes that follow the direction of the trunk and suggest the texture of the dried, shrunken wood.

Step 2. The modeling paste is thick and needs plenty of time to dry, so the artist now concentrates on the sky. First he brushes yellow ochre and white over the entire sky area. While this warm tone is still moist, he blends in the cooler sky tones with ultramarine blue, a little naphthol crimson, and white. Then he builds up the clouds with yellow ochre and white, plus an occasional touch of burnt sienna and ultramarine blue in the darker undersides of the clouds. He works very thinly because he wants the rough texture of the rocks and driftwood to stand out against the smooth texture of the rest of the painting.

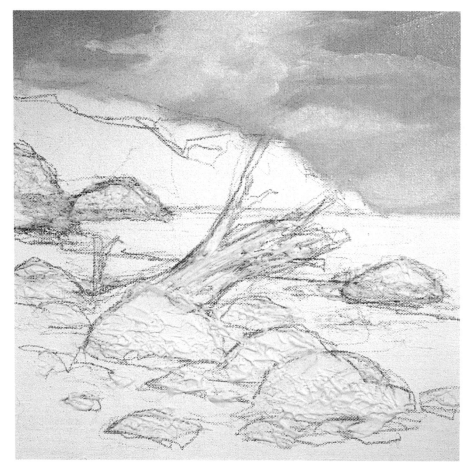

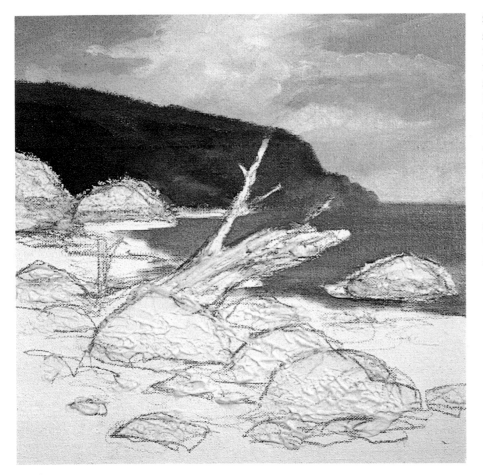

Step 3. The water is painted with smooth, horizontal strokes of ultramarine blue, yellow ochre, and white. The artist blocks in the dark side of the cliff with ultramarine blue, naphthol crimson, burnt sienna, and white, adding more burnt sienna in the darker areas. Along the top of the cliff, he indicates the somber tone of the foliage with ultramarine blue and yellow ochre. He drybrushes the color where the edge of the cliff meets the sky to suggest the rough texture of the coarse grass and bushes that grow along the shore.

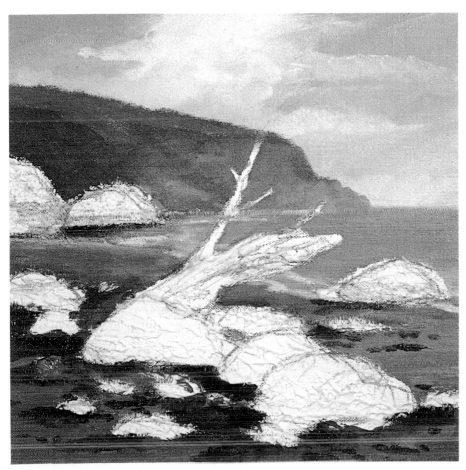

Step 4. A thin mixture of burnt sienna, yellow ochre, and white is brushed over the sand and carried carefully around the thick masses of modeling paste. The shadows of the rocks on the sand are added with burnt sienna and ultramarine blue. Around the rocks, the artist places small touches of this mixture to indicate scattered pebbles.

Step 5. The artist blends yellow ochre and titanium white with just a little burnt umber, and dilutes this with liquid medium. He brushes this pale, creamy mixture over the rocky shapes in the foreground. Then he drybrushes a darker mixture of burnt sienna, ultramarine blue, and liquid medium over the shadowy sides of the foreground rocks and over the dark mass of rocks at the left, just beneath the cliff. The ragged texture of the dried modeling paste breaks up these strokes to produce a coarse, granular texture. Now you begin to see why that rough underpainting is so important.

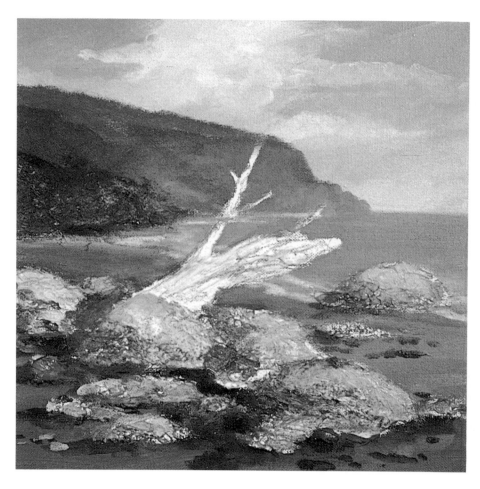

Step 6. Over the rocks, the artist continues to drybrush a thick, dark mixture of burnt sienna and ultramarine blue—diluted with liquid medium. The brush hits only the high points of the rough underpainting, and the texture becomes more obvious with each successive stroke. The deep shadows between the rocks are drybrushed with a darker mixture of ultramarine blue and burnt sienna. These strokes are also roughened by the underlying texture. This same color is used to reinforce the dark form of the distant rock formation at the left. Finally, the artist begins to indicate the shadows on the driftwood with a transparent glaze of this same mixture.

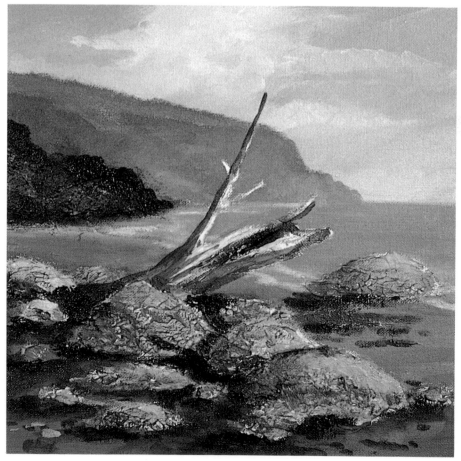

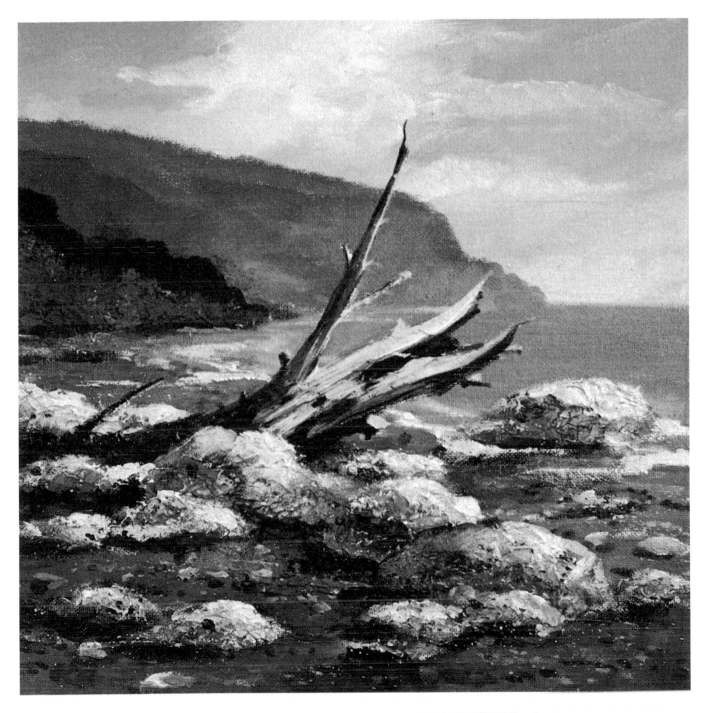

Step 7. To brighten the sunlit tops of the rocks, the artist blends a thick mixture of yellow ochre, burnt sienna, and white, plus acrylic gel medium, on his palette. He drybrushes this pale mixture across the tops of the rocks. The artist applies this sunny mixture to the bright areas of the driftwood with long strokes that follow the grain of the weathered trunk and branch. He then drybrushes a dark mixture of burnt sienna and ultramarine blue, diluted with liquid medium, over the shadows of the driftwood and along the shadowy edges of the rocks. With each stroke, the textures become rougher. To push the dark, distant rock formation further into the background, the artist scumbles a cool mixture of phthalocyanine green, yellow ochre, and burnt umber over the dark shape. He decides that there are too many rocks—he needs more beach to contrast with the rocky forms—so he paints out one rock in the lower left with the dark sand mixture he used in Step 4. To break up the rocks into different shapes and sizes for greater variety, he divides them with dark strokes, and then builds up their tops with the thick, sunny mixture. With this same mixture, he paints scattered pebbles on the beach, adding more white to paint the foamy edge of the water. With tiny touches of ultramarine blue and burnt sienna, he adds shadows beneath some large pebbles and scatters touches across the foreground to suggest smaller pebbles.

Step 5. The artist allows the entire painting to dry thoroughly again, since the remaining strokes must be applied to dry paper. He paints the dark shoreline at the left with burnt sienna, phthalocyanine blue, and yellow ochre—with a few touches of cadmium red light in the warmer areas. Then he suggests the reflection of the shore and the bare trees with a *very* dark mixture of phthalocyanine blue and burnt sienna. Note that the triangular shape of the shore is a kind of wet-into-wet mixture—with thicker paint. The artist paints the darks first; then he brushes the warmer, slightly lighter tones into the dark, wet undertone. The action of the brush blends the colors.

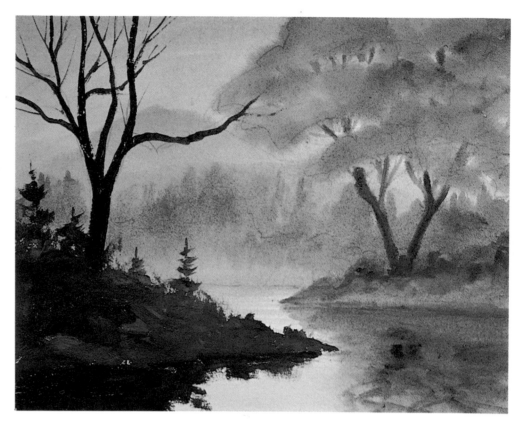

Step 6. More branches and slender twigs are added to the silhouette of the dark tree at the left with the original mixture of phthalocyanine blue and burnt sienna, diluted with enough water to permit precise brushstrokes. Within the blurred masses of foliage at the right, the artist adds soft shadows with a mixture of phthalocyanine green, burnt umber, yellow ochre, and a little white. With this same mixture, he adds more branches to these trees, indicates a few low evergreens on the shore, and places more strokes in the water to make the reflections more distinct.

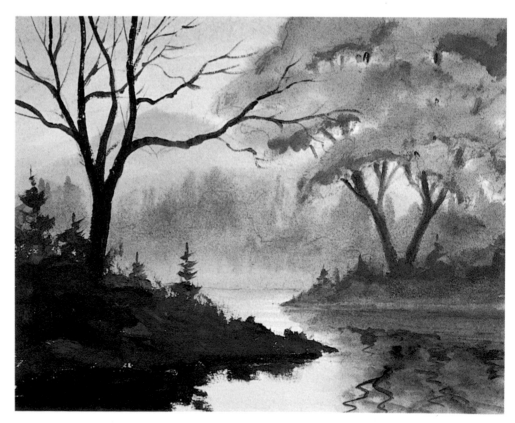

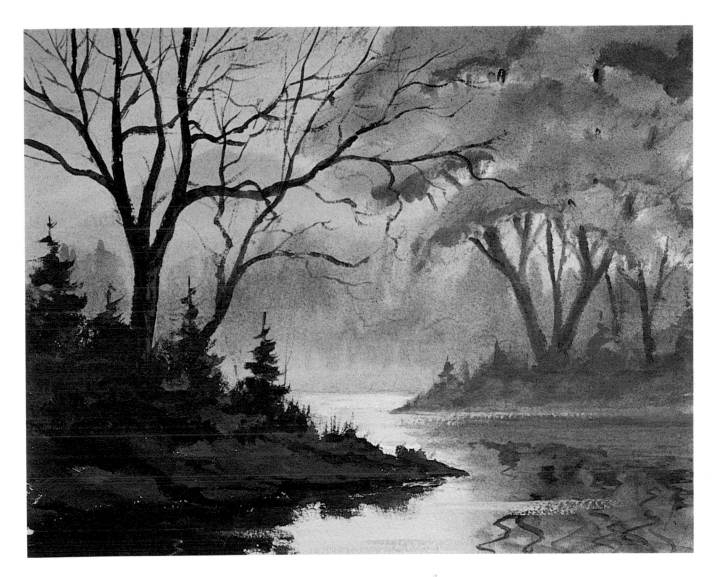

Step 7. On the dark shore at the left, the artist adds a second tree that leans over the water. He paints the trunk and branches—and adds a few more branches to the other tree—with phthalocyanine green, burnt umber, and enough water to make the paint flow smoothly. Darkening this mixture with a touch of phthalocyanine blue, he adds another low evergreen to the shore, and animates the silhouette of the dark shore with slender strokes that suggest leafless branches, shrubs, and weeds. To brighten the soft light on the calm surface of the water, the artist drybrushes horizontal strokes of yellow ochre and white. Now there's a more distinct flash of light on the pond beneath the far shore—at the very center of the picture—and there are also sparkling streaks of light in the dark reflections of the trees in the foreground. Although most of the picture is painted wet-into-wet—with the colors blended together on the wet surface of the watercolor paper—the artist knows that a picture may lack solidity if it's painted *entirely* in the "wet-paper technique." Instead, the soft, blurred forms—painted on wet paper—need the contrast of a few sharply defined forms, which must be painted on dry paper. Thus, the dark, distinct forms of the landscape at the left are necessary to balance the softer forms that appear in the rest of the picture. And these softer forms seem more magical and remote because of the contrast with the hard-edged shapes of the near shore. For wet-into-wet painting, watercolor paper or board is usually the best surface because it absorbs and holds water more effectively than the less absorbent surface of canvas or a gesso panel.

Step 1. In the nineteenth century, the Impressionist and Post-Impressionist painters discovered another method of mixing colors. They built up their pictures with a mosaic of individual strokes painted side-by-side, over one another, and *into* one another—directly on the painting surface. Over a pencil drawing on illustration board, the artist blocks in the sky with short, distinct strokes of yellow ochre and white. Over these, he places strokes of ultramarine blue and white, cadmium red light and white, and burnt sienna with a little ultramarine blue and white. For the soft tone at the horizon, the artist adds much more white to this last mixture.

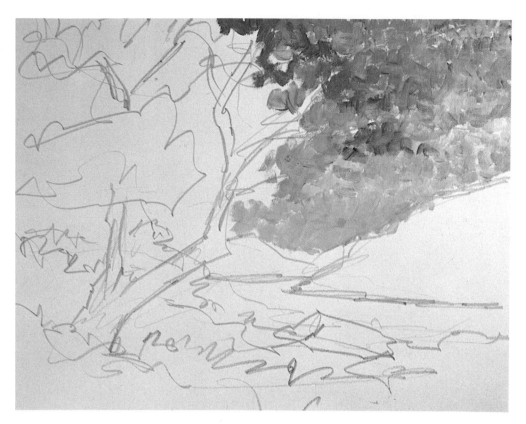

Step 2. He fills the upper sky with cool strokes of phthalocyanine blue, naphthol crimson, and white; and with warmer strokes of burnt sienna, naphthol crimson, yellow ochre, and white. He adds more white to these mixtures for the interplay of warm and cool strokes just above the horizon. Notice how he works carefully around the shapes of the trees, leaving the trunks, branches and foliage bare for the moment. Finally, he repeats the warm and cool sky mixtures in the water.

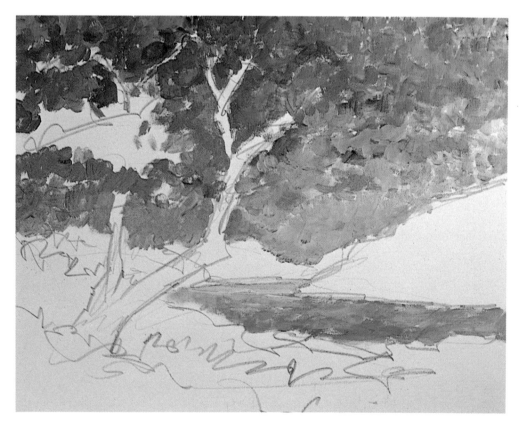

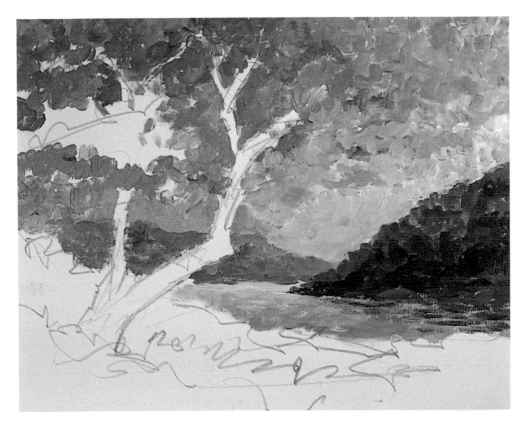

Step 3. The bright color of the distant shore at the left is painted with various combinations of ultramarine blue, naphthol crimson, a little yellow ochre, and white. As you can see, some strokes contain more crimson, while others contain more blue, and still others contain more white. The darker, wooded slope at the right is painted with deeper mixtures of these same colors, intermingled with strokes of burnt sienna and phthalocyanine green in the shadows. These dark tones are carried down into the water with slender, horizontal strokes that suggest reflections.

Step 4. The grassy foreground is first covered with strokes of phthalocyanine green, burnt sienna, yellow ochre, and a little white. Then, while these strokes are still wet, the artist adds darker strokes of varying combinations of ultramarine blue, phthalocyanine green, and cadmium red light. (The warmer strokes contain more red, while the cooler strokes contain more blue or green.) The artist doesn't consciously attempt to blend his strokes. But each fresh stroke tends to create an optical mixture with the dried color beneath—or creates a wet-into-wet mixture if there's wet color beneath. And each stroke is allowed to hold its own distinct shape.

Step 5. The trunk is painted with dark and light strokes of phthalocyanine blue, burnt umber, yellow ochre, and white. The lighter strokes obviously contain more white and yellow ochre, while the darker ones contain more blue and burnt umber. Because the artist lets each stroke stand unblended, his brushwork captures the rough texture of the bark. Then he moves into the upper area of the painting to block in the foliage with a dark mixture of phthalocyanine green, burnt sienna, and a bit of phthalocyanine blue. The shapes of the foliage are built up with a mosaic of individual strokes.

Step 6. The blossoms on the tree are small touches of three different mixtures. The cool blossoms in shadow are a blend of cerulean blue, yellow ochre, and white. The warmer blossoms are mainly yellow ochre and white, with a hint of burnt sienna. And the bright blossoms in direct sunlight are *almost* pure white with a drop of cerulean blue. The artist adds branches and strengthens the shadows on the trunks with phthalocyanine blue and burnt sienna. Then he brightens the sunlight on the trunks with the mixtures he's used for the blossoms. He carefully leaves gaps in the foliage to allow the sky to shine through.

Step 7. With small strokes of phthalocyanine green, burnt sienna, yellow ochre, and white, the artist extends the leaves across the sky. Among the leaves, he adds more blossoms with the same three floral mixtures he used in Step 6 so that we now see rich masses of flowers in the sunlight. Among the grass at the bottom of the picture, tiny strokes of these mixtures become wildflowers on the shadowy ground. Within the grass, the artist adds rocks with broad strokes of burnt umber, cadmium yellow light, ultramarine blue, and white. Blending more white into this mixture, he adds warm strokes to the sunlit edges of the tree trunk. He blends phthalocyanine green, and burnt sienna with a touch of phthalocyanine blue for the dark grass around the tree and rocks. Then he adds white to this mixture for the paler blades of grass. Finally, a few dark strokes are added to the tree trunks with phthalocyanine blue and burnt umber, to indicate the cracks in the bark. Now compare the completed picture with its early stages. In the first few steps, the mosaic of strokes may have seemed harsh, chaotic, and fragmentary. But as the artist gradually built up his colors, stroke over stroke, the painting began to knit together. Ultimately, all the strokes stay in their places, forming a unified, harmonious picture that's full of color, shimmering light, and lively brushwork.

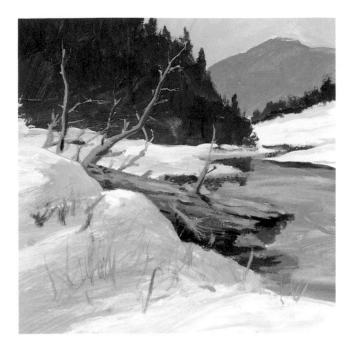

Warm and Cool. A successful color scheme not only achieves color harmony, but leads the viewer's eye to the focal point of the picture. Thus, the warm tone of the dead tree—a mixture of burnt sienna and cadmium yellow light—captures the viewer's eye because the tree is surrounded by cool shadows on the snow and the cool tone of the ice.

Bright and Subdued. Another way to carry the viewer's eye swiftly to the center of interest is to plan a contrast of bright and subdued color. Here the spot of brilliant sunlight is surrounded by the subdued colors of the shadowy road and surrounding trees. The artist also paints the darks with semi-transparent scumbles and the lights with opaque color.

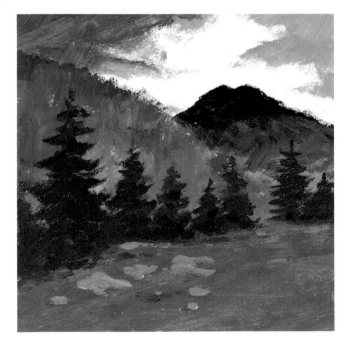

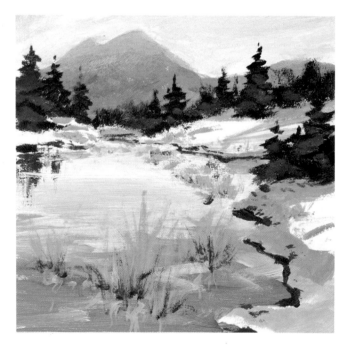

Light Against Dark. The artist saves his strongest contrast of values for the focal point of this landscape. The dark peak is silhouetted against the light shape of the cloud to bring the viewer's attention directly to the upper right. The light tone of the cloud is the white paper itself.

Leading the Eye. To carry the viewer's eye from the bottom of the picture to the mountains, the warm tones of the weeds create a curving path from the foreground to the center of interest. Next to this warm tone, a cool complementary tone follows the same path. The two complementary colors enhance each other as the eye moves into the picture.

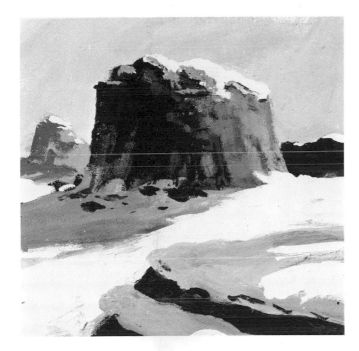

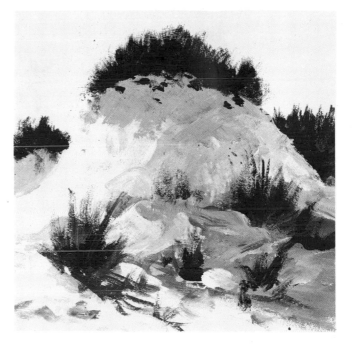

Cubical Form. Even though this book is about color, there's no color without light. So you must understand how light and shade behave on form. This blocky rock formation, is roughly cubical. The top plane receives the direct light. The right side plane is a halftone—midway between light and shadow. And the left side plane is in shadow. There's also a cast shadow on the snow.

Rounded Form. Many natural forms, like this dune, resemble spheres or hemispheres over which the light travels as it would over a ball. From left to right, you see the typical sequence of four tones: the light, the halftones between the light and shadow, then the shadow, and finally the paler tones of the reflected light within the shadow.

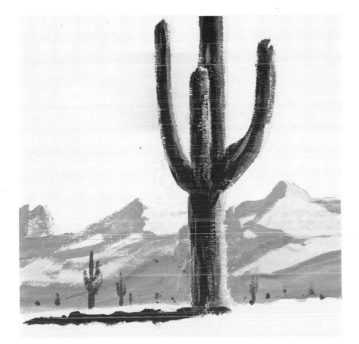

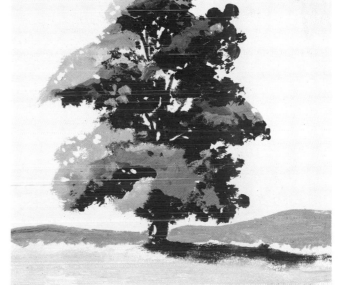

Cylindrical Form. Growing forms, like a tree trunk or this cactus, are often cylindrical. From right to left, you can see light, halftone, shadow, and reflected light at the shadow edge. The lighted areas are illuminated by the sun, while the reflected lights come from some secondary source—like the sand—that acts like a mirror, bouncing light back into the shadow.

Irregular Form. Although many forms—like this tree—are nongeometric, you can still see the same gradation of tones. Since the light comes from the left, you see the light, halftone, and shadow on the leafy masses. It's difficult to see reflected lights, but there's a cast shadow on the ground opposite the lighted side.

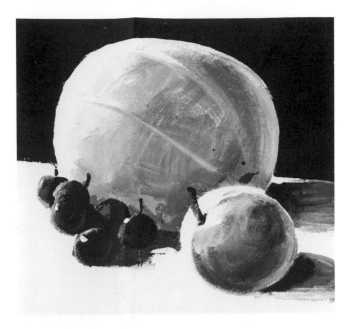

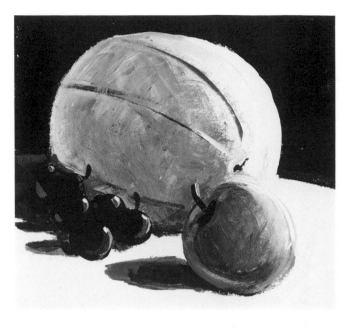

Side Lighting from the Left. When the light strikes the shapes of the fruits from the left, the gradation of light and shade moves from left to right. On the lighted sides of some of the grapes, there's a bright *highlight*—the point that receives the most intense light. Notice the cast shadows to the right of each form.

Side Lighting from the Right. Now the light strikes the fruit from the right, so the gradation of light and shade is reversed. You can still see those bright highlights on the lighted sides of the grapes, and the cast shadows on the opposite sides. Lit directly from the side, most of the form is in halftone and shadow, as you see clearly on the melon and the apple.

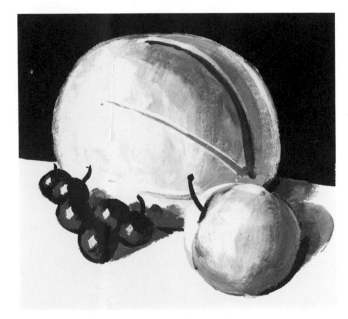

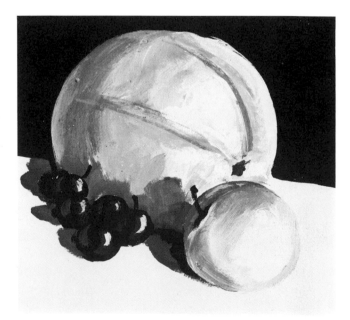

Three-Quarter Lighting from the Left. The light no longer comes from the side, but comes from above and behind your left shoulder. Now there's more light on the form, but less halftone and shadow. The light moves diagonally from left to right, and so do the cast shadows.

Three-Quarter Lighting from the Right. When the light moves diagonally over your *right* shoulder, the sequence of tones is reversed. There are large lighted areas and halftones on the forms, and rather slender shadows with reflected lights at the edges. Notice how the apples and grapes throw cast shadows not only on the table, but on the big shape of the melon behind them.

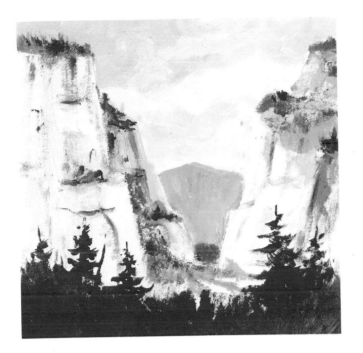

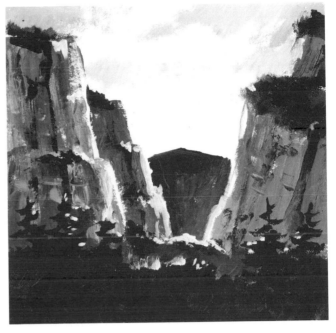

Front Lighting. It's worthwhile to spend a day painting the effects of the changing light on landscape subjects. When the light comes from directly behind you, it strikes the fronts of the cliffs. It's typical of front lighting that most of the areas are illuminated, with just slender shadows around the edges and within the cracks.

Back Lighting. The sequence of tones is reversed when the sun is behind the cliffs. Now the forms are mainly in shadow, with slender rims of light around the edges. (The effect is sometimes called *rim* or *edge lighting*.) You can accentuate the contrast by painting the lights with thick, opaque color, and painting the shadows with thin, semitransparent color.

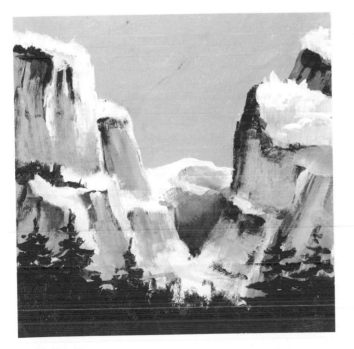

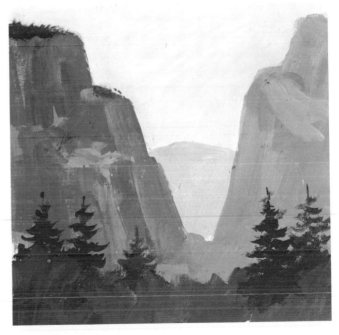

Top Lighting. When the light comes from directly overhead, the tops of the forms are brightly lit and the sides tend to be in shadow. There are dark tones in the concavities just beneath the tops of the cliffs. Making small monochrome studies like these will show you how many pictorial ideas you can get from a single subject.

Diffused Light. When there's a veil of fog, mist, or rain over the sun, the light is diffused. There's less distinction between light, halftone, shadow, and reflected light. But looking closely at this landscape, you can still see a subtle contrast between the light and shadow planes, although the halftones and reflected lights are almost invisible.

Sunny Day. Just as it's useful to paint the same subject at different times of day, you'll also learn a lot by painting the same subject under different weather conditions. On a sunny day, there are strong contrasts between light and shadow, and sharply defined cast shadows on the snow. Although there are extreme lights and darks, you can also see two middletones, one light and one dark. The distinctions between the values are obvious in bright sunshine.

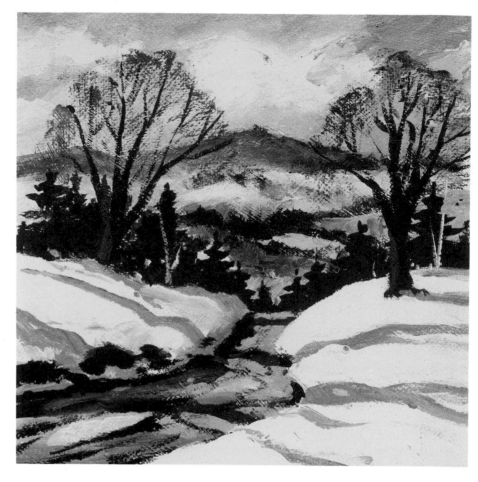

Cloudy Day. Under a cloudy sky, some parts of the landscape are darkened by the shadows of the clouds, while other parts are caught in the sun that breaks through. Thus, there are interesting, distinct, and unpredictable patches of light and shadow on the land. You can see this effect on the snowy foreground and the far hill. You can use these patches of cloud shadows and sunlight creatively, subduing some areas of the landscape and spotlighting others. Notice how the artist has painted the shadow areas of the snow in thin color, piling on thicker strokes in the lighted areas.

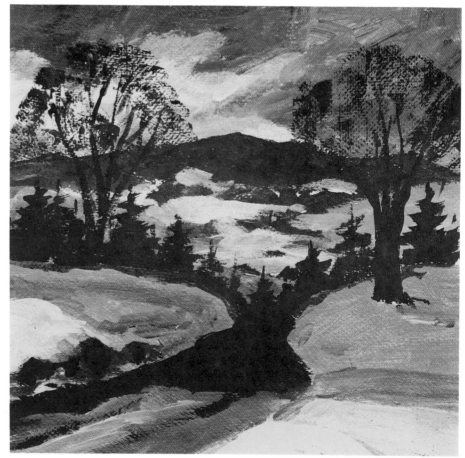

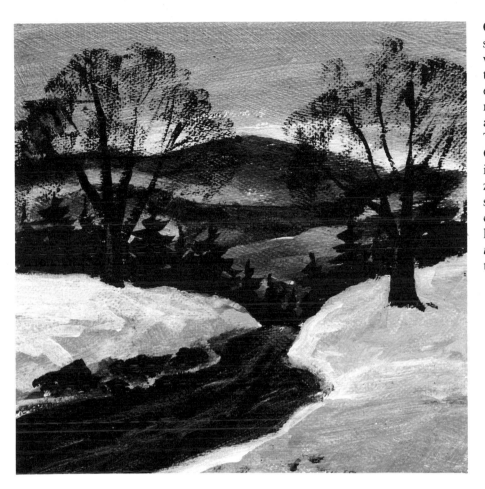

Overcast Day. When there's a solid screen of clouds over the sun, without those dramatic breaks in the sky, the entire landscape is generally grayer. On an overcast day, most tones come from the middle and lower parts of the value scale. There are almost no bright lights. Occasionally, there's a slight break in the clouds just above the horizon, and this light is reflected on the snow, as you see here. But if you don't find that hint of light at the horizon, there's nothing wrong with *inventing* it to introduce a bit more tonal contrast.

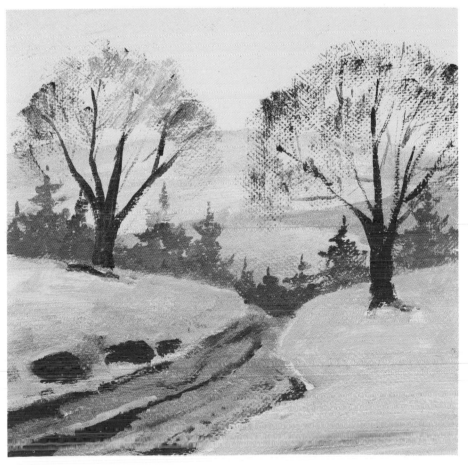

Hazy Day. On a hazy day, there's a soft screen of water vapor over the entire landscape. Oddly enough, a hazy day can actually be a bright day, particularly if you're painting the early morning haze that diffuses the rays of the rising sun. That's what's happening here. Typical of a hazy day, there are no gradations of light and shade on the forms. Each shape—tree, rock, snowbank—is a flat tone. The haze lightens *all* the tones, so that even the dark trees are pale. Most of the tones come from the upper part of the value scale, which means that you've got to add a lot of white to your mixtures.

High Key. As you paint monochrome studies outdoors, you'll begin to discover the phenomenon that painters call *key*. A landscape is a high-key subject when you can paint it almost entirely in values that come from the upper and middle points of the value scale. In other words, the lights and middletones are *all* quite pale, while even the darks are medium grays. This coastal landscape, painted in a thin fog, is an example of a high-key subject.

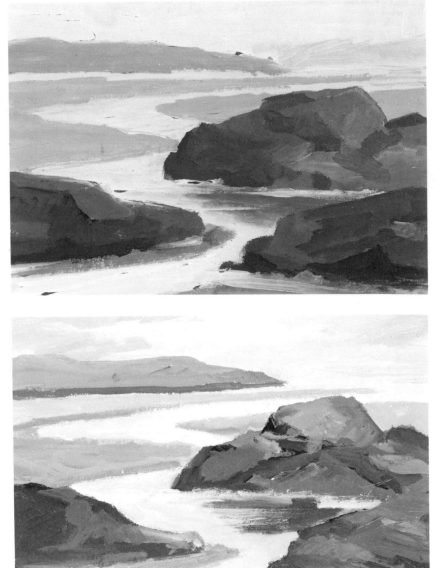

Middle Key. When the fog begins to melt away and the sunlight becomes stronger, more of the values in this subject come from the middle of the value scale, with only the strong lights coming from the upper part. With the changing light and weather, this high-key subject has become a middle-key subject. You'll find that most paintings are in this key.

Low Key. As the light begins to fade toward the end of the day, the whole landscape darkens. Now the most important values in the rock and the distant shore come from the lower part of the value scale. As you've guessed by now, this is a low-key landscape. Although not every subject has a distinct key that you can identify, many do. If you *can* identify a specific key, this will help you achieve the right values when you mix your colors. It will also help you plan the value scheme of the landscape with much more accuracy.

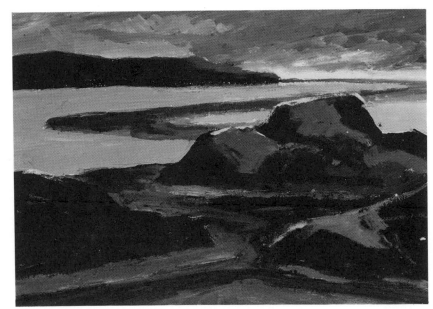

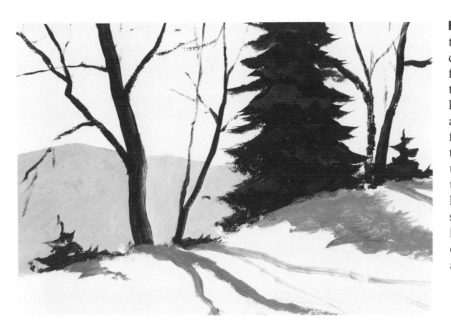

High Contrast. Besides *key*, another factor that you'll discover as you work outdoors, painting the same subject under different light conditions, is *contrast*. When the light is bright and clear, the tones of the landscape are likely to come from the top and bottom of the value scale, as well as from various places between these two extremes. Here, the trees are strong dark values, the sky and snow are light values, and there are two distinct middletones—one lighter and one darker. Because there are sharp contrasts between values, this is a high-contrast subject. But the tones are so diverse that you can't identify it as having a specific key.

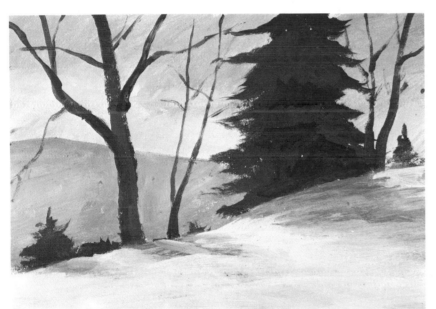

Medium Contrast. On a cloudier day, the darks in this landscape are paler, and the lights darker. In short, there's less contrast between light and dark—and even less contrast between the two middletones, which now may look like one value. This landscape is a medium-contrast subject. It also happens to be a middle-key subject, but medium contrast and middle key don't necessarily go together. *All* the studies on the opposite page are actually in the medium-contrast range.

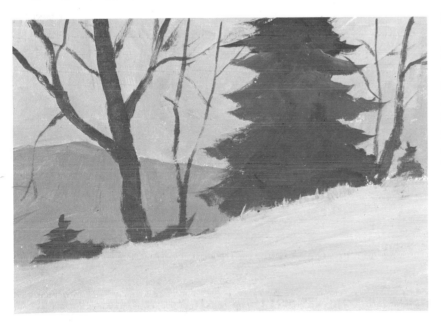

Low Contrast. On a very gray day or seen through a thick haze, the darks appear still lighter, the lights seem darker, and there's even less contrast between darks, lights, and middletones. The landscape is transformed into a low-contrast subject. Bear in mind that it would *also* be a low-contrast subject on a foggy day, when most tones are pale, or at nightfall, when most of the tones are dark.

Step 1. To paint a high-key landscape, the artist brushes a sheet of illustration board with a delicate value that represents the lightest tone in the picture. Next comes the brush drawing, which may seem rather dark, but will soon disappear beneath the opaque tones that come next. He blocks in the darker tones of the sky with a pale middletone, and then repeats that pale middletone in the reflections along the edge of the shore.

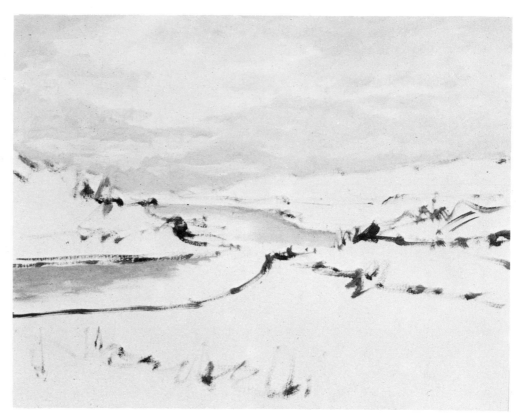

Step 2. Because it's important to keep the entire picture in a high key, the artist works gradually from light to dark. His next step is to block in the darker middletone of the distant shore. He repeats this tone in the reflections along the edges of the shore. He blocks in a light middletone on the shadow side of the shore at the left. On the dune in the foreground, he begins with a dark tone at the edge, then blends this softly into the pale shadow that curves down the side of the dune.

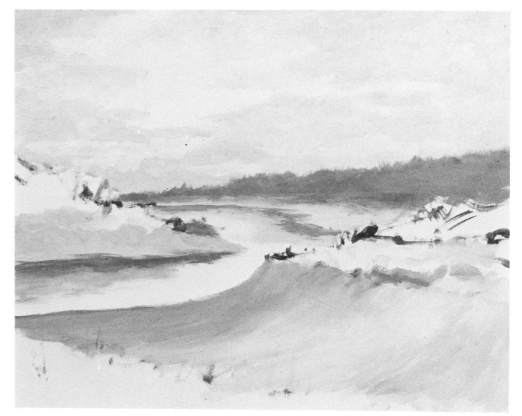

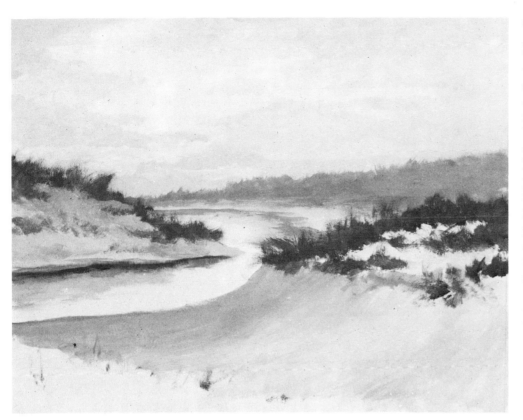

Step 3. The artist adds the grass on the top of the dunes with dark tones. He carries this dark tone below the shore at the left with a slender line that reinforces the reflection in the water. He brushes the pale middletone over the entire dune at the left. By the end of Step 3, the painting contains all four major values: the light value in the sky and water, the pale middletone in the sky and the dunes, the darker middletone on the distant shore and at the edge of the foreground dune, and the dark grass on top of the nearby dunes.

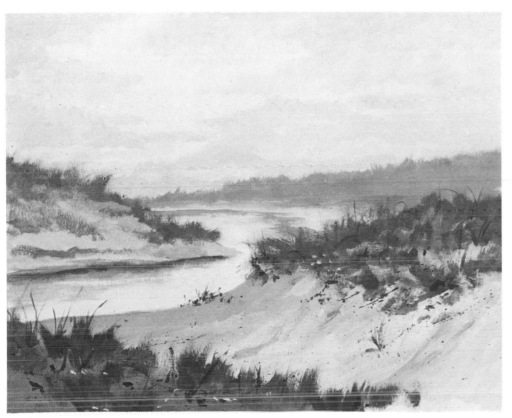

Step 4. The artist adds the rest of the beach grass on the dunes and in the immediate foreground. He varies these tones by introducing a few strokes of the dark middletone. Detail is added to the concave side of the foreground dune with delicate touches of the dark middletone. Finally, he dips his brush into the strongest dark to strike in a few individual blades of grass. (These last strokes actually represent a fifth value, but they're inconspicuous and simply melt away into the surrounding darkness.)

Step 1. For this picture, in which darks will predominate, the artist brushes two coats of acrylic gesso over a sheet of illustration board. One coat runs from top to bottom, and the other from side to side. The gesso is applied thickly so that the strokes, as they cross, produce a texture something like canvas. The rough texture of the dry gesso produces a slightly shadowy surface that will enhance the shadowy tone of the painting. When the painting surface is absolutely dry, the artist begins his preliminary pencil drawing.

Step 2. Since the sky is the source of the light and therefore influences the entire picture, the artist begins by painting the sky. He blocks in the lighter middletones—although there are subtle variations in value as he adds slightly darker strokes to suggest clouds against the overcast sky. As he moves down toward the horizon, he lightens his strokes with more white. This pale gray will be the lightest value in the picture.

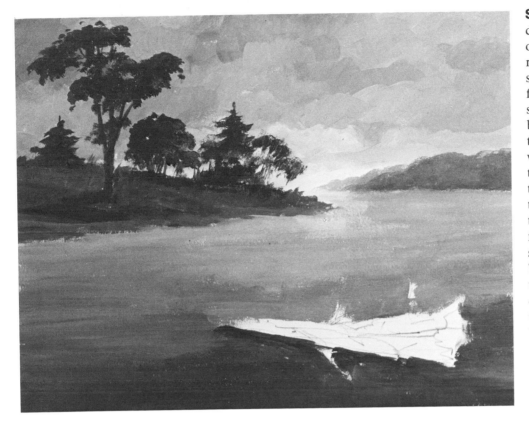

Step 3. The artist introduces the darker middletone of the distant shore at the right. Then he blocks in the shore at the left with a faintly darker version of the same middletone. He also brushes this dark middletone into the foreground water. Picking up the lighter tone of the sky, he brushes this across the water above the log—and blends it with the darker middletone in the foreground. Just where the sky meets the lake, he blends the palest value into the water. Then he introduces the darkest value into the trees and the shadows beneath the trees.

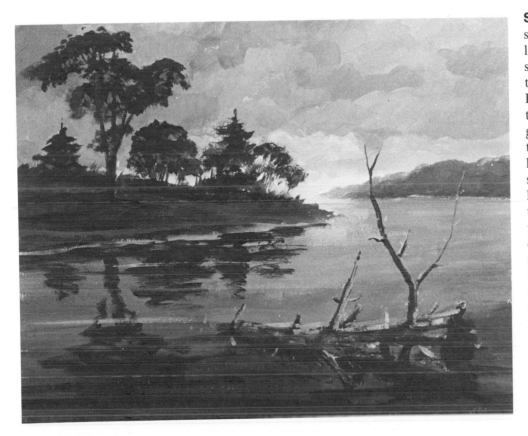

Step 4. He adds more dark shadows to the shore at the left and carries the dark strokes down into the water to represent the reflections. He strengthens the dark tone of the water in the foreground. Then he blocks in the floating log with the light middletone. He adds shadows and details on the log with the darker middletone and the dark. Then he paints the light-struck edges of the shapes with a few pale strokes of the lightest value. He solidifies the shapes of the trees on the shore by adding dark middletones. Finally, he paints a few light streaks in the water with the same pale tone that appears above the horizon.

Step 1. To accentuate the contrasts between light and dark, the artist first brightens the canvas board with an extra coat of acrylic gesso. Then he brushes in the shapes of the composition with dark strokes that will soon disappear beneath the dark values in succeeding steps. As before, the artist begins by painting the sky in a light value. He adds just a bit more white for the clouds, but the values of the sky and clouds are so close that they register as a single pale tone.

Step 2. The artist blocks in the distant hills with two values: a darker middletone for the foliage at the top of the hill, and a lighter middletone for the sloping side of the hill. We begin to see that the pale value of the sky actually represents the lightest tone in the picture. For the moment, the artist is keeping all the values fairly light so that he can darken them later on to accentuate the contrasts.

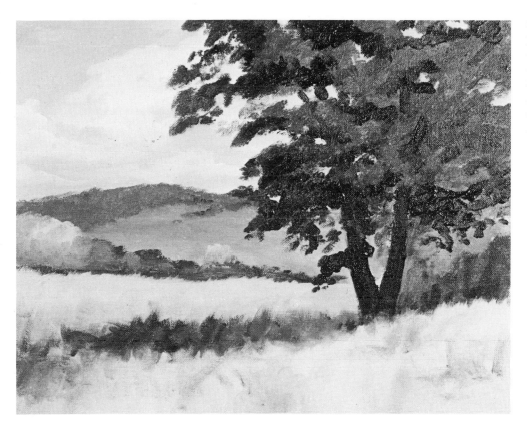

Step 3. At the foot of the hill, the artist paints a row of trees. He starts with a sunlit patch at the left and ends with a dark middletone like the one on top of the hill. He blocks in the foliage of the big tree with the same middletone and then carries this tone across the grass to suggest the shadow of the tree. He paints the distant sunlit field and the sunny foreground with the same value as the sky. Then he begins to block in the darks on the tree trunk and in the shadows beneath the masses of foliage.

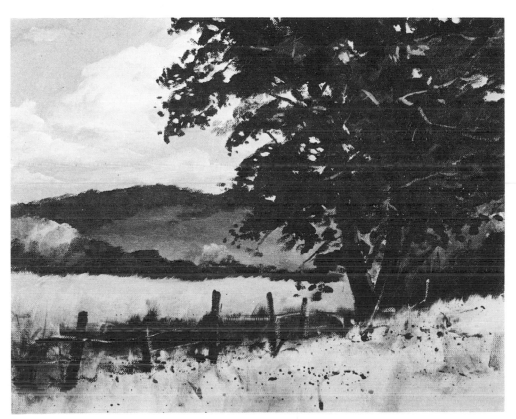

Step 4. Now the artist strengthens all the tones. He darkens the foliage at the top of the hill, the row of trees at the bottom of the hill, and the strip of shadow across the foreground grass so that they're all a dark middletone. He also darkens the side of the hill so that it's now a light middletone, distinct from the pale sky and the sunlit field. Finally, he strengthens the two tones on the tree, so that they're clearly a dark middletone and a dark.

Step 1. After defining the shapes of the wooded headlands with pencil lines on a sheet of illustration board, the artist paints the sky and water in a single operation. He starts with a pale value in the sky and gradually darkens his strokes as he moves down into the water. It's a foggy day, so the sky and water seem to flow together. At this stage, you may think that you're seeing a lighter and a darker middletone—but things will change.

Step 2. The artist blocks in the most distant headland with a value that's slightly darker than the sky, deepening the tone a bit to suggest the trees on the crest. Then he paints the triangular shape of the headland in the middleground with a faintly darker value, again deepening the tones to indicate the trees on the slopes, and lightening the values gradually at the base of the rocks to suggest a low-lying mist. He paints the rocky shore in the foreground with a similar value, and blocks in the dark rock in the lower left. The value scheme of the picture still isn't clear to the viewer, but the artist knows what he's doing, as you'll see in a moment.

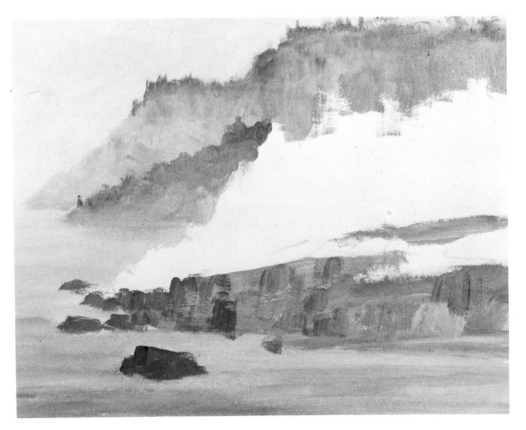

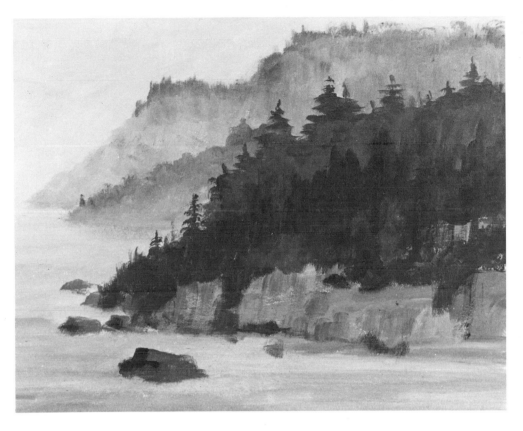

Step 3. When the artist blocks in the dark trees, the logic of the values becomes clear. The lightest tone is the sky, which blends into the lighter middletone in the foreground water. The most distant headland is the same light middletone, with a hint of the darker middletone at its top. This darker middletone reappears in the small triangle of the headland in the middleground and in the foreground shore. The strongest darks are the trees. They're actually *two* dark values, but they're so close that they register as a single dark tone when you look at the picture with half-closed eyes.

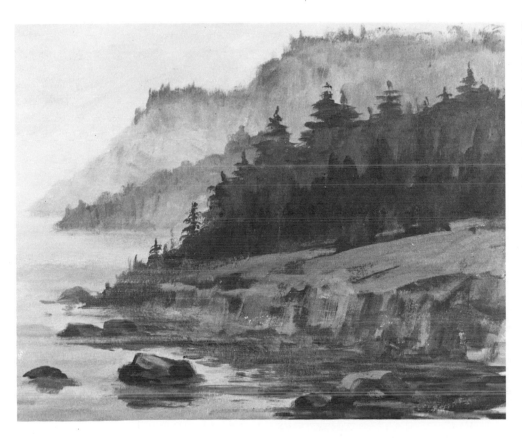

Step 4. The artist completes the complex tones of the foreground. He brushes the lighter middletone over the top plane of the shore. Then he alternates dark strokes with middletones on the shadowy sides of the shore and in the reflections. The rocks are further developed with similar combinations. In the finished picture, none of the darks come from the bottom of the value scale and none of the lights come from the top. Because all the values here are quite close to one another on the scale, this coastal scene is a low-contrast painting.

Sketch for Demonstration 1. Planning your values is so important to the success of any picture that you should develop the habit of making little value sketches before you begin an acrylic painting. Such sketches can be crude and scribbly, just as long as they give you a clear idea of the distribution of values in the picture. In this tiny pencil sketch, the artist decided how he'd use values to create a sense of aerial perspective in Demonstration 1.

Sketch for Demonstration 4. When you paint out-doors, take along a pocket sketchbook and a thick pencil or a stick of chalk that will make broad strokes. Working quickly, make several sketches and choose the value scheme that looks best. In this value sketch for the painting in Demonstration 4, the rocks, trees, and waterfall may be recognizable only to the artist. But the sketch clearly establishes the location of the darks in the foreground, the two middletones along the far shore, and the light tones of the sky and water.

Sketch for Demonstration 6. This value sketch actually had two purposes. As usual, the artist wanted to establish the distribution of lights, darks, and middletones. But he also used the sketch to record the shapes and locations of the fast-changing clouds. Obviously, this wasn't meant to be a precise drawing of each cloud. But a sketch like this one helps to fix the forms and placement of the clouds in the artist's memory, so he can paint them convincingly, even though the sky will change.

Sketch for Demonstration 9. As you remember, Demonstration 9 shows the wet-into-wet technique, which means that most of the shapes are soft and slightly blurred. In the preliminary sketch, the artist takes extra care to plan the contrast between the strong hard-edged darks and the pale, soft tones that fill the rest of the picture. Be sure to save all your value sketches—especially the *rejected* ones—for possible future use. Your little pocket sketchbooks will contain a wealth of ideas for future paintings.